20 -

Stormy Weather

Stormy Weather

F.H. VARLEY ❖ A BIOGRAPHY

MARIA TIPPETT

M&S

Canadian Cataloguing in Publication Data

Tippett, Maria, 1944-
 Stormy weather: F.H. Varley, a biography

Includes bibliographical references and index.
ISBN 0-7710-8524-9

1. Varley, Frederick Horsman, 1881-1969. 2. Painters – Canada – Biography. I. Title.

ND249.V37T56 1998 759.11 C98-931181-3

We acknowledge the financial support of the Government of Canada through
the Book Publishing Industry Development Program for our publishing
activities. We further acknowledge the support of the Canada Council for
the Arts and the Ontario Arts Council for our publishing program.

Typeset in Centaur by M&S, Toronto
Printed and bound in Canada

McClelland & Stewart Inc.
The Canadian Publishers
481 University Avenue
Toronto, Ontario
M5E 2E9

1 2 3 4 5 6 03 02 01 00 99 98

For David and Mary Huitson

CONTENTS

ACKNOWLEDGEMENTS

I am, first of all, indebted to the public institutions in Canada and abroad that helped me view paintings and photographs and study manuscript and printed material. They are: Agnes Etherington Art Centre, Queen's University; Art Gallery of Greater Victoria; Art Gallery of Ontario; Art Museum of Antwerp; Banff Centre; Beaverbrook Art Gallery; Bowen Island Public Library; Burnaby Art Gallery; Cambridge University Library; Canadian Broadcasting Corporation Archives; Canadian War Museum; Churchill College Library; Dominion Art Gallery; Edmonton Art Gallery; Emily Carr College of Art; Thomas Fisher Rare Book Room, University of Toronto Library; Greater Art Gallery of Victoria; Hudson's Bay Company Archives; Koninklijke Museum voor Schone Kunsten, Antwerp; London Regional Art and Historical Museums; MacKenzie Art Gallery, Regina; Massey College, University of Toronto; McCord Museum; McMichael Canadian Art Collection; Mills Memorial Library, McMaster University; Montreal Museum of Fine Arts; Mount Allison University; Musée du Québec; National Archives of Canada; National Film Board of Canada; National Gallery of Canada Library; National Library of Canada; Nationaal Hoger Instituut en Koninklijke Academie voor Schone Kunsten, Antwerp; Nova Scotia Museum of Fine Art; Ontario School of Art; Public Archives of British Columbia; Public Archives of Ontario; Queen's University Archives; Robert McLaughlin Art Gallery; Roberts Gallery Ltd.; Saskatchewan Archives Board; Sheffield City Archives; Sheffield City Art Galleries; Sheffield School of Art; Trinity College, University of Toronto; University of

British Columbia Art Gallery; University of Manitoba Library; University of Toronto Library and Archives; Vancouver Art Gallery; Winnipeg Art Gallery; Winnipeg School of Art; Women's Art Association, Toronto. Seminal to this study were two M.A. theses from Queen's University by K. Janet Tenody and Andrea Kirkpatrick. Also helpful were Chris Varley's two exhibition catalogues, *Frederick H. Varley*, 1979 and 1981, and Peter Varley's moving portrait of his father in *Frederick H. Varley* (1983). The late Kathleen McKay gave me several interviews over a period of twenty years; Jack Nichols, Hélène Tolmie, and Chris Varley also gave me interviews. Other individuals who contributed to this project were Jack Shadbolt, Fay Bendall, Margaret MacMillan, Louis Muhlstock, Marian Fowler, Dan Curtis, Jim Osborne, Beth Robinson, Florence Barbour, Fran Gundry, Bill Young, Alistair McKay, Susan Scott, and Peter Larisey. Special thanks to Maia-Mari Sutnik and Larry Pfaff at the Art Gallery of Ontario; Cheryl Siegel, Lynn Brockington, Rose Emery at the library of the Vancouver Art Gallery; Linda Morita of the McMichael Canadian Art Collection; and Ann Goddard at the National Archives of Canada. Modest funding was provided by the managers of the Smuts Memorial Fund, Cambridge University, the Research Fund of Churchill College, and the B.C. Arts Council. David Huitson cast his learned eye over the manuscript. Peter Clarke not only read, but listened to the story as it emerged. Finally, my publisher McClelland & Stewart, and Jonathan Webb, Peter Buck, and Douglas Gibson in particular, gave their support from the beginning of the project.

Stormy Weather

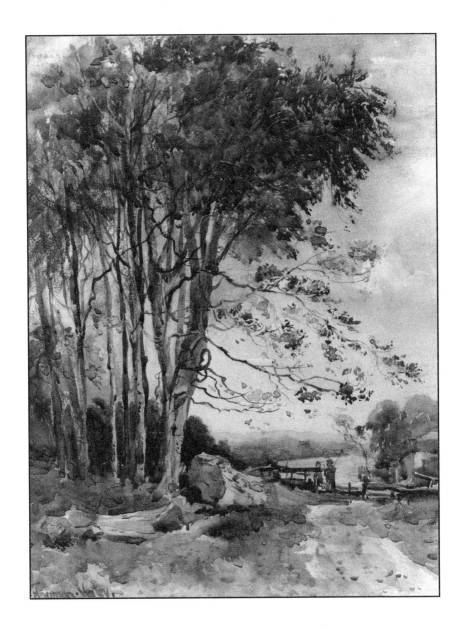

Seven Fields, 1900.

SHEFFIELD GALLERIES AND MUSEUMS

CHAPTER 1

Pride of Ancestry

On a visit to England in 1956, Fred Varley walked into the British Museum in London. By this time he was one of Canada's best-known painters. His reputation rested not only on his achievement as a war artist during the First World War and on his renown as a portrait painter: crucially, Fred Varley was a member of the country's most celebrated group of artists, the Group of Seven. A major retrospective exhibition of his work had just toured Toronto, Montreal, Ottawa, and Vancouver. In London, Varley now wanted to see the Elgin Marbles, which he had first viewed more than fifty years earlier when he had been a struggling black-and-white artist. He also wanted to show his travelling companion, Kathleen McKay, the watercolour paintings of the early nineteenth-century artist, John Varley.

It was a tenuous link that joined Fred Varley to the illustrious painter John Varley, who, with his brother Cornelius, had been a founding member of the Society of Painters in Water-Colour in 1804.[1] But Fred Varley made the most of his ancestral connections. These talented men had hobnobbed with William Blake and J.M.W. Turner. They had written books on the virtues of painting *en plein air*, on the principles of landscape design, and on perspective. Their interests had extended to science and astrology – Cornelius Varley invented the graphic telescope and the lever microscope – and to astrology – John Varley wrote a *Treatise on Zodiacal Physiognomy* in 1828. John was the better painter of the two men. His powerful and expressive style was well known, as was his ability as a teacher.

According to one commentator, John Varley was "the most sought out drawing master of his time."[2]

Fred Varley and Kathleen McKay found the Elgin Marbles at the British Museum, but they were unable to locate any paintings by John Varley. They approached a guard for assistance. Fred told him what they were looking for. "You can't see them today," the guard said, pointing to his watch, which indicated that the museum was about to close. But Kathleen persisted. She informed the guard that the man standing beside her was "Frederick Varley, our greatest Canadian watercolour painter." She ruefully recollected later that "it made no impression."[3]

There was no reason why the guard, or anyone else in London, would have been impressed by the diminutive, soft-spoken, seventy-four-year-old Frederick Horsman Varley. True, some of his landscape paintings and portraits had been exhibited in London, but always in the company of other artists. In 1919 his work as an official war artist had formed one small part of the *Canadian War Memorials Fund Exhibition* at Burlington House in Piccadilly. Five years later his paintings had been exhibited, alongside that of his colleagues in the newly formed Group of Seven, at the British Empire Exhibition at Wembley. And in 1938 Varley had had three portraits and two landscape paintings included in *A Century of Canadian Painting* at the Tate Gallery.

Thus, although Varley was one of the most distinguished artists in Canada, his work was virtually unknown in London. And when he and his companion boarded a train at St. Pancras Station and headed north to the Yorkshire city of Sheffield, things did not improve. According to Kathleen McKay, they found Varley's birthplace "very ugly" and "very dirty."[4]

Sheffield, lying on the edge of the coalfield abutting the eastern flank of the southern Pennines, was not as dirty in 1956 as it had been during Fred Varley's youth. Then, the skies above the "Steelopolis," which produced the largest share of Britain's cutlery, steel grates, silverware, and scissors, were lit with the molten glow

from the steel refineries. The foul-smelling smoke and the ink-black soot which oozed out of the tall chimneys blackened the stone and the brick façades of the buildings. It made skeletons of the trees. And it gave the city's inhabitants, who believed the soot to be a good disinfectant, a higher death rate from pulmonary disease than anywhere else in England.

But rebarbative Sheffield had its compensations for those who lived there in the late nineteenth century. Many agreed that "no larger town in the Kingdom [was] situated in the midst of so charming and picturesque a district."[5] The white limestone paths, bridleways, and lanes which scored the Don, Loxley, Sheaf, Porter, and Rivelin valleys led to high, rounded moorlands and to rugged inland scarps. Within half an hour of Sheffield's town hall, the energetic walker could be knee-deep in heather or bilberry wires or among copses of ash, beech, oak, and sycamore woodland. With an early start and the help of a horse-drawn coach or omnibus, the rambler could travel to Hope, then climb to the craggy shoulder of Kinder Scout, located in the middle of the Peak district, by noon. A day's outing on the "lonely mountain-moor lands" was uplifting.[6] It distilled and clarified the urban experience by providing a refuge from the frenetic pace of the smoke-blackened city.[7] And it offered the artistically inclined a varied range of subjects for the canvas or hot-pressed watercolour paper. Ever since Richard Wilson and J.M.W. Turner had painted Britain's mountain scenery at the end of the eighteenth century, painters and sketchers had sought out the Derbyshire Peak district lying to the west of Sheffield.

No one appreciated the contrast between the town and the countryside surrounding it more than Fred Varley. But he retraced his steps in 1956 not only to see the landscape which had inspired his first paintings. Fred Varley revisited Sheffield in order to be acclaimed as he was in Canada. The sad fact soon became apparent, Kathleen McKay remembered, that "nobody knew him."[8] This should not have come as a surprise to Fred Varley. He had not lived in Sheffield since emigrating to Canada in 1912. The only people he

knew there now were his older spinster sisters, Lilian and Ethel. The name of Varley was of no account in modern Sheffield, and whatever resonance that city had for the returning traveller now lay buried in the past.

Although Fred Varley was born in Sheffield in 1881, the Varley family hailed from Epworth in Lincolnshire. A few decades before the end of the eighteenth century, however, Fred Varley's great-great-grand-father, Richard Varley (1751-1791), moved to Hackney, Middlesex, then on the outskirts of London. Fred Varley's father was born in Islington, London, in 1849, the son of a boot- and shoe-maker, Samuel Varley, and his wife, Elizabeth Bloom Meggett Varley. They named the boy Samuel Joseph Bloom Varley. When he was eight, the family moved to Sheffield, where they settled. Young Samuel went to London for his training as a commercial artist before returning to Sheffield, where he quickly found employment with a print and design firm, Henry Pawson and Joseph Brailsford.

Advertising emerged as an industry during the 1870s, when more sophisticated printing techniques created a mass market. Lithographers, engravers, and illustrators decorated cheques and sheet music and designed pattern books, notepaper, and envelopes. They also fulfilled the public's "craving for visual representations of the world, of events, and of the great and the famous" by providing illustrations for newspapers, postcards, national magazines, the Penny Press, books, and, towards the end of the century, for the ubiquitous cigarette card.[9]

Pawson and Brailsford boasted that they employed only "Artists and Workmen of first-rate ability."[10] Samuel Varley did the firm proud by producing lively pen-and-ink sketches of "Old Sheffield" for the *Sheffield Independent*.[11] He made an exquisite drawing of hands for Pears Soap's famous advertisement using his wife, Lucy Barstow, as the model. But his most accomplished works were the coloured illustrations accompanying Henry Seebohn's learned text in *Coloured*

Figures of the Eggs of British Birds (1896). A competent and sometimes even a brilliant draftsman, the soft-spoken Samuel was, however, a pale reflection of his illustrious forebears, John and Cornelius Varley. Possessing a "pride of ancestry," Samuel Varley nevertheless strongly identified with his artist relatives. He collected reference material pertaining to the offspring of Richard and Hannah Fleetwood Varley from the *Encyclopaedia Britannica*.[12] And he coveted the silhouette portrait of his top-hatted father, Samuel.

Yet Samuel Varley had no contact with the succeeding generations of the London-based Varley family. This might have been due to Sheffield's distance from London, some two hundred miles away. Or it could have been simply a matter of class. As artists and engineers, Samuel's London relatives were firmly rooted in the middle class. As a lithographic draughtsman and the son of an artisan, Samuel was clearly lower middle-class, along with clerks, schoolteachers, commercial travellers, and other salaried employees.[13] Members of that class had few contacts beyond the perimeter of their village, town, or city. They could expect to spend their entire working career with one firm. Though their earnings were only marginally higher than those of an artisan, social pretension often forced them to emulate a style of living that was well above their salary. Acutely conscious of the fact that they were not working-class, they took Sunday observance and the practice of public worship very seriously. Like many lower middle-class families in Sheffield, the Varleys attended the Congregational Church. Yet it was the home that provided "the physical setting for, and the embodiment of, Victorian values of moral virtue, industry, thrift and sobriety, male superiority, and the obedience of wives and their children."[14]

For most lower middle-class families living in late-nineteenth-century Sheffield, home was a humble though respectable dwelling. It was generally located a reasonable distance from the busy main roads, and in between, or on the edge of, more prosperous areas. Samuel and Lucy's first home – a three-storey, two-rooms-to-a-floor, red-brick row house abutting the pavement on Cavendish Square – was situated in the centre of the noisy city. Their next home,

acquired in 1884, was a red-brick house which formed part of a terrace on the fringe of the well-treed middle-class district of Broomfield. Though the Havelock Square house had neither an indoor toilet nor heating in the upstairs bedrooms, it did have a large kitchen and dining and sitting room on the ground floor, three bedrooms on the second and third floors, a front garden, and a back garden that was dominated by a large elderberry tree. Since the house was within easy walking distance of Pawson and Brailsford, Samuel could still come home for his midday dinner.

Wherever the Varley family lived in Sheffield, the household revolved around Samuel. Lucy and the children had their morning wash at the kitchen sink. Samuel bathed in a basin of hot water in the privacy of his bedroom on the second floor. When Samuel came home for dinner at noon, one member of the family was always posted at the front door to greet him. And if Samuel happened to return home from work in the late evening, Lucy saw to it that her husband got more than the bread, butter, and jam that she and the children had eaten at 5:00 p.m.

While Samuel Varley might have had limited expectations for his own career, his expectations for his offspring were high. He saw to it that the family had a set of good books. He bought a piano, then gave his musically gifted children private music lessons. And, at no mean sacrifice to Lucy and himself, he made it possible for his children to take post-elementary schooling.

After the Education Act of 1870 allowed the establishment of school boards in England, Sheffield provided every child between the ages of five and thirteen with free instruction. And when the city founded the Central High School in 1880 — the first of its kind in England — boys and girls from relatively underprivileged families like the Varleys had a chance to prepare themselves for advanced education. Samuel and Lucy's first three children, Lilian, Alfred, and Ethel, who were born in 1875, 1876, and 1879, all graduated from the Central High School. Then, with the assistance of their parents, they enrolled in night school or attended daytime college and became schoolteachers.

When Samuel "got it in his bones" that his fourth and last child, Frederick Horsman, "was going to be a great artist," he did everything that he could do to make it happen.[15] Though good at mathematics, the young child "wasn't a bit interested" in any other subjects.[16] When this became apparent to Samuel, he removed Frederick from the free Springfield School which his other children had attended, and gave him private instruction under the science teacher, Professor William Ripper.[17] After Frederick had completed his elementary education, Lucy and Samuel dipped into their pockets once again. They sent their son to the Sheffield School of Art. And then they made it possible for him to study at the Académie Royale des Beaux-Arts in Antwerp.

To contemporary observers the Varley family would have appeared respectable, financially secure, devout, and upwardly mobile. Yet the family was deeply troubled. They were divided by conflicting loyalties. Lucy doted on her first-born, the clever and strong-willed Lilian. She also favoured her last-born, Frederick, who arrived at Cavendish Square on the couple's wedding anniversary, 2 January 1881. Lucy's concern for the boy began at the outset: there had been "a little trouble" at Frederick's birth.[18] Her exaggerated anxiety for her youngest child persisted because the skinny, small-boned boy with a shock of bright red hair was delicate. Frederick balked at his mother's overprotectiveness, feeling that "she didn't want me to grow up."[19]

Samuel also indulged his artistically minded second son, although it was his younger daughter, Ethel, whom he considered to be "the flower of the flock."[20] It was Ethel who accompanied Samuel Varley on his trip to the Isle of Wight and she who made her father laugh. Indeed, as Ethel put it in old age, she "wouldn't get married because she preferred to stay with Dad" and she gave up her career as a schoolteacher in order to look after her ageing parents.[21] Alfred was the least loved of the Varley children. He not only failed to win the favour of either parent, his siblings failed to understand him.

The division which cut the deepest in the Varley family, however, lay between Samuel and Lucy. It seems that things between them were fated to go wrong from the start. "Dad made a mistake," according to Ethel. This was because "he really was in love with somebody else but he had to marry [Mother]."[22] Lucy's father, Elias Barstow, did not help the young couple get off to a good start: he refused to attend their wedding, which took place in the Congregational Church on 2 January 1874. Apparently "bitter" over the imminent collapse of his insurance business, Elias left the bride to be given away by her uncle, George William Naylor, and by Samuel's sister, Mary Elizabeth Bloom Hadfield.[23] Even before the wedding took place, "a great wrong" appears to have befallen Lucy Barstow. The wrong which occurred involved Samuel's only sibling, Mary Hadfield. Family legend has it that Mary persuaded her brother "to go to a certain place to buy the furniture" for his new home. "That," Ethel recalled, "was a very great wrong for my mother." And Lucy never appears to have forgotten the incident nor to have forgiven her husband, Samuel, for his role in it.[24]

The bitterness which resulted from this and from other unfathomable incidents meant that "you never saw a bit of love" between Samuel and Lucy.[25] Christmas was a particularly joyless time. Lucy, who was "no fun" because "she couldn't see a joke," once forced the children to sit in front of their presents while she cleaned the house. "Christmas was unhappy – waiting, waiting, until she had finished the cleaning."[26]

What Ethel called the "secret sorrow" of her father's life made Samuel "low-spirited."[27] At home he appears to have retreated into his books – he was a great reader – and at Pawson and Brailsford he worked long hours for little pay, to the detriment of his fragile health. Solace came to him only on the weekends. Accompanied by Ethel and Frederick, Samuel headed for the moors and walked until it was time to return home for tea.

The bulk of these reminiscences, which chart the Varley family's home life, come from a daughter who confessed in old age that "Dad was the only man I ever loved."[28] Convinced that "he needed

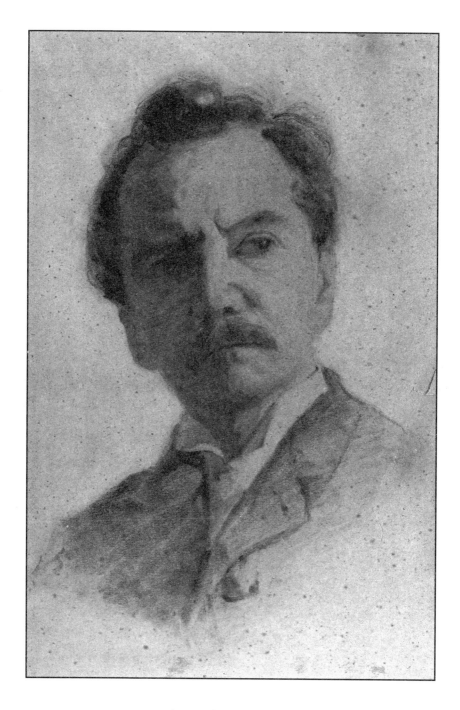

Portrait of Samuel J.B. Varley, c. 1900-02.

someone to love him," Ethel provided that love, with the result that "we were very happy together."[29] Ethel was subsequently remorseful about her favoured position, suggesting that young girls should move out of the family home since "the affection goes to the girl and the wife is left in the cold."[30] While the veracity of Ethel's reminiscences are no doubt skewed by the great affection she had for her father on the one hand, and by her dislike of her rival mother on the other, there is little evidence to counter her suggestion that Lucy Barstow Varley was overbearing and difficult, that the Varley home was an unhappy one, and that all of the children were affected by this in one way or another.

Lucy was two years younger than her husband. She was born in Sheffield to Elias Barstow, a bookseller and stationer who eventually became an estate agent, and to Thirza Barstow, a successful dress-maker and milliner. Lucy was equally "clever with a needle," having learned the trade from her mother. By 1868 she had her own premises at 39 Regent Street. Here Lucy was "a dress renewer for the old ladies" in the Broomwell Road where "the higher people lived."[31] Unlike her mother, however, Lucy Barstow did not work after she married because it was generally believed that a woman could best serve the community "by giving birth to healthy children to whose moral and mental nurture she can give the whole of her thoughts."[32] Like other lower middle-class women, Lucy Barstow Varley devoted all of her time to raising and disciplining her four children, to mend-ing, cooking, and scrubbing, and to bargaining with the butcher to ensure that meat appeared on the table once a day. "Relative to the other members of the household, the housewife did not get her 'fair share' of time off since *her* work facilitated their leisure."[33] Indeed, Lucy saw to it that the parlour in which Samuel read and the chil-dren played the piano and sang was comfortable. And it was Lucy who packed the cold lunch that Samuel, Ethel, and Frederick took with them onto the moors. Just as Samuel worked hard in the office, Lucy strove to improve the lives of her husband and her children at home. Although Lucy was assisted by a washerwoman, whom Frederick nicknamed "Annie Baggy Baggy" because her stockings

"always went in bags around her legs," all of the other household chores fell to her.34

Samuel's unhappiness throughout his married life might not have been entirely due to his difficult relationship with Lucy, or, if Ethel is right, to being in love with another woman, or to being over-worked at Pawson and Brailsford. What Frederick called his father's "low spirits" probably had more to do with Samuel's "frustrated ambitions" as an artist than with anything else.35 Almost everything Samuel produced as a lithographer was anonymous. His name did not even appear on his most brilliant effort: the drawings accompanying Seebohn's *Coloured Figures of the Eggs of British Birds*. (This omission left at least one admirer of his work puzzled as to who had produced the superb drawings.36) Not having realized his potential as an artist, Samuel placed a heavy burden on the one child in his brood who showed aptitude in that field.

To Samuel Varley's joy, Frederick displayed enormous talent at an early age. Before he was old enough to cross the street to attend the Springfield School, he made a drawing of hands and of the horses that stood at the cab stand around the corner from the house. And, at the age of six, he executed his first portrait — it was of himself. Though the work exists only in photocopy, the beautifully controlled lines delineating the head and the deftly shaded areas of the boy's jacket suggest that the original must have been an accomplished work for so young a child.37 Frederick clearly possessed a striking talent which Samuel was quick to recognize, appreciate, and support.

The last two decades of the century were a good time to be an artist in England. Public and private art galleries were opening across the country to cater to the downward movement of patronage on the social scale. Paintings by living British artists were being bought by more people than ever before, thanks to the vogue established by the early Victorians. Artists not only had a larger market for their work

than was the case earlier in the century; but with the arrival in England of Continental and American buyers in the 1890s, they could also expect to earn a decent living. "The elevated status of art in the late nineteenth century" was due not only to inflated prices.[38] The aesthetic movement's cult of the beautiful, along with the artist's enormous popularity as a character in fiction, biography, and journalism, made the career an attractive one. Moreover, as the *künstlerroman*, or artist-novel, of the day made clear, it was a profession in which someone without an aristocratic or even a middle-class background could make good.

Frederick began his formal art training at the Sheffield School of Art in 1894 at the age of thirteen.[39] Founded in 1843, ostensibly to teach "the utilitarian aspects of artistic skill," the school was "something more than a mere training ground for industrial craftsmen."[40] Courses on the "Principles of Ornament and Design" were taught alongside "Drawing, shading, and modelling whole figures from the cast." Students followed a rigorous regime, choosing from eight elementary and twenty-eight advanced subjects. The South Kensington Museum's Science and Art Department in London set the subjects, then chose illustrators and painters of the calibre of Walter Crane, George Clausen, and Frederick Brown to examine the students' work. Completion of the course work prepared graduates for a career in commercial art or gained them admission to the Royal Academy Schools in London or to a salon, atelier, or art school on the Continent.

Every course at the Sheffield School of Art was designed to teach the co-ordination of hand and eye, as well as close observation. In drawing from the Antique, students learned "to seize proportion, and find proportion with beauty of movement and form." In drawing from the clothed model – misleadingly called the Life Class – students were taught "to quickly catch movement, character, and get familiar with the beauty of curves in the lines of the human figure," while sketching from memory prepared them to retain "in the mind whatever the student may have drawn or seen."[41] The course work at the school was, for the most part, sheer

drudgery. Students began by drawing a straight line, then two intersecting lines, then curves, then they studied the principles of linear geometry and linear perspective.[42] Many of the exercises and examinations entailed copying: ornaments, plaster casts, engravings, skeletons, musculature, and paintings or engravings executed by other artists. Students advanced to the Life Class only after they had mastered the lessons in the elementary course. Once there, they followed a set of strict rules – seven and a half heads make the height of a figure and the greatest width of the shoulders is equal to two heads – as set out in Arthur Thompson's famous *A Handbook of Anatomy for Art Students* (1896). Thanks to Thompson, however, the students acquired "the ability to judge with considerable accuracy the direction, proportion and character of lines." They studied planes and solids and learned to feel at home with their medium. They were taught how to edit, summarize, emphasize, and condense, without distorting the figure.[43] And, most important of all, they discovered that the model could be an inspiration as well as a dictionary for the artist.

There is little work remaining from Frederick Varley's student days. Three pen-and-ink drawings, probably executed in 1897, are exercises in shading in the round. One of these works, *Still Life, Skull and Lantern*, shows the high standard which Frederick achieved as a young student of art.[44] Though reminiscent of the precise drawings which Samuel Varley had produced of "Old Sheffield" for the *Sheffield Independent, Still Life, Skull and Lantern* possesses much more flair and bravado. Even at this stage Frederick was leaps and bounds ahead of his father.

For the future Group of Seven artist, Arthur Lismer, who attended the Sheffield School of Art just after Varley, the instruction was academic and devoid of inspiration. Though Varley later concurred with Lismer's view – "for several years I swallowed classroom formulas" – he was indebted to the teacher who gave him his first lesson in drawing the human figure from the plaster cast.[45] Henry Archer possessed "a kindly disposition coupled with painstaking earnestness in his teaching work" which endeared him to all of his

pupils.[46] Frederick appears to have received special attention. Every morning Archer took him to a plaster torso of Phidias, or a slave, or Michelangelo's David.[47] Then he made his young student "feel their form" with his hands until he could draw them from memory. This is how Frederick learned to get "that feeling of life pushing out when you put that line on paper."[48] Though Henry Archer was "innocent of all the modern methods of art teaching," his advice gave the young artist a sound knowledge of human anatomy.[49] It formed the basis of Fred Varley's seeing and his feeling.

By the middle of the 1890s Sheffield could boast that it had one of the finest art schools in Great Britain. During that decade its students, numbering up to four hundred a year, received more gold medals from the South Kensington Museum examiners than any other institution in the country – and there were more than one thousand schools of art in Britain. Almost two decades before Frederick entered the school, Elizabeth Siddal – the artist and companion of the Pre-Raphaelite painter Dante Gabriel Rossetti – had been a student in Sheffield. Two fellow students of Varley's, Charles Sargent Jagger and Dudley Hardy, would go on to distinguish themselves in London: the first as the sculptor of the striking First World War memorial to the Royal Artillery at Hyde Park Corner, and the second as a prominent magazine illustrator. And Varley, along with Arthur Lismer, Elizabeth Styring Nutt, and Hubert Valentine Fanshaw, would all make their careers in Canada as artists and teachers.[50] It was the school's female students who took the lion's share of the prizes at the end-of-year conversazione celebrations. However, most, like the gold medallist Agnes Kershaw, sank into oblivion once their studies were over.

The Sheffield School of Art's success lay not only in the forceful personalities of its headmaster, John Thomas Cook, and his assistant, Henry Archer. Generous financial backing from the city council, voluntary subscribers, and the national exchequer allowed

the school to acquire more and more space in the collection of buildings fronting Arundel Street, to build an excellent library, to purchase the Bateman Collection of antiques, and, finally, to found a small art museum. (The museum's exhibits were borrowed from the Science and Art Department of the South Kensington Museum in London.)

The high esteem in which the city held the Sheffield School of Art was demonstrated at the school's annual conversazione. This end-of-year event brought public and private patrons, students and their parents, and the school's teaching staff to the central hall of the Mappin Art Gallery. Here they viewed students' work, witnessed the presentation to them of prizes, medals, and certificates, consumed refreshments, and listened to the music provided by Mr. Charles Harvey's band. These occasions gave Frederick a sense of belonging to an artistic community and to an artistic tradition. Not the least significant part of the proceedings was the talk that was delivered by the guest speaker who had been brought in from London.

Every speaker who addressed the conversazione during Frederick's time at the school praised the Sheffield School of Art's contribution to commercial as well as to fine art. Some, like John D. Crace, put more emphasis on the first: he encouraged students to devote themselves "to the practical side of art," assuring them that it was "as beautiful and ennobling as what was generally spoken of as 'fine' art."[51] Others, like James Orrock, who was billed as "the greatest authority on early English water colour art," and a fine painter to boot, devoted most of their talk to painting. Orrock told his audience that while foreigners might denounce "England as a barbaric nation in matters of fine art," he could assure them that the country had "produced great masters." He singled out the work of England's portrait painters – Hogarth, Reynolds, and Gainsborough – England's landscape painters – Turner and Constable – and England's most prominent art critic, John Ruskin. He also championed the work of John Varley, whom he called the most "original painter in water colour as to method and artistic arrangement and manner" and the most important teacher in the field of watercolour

painting. Orrock's praise of John Varley's painting must have struck a chord with Frederick and Samuel, who were both at the gathering.[52] John Varley remained an important figure despite his death some five decades earlier. And even though Samuel had lost contact with the London Varleys, he maintained a connection with his famous forebear by proudly displaying two of his watercolour paintings in the front parlour of his home.

To his friend and fellow student Elizabeth Nutt, Frederick was "a brilliant young man and a splendid draughtsman."[53] He won first-class standing at the end-of-the-year examinations in anatomy and in drawing from the antique and from life. He obtained the same mark in drawing in light and shade and from memory, and in painting from still life. His work was commended by the South Kensington Museum's examiners, earning Frederick a Departmental Free Studentship of nine pounds, six shillings, which more than covered his school fees for the 1897–98 academic year.[54]

Although Nutt insisted that "none surpassed him in our College," Frederick never won the gold, silver, or bronze medals that were handed out at the end of the year by the South Kensington Museum's examiners.[55] In fact, Elizabeth Nutt's own scholastic achievements outshone Frederick's. But winning medals required regular and punctual attendance. Students who had been to fewer than twenty classes a year could not sit for the year-end examinations. Frederick did skip classes. He went on picnics at Froggatt Edge with Elizabeth Nutt and Annie Hibberson, both of whom had "a great affection" for him.[56] And, by his own admission, he was "a smug precocious little brat."[57] As Arthur Lismer recalled, even then Fred Varley was "a rebel" who "always went the limit."[58]

Fred Varley's formative training cannot be measured by the number of commendations, awards, or medals that he did or did not receive while he was a student at the Sheffield School of Art, or by the hours that he spent in the classroom. Becoming an artist was a

process that took place as much outside the classroom as in it. It entailed squinting at, appraising, and comparing the size of objects. It involved calculating distances, noting movements and gestures, discovering harmonious relationships between lines, colours, planes, and masses until everything registered so automatically that it became part of the artist's subconscious.[59] Nor was art training solely a matter of co-ordinating the eye with the hand. Artists like Fred Varley were made by their life experiences as much as by their instruction in the classroom.

Frederick was an active child and a busy young man. Accompanying his boisterous uncle, the Reverend George Hadfield, to the less salubrious parts of Sheffield, he encountered "hordes of miners streaming home from work — black as the pit itself."[60] After a day at the school Frederick gave art lessons to a much younger art student, Frank Horratin, whom he "'adopted' and showed how to draw."[61] He attended celebrations. In 1887 Frederick witnessed the erection of what he later called "a dumpy little figure" in the centre of the Town Hall Square marking Queen Victoria's Golden Jubilee.[62] A decade later he saw the Queen herself at the official opening of Sheffield's town hall. On most Saturdays Frederick and his friends from the school listened to "a host of throaty voices" in the centre of the town. "Soap-box orators, the religious and irreligious fanatics, the ranting atheists, those agin' the government," and the Salvation Army. While the Army's converts sang, a "sister passed not only among her crowd but [among] the others as well, inveigling the pennies from the pocket to the jingling tambourine."[63]

Frederick would most certainly have also spent part of his leisure time in St. George's Museum. It was built in 1875 by the cultural critic and artist who championed the emergence of an indigenous landscape-painting tradition in Britain, John Ruskin. With a view to giving Sheffield's citizens a visual demonstration of his belief that "everything was more or less reflected in everything else," Ruskin put his vast collection of minerals, engravings, plaster casts, old-master copies, English watercolours, and books on display in St. George's Museum.[64] Built at the top of the Rivelin Valley in the suburb of

Walkley, the museum was intended to be a place "of noble instruction" for the city's workers.[65] But it was more successful in providing the city's art students, who were admitted free of charge, with their first taste of Turner, of the etchings of Albrecht Dürer, and of a whole host of paintings that had been copied from the work of Giotto, Fra Angelico, and Titian.

Sheffield was never a centre of art and patronage like Norwich, Bath, or its neighbour on the other side of the Pennines, Manchester. But it did have a museum, the Central Museum, which displayed pottery and cutlery; a library, the Public Free Library, which made it possible for everyone to borrow books; and a gallery, the Mappin Art Gallery, which housed John Newton Mappin's collection of about 150 popular, albeit minor, academic paintings. Visiting these cultural institutions, as well as playing sports in the gym and on the cricket pitch, consumed Frederick's non-studying hours. Eventually, however, he recalled being "wooed away from them by a sketch-book and the countryside . . . thanks to my father who led me to it."[66]

"We used to set out from the smoky city of Sheffield and walk forty miles a day," Arthur Lismer recalled. And Fred Varley "would do more."[67] From the moment Samuel Varley took his son onto the moors, Frederick revelled in the landscape. He later remembered that "the wilder the country and the wilder the weather, the better I liked it, and often before dawn, climbing the streets of the town before the gas lamps were snuffed out, I would be on the moors to see the stars pale into the day, returning only at nightfall." "Sometimes returning late, the wild weather shaking the house, Mother, for love of me, lost her rare temper when she knew that I was home again," he continued, "and I got to know the moment when it was wise to yank my sketches out for Dad, knowing that he would be more interested in them than in the admonishment of me."[68]

The moors were hardly the open smiling tracks of countryside that Varley later remembered. Up to 1932, the year some four hundred ramblers demanded the "right to roam" during a dramatic demonstration on the Kinder Scout plateau, the moorlands surrounding Sheffield were largely in private hands.[69] Walking in the

Derbyshire Peak District, especially during the grouse-breeding or -shooting season, could result in arrest. Rambling not only held a frisson of danger for Varley and his father; the moors were also redolent of history and romance. Samuel gave Frederick his first history lesson on the moors at Win Hill. Pointing to Lose Hill on the opposite side of the Derwent Valley, Samuel indicated the spot where the Norman invaders had fought a major battle. Hiking further up Win Hill, Frederick found a beautifully shaped stone which Samuel identified as an arrowhead.

Frederick and Samuel saw real as well as imagined encampments during their long walks. It was not unusual for them to encounter a group of Gypsies. To one late-nineteenth-century artist "the blue smoke from a Gypsy fire, where a merry picnic party are grouped by a water margin," made the landscape more picturesque.[70] The Gypsies' physical beauty – "graced by a pretty style of dress and ornamentation" – along with their closeness to nature and unbounded freedom, made them an attractive subject for the artist.[71] It is not surprising that Frederick was fascinated by Gypsies at an early age. They added an exotic note to his wanderings with his father and they became a motif in his early drawings and watercolour paintings of the landscape.

All of these experiences during Frederick's formative years in Sheffield were coupled with the absorption and the rejection of ideas and with the act of imagining himself to be an artist. Samuel had instilled in his son the notion that artists were a special kind of being with a special kind of life. They not only painted, they had opinions. Frederick, whom Samuel called his "petit philosopher," was never lacking an opinion, however obscure the topic might be.[72] Nor was he shy about putting his thoughts before anyone who was willing to listen. As he later remembered, he was not only ignorant during his boyhood, he also had plenty of gall.[73]

Crucial in giving Frederick a framework in which he could both imagine himself to be an artist and find a purpose for his chosen profession, was John Ruskin. Though "beset by bouts of depression and fits of insanity," Ruskin was an artistic icon during

Varley's years as a student.[74] Even if Frederick did not read Ruskin's most important work, *Modern Painters*, which was available to him in a two-volume condensed version in 1897, he would most certainly have heard something about him from his teachers, Cook and Archer. When Fred told an audience in 1924 that a work of art lived because of "the truthfulness with which it portrays life," he was echoing Ruskin's most deeply felt beliefs.[75] Ruskin's philosophy, attributing to landscape painters powers of observation that enabled them to commune with nature and thereby "reveal the essential truth of things," would lie at the heart of Fred Varley's artistic project throughout his life.[76] By putting the landscape "so squarely at the centre of social, political, and environmental morality," Ruskin ensured that art and morality, and even the artist and God, were in perfect step.[77] Even though Varley later dismissed the art critic as ignorant for condemning the late, proto-Impressionist paintings of Turner, Varley nevertheless remained the living embodiment of Ruskin's thought.[78]

Formal religion played a less important role in shaping Frederick's view of the world than did the teachings of John Ruskin. Though he sang in the choir of the Congregational Church as a boy, Ethel does not remember her teenage brother accompanying the family regularly to church. After reaching puberty, Frederick left the Congregational Church for the more formal Anglican Church: "I remember as a kid — about 16 or 17 — every day I stole away from art school for a half hour midday service at St. Paul's." The depth of his commitment to Anglicanism was so strong at the time that he asked the Archdeacon to ordain him. The bishop responded by giving the young man "an empty flabby hand" and telling him "to grow up."[79] Undaunted by this rebuff, Frederick formed a religious group of his own. Wilfred Hobbs, along with two other friends from the school, met Frederick on the moors for worship during the week. In the quiet offered by their dramatic surroundings they studied the gospels and exchanged their thoughts.[80] "One winter midnight," Varley remembered:

I went up with three devout friends to Stanage Edge, a high bleak moor ten miles from Sheffield. The top was covered with snow and the view of industrial lights below was beautiful. All of a sudden the four of us knelt to pray. We emptied ourselves. We knew then that God does not belong to this church or that. And afterwards we felt so exhilarated and exultant that we laughed and wrestled and snowballed each other for half an hour before walking down to Sheffield.[81]

When the University of Sheffield heard of this religious group, according to Frederick, they "sent their delegates to ask us whether we would be affiliated with their similar movement." Frederick demurred because "it couldn't be the same as two or three gathered together."[82]

Frederick's dissatisfaction with the established church during these years of "seeking to find" was not unusual.[83] The scientific and social revolution of the late nineteenth century had bred a technological and secular-minded society. It also created a massive working class which was determined to secure its place in the sun. Organized religion's failure to respond to the secular world saw "a gradual weakening of the position of social influence enjoyed by the churches."[84] Movements ranging from socialism to spiritualism emerged to challenge conventional Victorian ideals and conventional forms of worship.[85] "Restlessness" and, as Arthur Lismer remembered, his search for "something beyond the materialism of the age," made Frederick receptive to a wide range of unorthodox forms of religion.[86] He dabbled in Buddhism, which he discovered through reading Edwin Arnold's popular poem, *The Light of Asia* (1879), chronicling the life and character of Prince Gautama, the founder of Buddhism. He was introduced, through Arthur Lismer, to Theosophy and to the ideas of the leader of the Socialist Society, Edward Carpenter.[87] Varley was particularly attracted to Theosophy. Its synthesis of science and religion, as well as its adaptation of Eastern religion to modern society, struck a chord with him. He was

no less impressed by Edward Carpenter's anti-materialist view of the world, which held that "The Art of Life is to know that Life *is* Art."[88] Yet after his foray into the Anglican Church, Varley never attached himself to any belief, however esoteric. He dabbled, he mused, always remaining at a quizzical distance.

During the last three decades of the nineteenth century, "the growing abstraction of religious thought," due partly to the influence of John Ruskin, saw the "transference of spiritual feeling from traditional religious subjects to natural beauty."[89] Nature took the place of the church, the artist of the priest. The contemplation of a beautiful object, like the reading of the Bible, was a spiritual act. Watercolour paintings were particularly well suited to this purpose. The luminosity and softness of the medium allowed the artist to imbue the landscape with a spiritual quality that enhanced the viewer's emotional response to the subject. Unlike oil, the watercolour medium was transportable. The artist could make the underlying pencil drawing, note the gradations of colour and atmospheric effects, and sometimes even add the colour, thereby completing the painting *in situ*. Painting *en plein air* ensured that the finished work was a product not only of the artist's direct response to nature, but also of his or her truthful transcription of the scene.

When Frederick painted *Seven Fields* sometime during the summer of 1900, he attempted to do just that.[90] He achieved a naturalistic representation of the scene through the close observation of nature. By applying small daubs of paint to the paper in close gradations of colour, he gave the work a vibrancy and a luminosity that would have been difficult to achieve in oil paint. Yet *Seven Fields* remains an urban response to a rural subject. The two figures, placed in the middle ground of the painting, seem indifferent to the landscape surrounding them. Like the fence and the cottage, they are mere accessories. There is no indication in the painting of the

increasing mechanization of the countryside which heralded the decline of agriculture in the 1870s. Frederick was clearly not interested in depicting the social and technological changes that were transforming the rural areas surrounding Sheffield. He wanted to convey "the unchanging realities of the natural world."[91] In this sense, *Seven Fields* is a nostalgic idyll of rural England.

Frederick's painting owes nothing to the imaginative pioneering work of James A. McNeill Whistler or to the proto-Impressionist work of Turner. Nor does it give any indication that he had been exposed to the work of his more advanced teachers at the Sheffield School of Art: Austin Winterbottom, whose *juste milieu* style stood midway between academic art and Impressionism, and John Thomas Cook, who flirted, in his high-relief paintings, with art nouveau design. The parameters within which Frederick worked at this stage of his training were in line with the tradition that John Varley and his circle had established at the beginning of the century and that John Ruskin had perpetuated throughout it. Above all, Frederick's approach in this early example of his work was in keeping with that of his most beloved teacher, Henry Archer, who was "fiercely antagonistic to the modern movements."[92]

There is nothing remarkable, therefore, about *Seven Fields*. It is a conservative response to a traditional subject. Far from being a "true" representation of rural England at the end of the century, it depicts an era that was created – or in many cases invented – by artists of an earlier era. For Frederick Varley, as with so many artists of his generation, the landscape was simply a repository upon which he imprinted his urban experience. Sometimes it fuelled his search for and expression of God. At other times it facilitated his escape from the woes of the city by offering him a refuge. His approach was in tandem with John and Cornelius Varley's. In this sense the young Frederick was following family tradition, and thereby displaying his own "pride of ancestry."[93]

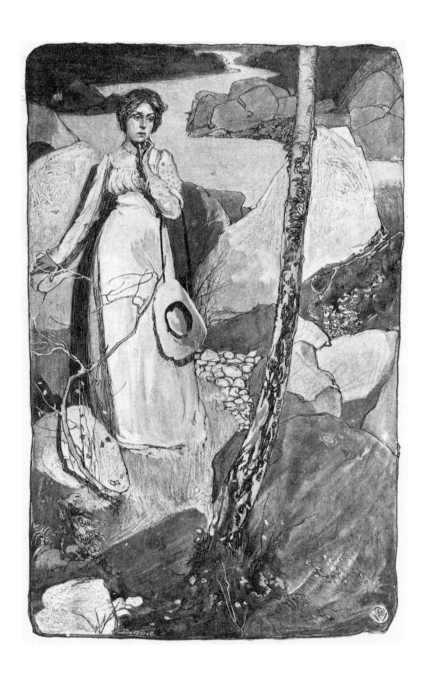

"Eve wandered in the valley ill at ease."

THIS ILLUSTRATION APPEARED IN *THE GENTLEWOMAN*, OCTOBER 24, 1903.

CHAPTER 2

Venturing Forth

At some point during Varley's final year of study, the Sheffield School of Art was, according to Ethel, "deemed inadequate" to further her brother's artistic talent.[1] Frederick gave a different reason for his departure from the school in 1899. "The Director delicately suggested to my Dad," he recalled years later, "that he take me away – send me away – anywhere – somewhere in Europe possibly."[2] Harbouring visions that his son would hold "high the ancestral torch," Samuel sought advice about art schools in Europe.[3] His colleagues at Pawson and Brailsford warned him that he would be "very unwise" to send Frederick abroad to study.[4] But Samuel was determined to give his nineteen-year-old son the best chance he could possibly have to develop his talent. So he ignored the warnings of his colleagues at the office and, "after much hard thinking," dipped into his pocket once again.[5]

Antwerp must have seemed like a good choice to Samuel Varley. It was within easy reach of northern England: there were regular sailings from Hull and Harwich to the Belgian port. It had long-standing commercial links with Sheffield: merchants in Antwerp supplied ivory from the Belgian Congo to Sheffield cutlers for the handles of their knives. Ever since the sixteenth century, Antwerp had been an important centre for art, and a mere visit to the city could enhance an artist's reputation. During the seventeenth century, two artists, Rubens and Van Dyck, brought Antwerp its greatest renown. The city had reinforced its artistic reputation in that century by establishing an academy of art. Situated within the winding corridors and

vaulted ceilings of an ancient Franciscan monastery built in 1663, the Académie Royale des Beaux-Arts was the third-oldest art school — after Rome and Paris — in Europe.

It was not until the middle of the nineteenth century, however, that the Académie began attracting British students and British associate academicians, of the calibre of Alma-Tadema, Landseer, and Leighton. From then until the early decades of the next century, the putative student could expect to receive an education that was "characterized by a breadth and manliness which placed it half-way between the modern British School and the French."[6] Students acquired sound draughtsmanship, careful modelling, and a knowledge of chiaroscuro. The kind of instruction they received was best summed up by one of the school's most illustrious teachers, Professor Charles Verlat: "Draw what you *see*, don't draw what isn't there."[7] Classes were taught to the foreign students, who made up one-fifth of the advanced class, by instructors who spoke "'English' after a fashion." The atmosphere in the state-run school was strict. No smoking was permitted within the school. Regular attendance was expected. And men and women were segregated. Breaches of discipline, according to a writer in *The Studio*, were "punished by giving the offender compulsory holidays of two or three days or sometimes weeks."[8]

It was not just the free tuition, granted to anyone who could pass the entrance examination, that made the Académie Royale des Beaux-Arts an attractive place to study. Provided a student was not overly fond of patronizing the music-hall or the public house, and was willing to do a bit of cooking over the hearth "on their own hook," living costs could be kept to a few shillings a week.[9] Things were particularly good for the students enrolled in the two-year postgraduate course offered by the Académie's Institut Supérieur des Beaux-Arts. Obliged to attend classes only in the morning and evening, students had plenty of time to sketch the infinite expanse of flat fields surrounding Antwerp, the vast docks lining the Scheldt, or the gabled houses and church spires crowding the narrow streets in the old quarter of the city. Some used their afternoons to study the

works of Rubens and the other Flemish masters housed in the Musée Royale des Beaux-Arts, a short walk from the Académie.

When Varley arrived in Antwerp in the autumn of 1900, the international centre of art had shifted to Paris. Brussels, which was already the legislative, economic, and administrative capital of Belgium, had recently overtaken Antwerp in artistic matters. The Académie, which had reached its peak of excellence in the middle of the century, was now in decline. Nevertheless, its teachers continued to uphold seventeenth-century Flemish artists as models by insisting that their students draw in the precise manner that characterized their work. They also favoured the Realist principles of Courbet and Millet, following a curriculum that was "based on the close observation of nature."[10] The teachers at the Académie were, not surprisingly, against the most avant-garde group of the day: the French Impressionists. They were even against Belgium's own modernists. (Les XX, who championed Impressionism and Symbolism and brought artists of all nationalities and styles within its ambit, came in for a good deal of criticism from the Académie's conservative art masters.) Students who deviated from the taste of their instructors were in trouble: their work was hung in the most obscure corner at the Académie's year-end exhibition or, even worse, it was rejected for exhibition altogether.[11]

One student who felt uncomfortable with the Académie's dogmatic approach to art instruction was Vincent Van Gogh. "I irritate them," he told his brother Theo in 1885, "and they me."[12] Another artist, the less-well-known Irish painter Dermod O'Brien, who attended the Académie a few years later, encountered uninspiring teachers, uninteresting models, and lazy students.[13] A Canadian student who followed Fred Varley and Arthur Lismer to Antwerp in the 1920s found the school's antipathy to modernism still intact. "The Academy was of no use to us," Lowrie Warrener told a fellow artist back home. "Our morning teacher kept asking us if we were going to work their way or ours," and, he continued, "At last they got quite sore about it, and we decided it was time to leave."[14] Van Gogh, O'Brien, and Warrener each successively moved to Paris.

For many students, then, Antwerp and the Académie provided a stepping-stone to somewhere else, or, at best, it was a place from which students like Arthur Lismer visited Paris or explored the French countryside which had inspired the work of Corot and Daubigny.[15] Yet Paris, with its reputation for high living and a bohemian lifestyle, was precisely what the parents of O'Brien, and most likely of Varley, wanted their children to avoid. This made the Académie's solid academic training and the city's low-key living — providing one stayed clear of the night life along the docks – just right.

Yet Samuel Varley had little to fear. For one thing, Frederick did not travel to Antwerp alone. Three other students from the Sheffield School of Art — Albert Clarke, Thomas Somerfield, and John Yates – accompanied him. The three young men even took lodgings with Varley at 64 Kroomstraat. (Located in the leafy bourgeois district of Borgerhout, it was a short tram ride to the centre of the city.[16]) Moreover, his letters to his sister Ethel, who was studying at a teachers' college in Saffron Walden in Essex, reveal that he was an overly serious, even stuffy young man who had "no time for frivolities." Varley was dismissive of his less-committed roommates. Somerfield, Yates, and Clarke showed no interest in poetry or classical music. They spoke with one another "in light and flippant words," Frederick told Ethel. "I can never like them and when in their presence I feel pulled down to commonplace."[17]

Initially Varley had no intention of enjoying himself in Antwerp. He had only one goal in mind: to succeed as an artist. Deeply religious in an unconventional sense, he confided to Ethel that "I have on bended knee, prayed to my dear Maker to make me purer, enriching me with love & open mine eyes to see the beauty of His wondrous work in mankind."[18] "Pray that I may be successful Ethel," he asked her some months later, "not because of myself but because of Father – for it will please him so."[19]

Though Frederick was eager to please Samuel Varley and was spurred on by the excitement of painting from the partly draped nude for the first time, he was up against some stiff competition. A

number of his fellow students in the two-year advanced class —
London-born Sidney Venning was one — had worked as professional
artists. Some had the advantage of former training in Continental
academies, while others had come top of their class at art schools in
Russia, Australia, the United States, and Canada. Though Varley
had done well at the Sheffield School of Art, he was by no means the
school's most distinguished student. Once in Antwerp, he quickly
discovered the extent to which his exposure to and knowledge of
European art was limited. "The truth was vividly impressed upon
me," he recalled, "that I knew nothing."[20]

Yet Varley's initial response to Flemish art and to the voluptuous
women, the vivid colours, and the theatrical canvases of Rubens,
was far from positive. Indeed, he pronounced Rubens's paintings
"awful things." "I couldn't understand them at all until gradually it
sunk in, and got into me until I felt them more clearly."[21] Certainly
Rubens's emotionally charged paintings *The Descent from the Cross*
(1612) in Antwerp's Cathedral of Our Lady and *The Adoration of the Magi*
(1624-26) at the Musée Royale des Beaux-Arts, displayed a mastery
of composition, of movement, and of execution that Varley would
not have previously encountered in the clearly delineated watercolour
paintings of Britain's late-nineteenth-century landscape painters.
After studying the way in which Rubens introduced small patches of
pigment into large areas of contrasting colour and the way in which
he endowed his carefully modelled forms with an aggressive plastic-
ity through a glittering play of light and shadow, Varley retreated
from his initial judgement. He would later joke that Rubens's
"sacks" of women made his canvases smell "too much of the
flesh."[22] Yet he remained convinced that the Flemish artists of the
seventeenth century, including Rubens, knew "how to paint . . . how
to develop."[23]

It did not take Varley long to realize "that all I had learned at
Sheffield had been finicky, niggling, and petty."[24] He attempted to
remedy this by endowing his own work with the exuberance, the flair,
and the vivacity of the High Baroque painters. He "slogged" and,
during the process of learning, unlearning, and forgetting, he was

spared no pains.[25] "I started as I had been taught to paint in Sheffield," he recalled years later, "then one day, the teacher crept up behind me, snorted, seized my palette knife, and scraped my paper clean." The art master then took Varley's brush and, after painting "a few clear, free, audacious strokes," he shouted: "Like this . . . like this."[26] According to Ethel, humiliating incidents such as this marked the beginning of her brother's success.[27] While Varley learned much by studying Rubens's work housed in Antwerp's Cathedral and Museum, it was at the Académie Royale des Beaux-Arts that he learned how to draw.

Even the most discontented art student admitted that drawing with the brush as well as with the pencil was the most valuable part of his or her instruction at the Académie. At home during the summer and early autumn of 1901, Varley had a chance to apply what he had learned in Antwerp to familiar subject matter. In *Burbage Brook* (1901) he set aside his earlier obsession with detail.[28] He used the brush and the watercolour medium as though they were pencil and lead. He juxtaposed light and dark hues, he introduced high colour – the crimson flames from a Gypsy encampment – he drew the eye to the middle ground of the painting, and he charged his work with a sense of drama and movement that owes much to the work of Rubens.

Yet *Burbage Brook* is also in line with the late-nineteenth-century romantic notion that a painting should be "a vehicle for the unique, creative insight of its author."[29] It adheres to the advice which Varley gave to a group of Sheffield artists a few years later: "paint nature vigorously, and with feeling for atmosphere and tone." "Individuality and feeling," he continued, are "more essential to the artistic work than clean colours, careful drawing, and studied technique."[30] Though Varley would never fully depart from the English landscape tradition, his work after Antwerp emerged out of a direct and sustained confrontation with nature.

Varley did not immediately rise to the top of his class. Frans Lauwers, who taught him drawing from the draped nude, and Piet Verhaert, who was in charge of drawing from plaster casts, both

placed Frederick second in their classes, which comprised some forty students. (In the morning class Varley lost to British illustrator Sidney Venning, and in the evening to Belgian painter Albrecht Crahay.) During Varley's second year at the Académie, however, his standing improved. Painting in oil from the clothed model under the guidance of the director of the Académie, Juliaan De Vriendt, Varley shared first place with Australian painter Clewin Harcourt. And, thanks to the instruction of Eugène Siberdt, he won first place and thereby received the silver medal for drawing from the draped nude figure.[31] Winning two silver medals during his second and final year, Varley earned the right to be chaired through the town on the shoulders of his fellow students. As the group wound its way through Antwerp's medieval cobblestone streets, the students sang "For He's a Jolly Good Fellow" and "Marlbrook se va t'en guerre" to the same tune.[32]

Varley had obviously pleased his art masters at the Académie by learning how to make an accurate, well-observed drawing of the human figure. Invented by the Greeks in the fifth century BC, "a perfect replica of the model" was "the highest ideal of the academician."[33] An accurate rendering of the nude — draped or undraped — attested to a student's ability to summarize, emphasize, and condense the subject without distorting it; to understand the character, proportion, and the direction of a line; to know something about planes and solids; and to feel at ease working in a variety of media. Behind Varley's achievement lay hours of drawing, of observing, of rubbing out the charcoal with scraps of bread or scraping off the paint with a palette knife, time and time again.

Most of Varley's friends were likely the Australian, Canadian, New Zealand, and British students whose names appear alongside his in the school's register. He sketched in the countryside with his rival, the London-based Sidney Venning. And the students with whom he drank at what he called "the Club" were English-speaking. By the end of his second year in Antwerp he must have dropped his prissy, over-critical manner, because the night he took his first drink, the town went "wild."[34] Moreover, his reputation was not forgotten

once he left the school. When Arthur Lismer arrived in Antwerp four years later, Frederick Varley "was spoken of at the Academy in hushed tones."[35]

Throughout his stay in Antwerp, Frederick received "bright" and "encouraging" letters from his mother and his sister Lilian. But Ethel and Samuel were his best correspondents. Their missives gave him strength. They helped him to throw off "the dark mantle of gloom" which had surrounded him before his departure from Sheffield.[36] Samuel's letters were full of news from home: "you will be sorry to learn that the heavy rains have caused a landslip at Whitby and demolished two houses burying nine people and killing three." They celebrated his love of nature: "I notice that the shadows are shortening, the snowdrops have made their appearance there is a promise of new life in the shrubberies." And they reinforced his disdain for city living: "the town is the same dismal old place."[37]

Ethel was Frederick's most intimate correspondent. He shared his thoughts with her about books such as Edwin Arnold's devotional biography, *The Light of Asia*. After reading Dante Gabriel Rossetti's metaphysical poem, *The Blessed Damozel*, concerning long-suffering lovers, he expressed his pleasure. He also conveyed his enthusiasm to her over the "depth and largeness" of the New Testament's book of Corinthians, which he compared to Buddhism.[38] He wrote lengthy descriptions of the Flemish countryside and, in order to stave off homesickness, he created word pictures of the Derbyshire moorland. And, finally, he told Ethel of his guilt about not working as hard as he thought he should and his fear of being "licked" by Sidney Venning in the Antique class at the end of his first year.[39] He was "striving after some things," he told Ethel one Sunday afternoon, which were "very difficult" to achieve.[40] Having someone to talk to on paper was a great help in moving him closer to his goals.

Ethel was the first of a long line of women who, throughout Varley's life, served as epistolary confidantes. Finding it easier to

express his fears and desires in prose than in conversation, Frederick rose above personal differences, sometimes losing his sense of time and place, and often losing awareness of the person to whom he was writing. The act of writing letters, like the rendering of a watercolour painting, allowed Frederick to commune with the poetic side of his character. Intent on striking the right tone, refining a thought, or perfecting a descriptive passage, his letters often went through several drafts. Written frequently during the early hours of the morning and sometimes over a period of days, Frederick's reveries gave his reader a rare insight into the meanderings of his mind.

Frederick not only entranced his family with the letters he sent home from Antwerp; shortly after returning to Sheffield, he also impressed them by producing an uncanny likeness of his father.[41] The charcoal drawing of Samuel Varley was executed one Sunday evening just after the family had returned from church: "We were all in the dining room with our hats and coats on," Ethel reminded her brother years later,

> when you entered with drawing material and abruptly said "Dad, I want to draw you." You were so determined. No one uttered any objection. The question was "Well where shall we go." The kitchen was chosen because no one would disturb [you]. Dad sat on the corner of the kitchen table and soon you were at work. It just seemed as though a Holy Spirit was in the house. None of us in the room felt as though we dare speak above a whisper and the silence was not broken until we heard movement in the kitchen.[42]

The drawing met with the approval of the family because, according to Ethel, it was "so perfectly Dad."[43] The skill with which Frederick executed the charcoal portrait demonstrated that he possessed a sound knowledge of light and shade, of modelling, and that, even at this stage, he was capable of projecting, through a charcoal drawing, the character of his subject.[44]

While Varley had a captive audience for his work among his family when he returned from Antwerp, Sheffield's economic slump made it unlikely that anyone living beyond Havelock Square would commission him to paint a portrait or purchase one of his landscape paintings. Even so, the general interest in matters relating to art in Sheffield had improved since the 1890s. The Sheffield Education Committee had finally agreed to allow students at the Sheffield School of Art to work from the nude model. The recently reorganized Sheffield Society of Artists invited artists, architects, and commercial artists to submit work to its annual exhibition. The members of the less pretentious, and more lively, Heeley Art Club held discussion groups, art demonstrations, and exhibitions in the city's Vestry Hall once a week. The availability of books and magazines devoted to ancient and contemporary art made Sheffield seem less remote from London than it had been in 1900. Two inexpensive series of art books – Little Books on Art and Masterpieces in Colour – introduced the work of British and European artists to a large public. Finally, art journals such as *The Connoisseur* (1901) and *The Burlington Magazine* (1903) established much-needed standards of scholarship based on notions of taste and quality.[45]

While collectors, patrons, and dealers residing in the provinces were reasonably well informed about what was going on in London and on the Continent, they were less interested in, and therefore reluctant to support, the amateur artists in their midst. In a provincial city like Sheffield there was a social stigma attached to anyone pursuing art full-time. "One was shown a lot of people who were 'warnings,'" the novelist V.S. Pritchett recalled of his boyhood visits to relatives in Edwardian Yorkshire, with one cousin singled out as "the warning against the miseries of art."[46] Pursuing a career as a full-time artist was only possible if one undertook it somewhere else – namely in London, where commissions, patrons, exhibitions, and reputations were easier to come by than in the provinces.

Local employment as a commercial artist was another matter. Samuel Varley had made good without leaving Sheffield. In 1902 he became manager of Pawson and Brailsford's lithography department.

The handsome salary that went with the job enabled him and Lucy to build a large semi-detached stone house on the Manchester Road. Set high above the smoke and grime in the bourgeois district of Nether Edge, the house offered extensive views of the city. It was also close to the moors.

Samuel Varley's rise to the middle class did not, for the moment, bring financial benefit to his younger son. In fact, Samuel told Frederick that he would not keep him beyond the age of twenty-one. Samuel's other children were providing for themselves: Lilian and Ethel taught school in Sheffield; Alfred had found employment as a teacher at a school in southern Wales. Samuel no doubt felt that it was high time that Frederick, who was twenty-one when he returned from Antwerp in 1902, found employment too. Yet Frederick had become accustomed to letting "Dad pay." He even referred to his father as "my bank." This way of thinking made some people in Sheffield consider Frederick Varley a "sponger and a cadger," and, Arthur Lismer continued, made them think that Fred Varley thought that "the world owed him a living."[47]

While Antwerp clearly marked a "turning point" in Varley's growth as an artist, he found few opportunities once he returned to Sheffield in the spring of 1902.[48] With "nothing to do," so Ethel Varley recalled, her brother "lost his rudder."[49] In an effort to improve his situation, Frederick ignored John Crace, who had posed the rhetorical question at the Sheffield School of Art's conversazione in 1896 – "Why let them be attracted to London, or Birmingham, or elsewhere?" – and departed for London.[50] There, Frederick hoped to pursue the career for which his training and the expectations of his family had prepared him. Samuel must have supported his son's move. It is difficult to see how Frederick could have paid his own way to London unless Samuel dipped into his pocket once again. In this way Frederick probably did cash in on the Varley family's improved financial circumstances.

❖ ❖ ❖

After studying in Paris or Antwerp most English art students ended up in London, where they put all of their effort into establishing careers as full-time artists. Some flocked to Chelsea or, if they could not afford studios and lodgings in what was becoming known by the turn of the century as London's Latin Quarter, they crossed the Thames and settled in Battersea. Accommodation on the south side of the river was readily available and inexpensive. Yet wherever one lived in London, studios were much the same: "some were in terraces with Virginia creeper covering the outer walls; others were in large barn-like buildings, down dark corridors or across timber-yards."[51]

Varley found "a great little studio" in Melton Chambers close to Battersea Bridge and Battersea's two-hundred-acre park.[52] The studio was dominated by a large sloping window which spanned the entire breadth of the ceiling. Varley furnished the large bare room with a camp-bed, a couple of chairs, and an easel. Eventually he added oriental carpets and "a beautiful bed."[53] He also acquired a cat that slept in his shoe. It was here that he cooked kippers, ate bread and jam, and brewed his tea.

Though ostensibly in London to paint, Varley spent a good deal of time walking around Battersea Park, Chelsea, and the West End. He frequented pubs – the Seven Veils became his favourite watering hole. He attended cinematograph shows at the London Hippodrome – two screenings could be seen in one day. He went to plays and probably to the music-hall. He made frequent visits to the British Museum, where he studied the Elgin Marbles. And at London's National Gallery he admired the "nice fat lines" and the "lovely woman" in Tintoretto's *The Milky Way*.[54]

There was much to excite a young artist in London in the early years of the twentieth century. According to a writer in *The Studio*, "England's artistic outlook in 1905 was never so full of splendid promise."[55] The art establishment had paid homage to contemporary British and European art when it opened the Tate Gallery to commemorate Queen Victoria's Diamond Jubilee in 1897. Varley could walk across the Chelsea Chain Bridge and view that gallery's

permanent collection. There were large gilt-framed works by the Pre-Raphaelites, early-nineteenth-century British landscape paintings, and society portraits by John Singer Sargent. In 1906, twenty-one previously unexhibited oil paintings by Turner were put on show. The growing interest in European culture during the Edwardian era prompted public art galleries to give their exhibition space over to European artists of every era.[56] In 1903 the Guildhall Gallery in the City mounted a grand display of Flemish painting which complemented the Royal Academy's winter exhibition of Old Master paintings. In 1905 Durand-Ruel's Impressionist exhibition at the Grafton Galleries introduced Degas, Manet, Renoir, and Van Gogh, among other modernist artists, to a sceptical British audience. A year later, the Burlington Fine Arts Club's exhibition, Ancient Greek Art, was mounted in the West End.

But it was at the private galleries in Bond Street and in Mayfair that Varley saw work by his English contemporaries and by those artists who had flourished a generation earlier. Shortly after he arrived in London in 1903, the paintings, pastels, drawings, and etchings of Augustus John and his sister Gwen were displayed at the Carfax Gallery. The following year, the Leicester Gallery mounted a retrospective exhibition of drawings by Rossetti and Burne-Jones. The cultural event that dominated London's art scene every summer during Varley's years in London was the Royal Academy Exhibition which took place at Burlington House in Piccadilly. There, academicians, associates, and invited guests jostled for space in the main galleries so that they could establish, maintain, or enhance their reputations.

The likelihood that a young unknown artist like Frederick Varley would get his work shown in a major London gallery was remote. Edwardian London was as socially divided as it was economically disparate. "Being 'hung,'" as the Australian artist-couple Dora Meeson and George Coates discovered, was "often much more a matter of chance or favour than merit."[57] Indeed, "the days of the great frontal assault upon the public were gone." In its place

was "a semi-clandestine system of recommendation by letter, or by word of mouth, or by the deft planting of one small canvas in a mixed exhibition" – providing the newcomer could get a work accepted in the first place.[58]

Unlike Meeson and Coates, Varley had not attended the Slade or any other art school in London, which would have given him an entrée to the New English Art Club – "the most forward-looking exhibiting society in London" – or provided him with a circle of well-connected artist friends.[59] Nor does he appear to have had any contact with the London branch of the Varley family. John Varley – the famous painter's grandson and an artist of Frederick's own age – was living in London. In 1905 he contributed drawings and paintings to Annie Besant and C.W. Leadbeater's theosophical work, *Thought Forms*.[60] Several other members of the Varley family were working as professional artists in London, too – but they were by now distant relatives in every sense.

Frederick Varley did, however, make contact with a number of acquaintances from his student days in Sheffield and Antwerp. Sidney Venning, whose father was a London-based picture dealer, was a frequent companion. The Australian artist Clewin Harcourt, with whom Varley had shared the silver medal in his final year at Antwerp, was temporarily residing in London, where he was trying to establish himself as a professional painter. And Valentine Fanshaw, who had followed Varley from the Sheffield School of Art to the Académie in Antwerp, moved to London in 1903 to work as an assistant in a design studio.[61] Attempting to establish their own careers, these friends were of little professional help to Varley, for they were equally unknown.

Although "it was important for the young aspirant to recognize the character and reputation of an exhibition society and to be assured that his work was seen in the right company," this was not easy to do.[62] London was crawling with artists. As one writer noted in 1908, it was "physically impossible to find room for the works of more than a fraction of them in the Academy or in the other standard

exhibitions." Unlike the Paris Salon, in which an artist could expect to have a good painting exhibited, albeit with hundreds of others, the Royal Academy's premises were "so small that only a very small proportion of good works sent in are being accepted — let alone hung." Private galleries were hardly more accessible. Mounting a show in a Mayfair or Bond Street gallery was not only "very costly," the dealers found it difficult to accommodate more than "a relatively small number of works."[63] Dora Meeson and George Coates "had endless disappointments" trying to get their work shown. Much to their dismay they discovered that "9/10ths of the annual exhibitions were arranged by London art societies, which, after hanging their members' work . . . [had] space for very few outsiders or non-members."[64] Things did not improve for Meeson, Coates, or for any other artists until 1908. That year, eight hundred artists formed an exhibition society which emulated the Paris Salon des Indépendants. The Allied Artists' Association guaranteed any painter or sculptor a place in its annual show, provided the artist could come up with the subscription fee of one guinea. Having left London before the Allied Artists' Association mounted its first show in 1908 at the Albert Hall in Kensington, Varley missed a chance to exhibit his work during the formative stage of his career.

Though he was living across the Thames from Augustus John, James A. McNeill Whistler, William Orpen, and many other prominent artists residing in Chelsea, Varley was outside the artistic establishment. And this is where he remained throughout his years in London.

Given the difficulty of exhibiting and selling paintings and sculptures, many artists were forced to undertake commercial art work. The money earned by what some commentators called the "black-and-white men" paid "the expenses for models, costumes, and time employed in painting pictures."[65] A well-known artist like Frank

Brangwyn commanded no less than sixteen pounds for every drawing that he published in *The Graphic*. No wonder he viewed illustration work as "a positive Eldorado for artists."[66]

There was nothing demeaning about taking on illustration work, even though George Gissing criticized a "hungry painter" in his novel *Will Warburton, A Romance of Real Life* for indulging in "the vulgarity of advertising."[67] The Art Nouveau movement certainly owed its emergence to the imagination of graphic designers and illustrators. And, as George Gissing's contemporary, Arthur Ransome, wrote in 1907, "many men who have achieved but a modest mastery of black and white have afterwards gained considerable success as painters in colour."[68] This was certainly true of Aubrey Beardsley, Walter Crane, Joseph Pennell, and other established artists. Even those who had established themselves first as painters – Rossetti, Augustus John, and Whistler – boosted their reputations when they began making prints and illustrations, and turning out designs.

This is not to suggest that illustration, or "outline work," as it was also called, was easy to do. According to Arthur Ransome, "no superficial technique, dexterity or surface quality can conceal errors in drawing, perspective, proportion or composition, which in a painting may easily pass unnoticed under the distraction or fascination of colour."[69] An illustrator needed sound training in drawing and composition, an ability to grasp quickly the essentials of the subject, a good understanding of print-making techniques, and a keen business sense. Co-ordinating a sketch or a wash drawing with the written word required a further skill. Illustrators had to tell their readers what they needed to know without offsetting the balance between the text and the visual image. Rendered by an insensitive illustrator, "extra visual information could easily displace or disperse the central interest in the episode."[70] Even writers like Charles Dickens, who collaborated with the little-known artist H.K. Browne, depended on illustrators to enliven their text.

Late-nineteenth- and early-twentieth-century London was as inundated by "picture-papers," magazines, weeklies, and illustrated novels as by public and private art galleries. This created a demand for

a wide variety of artists who could undertake design work and decorative lettering, who could provide a good likeness of a famous person or an accurate representation of such popular Edwardian subjects as transportation and communication, migration, pioneering life, and the indigenous peoples of the Empire. Above all, artists who could illustrate a story were needed. Some publications had a regular stock of artists on the payroll. The "special artists," for example, were paid to produce "events of the moment" in the field; their sketches were usually transformed into finished drawings by an artist closer to home. Other illustrators who worked for publications such as *The Sphere* were employed on a contract basis or hired to produce a specific drawing or watercolour sketch.

Some artist-illustrators preferred to undertake specific commissions and work to a deadline. Others chose to produce cover designs, illustrations, or studio drawings at their leisure or when circumstances demanded it. Varley seems to have worked in both of these ways. In 1903, watercolours and pen-and-ink drawings by F.H.V. accompanied Eden Phillpotts' novel *The Farm of the Dagger*, which *The Gentlewoman* serialized over the autumn and winter months. In 1904 he provided the decorative architectural additions to Seppings Wright's drawings accompanying an article on the new Roman Catholic cathedral at Westminister for *The Illustrated London News*. And a year later, he produced drawings to accompany Sidney Hesselrigge's romantic story, "The Letter-Box Charm," which appeared in *The Idler* in March 1905.

In Varley's view, a commercial artist never produced "anything worthy to be treasured." "Commercial work in itself is nothing apart from the moment," he wrote a few years after leaving London. "It is glanced at and passed by."[71] Yet during his first years in London, the money that he earned by selling his pen-and-ink illustrations and wash drawings to *The Illustrated London News*, *The Idler*, *The Gentlewoman*, and possibly to other magazines, enabled him to eat — if only kippers, jam, bread, and tea — and to have a studio as well as an apartment.

Precisely how much commercial art Varley produced during his years in London is difficult to ascertain. Commissions were not easy

to win. After "an endless and futile struggle to get an opening for our black and white drawings in London" Dora Meeson recalled, she and George Coates were rebuffed.[72] Nor is it easy to attribute illustrative work to Varley because lettering, decorative work, and even finished drawings were often published without credit. Yet, unlike George Coates, Dora Meeson, and many other budding artists, Varley did get some of his work published. Moreover, it frequently appeared in good company. His predecessor in *The Gentlewoman* was the well-known illustrator Arthur Rackham.

But what were Varley's illustrations like? True, he was the son of a lithographer, had acquired a knowledge of basic printing techniques at the Sheffield School of Art, and had studied the etchings of Rubens, Van Dyck, and Jordaens at the Plantin-Moretus Print Museum in Antwerp. Yet there is nothing remarkable about what he produced during his years in London. His wash drawings accompanying *The Farm of the Dagger* are well composed. They possess a breadth and an ease of execution which display a virtuosity in the handling of watercolour. They capture the dramatic moment and thereby illuminate the text. But reduction by one-third of their original size for transcription into the print medium did his work no service. His black-and-white drawings were too detailed for print; they lacked tonal contrast to the point at which they appear muddy. When a commission demanded illustrations over the course of several months, he jumped from one style to another. In Eden Phillpotts' *The Farm of the Dagger*, he commenced with muddy, loosely handled wash drawings, then changed to beautifully controlled Art Nouveau watercolour drawings, and ended up with sharp-edged, nervously detailed pen-and-ink drawings that were more representative of nineteenth- than of early-twentieth-century illustrators.[73] Finally, while some of his wash drawings are rendered in the style of Maurice Grieffenhagen, whose illustrations appeared at regular intervals in *The Sphere*, Varley's work is a pale reflection. Varley's illustrations lack the simplification, achieved by selection and elimination, which distinguished the best illustrators of the day from the

ordinary "black-and-white men." Moreover, they are alarmingly derivative of the Belgium-trained illustrators, Gisbert Combaz and Privat Livemont, and of England's "Beggarstaff Brothers" – William Nicholson and James Pryde.

According to the distinguished illustrator Joseph Pennell, illustrators failed to develop a style of their own because publishers dampened their "attempt to say anything in one's own fashion." Varley would have agreed with this and also with Pennell's view that "any spark of originality" was "stamped out" of artists.74 Yet Varley disliked commercial art work for other reasons too. It was the profession of his frustrated-artist father, Samuel Varley, he was not particularly good at it, and, most important of all, it intruded upon what he had come to believe was his real profession: that of a full-time painter. For Frederick Varley, illustrative work was a bridge, a stepping-stone.

At some point during his London sojourn Frederick moved temporarily back to Sheffield. On 7 March 1906 he gave a critique of the paintings done by members of the Heeley Art Club at Meersbrook Hall. The same year he taught an outdoor sketching class in Sheffield – David Jagger and Elizabeth Nutt were among his students.75 He saw Arthur Lismer off for study in Antwerp. And he met his future wife, Maud Pinder.

Maud taught at a school in the nearby town of Doncaster. She met Frederick during a weekend visit to her mother and father in Sheffield. "We just kind of saw each other," Maud remembered, "and that was it."76 The relationship was intense from the start. Maud "absolutely fell head over heels in love."77 Frederick kept that love alive by sending her telegrams almost daily. He courted her every weekend. On Sundays they tramped on the moors. On Saturday evenings they walked to a place where the nightingales sang, or they sat in the first row of the orchestra stalls in Sheffield's leading

cinema, the Hippodrome. Once they took a week-long vacation to Whitby on the east coast. Frederick had earlier sketched the abbey which loomed above the harbour and an embracing couple who stood at the bottom of the steps leading from Copper Street to the sea.[78] Maud remembered the early months of their courtship as "a wonderful time for both of us." "He never took a drink," she recalled in old age. "I suppose he hadn't needed it."[79]

Though five years younger than her beau, Maud Pinder was "a bit ahead of him" when they first met.[80] Reading aloud, Maud steered Frederick through the classics which were available in inexpensive, reasonably printed, and well-bound editions through Everyman's Library and the World's Classics. She introduced him to the works of Gorky, Conrad, and other writers who became Fred's favourite authors. Possessing a fine contralto voice, she appreciated music as much as he did. Though Maud had little knowledge of the art world, she had some idea of how an artist should dress. She crocheted Fred a set of white silk ties. Wearing them contributed to his bohemian image.

Fred was a striking young man. Erect in posture, he appeared much taller than his actual size – he was about five foot seven inches. He possessed piercing blue eyes and a mane of red-gold hair which Arthur Lismer claimed "burned like a smouldering torch on the top of a head that seemed to have been hacked out with a blunt hatchet."[81] No one could ignore Fred Varley, a former student recalled, because "one felt at once the electric dynamism of the man."[82] Maud was small compared to Fred and had a heavier Yorkshire accent. She was also less striking. Her pince-nez spectacles and her pudding face made her decidedly plain. But if Maud had a less dynamic bearing than Frederick, her feet were planted firmly on the ground. She was much the wiser of the pair.

According to Virginia Woolf, "a man needs a woman to reflect himself back to himself at twice his normal size."[83] Years earlier Alphonse Daudet observed in *Artists' Wives*: "To that nervous, exacting, impressionable being, that child-man that we call an artist, a

special type of woman, almost impossible to find, is needful."[84] Maud Pinder was that "special type of woman." She was Frederick's Madonna, his muse, and his model. And, until she made room for a succession of other women, she was Frederick's lover.

Maud recalled that she and Frederick had "a lot of things in common."[85] Yet there were more differences than similarities between them. Maud had no appreciation of or interest in the visual arts — "can you imagine anything more terrible than to marry a woman who does not care for your art?" Alphonse Daudet asked.[86] Maud had been raised in more prosperous circumstances than Frederick — Charles Edward Pinder, who died shortly after the couple married in 1910, was a successful silversmith. But like Fred, Maud was her mother's favourite child. According to Ethel, Sarah Pinder "was so fond of Maud she never let her do any housework."[87] Consequently Maud had little knowledge of, or inclination to learn, how to run a household. She would rather read a book than clean the house. Once there were children, it was they who took on many of the household chores.

One family friend recalled that Charles Pinder "didn't like Fred; he didn't think he would ever settle down and make a good husband." As he feared, Fred was reluctant to "accept the responsibilities of a wife and a family."[88] He had no sense of money or of time. He had difficulty dealing with people — especially with anyone who disagreed with him or, on the other hand, did him a favour. Shamelessly "fond of the ladies," he believed that artists were exempt from the limitations on behaviour that governed most people's lives. And, as Maud quickly realized, "His work was the only thing that ever mattered to him."[89]

The Varley family was also opposed to the match. Foreseeing disaster if a permanent liaison between the young couple were to take place, Samuel told his son not to marry Maud.[90] Frederick disagreed. He refused to reconsider his proposal to Maud. He balked at his father's suggestion that he seek employment as a cutlery designer. Father and son had words. "That night," Arthur

Lismer recalled, "Varley arrived wet through to the skin at my brother-in-law's home at Nether Edge . . . and slept on the rug in front of the living-room fire."[91]

Varley had moved out of the house. He took up residence in a public house situated on the edge of the moor. Fred Marsden was the landlord of the Three Merry Lads, which had been built by his father above a cow-shed in 1861. Varley had visited this establishment before he moved to London. It was here that he perfected his playing on Fred Marsden's harpsichord and perhaps even learned how to play the violin. And it was from the Three Merry Lads that he had walked to the moors to sketch. Besides drink, the Three Merry Lads now offered Frederick heat, light, food, newspapers, good conversation, and – most urgently needed by Varley – lodgings. This is where he lived until he returned to London towards the end of 1906.

The next two years of Varley's life are difficult to chart. No signed illustrations by him appeared in the London press after 1905. No eyewitness accounts have surfaced to help plot his movements. Ethel remembered that her brother now "had a very bad time in London illustrating stories."[92] Sensing that he had fallen on hard times, Lilian and Ethel sent him five pounds. Lucy Varley also helped. She sent her son a box of food. But it was Samuel who "played the role of a modern Dick Whittington" and travelled to London to offer Frederick encouragement and no doubt further financial assistance too.[93] After this encounter, Fred is said to have vanished. This was his first, but not his last, fall into poverty and oblivion.

While most lower middle-class men in Edwardian England spent their working lives with one employer, freelance artists did not. This made them vulnerable to the technological changes that were taking place in the print and communication industries. By 1905, most weeklies and illustrated newspapers had begun substituting half-tone photographs for illustrations. This put a host of London-based artists, lithographers, and print-makers out of work. Without any external or local contacts, the lower middle-class worker could quickly become a casual unskilled labourer; he might even end up working on the docks in the Pool of London.

The novelist George Gissing began the vogue for writing about journalists, illustrators, and artists who fell upon hard times as a result of being alienated by "modern" society. His friend H.G. Wells described the social and economic difficulty of making a living in Edwardian London. Leonard Bast, in E.M. Forster's novel *Howards End* (1910), showed how easy it was for a socially aspiring lad to slip off the rungs into abject poverty. Edwardian London was no place for the weak, the apathetic, the timid — or for the unemployed.[94]

Varley's close friend and companion during the last decade and a half of his life, Kathleen McKay, provides the fullest account, based on what Varley told her in old age, of what likely happened. "He fell on hard times and he lost most of his furniture except his bed, and he walked through the streets to find just a room with a cat on his shoulder." "Then," she continued, "he went to live in a place where there were other people and then he had no food for three days."[95] Apparently, a doctor was called to the now unconscious Varley. His own recorded recollections are more succinct and less circumstantial. Answering a question-sheet for the National Gallery of Canada a few years before his death, Varley wrote that he spent "several years illustrating in London and several years drifting in the underworld."[96]

Did Varley's foray into "the underworld" owe more to his incompetence, stubbornness, or laziness than to the exigencies of the illustration world? And were things really so bad? Though he later claimed to have lost contact with his family, Maud insisted that they wrote "backwards and forwards" to one another almost every day.[97] Did Frederick succumb in old age to the myth of the starving and lonely artist that had been characterized by artists like Van Gogh in the previous century? Was he living out the Balzackian notion of the artist as hero? Or was he emulating his distant artist-relative, John Varley, whom he would later recall was in and out of debtors' prison for most of his life?

❖ ❖ ❖

Whatever happened to Frederick Varley during these years, and however he chose to recount his life in "the underworld" years later, "he was in very bad condition" when sometime in late 1907 or 1908 Maud got "enough money together" to get him to Hull. Maud's brother was a steward on a ship which sailed out of the east-coast port. He found Frederick work as a stevedore. "It was a difficult job," Maud remembered. "He was carrying heavy loads across a plank to the boats." For someone of slight build and unaccustomed to physical labour, working on the docks could not have been easy. But Frederick "stuck it."[98]

By the time Frederick surfaced in Hull, Samuel and Lucy Varley were living in the opulent seaside town of Bournemouth in southern England. Samuel had built a home called Mooredge on Heathwood Road in the suburb of Winton. The death of Pawson in 1907 – Brailsford had predeceased his partner in 1891 – and the subsequent relocation of the printing house that year, prompted Samuel to take early retirement. Ethel and Lilian remained in Sheffield, but moved into lodgings, and made frequent visits to Bournemouth. Samuel and Lucy visited their daughters in Sheffield until they were too infirm to travel. When this happened, Ethel left her job as a teacher and moved to Bournemouth, where she looked after her ageing parents. Shortly before Samuel and Lucy died in 1934 and 1935 they moved back to Sheffield.

When Samuel heard that Frederick was working on the docks in Hull, he sent his elder son Alfred to try to persuade him to return to Sheffield. Samuel wanted Frederick to take up a full-time job as a lithographer, but Frederick lacked the will to gain employment through conventional means, and refused to follow his father's advice. He remained in Hull until Maud found him a job as a clerk in the railway office in Doncaster. He was "a marvel" as a book-keeper – allegedly because he knew French.[99] But working as a clerk in a provincial railway office was a far cry from following the profession for which he had been trained.

By the spring of 1910 Frederick must have been earning enough money to set up a home with Maud. He was now twenty-nine; she

was twenty-three. The couple were married at the general registry office in Doncaster on 2 April 1910 in the presence of Maud's half-sister, Dora May Pinder, and S.O. Marshall. No member of the Varley family seems to have been present. Shortly after their marriage, Fred quit his job at the railway office and he and Maud relocated to Sheffield, where their first child, Dorothy, was born in August 1910. Initially they lived with Maud's mother, Sarah Pinder, on Junction Road. Then, with her help, they rented a four-room cottage on Brincliffe Edge Terrace overlooking a ravine leading towards the Sheaf Valley. Though Frederick and Maud made one visit to Bournemouth with their new baby, they had little contact with the Varley family. Kathleen McKay recalled that "his family were not pleased that he married Maud" and that "his mother and his two sisters didn't speak to Maud."[100] Sarah Pinder, by contrast, played a dominant role in the young couple's life. She lent them furniture when they moved into the cottage, and, when they could no longer afford to pay the rent there, Sarah Pinder welcomed them back to her home on Junction Road.

On the day of his marriage, Frederick received a commission to illustrate a brochure for a railway company in southern England.[101] When he and Maud moved from Doncaster to Sheffield a few weeks later, he found further employment in the offices of the *Sheffield Daily Independent.* According to Maud, he "was relay man arranging all the pictures" for which he earned two pounds, two shillings, a week — this was equivalent to the wage of a skilled worker. In order to top up his wage Varley produced the occasional black-and-white illustration for the same newspaper.[102] While he only had one pound, fourteen shillings, to live on after paying eight shillings a week for the cottage on Brincliffe Edge, by 1911 he found enough money to rent a studio. Located on Norfolk Street in the centre of town, the premises were shared by estate agents, solicitors, watchmakers, and chartered accountants. It was a far cry from the artists' studios in Chelsea and Battersea, but it enabled him to list his profession in the city directory as "artist."

It was in his Norfolk Street studio that Varley persuaded the

young wife of David Jagger, his former student, to pose for his most ambitious painting to date, *Eden*. Unfortunately, the painting has vanished. A reproduction of it, which appeared in the *Sheffield Daily Independent* on 29 February 1912, gives a grainy likeness. *Eden* was large, perhaps the largest work that Frederick had painted. And it was daring.

While the acquisition of the Elgin Marbles at the beginning of the nineteenth century had validated the individual model as a subject for a work of art and contributed to the representation of women's bodies as a sexual spectacle, these were the days of steel corsets and wasp waists. To paint an unswathed, uncorseted figure, as a reporter for the *Sheffield Daily Independent* noted, was bold. But the reporter chose to focus his reader's attention on the technical aspects of the painting. "One of the most difficult problems," he noted, was "that of painting the nude in sunlight."[103] The painting was not only bold, it also demonstrated the extent to which Frederick had been influenced by the two-dimensional surface patterning of the Art Nouveau artists, by the Pre-Raphaelite artists' positioning of the figure in the foreground of the canvas, and by the eroticism that had crept into popular illustrations of women. Encased in the interior light of the painting and surrounded by swirling vegetation, Varley's Eve is exposed yet hidden, sensual yet distant, both real and abstract. Sacred and untouchable, she bears little resemblance to the flesh-and-blood women whom Frederick had admired in the paintings of Rubens in Antwerp. Frederick chose to portray Eve as Everywoman. This was in keeping with the popular illustrations of women which celebrated their beauty and womanhood, not their individual personalities.

Varley's painting of Eve reflects the anxiety about the pace of change regarding women's social position in society and the "attempt in some sectors of society to reclaim the indefinable charm of womanhood and thus the respect of men."[104] If one accepts the view that painting a nude is "a self-assured invitation for the artist to speak intimately, about himself, [and] about desire and distance,"

then this portrait does just that.[105] Varley chose the model. He dictated the terms of the pose. He chose to make the breasts the focal point of the work, to cover the lower torso with vegetation, and to tilt Eve's head upwards, thereby obliterating any suggestion of individuality. And after finishing the painting he chose to pose beside it for a photograph in a local newspaper. Palette in hand, Varley proudly lays claim to authorship over a painting. The juxtaposition of the clothed artist to the undraped model inevitably associates women with nature and men with culture, and implicitly reflects Varley's view of women as passive, anonymous, and powerless creatures and of men as active, creative, and powerful individuals.

Making his mark as an artist with a photograph of himself beside a risqué painting in the local newspaper did not, however, pay the rent. Yet Varley's precarious financial position had less to do with the kinds of works he was producing than with the difficult time that most artists in the provinces had in making ends meet. His fellow members of the Heeley Art Club, William Broadhead and Arthur Lismer, had both attempted to set themselves up as full-time commercial artists. Lacking regular work after joining forces with fellow illustrator Denton Hawley in 1908, Lismer struggled "to make the business pay enough for his own livelihood."[106] Even with a father in the printing business, William Broadhead found work no more plentiful – until he went to Canada in January 1910 and found a job there as a commercial artist. Within a month of arriving in Toronto, he told his sister Gertrude: "I get all kinds of work to do and so far have not been stuck in the least." Moreover, it seemed that Broadhead's English training was an asset with his new firm. "I have just secured them an order for some calendars, for which they have been submitting designs for years," he continued, "but never with success."[107] Broadhead's competence prompted his Canadian employer to ask if he knew "any fellow in the old country who would care to come out here to do similar designs." Broadhead promised to "write to some of the fellows at home." A few days later he received "a letter from Arthur Lismer saying that he was sick of

Sheffield and wanted to know if I could possibly find him something to do out here."[108] By January 1911 Arthur Lismer had solved his financial problems by moving to Toronto. Frederick Varley solved his by travelling to Canada a year and a half later.

Canada was the destination of more than a million British citizens in the early twentieth century, half of them during the four years from 1910 to 1913. Frederick could hardly have missed the illustrations and engravings in *The Illustrated London News*, which provided some of the most striking imperial and militarist images of the age. Nor could he ignore the spate of spectacular colonial exhibitions which celebrated the "white man's successful transplantation to the farthest reaches of the globe, and his creation there of societies modelled on European lines." Canada, according to the social historian John MacKenzie, was particularly active in encouraging migration, building an impressive exhibition pavilion at Wolverhampton in 1902, and ensuring that it got an opportunity to advertise its wheat-growing, fishing, and lumbering industries at the Crystal Palace Exhibition in 1911.[109] Nor was the province of Ontario shy about promoting its splendours through books and brochures. "If there is a city in the world whose steady growth is certain and justified, it is Toronto," wrote A.G. Bradley in *Canada in the Twentieth Century*, which appeared in 1911.[110] An effort was made to show that the wilderness depicted in the *Boy's Own* adventure stories was misleading. "In Ontario the charm of English country life is very closely reproduced." Most ignored this debate. They were easily seduced by government propaganda: "Nowhere on earth can the man with a little money to start with, more quickly render himself independent than by becoming his own landlord in Ontario."[111]

Broadhead's letters home, along with the visit to Toronto in 1910 of the commercial artist Fred Brigden, confirmed what the literature, the magazines, and the fairs said about Canada: stability, money, land, and prosperity were to be had by all. A visit from Lismer in January 1912 – he came home to fetch his bride, Esther Mawson – convinced Frederick that emigration was a good idea. Lismer had got

a job as a commercial artist within a day of arriving in Toronto. And Frederick, who, according to Lismer, was "in grave financial difficulties, and still wracked by alternating bouts of gloom and beery exultation" when he encountered him on his short visit home, hoped that he might be able to do the same.[112]

Pulling up roots was not difficult. Estranged from his parents, unable to make his way on part-time commercial work and full-time painting, his departure was so sudden that he did not even have time to move out of his studio. Maud, who had given birth to their second child, John, in March 1912, did this with the help of her half-sister Dora's future husband, the tall red-haired illustrator Bert Jefferson. Varley somehow managed to raise the cost of transportation — he could travel third-class for as little as five pounds — and the subsistence money required to enter Canada — five pounds or twenty-five dollars. On 12 August 1912 he set sail from Liverpool on the SS *Corsican*.

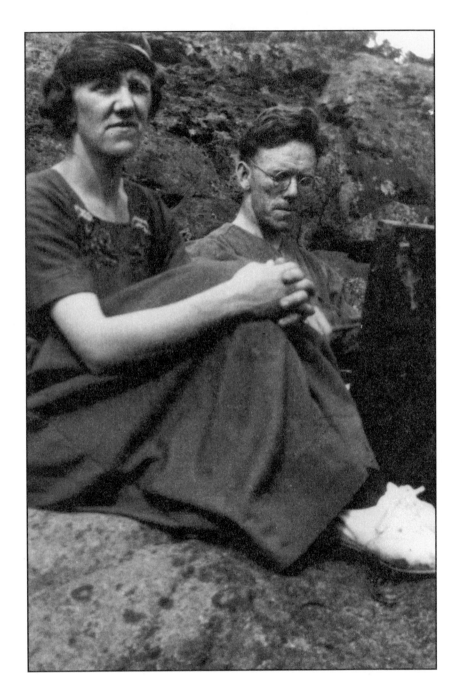

Maud and Fred Varley at Georgian Bay.

CHAPTER 3

The New World

It is not unusual to see icebergs floating in the North Atlantic during the spring and summer months. In 1912, however, their sheer quantity was unprecedented – and made sailing treacherous. An iceberg brought the 46,000-ton ss *Titanic* to the floor of the ocean during its maiden voyage in April of that year. Four months later, another passenger liner crushed the upper part of its bow from the deck to within ten feet of the waterline when it collided with a 150-foot-high iceberg 120 miles east of Belle Isle. Though the danger to the crew and passengers was slight – drinks toppled over in the smokeroom – it put the liner out of commission for several weeks. This happened on the ss *Corsican*'s return journey to Liverpool – a couple of weeks after Fred Varley had disembarked from its outward journey to Quebec City that August.

Varley had a pleasant journey out. He hobnobbed with the porters. He amused the grass widows in the music and smoking rooms. He ate three square meals a day and consumed large helpings of tea and bread and butter in between. As the publicity brochures claimed, "the modern steerage passenger is often better provided for than when in his home."[1] Fred confirmed this when he told Maud, who was preparing for her own voyage across the Atlantic, "it's just a big hotel full of good things."[2]

Shortly after arriving in Montreal by train from Quebec City, Varley tossed a dime into the air. Heads, he'd go to New York, tails, to Toronto. The coin came up heads. He still went to Toronto.[3] Bet or no bet, it had been his destination from the moment he left Sheffield. He had contacts in Toronto through his old Sheffield

friends, the commercial artists William Broadhead and Arthur Lismer. Those contacts would, he hoped, enable him to get what he had come to Canada for: a steady job.

The Ontario government's publicity brochures, along with the myriad publications on British immigration to Canada, described Toronto as a substantially built city of stone and brick with clean sidewalks, paved streets, and modern streetcars. Surrounding a natural harbour on the shore of Lake Ontario and bisected by the Don and Humber rivers, the city had an abundance of "parks and gardens, stately residences on embowered boulevards" and "rugged ravines of picturesque grandeur."[4] Deemed to be the "soul" of Canada by the English poet Rupert Brooke, who visited the city in 1913, Toronto was the country's second-largest metropolis after Montreal. It was also the centre of English Canada's clothing, printing, publishing, metal-fabricating, and food-processing industries.[5] But the province's wealth was not confined to Toronto. To the southwest of the city, fruit orchards and vineyards covered the fertile Niagara Peninsula. To its north, mining camps, much-diminished logging operations, boys' and girls' camps, and summer cottages peppered the wilderness landscape. With a population of 250,000 — a quarter of whom were British-born — Toronto, and the province of Ontario, which comprised more than two and a half million people, offered "scope for many types of human beings to develop physically, mentally and spiritually."[6]

Lismer had told Varley during his brief visit to Sheffield in the late spring of 1912, that "the streets were practically paved with gold."[7] He was of course exaggerating. Yet food staples were inexpensive — a clear 30-per-cent lower than in England. Rents were relatively high, but so too were wages. And Canadian women, who were outnumbered by men, were said to possess "a sang-froid, and attractiveness, and a vivacity free from restraint yet perfectly developed such as will certainly not be excelled."[8]

Soon after he set foot in Canada, Fred told Maud, "I like it." "It's an entirely new world," he continued in his first letter home. The people were "wonderful" and "full of willingness to help." Best of all, "the fellows here never talk of being out of work."[9] Within a few days of arriving in Toronto, Varley had found a cheap room in the centre of town – a boarding house on 119 Summerhill Avenue just south of St. Clair Avenue and Yonge Street. He had sent a number of postcards to friends back home. (Characteristically, his letters bore insufficient postage, forcing the recipients to make up the difference.) He had submitted four paintings, brought with him from England, for display at the Canadian National Exhibition.[10] He had sold a drawing to a newspaper, the *Canadian Courier*.[11] And he had secured a full-time job. No wonder Fred told Maud that he had "no fears" about the future.[12] With the prospect of having the equivalent of seven pounds in his pocket at the end of every week, his earnings were three times his wage as a layout man for the *Sheffield Daily Independent*.

The Grip Engraving Company, which gave Varley his first job in Canada, was the first design firm in the country to produce engravings in metal. Though its managers had a reputation for being "tough and meticulous," their artists had free rein in designing layouts for real-estate companies, in making advertisements for furniture stores, and in illustrating railway posters and mail-order catalogues.[13] Yet when Varley joined the firm in August 1912, "the fellows seemed unsettled."[14] British-trained designer and poet J.E.H. MacDonald had left the firm the previous year. The equally talented head of the art department, Albert H. Robson, was about to follow. (Robson moved to Grip's rival, Rous and Mann, taking Grip's artists Tom Thomson, Frank Johnston and Frank Carmichael with him.) Though initially content with the job, Varley came to feel that Grip didn't give him the right kind of work, so he moved to Rous and Mann too.[15]

It is not clear how long Varley remained at the Grip Engraving Company. With no correspondence extant between Fred and Maud or between Fred and his most consistent correspondent, Ethel, from

the middle of August to December 1912, what Fred did during these months must remain, like his voyage through London's "underworld" a few years earlier, a matter of conjecture. One source suggests that Fred might have worked for the *Globe* or been employed by the Nelson Mines in northern Ontario.[16] In a letter to Maud, Fred explicitly states that his sister Lilian visited him some time during the autumn of 1912. "Now look here my dear one," Fred counselled Maud in reference to Lilian's visit to Toronto's Centre Island, "don't let imagination run riot when you hear Lil talk of bungalows, pinewoods, lapping of golden waters and golden squirrels."[17] Had Lilian immigrated to Canada too? Or did she simply visit her brother — presumably sometime before the ferry, which connected Centre Island, a narrow strip of natural breakwater, and Toronto about a mile away, was put out of commission for the winter months? What is known, however, is when Varley began working for Rous and Mann on a full-time basis. In January 1913 Fred told Ethel that he had completed his "first week in full-swing" with the firm.[18] This was the first and only job that Varley would hold for any length of time; he remained with Rous and Mann until the spring of 1918, a full five years.

Varley was euphoric about his new job. "If Rous and Mann can give me plenty of work and treat me liberally, I shall stick in Toronto," he told Ethel, "for in a few years time it will compete keenly with Philadelphia and New York in high class commercial work and ultimately in the art of picture painting." Varley was not only happy with his new job, he also was optimistic about the future: "I'm ambitious enough to want to be the topmost on the tree in Canada."[19]

Working for Rous and Mann suited Varley's mercurial temperament. He could come and go as he pleased. He wasn't "hampered by anything or anybody." He had the satisfaction of working for "the man [Robson] who can get the highest class work in Canada." He was earning a good income. (When Varley worked overtime, his take-home pay at the end of the week was just under forty dollars — at least three times what he had earned in Sheffield.) The job also

allowed for the full play of Varley's imagination. "I've turned out quite a number of designs with little babes — puffy-light clouds, spring blossoms, young lambs, spinning wind-mills," he told Ethel, referring to the Easter cards he had designed at the end of his first week on the job. But, best of all, at Rous and Mann, Varley met like-minded artists whom he soon considered to be "the staunchest and sincerest fellows I've ever been fortunate enough to meet."[20]

Friends had always been important to Varley. Now they were essential. Prejudice against the immigrant Englishman, who had a reputation for being "too fond of comparing the ways and methods of Canada with those . . . in his own country," was rife in early-twentieth-century Canada.[21] Yet Varley appeared to have little to fear about "stroking the Canadians the wrong way."[22] For one thing, he was frequently taken for Scots or Irish. For another, he was not burdened, like the class-bound British artist-immigrant in J.G. Sime's novel *Our Little Life*, by his lower middle-class origins. Fred was becoming "more of a distinctive human being."[23] Indeed, within days of arriving in Toronto, Varley told Maud, "I am already a Canadian."[24]

Becoming a Canadian was not a difficult transition for Varley, or for any other British immigrant to make. Canada was part of the British Empire, Canadians were British subjects. They had British schoolbooks; they listened to British music-hall songs; they watched British pageants; and they attended British plays whose content reminded them of the similarities between Canada and the Mother Country and between Canada and the rest of the Empire. Canada's Britishness was reinforced for Varley by his association with people of British stock. There were his close friends, Arthur Lismer and William Broadhead, and his acquaintances, Harold James and Tom Graham, all of whom were from Sheffield. Varley's new Canadian-born friends — Frank Carmichael, Albert Robson, and Tom Thomson — with whom he worked at Grip, then at Rous and Mann, were of British parentage. J.E.H. MacDonald was a North Country man, and George Hulme, his apprentice, came from Manchester. Lawren Harris and Vincent Massey, whom Varley met after joining

the Arts and Letters Club in November 1912, had kinship with Britain too.

Since 1908, the Arts and Letters Club had sought to bring together those men who were interested in the promotion, the production, the critical reception, or simply the appreciation of the fine and performing arts. It included the amateur as well as the professional, the commercial artist and the independent painter. One half of its members supported modernist trends; the other half clung to tradition. Some were staunch Canadian nationalists; others Canadian imperialists. They usually met during the day for lunch. Sometimes, in the evenings, they assembled to hear a fireside talk on some aspect of the arts or to listen to a chamber-music concert or a poetry reading. They also mounted exhibitions, held banquets, and staged plays. Seeing themselves as the representatives of Toronto's Anglo-Canadian cultural élite, they played host to British poets — Rupert Brooke was one — and to Canadian dignitaries — Prime Minister Wilfrid Laurier visited the club when he passed through town.

But the Arts and Letters Club was more than "an obscure haunt where members could escape the demands of materialism, relax in an atmosphere of congenial companionship, and find inspiration and stimulation in intellectual intercourse."[25] The very existence of a club devoted to the promotion of culture challenged the view that "Canadians had no time for the spiritual refinements of life."[26] Counting Canada's leading cultural producers among its membership, the club served to diminish the popular belief that Canada's artists, writers, musicians, and other cultural producers were second-best in comparison to their European counterparts. Some of its more liberal-minded members made it clear that they wanted a culture which reflected the landscape, the indigenous peoples, and the unique experience of the Canadian men and women in their midst.[27]

Not only was Varley introduced to English Canadians at the Arts and Letters Club, he also was put on the inside track of the cultural community in Toronto. He met important patrons like the president of the Canadian Bank of Commerce, Sir Edmund Walker, who had established the Royal Ontario Museum, had been chairman

of the Advisory Arts Council, and was in the process of founding the Toronto Art Museum – later known as the Art Gallery of Ontario – and of chairing the National Gallery of Canada's first board of trustees. Varley also met Vincent Massey at the club. He was to become English Canada's most prominent cultural impresario as well as the country's first Canadian-born Governor General. And Varley encountered University of Toronto ophthalmologist Dr. James MacCallum, who with Lawren Harris helped finance the construction, in 1913, of the Studio Building. Located on Severn Street in Toronto's Rosedale Ravine, the three-storey building with north-facing windows and eighteen-foot-high ceilings offered any artist who could afford the rent a congenial environment in which to work.

The Arts and Letters Club also had among its membership the city's leading art critics and cultural commentators. M.O. Hammond and his fellow Yorkshireman, Barker Fairley, soon became Varley's friends. He came to know some of the more conservative-minded and influential art critics, including Hector Charlesworth and Henry Franklin Gadsby, though he usually avoided them because he sat at the artists' table almost every day for lunch. This also brought Varley into contact with A.Y. Jackson, Lawren Harris, and J.E.H. MacDonald, among other artist-members of the club.

Being a member of the Arts and Letters Club forced Varley to reach out to the cultural community at large and to partake in a variety of cultural activities. He was expected, for example, to join and exhibit with the Ontario Society of Artists as well as to share his work with his fellow club members. (The Arts and Letters Club gave Varley his first solo exhibition in February 1916.) He also designed the program cover and the title page for the club's production of Thomas Hardy's *The Dynasts*. According to one source, Varley was even a member of the cast.[28]

The Arts and Letters Club not only introduced Varley to people with whom his name would be associated for the rest of his life, it also drew him into the heated debate concerning the possibility of developing an indigenous culture in Canada. Always quick to express his opinion, he told Ethel that Canada possessed artists who "could put

some of the recognized English painters to the blush." Always ready to contradict his own point of view, he wondered whether Canada was "ripe enough for the fine arts."[29] Like many artist-immigrants, Varley envisioned Canada's cultural development taking place within Britain's, and, to a lesser extent, within Europe's ambit. He made no secret of the fact that he considered European culture to be superior to Canada's. Shortly after arriving in Toronto he spent what little money he had earned on a reproduction of an engraving by the traditional, now long-forgotten, German print-maker Raleigh Gruger. He hoped to return to Antwerp in order to hone his artistic skills. And he looked forward to making his artistic debut in the most conservative artistic institution in the Empire, the Royal Academy in London.

It is not surprising that Varley wondered whether the Canadian landscape would be a fitting subject for his art. During his first year in Toronto, he exhibited work that he had brought with him from England; the watercolour paintings he produced in Toronto were based on sketches that he had made on the outskirts of Sheffield. The muddy side-wings, vigorous brushwork, and low-keyed palette evident in *The Hillside* (c. 1912) were in keeping with the English landscape tradition and the painting techniques that Varley had acquired as a student in Antwerp.[30] The subject of this painting — the forest and the Gypsy encampment — supported the notion that mystery and fantasy, along with the human presence, were an inextricable part of the forest landscape. By retreating to a subject that he knew well, Varley was indulging in the imaginative recovery of the Derbyshire moors and its inhabitants. He was catering to popular taste by producing paintings of "Home" for the parlours and dining rooms of Toronto's largely English-Canadian population. Had he never met Lawren Harris, A.Y. Jackson, J.E.H. MacDonald, Frank Carmichael, and Tom Thomson through his membership in the Arts and Letters Club and his employment at Grip and then at Rous and Mann, he might have continued to produce watered-down versions of the English landscape.

❖ ❖ ❖

A year before Jackson reputedly "weaned Tom Thomson away from Fred" and opened his eyes "to new possibilities in the use of paint," Thomson and Varley were "exceedingly close."[31] It may have been their mutual loneliness which drew the two men together in the early autumn of 1912. Tom "was very lonesome" and, as Fred recalled, "I was very lonesome too."[32] But the two men – one dark-haired, well-built, and tall, with the hands and the stride of a woodsman, the other small, slight, erect, light on his feet, and possessing a florid complexion that was almost as red as his hair – had more than their loneliness in common. They were both independent-minded, complex, and difficult men. They were both commercial artists. They both loved poetry and music. As well as the cornet and the mandolin, Tom played the violin, to which Fred provided the accompaniment on the piano. They prided themselves on being physically fit. Fred marvelled at how Tom "could jump in the air and snap at a centre drop light in a room we shared off Yonge Street by catching the cord attached to the socket between his feet" then land "like a cat back on his two feet in the middle of the room."[33] They were passionate lovers of nature. While Fred sang the praises of the Derbyshire moors, Tom, who had made his first trip to Algonquin Park just after meeting Fred, was ebullient about his discovery of the forest reserve which the Ontario government had designated as parkland in 1898. But there was something else which drew the two men together: Tom liked his drink and his women almost as much as Fred did. According to Joan Murray, Thomson "had picked up the habit of drinking when he was young" and came home "more than once drunk" to the Studio Building where he lived from its construction in 1913.[34]

Before Maud Varley arrived in Canada in April 1913, the two men spent much of their time in one another's company. When Fred was not at the Arts and Letters Club, he and Tom shared their midday meal at a lunch counter. During the evenings they ate their dinner at a Greek restaurant on Yonge Street, meeting frequently at the door without prior arrangement. (This happened so often that Fred was convinced that Tom possessed psychic powers.) On Saturdays they

hiked to the outskirts of the city or took the ferry to Centre Island. And on Sundays they turned Rous and Mann, where they had worked shoulder to shoulder during the week, "into a kind of studio" and painted.[35] Their friendship remained intact even after Maud Varley arrived in Canada. "There was a cot bed always ready for him whenever he felt like staying," Maud recalled years later. Indeed Thomson became "almost a member of the family."[36]

Thomson was a commercial artist through and through. Unlike most of his artist friends, he had received no formal art-school training. He began "his career as a painter in 1906 by copying the work of others."[37] When he began to paint seriously in 1911, he not only received help from Jackson, but also from J.E.H. MacDonald, Lawren Harris, and the often-forgotten Toronto painter Florence McGillivray, who gave him "some helpful hints."[38] When Varley met Thomson in 1912, he encouraged his companion, five years his senior, to devote more time to art. Varley got Thomson to work in a larger format. He persuaded him to submit work for exhibition to the province's largest and most prestigious exhibition society, the Ontario Society of Artists, as well as to the Canadian National Exhibition. Varley's enthusiasm for Thomson's work was ratified when his painting *Northern Lake* was purchased by the government of Ontario at the Canadian National Exhibition in 1913. This was Thomson's first important sale; it gave him the confidence he needed to devote even more time to his painting.

Varley was as determined to see Thomson form a permanent relationship with a woman as he was to help him become a full-time painter. Knowing that his own loneliness would subside once Maud arrived from Sheffield and fearing that Tom's would increase, Fred played matchmaker. He was hopeful that Maud's half-sister, Dora, who was accompanying her to Canada, might be a suitable candidate. Tom balked at Varley's suggestion that he acquire a female companion. He "wasn't fit for a good girl," he told Fred, because he had been "a wild man." Fred thought otherwise. "He's the straightest gentleman I've ever met," he told Maud.[39] And he looked forward to having Tom as a brother-in-law. Dora liked Thomson when they met.

Encouraged by her response, Fred "pushed" the relationship. Though Maud found Tom "shy and very gentle," she was against the match from the outset.⁴⁰ She felt that a liaison between Thomson and her half-sister would "have been a catastrophe."⁴¹ Sensing danger, and feeling unworthy in any case, Thomson made no effort to pursue Dora. He remained a bachelor until his untimely death in July 1917.

In spite of wanting to see Thomson tie the knot with Dora, Varley envied his friend's freedom. It was difficult, as Mr. Pinder had foreseen, for Fred to fulfil the role of husband and father. He was a poor provider and an erratic correspondent. When Fred did occasionally write to Maud, he was full of concern for the children and for his "darling little girl," his "dear wife," and "my darling," as he variously called Maud. He encouraged her to share all her thoughts with him: "Now dearest you must tell me about your feelings." "Don't conceal anything if *it is* worrying you," he told Maud in his first letter home, "but out with it straight."⁴²

It was always easier for Fred Varley to express concern for his family's well-being than to provide for them. "Well dearest, this week I'm only sending you £2, I can't spare more – but I send every scrap of love – armsful full [sic], body full – heartfull, oh Maud, just to hold you tightly in my arms and see you nestling there is almost too much joy."⁴³ The purchase of a canvas, a frame, a new suit – or the enjoyment of a night out on the town – usually took precedence over slipping a few dollars into a letter destined for home. "I ought to have sent you more money so that you needn't have borrowed any at all," he confessed to Maud in March 1913, "but I don't know, it takes time to settle into new work and ways and overstraining to remove mountains is dangerous."⁴⁴ Fred was shamelessly willing to let others support Maud and the children for him. He was "very pleased indeed" when he heard that Maud's Sheffield acquaintance, Mr. Rogers, had given Maud fifty pounds,⁴⁵ and happy when Dora agreed to lend Maud ten pounds towards the cost of her journey to Canada.

That Fred was fallible was certain. That he – and Maud – knew it was also clear. "If I am weak at times and seem to fail you – it is

not that my love is less — just that I am weak."[46] But Fred's troubles, as the following "confession" suggests, were not only financial:

> Do you know dear, it might have been wrong — I don't think it was, but coming home tonight I would have given much for a talk with a girl — I longed ever so, to talk quietly in a cosy room. To make a life of 2 hours: to live in reality a little of life nearer to you and I — I felt it would be nearer. I could not be with any girl without having you there. It would be no pleasure, simply a sense of wrong through all. Well, I didn't see that girl who could have been a Chum so I came home.[47]

When Fred reached his boarding house on Summerhill Avenue, so he told Maud, he stripped off his clothing. But as he was about to step into the bathtub, he discovered that the water was cold. The boiler had burst. Undeterred, Fred took his bath anyway, in cold water.

What can one make of this passage? Was it pure fantasy, created during the course of writing the letter? Did Varley really have a liaison with this woman during his solo months in Canada? And, if so, was he simply taking the liberty — one that he had given to Maud — of sharing it with her? Whatever may or may not have happened between Varley and another woman, the letter could not have made pleasant reading for Maud, who was beset with financial difficulties, stranded on the opposite side of the Atlantic and uncertain as to when she would be reunited with her husband.

However desperate Fred might have been for female companionship, after the date of Maud's arrival in Canada was set, his letters to her became more frequent. He showed more concern for her precarious financial predicament. He grew genuinely excited about the prospect of having his wife and his children close at hand. There was much for Maud — and for Dora — to do once they arrived in Toronto. Fred's clothing required attention. He had a hole the size of his fist in his hat. His suit and the rest of his "stuff," as he called his clothing, needed to be put "in docket order."[48] These tasks were women's work

which, he assured Maud, would be undertaken in congenial sur-
roundings because he had taken a six-month lease on a cottage on
Centre Island. There, Maud could look forward to "a lovely aban-
donment" and a "carelessly free" lifestyle. Since everyone lived out-
of-doors during the summer months, she, Dora, and the children
would also have plenty of "fresh air and healthy exercise."49

Varley had long been receptive to the idea that the countryside
possessed regenerative powers. Like previous generations of city-
dwellers, he had sought solace and renewal through his contact with
the landscape. After arriving in Canada, he continued that tradition
first by hiking to the outskirts of Toronto on the weekends, and then
by taking up residence on Centre Island.

Baedeker's Canadian travel guide for 1907 does not make Centre
Island sound particularly attractive. Its 325 acres were "nothing but a
large sandbank, fringed with flimsy summer-cottages."50 Yet his res-
idence there during the spring, summer, and autumn of 1913 gave
Varley a bolt-hole. It provided him with an escape from "the modern
battle" of city living. "Today is warfare unceasing," he told Maud
just before she arrived in Toronto. "The world never lived so quickly
& vividly as at the present time and one must have the silence for a
few moments in order to keep strong."51

Varley was certainly not the only person in Ontario who was
convinced that the city-dweller needed a refuge from the fast pace of
urban living – though most would have preferred to rent a cottage
more distant from Toronto than Centre Island. When advances in
the technology of travel had opened up Canada's hinterland at the
end of the nineteenth century, middle-class Canadians made con-
tact with the Ontario wilderness by establishing woodcraft move-
ments, by building summer cottages, children's camps, and lodges, by
making hunting and fishing expeditions, and by turning vast tracts
of land into provincial parks. When innovations in the packaging
and marketing of painting materials made it easier for "artistic

scene-seekers . . . to acquaint themselves with the ever-retreating frontier, painters joined the throng to the wilderness too."[52]

Professional and amateur artists hoped that their work might renew and uplift the city-dweller. This had been the intention of central Canada's railway artists who, during the last two decades of the century, produced paintings of the unpopulated Rocky Mountains for the Canadian Pacific Railway in exchange for free railway passes. Artists associated with Toronto's Art Students' League (1888–1904) followed suit by decorating their calendars with rural scenes of the Ontario landscape. Art societies, like the Canadian Art Club, encouraged their members to "produce something Canadian in spirit . . . strong and vital and living, like our North West land."[53] And individual artists living in central Canada – Maurice Cullen, Homer Watson, Edmund Morris, Ozias Leduc, William Brymner, to name just a few – were equally caught up in the wilderness ethos of the Canadian landscape long before Varley ever thought of immigrating to Canada.

Though many Canadians were painting the landscape before the First World War, no artist, according to Montreal critic Harold Mortimer-Lamb, had "expressed the spirit of the great northland."[54] Lamb was not suggesting that the Canadian landscape was unpaintable or an unsuitable subject for the landscape painter; on the contrary, he felt that the "strong colour and rugged line" of the northern wilderness provided the artist with a fitting subject. Yet most artists were uncomfortable depicting the *uninhabited* wilderness landscape. This was because they worked within British and European traditions that demanded that the artist include some human presence in their paintings of the land. Evidence of habitation was not, of course, always easy to find, especially in remote areas of the northern Ontario landscape, let alone in the Canadian Rockies.

The notion that the wilderness landscape could offer a suitable subject for the Canadian artist was only fully appreciated when Canadian artists saw how painters from other northern countries were painting their landscapes. After viewing an exhibition of Scandinavian art in 1893, Ontario artist Charles W. Jefferys was

impressed by the extent to which Europe's northernmost artists "were grappling with a landscape and climate similar to our own."[55] When Lawren Harris and J.E.H. MacDonald viewed an exhibition of contemporary Scandinavian art in Buffalo, New York, some twenty years later, their response was similar.[56] To MacDonald, the Scandinavian paintings "might all have been Canadian." Moreover, the experience of viewing them made him realize that "This is what we want to do with Canada."[57] Lawren Harris was "profoundly stirred" by the Scandinavian paintings too, but he gave the painters in the exhibition less credit for shaping his own approach to the wilderness motif. "Our own idea was," Harris wrote, "corroborated, our conviction deepened and our enthusiasm projected itself into future possibilities."[58]

Harris and MacDonald were not drawn to every painting in the Buffalo exhibition. They were indifferent to the work of the more extreme modernists like the Expressionist painter Edvard Munch. They were attracted, on the other hand, to the subdued paintings of Gustav Fjaestad, Bruno Liljeforg, Harald Sohlberg, and the other naturalistic artists in the exhibition. These men were influenced by Symbolist and Jugendstil tendencies – the simplicity of expression and elimination of detail, the use of bold outlines and silhouetted screens of vegetation, along with the flat areas of colour and the repetition of rhythmic patterns – which originated in the commercial-art world. It was not, therefore, just the northern subject matter that struck a chord with Harris and MacDonald. The Scandinavian artists impressed them because they were speaking a language informed by commercial art, which MacDonald at least knew well.

A.Y. Jackson subsequently acknowledged the debt, evident in paintings like *Northern Lake*, that Tom Thomson owed to his training as a commercial artist. The engraving house where Thomson worked possessed in Jackson's view, an atmosphere where "originality was not discouraged," where colour, line, proportion, and pattern were problems which bore a close relation to his later work, and where "he was able to apply them with absolute freedom."[59] Jackson's remarks were equally relevant to the future members of the Group of

Seven. They all believed that "there was a rich field for landscape motifs in the north country if we frankly abandoned our attempt at literal painting and treated our subjects with the freedom of the decorative designer."[60] Jackson's *Terre Sauvage*, MacDonald's *Tangled Garden*, Thomson's *Northern Lake*, Lawren Harris's *Winter Morning*, and Varley's *Indian Summer* were all painted within a year or so of the Scandinavian exhibition in Buffalo.[61]

Varley's friendship with Tom Thomson and his association with the other painters and illustrators he met at Grip and later at the Arts and Letters Club made him feel, perhaps for the first time since his art-school days in Antwerp, that he was among like-minded artists. As he told his sister Ethel in 1914, six years before the formation of the Group of Seven in 1920: "there's a small party of us here, the young school, just 5 or 6 of us and we are working to one big end."[62] Jackson had likewise noted the emergence of a "Canadian School" the same year.[63] A full year before this, the critics had dubbed the artists occupying the six ateliers in the Studio Building on Severn Street the Severn Group and, when they were less disposed to their modernist painting, the Hot Mush School. But even before this, J.E.H. MacDonald had referred to his artist friends as "the bunch."[64] Contact with "the young school" made Varley conscious of the fact that Canada possessed subject matter that was worth taking seriously. Before the end of his first year in the country, he had abandoned painting and exhibiting British landscape scenes, and by the winter of 1914, he was "aching and gnawing" to express what he called Canada's "environments."[65]

Varley's urge to paint the Ontario landscape was fuelled by his growing conviction that commercial illustration constituted "killing work for the artist."[66] As he told Ethel in May 1914, "in the commercial field I cannot find the opportunity of saying what I feel." When Thomson, Jackson, MacDonald, and Lismer quit their jobs as full-time commercial artists to devote more time to painting,

Varley realized that there was only one way "to speak and that is with a more powerful and sincere medium, picture-painting."[67]

Varley's decision to devote more time to "picture-painting" and to rendering Ontario's "environments," as he called the landscape, came just after Samuel and Ethel expressed their pride in his success as a commercial artist. "Such praise as you both gave me," he told Ethel in response, "was miles ahead of anything I could think of and do you know I never thought I could give so much pleasure to others through my feeble work."[68] Yet however satisfying this recognition might have been, Fred's goals had shifted. He wanted more than a steady job. He wanted an opportunity to "put down sincerely on canvas what is restless and waking — wayback in the lap of the gods." From the spring of 1914, commercial art for Fred Varley was never to be anything more than a means to an end. From now on, he told Ethel, he would endeavour to express "*Happiness*. Sunlight. Laughter" by painting "outdoor pictures — portraits." "After all," he continued, "this is an outdoor country."[69]

In February 1914 Tom Thomson introduced A.Y. Jackson to Algonquin Park. In March of the same year, J.E.H. MacDonald and William Beatty painted there too. In May, Arthur Lismer and Thomson set up camp in the park on Molly's Island in Smoke Lake. This is where Lismer got his first experience of travelling by canoe. Then, in the middle of the summer, Thomson, who had taken up James MacCallum's invitation to sketch at his cottage on Georgian Bay, returned to Algonquin Park. He was joined there by Jackson. Just before the first frost had stripped the maples of their foliage, Varley accepted MacCallum's offer of financial support and adhered to Tom's advice to "wake up and come." In early October, Fred, Maud, and the Varley children joined Jackson, Thomson, Lismer, Beatty and their families, and two other artists, Miss Beatrice Hagerty and Mrs. Robertson, in the park.[70]

Algonquin Park is situated some two hundred miles north of

Toronto. In 1914, getting to Canoe Lake Station by Arnprior and Parry Sound Railway from Toronto took several hours. The park was sufficiently isolated to make city-dwellers believe that they were in the midst of the wilderness. Though much of it had been logged, Thomson and Jackson had no difficulty finding a secluded grove of birch trees in which to pitch their tent. The other artists in the party, however, rented rooms in a more civilized two-storey, white-washed building which had originally been a boarding house for the employees of the Gilmour Lumber Company.

Mowatt Lodge, where Varley and the others lived, offered good food and moderate rates. Yet it was far from comfortable, attractive, or quiet. It faced the old mill-yard and its dilapidated buildings. It buzzed with fishermen and fishing guides, forest rangers, railway maintenance men, gravel-pit workers, and American tourists. And the area surrounding the lodge was anything but beautiful. Over thirty acres were fire-swept, dammed by beaver, littered with logs, slash, and all of the other debris that had been left over from the logging operations which had ceased a decade earlier when the Ontario government stopped issuing timber licences to logging companies. Nevertheless, Mowatt Lodge was the best point from which to reach, by canoe and portage, the solitude, the rock, bush, muskeg, and thousand lakes in the heart of the park.

The colours that autumn were exceptionally brilliant. "The maple, the birch, and the poplar," Jackson recalled, "ran their gamut of colour."[71] The tamarack was tinted with shimmering gold. The weather consisted of bright sunny days and crisp cool evenings. While the mosquitoes and the black flies had retreated since the summer, the woods were far from empty. As one observer noted, the park "seemed to be full of artists."[72]

Thomson, who was the group's interpreter and guide – he taught Varley how to paddle a canoe – was the first of the party to send news from the park. He told MacCallum that Varley and Lismer were "greatly taken with the look of things here."[73] Jackson confirmed this observation a few days later: "Varley, Lismer and company are enjoying themselves thoroughly."[74] In his letter to MacCallum, Lismer

gave a slightly different account. He and Varley were "finding it far from easy to express the riot of full colour." Indeed, he told MacCallum that they were "struggling to create something out of it all and hope to have something to show as a result of our efforts."[75] Varley concurred in this view. While the landscape was "a revelation," it "completely bowled me over at first."[76] But then things improved. According to Jackson, Varley's palette went "up in key."[77] And, by Varley's own account, he was "going full tilt" and busily "'slopping' paint about."[78] He was pleased not only by his own progress; he was equally excited by what Thomson had achieved. Jackson thought otherwise. In his opinion, Thomson's paintings were "the least suggestive of the north country."[79]

Lismer and Varley had difficulty finding their stride during this first trip to Algonquin Park. The air was too clear; the foliage too vivid. They were not well-seasoned outdoorsmen like Thomson and Jackson. Varley neither fished nor swam. His painting excursions had been confined to Centre Island, High Park, and to the outskirts of Toronto. He and Lismer were ramblers. They were accustomed to walking on well-marked paths and to making day-long outings, not overnight trips into the countryside. It would never have occurred to them to spend a night on the Derbyshire moors or to have cooked their dinner over an open fire. Indeed, Varley's decision to live in the lodge rather than to camp with Thomson and Jackson did not go unnoticed. "Varley would be a hot musher in a few weeks," Jackson told MacCallum, "if he would live outside."[80] But above all, Varley and Lismer were still working within the English landscape tradition that had been shaped by the ideas of John Ruskin. Certainly, Varley's inclusion of Maud in his Algonquin Park painting *Indian Summer*, as well as Lismer's focus on the shack in *The Guide's Home, Algonquin*, paid homage to Ruskin, who demanded that artists include some evidence of man in their paintings of the landscape.

Varley and Lismer did have one thing in common with their artist companions on that trip: the extent to which their knowledge of commercial art informed their paintings. Even before the trip to Algonquin Park, Fred told Ethel that he and his friends were

"endeavouring to knock out of us all of the pre-conceived ideas."[81] In an interview years later, he chided himself and his painter friends for having produced little more than decoration. "It's just decoration . . . simply decoration," he repeated again and again in reference to the "foolish ideas" that he and his colleagues in the emergent Group of Seven had to eliminate from their work.[82]

It is not surprising, therefore, that when Varley sketched Maud among a grove of birch trees on that trip to Algonquin Park and later transformed his sketches onto the canvas in *Indian Summer*, he employed a number of stylistic devices which were drawn from commercial art. The two-dimensional plane, the attention given to the middle ground, and the screen of decorative trees in this work were devices also found in Thomson's *In the Northland* and Jackson's *The Red Maple*.[83] Varley, Lismer, MacDonald, Jackson, and Thomson all applied their training as commercial artists to their oil and watercolour paintings of the northern Ontario landscape. Doing so allowed them to distinguish themselves from the tradition-bound full-time academic artists who clung to well-worn styles, and to adapt the northern-landscape motif in a new way. It further contributed to their hope that the commercial artist, who painted only on the weekends and during vacations, could be taken as seriously as the full-time professional painter.

When Varley returned to Toronto from Algonquin Park in late autumn, he was "determined that next year I'll bring the family up for a few months and paint the out-door figure." Yet he did not visit the park the following year.[84] MacCallum gave Varley no financial support. Unlike Lismer, Jackson, and Thomson, he was unsuccessful in selling his work either to the Ontario government or to the National Gallery of Canada when he exhibited it at the Ontario Society of Artists' annual exhibition and at the Canadian National Exhibition. Moreover, during the early months of 1915, Varley had creditors on his back, and the family moved house for the fifth time

since Maud's arrival three and a half years earlier. He and Maud also had a third child; James was born on 2 July 1915. And he was producing few paintings during his non-working hours.[85]

Was Varley's small output the reason MacCallum withdrew his support that year? Was MacCallum unsympathetic to the few paintings that Varley did produce? Or did something else stop MacCallum from putting Varley on a full-time salary, as he did with Thomson and Jackson, or from financing another trip north, as he did for Lismer in 1915? Certainly the goodwill that MacCallum extended to Varley the previous year seems to have run its course. And it was not only MacCallum who appears to have grown tired of Varley. During an evening at Arthur and Esther Lismer's home in the spring of 1915, Fred showed "a side of his nature, which does not always make for sociability": he lost his temper. Everyone, including Tom Thomson and Frank Carmichael, who were also there, was annoyed by Fred's unprovoked outburst. The following day Lismer, Thomson, and Carmichael "had it out." "It is rotten and I feel as if I want to chuck Fred entirely," Carmichael told his wife, Ada, "as one never knows what or when one is going to be subjected to a process of freezing which is anything but pleasant."[86]

This was not the first time that Varley had soured a congenial evening with his friends. According to Jackson, he was "always getting into trouble."[87] Before the end of his first year in Canada, Fred had acquired a reputation for displaying the kind of disruptive behaviour that had made him famous in Antwerp. Had James MacCallum been at the receiving end of Varley's temper and "freezing"? Is this why MacCallum did not invite him to help Lismer, Thomson, and MacDonald paint murals on the walls of his Georgian Bay cottage in 1915? Varley would never have purposely endeared himself to MacCallum. He would have had little patience with MacCallum's scant knowledge of painting. The art patron's unbounded enthusiasm for the work of Jackson, Harris, Lismer, Carmichael, Johnston, and Varley was predicated on the content of their paintings, not on the innovative way in which they depicted their material. "Did the Doctor know much about art?" Jackson

once mused. "I would say no, not very much, but he knew and loved the north country and looked for the 'feel' of it in pictures with the same sense a lumberjack has for the 'feel' of an axe, or as the trapper has for a paddle."[88]

Varley might have shown his disapproval of MacCallum's tendency to shift from the stiff and socially acceptable persona of the Toronto consultant to the personality of the rugged outdoorsman and eccentric supporter of Toronto's quasi-bohemian artists. If this is what happened, however, Varley also forfeited the possibility of being supported by one of Toronto's most generous and consistent patrons of art. Varley's penchant for biting the hand that fed him would have been met with MacCallum's forthrightness. According to Jackson, MacCallum had a reputation for sizing people up "and if he does not like them they get nowhere."

Whatever reason MacCallum had for not helping Varley in 1915, he was willing to finance his trip to Georgian Bay the following summer. This entailed covering the cost of Varley's train journey from Toronto to Honey Harbour, then providing a boat that took him to the island near Split Rock. MacCallum was well rewarded for his generosity. It was at Georgian Bay that Varley produced the sketches for his landmark painting, *Stormy Weather, Georgian Bay*.

The execution of this work erased any doubts that Varley was simply a painter of figures, or merely a commercial artist, or had not yet caught the spirit of the Canadian landscape. *Stormy Weather, Georgian Bay* was to establish him as a fellow-visionary of the group of artists he had come to know during his first three years in Canada. The painting was also to become Varley's signature piece and his ticket – despite his difficult voyage – to membership in the future Group of Seven.

Stormy Weather, Georgian Bay, as the painting was called in 1924, was first exhibited as *Squally Weather, Georgian Bay* at the Ontario Society of Artists' forty-fifth annual exhibition in the spring of 1917. It was

then exhibited at the Royal Canadian Academy and, later that year, at the Canadian National Exhibition, where Varley asked the grand sum of $500 for its purchase.[89] Unsold by the end of the exhibition, the painting was returned to his studio. Despite having failed to sell the painting, Varley nevertheless continued to think highly of it. When he was in London as a war artist in 1919, he asked MacCallum to send him two "large" pictures for exhibition at the Royal Academy's spring show. One was the painting of Maud executed after his 1914 trip to Algonquin Park. The other was "a view of the Bay from your island."[90] MacCallum sent *Indian Summer* to London. But the other painting, *Squally Weather, Georgian Bay*, remained in Varley's studio until he exhibited it once again. This time it was shown at the Art Gallery of Toronto in 1921. Varley changed its name to *Georgian Bay*. He increased the price by $250, and this time found someone to buy it. The National Gallery of Canada purchased *Squally Weather, Georgian Bay* for $750. When they exhibited it at Wembley in London three years later, it bore a new title, *Stormy Weather, Georgian Bay*, which it has kept to this day.

Most art historians claim incorrectly that *Stormy Weather, Georgian Bay* was painted in the autumn of 1920, following Varley's second trip to Georgian Bay.[91] There is the often-told story that Varley and Lismer painted the same lonely pine tree, from the same viewpoint, on the same windy day. Lismer made the sketches for his canvas *September Gale* and, so the story goes, Varley made his preparatory sketches for *Stormy Weather, Georgian Bay*. Shortly after setting up their sketch boxes, however, the two men are said to have had an argument. Angry, Varley took a vantage point a hundred feet above Lismer – thus explaining why *Stormy Weather, Georgian Bay* and *September Gale* have different viewpoints. This story does not, however, explain why the wind is blowing in opposite directions in the two paintings, or why the sketches that Varley executed on this trip with Lismer bear little resemblance to the finished canvas *Stormy Weather, Georgian Bay*. One of the sketches that Varley made on that 1920 trip, *Georgian Bay Sketch No. 5*, is rendered in a low-keyed palette; the paint is applied with sweeping and vigorous strokes; the overall structure of the sketch is

achieved by building up solid areas of colour. This, along with the other panel sketches from this trip, has more in common with Jackson's *March Storm, Georgian Bay* (1920) and Lismer's *Go Home Bay* (1921) than with Varley's earlier work, *Stormy Weather, Georgian Bay*.

Stormy Weather, Georgian Bay's distant viewpoint, its stippled paint, and its luminous and vibrant colours belong to the pre-war era of Varley's oeuvre. The studied effects of light and atmosphere pay tribute to Turner's dictum that colours are more than a set of hues; they function as light and shade. The painting's composition and its symbolic tree owe something to the English landscape tradition, something to the conventions devised by commercial artists, something to contemporary Scandinavian painting, and something to Jackson's *The Red Maple* (1914) and Thomson's *The Jack Pine* (1916). Its windswept tree also echoes Lawren Harris's poem "The Old Pine," in which a fierce gale makes a tree "moan over and over again, I am beautiful because I struggle."[92] *Stormy Weather, Georgian Bay* would soon become famous for its absence of human artifice, for the characteristics it shares with the work of Varley's artist friends, and because its subject, "a pine tree by a northern lake," was, as Arthur Lismer noted of Tom Thomson's paintings in 1934, "surely our national symbol – the theme song, as it were, for a nation's story."[93]

Yet *Stormy Weather, Georgian Bay* was hardly an accurate representation of Go Home Bay. When Varley was there during the summer of 1916 the area hummed with motorboats and cottagers. Two years earlier, Tom Thomson had found that it was "too much like North Rosedale . . . all birthday cakes and water ice."[94] But Varley did not set out to produce a realistic painting. He wanted to capture the unsettled mood of the scene and to give his painting a sense of gravitas. Though he did not intend to produce an auto-biographical painting, *Stormy Weather, Georgian Bay* is also a metaphor for his turbulent life. The twisted tree and the churned up lake represent Varley: his financial struggles, his struggle between having to earn his living as a commercial artist and wanting to paint full-time; his struggle to eliminate the decorative elements of commercial art from his work; and his struggle to live as a free

spirit. And the inconsistencies in the painting – the diagonal lines depicting the waves jar against the tree and the flat areas of colour in the foreground – represent the contradictions in Varley's own life. *Stormy Weather, Georgian Bay* was inseparable from Varley's mood, his spiritual condition, and his material situation.

A week or two after Varley submitted *Stormy Weather, Georgian Bay* to the Canadian National Exhibition, Tom Thomson went missing on Canoe Lake. His disappearance there on 8 July 1917 and the later recovery of his body prompted Jackson to observe that "without Tom the north country seems a desolation of bush and rock."[95] Yet without Thomson's death, his friends would not have had the myth that they needed to coalesce as a group, or to attract institutional support, or to receive the attention of the critics and the public at large. As critic Robert Ross put it, the Group of Seven "felt a sense of mission about Tom because he was not only their discovery but, in an important sense, their invention."[96]

A few weeks before news of Thomson's death was widely reported in Toronto's newspapers, literary critic E.K. Brown claimed that the country lying north of Toronto was now "the home of every Ontarian's imagination."[97] Yet Harold Mortimer-Lamb had wondered a year earlier "whether the present movement," which he dubbed the Algonquin School of artists, would "lead . . . to the development of an art distinctively nationalistic."[98] After Thomson died, there was no doubt as to where it would lead. For one thing, Thomson's death brought the emergent Group of Seven to the attention of Eric Brown, the director of the National Gallery of Canada. Brown, who sported English tweeds and a monocle, and spoke in a "high pitched slightly nasal English accent," was tailor-made for these artists.[99] He was English-born and British-bred. His strong British identity led some to accuse him of favouring MacDonald, Lismer, and Varley because they, like Brown, were from the north of England. He was also an ardent camper. "Eric and I

worked out a grand life together," his wife Maud recalled, "and our best holidays were when we went camping, packing tent, blankets and food into a sixteen foot canoe, leaving behind civilization to explore the bush, lakes and mountains."[100] But most important of all to the success of the future Group of Seven, from the moment Brown took on the directorship of the National Gallery of Canada in 1910, he was on the lookout for a distinctive group of Canadian artists. After reorganizing the gallery in 1914, he told Sir Edmund Walker that he intended to spend more money in order to acquire "good Canadian pictures."[101]

The possibility of purchasing some "good" paintings by Canadian artists presented itself when Brown saw "some excellent work" at the Ontario Society of Artists' spring exhibition in February 1914. "The whole exhibition," he told Walker, gave evidence of "the progress of a school or group of young painters who will be really Canadian and national in their work."[102] A year later, Brown confirmed when he wrote in *The Studio* that "a younger generation is coming to the fore, trained partly in Canada, believing in and understanding Canada, and at least to some extent encouraged by Canadians." "They are painting their own country," he continued, "its wonders and its individuality with an outburst of colour and strength."[103] Eric Brown was not only an early supporter of the future Group of Seven, he was among the first to champion Thomson. He bought *A Moonlight Scene* for the National Gallery in 1914.

Thomson's death gave the Canadian public and the critics what they were looking for: a home-grown cultural hero. Thomson differed from the artists who tried to adapt European styles and modes to the Canadian landscape. He was an amateur artist with no formal art-school training, which allowed him to respond intuitively to his environment on canvas. He was a woodsman, which, as Lismer observed, enabled him to reveal "to us our environment, changing the direction of our thoughts and aspirations from material and utilitarian considerations to contemplation of the beauty of Canada." All of this contributed to the belief that Thomson was "the manifestation of the Canadian character."[104]

Through their close association with Thomson, his artist friends were able to win new patrons and new supporters among the general public. After Thomson's death, Jackson observed that "Dr. MacCallum became a kind of patron saint to the Group of Seven."[105] This kind of support helped the founding members of the Group make the wilderness landscape a legitimate motif for Canadian artists. It reinforced their belief that Canada was a northern country. It lent credibility to their anti-scientific and anti-materialistic approach to life. Finally, it legitimized their departure from traditional art forms and their use of decorative motifs derived from commercial art.

Thomson's example enabled Varley and his friends to sidestep membership in the academy, to prove that, despite their training and work as commercial artists, they were worth taking seriously. This is how they won the support of the anti-academic, anti-establishment public, and, most important of all, the support of institutions like the National Gallery of Canada and the Art Gallery of Toronto. This is how they survived — and even turned to their advantage — the adverse criticism they received from the critics in the local press. Thomson's death validated what J.E.H. MacDonald had written in his letter to the editor of the Toronto *Globe* more than a year earlier: "We have a new country and a country practically unexplored artistically and it would seem therefore that courageous and thorough experiment is not only 'legitimate' but vital to the development of a living Canadian art."[106]

Tom Thomson's death pushed his friends to the forefront of Canadian art. Almost overnight Varley became Thomson's protégé rather than his teacher. After Thomson went missing on Canoe Lake, the Canadian artist was no longer a studio-bound aesthete, but a hairy-chested outdoorsman.

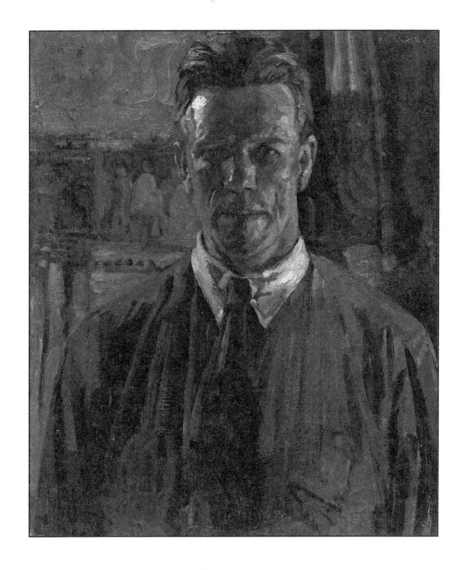

Self-portrait, 1919.

CHAPTER 4

War Artist

Varley was in Algonquin Park with Jackson, Lismer, Thomson, and Beatty shortly after the First World War broke out in August 1914. They were not tempted to interrupt their first collective painting excursion and join the volunteers who were flocking to the recruiting offices. While initially unenthusiastic about laying down their lives for King and country, they were nevertheless willing to help raise money for the Canadian Patriotic Fund. Upon returning to Toronto, Varley and his artist friends donated their work to an exhibition organized under the auspices of the Royal Canadian Academy. Some eighty works, representing Toronto's and Montreal's leading artists, went on exhibition in art galleries from Winnipeg to Halifax, then were sold through auction. The venture, which raised over ten thousand dollars for the Patriotic Fund, was hailed a success by Harold Mortimer-Lamb. Writing in *The Studio*, the Montreal art critic opined that "no class has shown a more earnest disposition to be patriotically helpful to the national and common cause."[1]

Other observers felt differently. They wondered how art contributed to the war effort and challenged artists' right to paint during the hostilities. Some commentators were even gratified that "ultra-modern art which had its birth in Germany" appeared to have been "killed by the war."[2] Most artists did not, of course, agree with these views. Indeed, many were eager to show the public how their work could be put to the service of war. In 1915 Homer Watson sketched the troops undergoing training at Camp Valcartier in Quebec. A year later he produced two large (if mediocre) paintings

for the Canadian government. *Camp at Sunrise* and *The Birth of an Army* earned Watson the large sum of ten thousand dollars. Other artists produced war-related watercolours and canvases without the benefit of a government commission. The annual exhibitions of the Ontario Society of Artists and the Royal Canadian Academy were replete with paintings depicting the home and war fronts. In 1916 Varley contributed a portrait of *Captain H.P. Langston* to the Canadian National Exhibition. Paintings like this did little to placate the critics who believed that Canada's artists were "given over to idleness and depression" during the Great War. Nor did it stop the federal government from cutting the National Gallery of Canada's annual budget by three-quarters and reducing the Royal Canadian Academy's pre-war operating budget by one half. And it did nothing to alter the Ontario government's decision to cease purchasing work by Canadian artists or funding the Ontario Society of Artists for the duration of the hostilities.

Private patronage went the same way as government support – it collapsed. Many art collectors believed that it was unpatriotic to buy paintings during the war, and put their money into war savings bonds. This meant that "the rather meagre patronage" that artists like A.Y. Jackson had enjoyed "dried up."[3] The situation for commercial artists was equally dismal. Jobs were few and far between after hostilities began.

All of these things had "a depressing effect on the arts." "If the war gets worse," A.Y. Jackson wrote in the autumn of 1914, "the only jobs will be handling guns."[4] After he heard about the Germans' second gas attack on the Canadians at the 2nd Battle of Ypres in April 1915, Jackson fulfilled his own prophecy: he enlisted as a private in the 60th Battalion. Lawren Harris followed Jackson to the recruiting office a year later. He became a musketry instructor at Camp Borden. Varley's old friend from Sheffield, William Broadhead, and the Ontario-born painter David Milne, who were trying to establish their careers in the United States, returned to Toronto and enlisted in the Canadian Expeditionary Force.[5] A host of other artists –

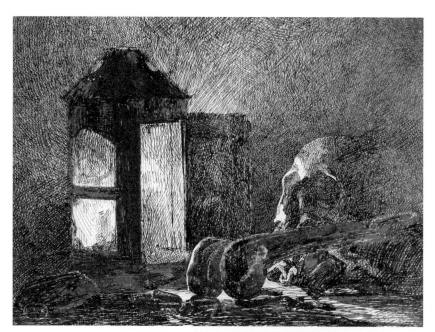

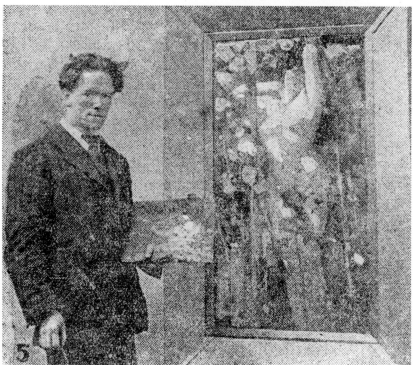

Top: *Still Life – Skull and Lantern*, c. 1897. McMICHAEL COLLECTION
Above: Varley with *Eden*. This photograph appeared in the Sheffield *Daily Independent*, February 29, 1912.

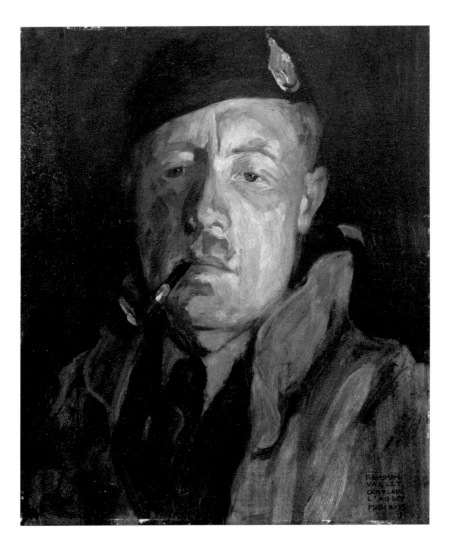

Cyril H. Barraud, 1919.

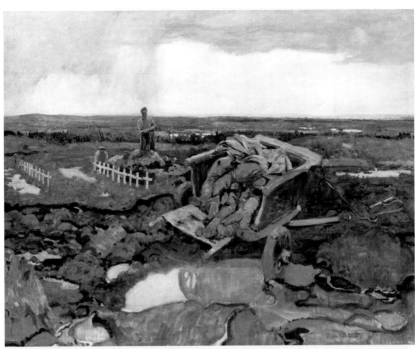

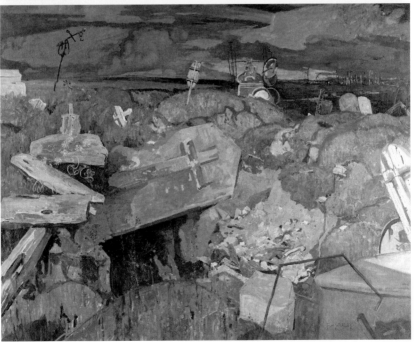

Top: *For What?*, 1918. CANADIAN WAR MUSEUM
Above: *Some Day the People Will Return*, 1918.
CANADIAN WAR MUSEUM

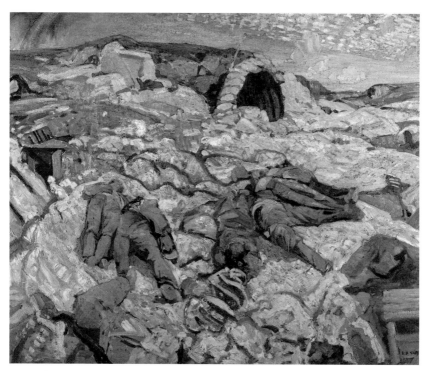

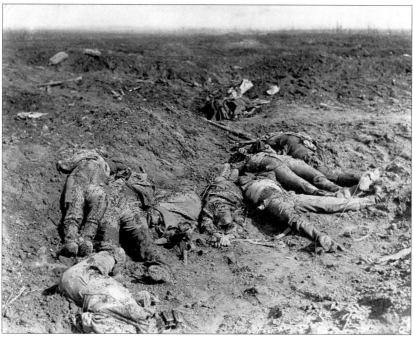

Top: *The Sunken Road*, 1919. CANADIAN WAR MUSEUM
Above: The battlefield after a Canadian charge, 1916.

Above: The Cloud, Red Mountain, 1927-28. ART GALLERY OF ONTARIO
Below: Dhârâna, 1932. ART GALLERY OF ONTARIO

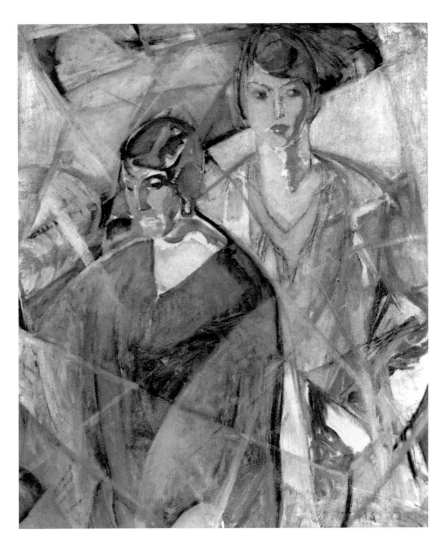

Complementaries, 1933.
ART GALLERY OF ONTARIO

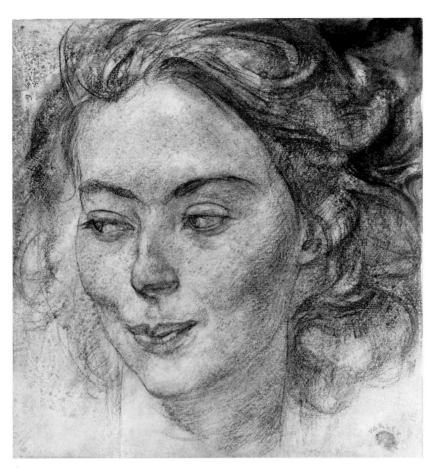

Above: *Head of a Girl*, c. 1934. NATIONAL GALLERY OF CANADA
Below: Vera Weatherbie, *Solitude*, c. 1932. ART GALLERY OF GREATER VICTORIA

The Open Window, c. 1933.
HART HOUSE

Randolph Hewton, Ernest Fosbery, J.L. Graham, Louis Keene, and Robert Pilot – were also in uniform by the end of 1916.

Varley did not follow their example. He had a young family to care for. He had a reputation to build. He had pictures to paint. And, unlike most people, Varley did not believe that the war would be over by Christmas. Tom Thomson had warned him about the absurdity of thinking along those lines. In the autumn of 1914, he, Fred, and Maud had stood at the corner of Bloor and Yonge streets for one and a half hours watching "12,000 men pass by eight abreast." "Gun fodder for a day," was Thomson's response to the military parade. "Six Months! Hell 3 or 4 years it must be."[6] Maud vividly remembered Thomson being "really upset with the idea of what [the marching men] were going to."[7] Varley went so far as to attribute Thomson's death in July 1917 to the fact that "everyone was worrying him about joining up." It was the pressure to enlist in the army, Varley later claimed, that made Thomson deliberately "upset the canoe" and end his life.[8]

Varley was not as disturbed by the war as his friend. Moreover, he fared better than most artists during the early years of the hostilities. He had a secure job as a commercial artist with Rous and Mann. He had several freelance commissions on his plate: illustrating a recruiting manual for the Imperial Royal Flying Corps; producing a series of drawings of David Lloyd George, Woodrow Wilson, and Robert Borden, among other dignitaries, for *Canadian Courier*; and providing drawings to accompany short stories in the *Canadian Magazine*. But most important of all, Varley took up the offer of a lifetime when, during the last year of the war, he agreed to become an official war artist. The job, which came with the rank of captain, made him into an officer and a gentleman. It put him on a salary of $1,900 a year. It gave him another $600 per annum for art materials. And it helped him find himself as an artist.

❖ ❖ ❖

The idea of hiring artists to paint the war was the brainchild of Lord Beaverbrook, a millionaire from New Brunswick. In 1915 Beaverbrook, who had moved to London as Max Aitken in 1910, created the Canadian War Records Office for the purpose of publicizing Canada's role in the war. Though successful to the point at which the British complained that it seemed as though the Canadians were the only troops fighting in France and Flanders, the photographs, films, and newspaper articles commissioned by the Canadian War Records Office were ephemeral. They were unsuitable for commemorating Canadian soldiers' contribution to the war, and they could not recreate the events that had taken place before the photographers and film-makers had arrived in the field. Believing that paintings and sculptures could provide long-lasting, prestigious, and fitting memorials, and depict otherwise unrecorded events, Beaverbrook and fellow press baron Lord Rothermere established a scheme whereby the best British artists were hired to paint the activities of the Canadian Expeditionary Force.

Beaverbrook and Rothermere had no difficulty finding volunteers to paint for the Canadian War Memorials Fund in 1916. The situation for artists in Britain was as precarious as it was for artists in Canada. Beaverbrook had the pick of the crop. By the end of 1917 some of Britain's most prestigious artists – Augustus John, Sir William Rothenstein, and Sir William Nicholson – and some of its most controversial – C.R.W. Nevinson, Percy Wyndham Lewis, and Paul Nash – were all painting for Canada.

The war artists were hired by the Canadian War Memorials Fund's art director, the colourful art critic for the *Observer*, Paul Konody. Some worked full-time, others were commissioned to produce only one work. Like photographers, film-makers, and journalists, war artists were instructed to record the events as they happened at the front or in the munitions factories, shipyards, airbases, and army camps in Britain. Things ran smoothly at first. Artists made on-the-spot sketches which they later transferred to canvas in the comfort of their studios. A small number of works were reproduced in the Canadian War Records Office's official publication,

Canada in Khaki. Some were even put on show in London's West End galleries whenever Konody could arrange it. But things soon changed. When Canada's artists heard that British artists were painting their soldiers they were "up in arms."9 Why, they asked, were British artists painting their troops? Why had Canada's own artists not been invited to participate in the war-art program? As the Canadian Pacific Railway's art director, John Murray Gibbon, wrote Eric Brown in 1917, it seemed absurd that "at a time when the Government had withdrawn its usual purchases, Canadian artists should be overlooked."10

Anxious to avoid conflict, Beaverbrook responded to the complaints immediately. He invited Eric Brown and Sir Edmund Walker, now chairman of the National Gallery's board, to suggest the names of four Canadian artists who might be willing to work for the war-art program in England and at the front. But the National Gallery director and the chairman of the board were unwilling to choose one artist over another. Moreover, they were unconvinced that warfare presented a "pictorial" subject for the artist. Brown and Walker therefore turned the matter over to representatives of the Ontario Society of Artists and the Royal Canadian Academy.11 It was a joint committee, composed of officials from these two organizations, that put forward the names of two Montreal painters, Maurice Cullen and Charles Simpson, and two artists from Toronto, C.W. Jefferys and William Beatty. And it was the same committee that chose Fred Varley to replace C.W. Jefferys when he declined the invitation.

In February 1918 the *Canadian Courier* told its readers why Beatty, Cullen, Simpson, and Varley had been chosen: "They are all non-studio painters; men of the out-of-doors; men to whom the field and the sky, the human figure and the battered wall are more than posings in a studio." Varley, who was "well known to all readers of the *Courier,*" got more press coverage than the other three. "I don't think he is strong on scenery or that he cares much for what may be called a mere landscape," the writer noted, but "observation of this north-of-Englander as he bangs about here in Canada suggests that he goes hard after the big, essential virilities." The correspondent

went on to praise Varley's painting for its "strength and realism" and for its "strong massing of forms and colours," all of which left the viewer with "the impression of a recreated reality." But it was Varley's personality which interested the writer most:

> He has had a lot of experience that knocks the guff out of any man. He knows what it is to be a wayside man without enough to eat, a dock walloper, a companion of those who never see three meals straight ahead in a row, the knights of the empty pocket and the full soul. He believes in the splash of rain on the pelt, the bite of the hard wind, the glint of a naked, hot sun. No fear but he will get as good a stranglehold on the tremendous things that high explosives have left in France as any of the contingent. Augustus John . . . had better keep an eye on Varley.[12]

This first extensive reference to Varley in the Canadian press illustrates that he was known to a small circle of people as a bohemian, as a man of the outdoors, as a commercial artist, and someone who straddled the modernist and the realist world of portrait and landscape painting.

Varley's paintings were, on the other hand, not known to the Canadian public. His artistic output since coming to Canada in 1912 had been small. A modest number of his Georgian Bay paintings had been exhibited at the Canadian National Exhibition, the Ontario Society of Art, and even at the Royal Canadian Academy. But, as the writer for the *Canadian Courier* made clear, Varley's reputation as an artist rested on his illustrative work in the popular press. He was nevertheless treated as a major figure in the Canadian art world because he possessed all of the qualities that, since the death of Tom Thomson, had become the trademark of the modern Canadian painter. He was a rugged individualist. He had a background in commercial art and illustration. He was a non-academician. He painted in the wilderness areas of the province and was not therefore tied to a studio. And he was not a member of the country's official body of art, the Royal Canadian Academy.

Everyone agreed that Varley was "a good choice for the job." "If he can sustain his enthusiasm," Lismer told MacDonald, Varley would "do some fine work."[13] Nor did Varley doubt his suitability for the position either. He knew that this was the opportunity of a lifetime. And when he and Beatty received "best wishes for their welfare and success in their patriotic undertakings" at a meeting of the Ontario Society of Artists shortly before they departed for England, they promised to be a credit to the Ontario Society of Artists and their country.[14]

Varley had just enough time to observe the "noble work" that Lismer was doing as the principal of the Victoria School of Art before boarding ship in Halifax harbour.[15] The voyage, which began on 25 March 1918, was uneventful. The RMS *Grampian* withstood the rough weather encountered on the second day out better than most of the other ships in the convoy, including the SS *Corsican*, which had brought Varley to Canada in 1912. Fred told Maud that he lost neither his "foothold or other things" from his "hold" like many of the 1,800 other men and women who spent much of the voyage below deck or hanging over the edge of the ship.[16] Varley promenaded around the ship so many times that he earned a reputation for being the most energetic man on board. In addition to getting plenty of exercise, Fred ate well and, ever on the lookout for someone with whom he could share "the sweet silvery moonlight," he claimed to have charmed as many of the fifty-six women, who were on their way to join the Voluntary Aid Detachment in London, as was possible during an Atlantic crossing.[17] Varley had only three complaints: the compulsory wearing of a lifebelt, the noise from gun practice, and the "rotten" music produced by a pianist and a ukulele player during a concert in the ship's music room. Other than that, Varley would have agreed with William Beatty's assessment of the trip. "We had a fine passage over," Beatty told the artist Robert Gagen, referring to himself and his three artist companions. On the morning of their

arrival in Britain, the artists sailed up the Clyde past "wonderful" shipyards, then boarded a train in Glasgow. The ensuing trip down to London by night was, by comparison, "cold" and "cheerless."[18]

"Well the boys arrived, all four looking fine," Jackson reported to MacDonald on 6 April, adding that it was "a pleasure to see them." According to Jackson, "the boys" appeared "somewhat lost." They had no art supplies, no studio, and no orders. Moreover, the German offensive that spring had brought the war-art program to a temporary standstill. This meant that there was "little chance of getting permission to go to France for some weeks."[19] So Varley and his fellow war artists spent their first three weeks "kicking our heels" in London.[20]

Varley did not mind. He was euphoric about the circumstances in which he now found himself: he lived in the Strand Palace Hotel, travelled on the train for half price, had enough money to buy himself a new suit of clothes, and he had time to visit Samuel and Lucy Varley in Bournemouth where they were living in retirement. As he told Maud: "We travel 1st class & swank and tip the plebeians as if we were lords — What a life, eh what? I've never swanked so much in all my life."[21]

Any tension that might have existed between Varley and his parents when he departed for Canada five years earlier had been dissipated by his success as a commercial artist in Toronto. Now, in the spring of 1918, Lucy and Samuel had further reason to be proud of their wayward son. He wore the uniform of an officer, and was serving his country as an artist. Lucy Varley soon became the doting mother. She insisted on taking care of Fred's laundry. She buried the past and agreed to meet Maud's mother, Sarah Pinder. Samuel Varley, who according to his daughter had contemplated suicide since relocating to Bournemouth, welcomed his son's arrival, and urged him to visit Bournemouth as often as possible. During Fred's visits, Samuel accompanied him to the music-hall. "He quite revelled in it," Fred reported to Maud after his visit to the Boscombe hippodrome with his father.[22] Samuel Varley rediscovered the warm and lively companion who had walked with him on the Derbyshire

moors so many years earlier. Fred and Samuel got on "A.1" and became "quite chummy."[23] "Dad's a wonder," Fred told Maud. "He's grown into a lovely man in every way" and, he continued, "I'm real proud to be his son."[24]

Varley travelled to Sheffield shortly after he returned to London from Bournemouth. He stayed with Sarah Pinder, sleeping, he told Maud, "in the room so full of memories" which they had shared before his departure to Canada.[25] His favourite sister, Lilian, met him at the station. Fred had never seen her looking "so well and happy."[26] She was living on her own, and had become a member of the Labour Party. In order to give further support to the advancement of women through female enfranchisement and equal employment, she had also become a suffragist. Fred was impressed by this, as well as by the news that she was having an affair with a married Labour MP from Scotland. Lilian was, he told Maud, "hopelessly in love."[27] Fred took a great interest in his sister's clandestine relationship. He shared it with Sarah Pinder, who enjoyed analysing with him "the ways of the many married with their side-lines."[28] Conversations concerning Lilian's affair brought Fred close to his mother-in-law, the two getting on "fine." The more Fred saw of Maud's mother on subsequent trips to Sheffield, the "more & more dear to me and more big in character" she became.[29]

Besides visiting members on both sides of his family, Varley saw his old friend Thomas Somerfield. He found him "just as animated, just as beery and just as suggestive in his looks and conversation" as he had been during their student days in Antwerp.[30] On another trip to his home town, Varley had "2 glasses of foamy ale" with Arthur Lismer's father and called on the son of his father's old boss, Jim Mawson.[31] He also visited Elizabeth Nutt, who continued to admire him as she had when they were students at the Sheffield School of Art.

There were fewer friends, by comparison, for Varley to visit in London. Though he did meet Percy Lindley and David Jagger shortly after arriving, most of his former acquaintances had been dispersed by the war. The Australian painter Clewin Harcourt had

returned to teach in Melbourne, where he was having some success as an artist. Among Varley's other friends from Antwerp, his friend Wickson had become an art master at a technical school in New Zealand. A.H. Dowes was with the spring offensive when Varley arrived in Britain, then spent the summer of 1918 in a hospital in Bradford recovering from a "blighty" – a war wound sufficiently serious to merit treatment back in England. And John (Jack) Yates, "born unlucky," had been killed in action shortly after Varley arrived in England. "Poor Jack," Fred told Maud, "he never had a ghost of a chance."[32]

Varley was not, however, entirely without friends in London. A.Y. Jackson, who had been seconded to produce paintings for the Canadian War Memorials Fund in August 1917, became a frequent companion. When Fred arrived in England, Lieutenant Jackson had just returned from the front, where he had sketched the Canadian troops near Poperinghe. Varley found a very different man to the one he had known in Canada. Jackson was "more sensitive" and less begrudging. "I'm sure if he had to go through the fight any more," Varley told Maud, "he would be broken."[33]

It was Jackson who introduced Varley to the exigencies of being a war artist. During Fred's visits to 3 Earl's Court Road, Jackson told him about the difficulty of balancing "a sketch box while shells were dropping here and there" and of finding something of interest to paint in the first place.[34] The war refused to pose for the artist because it was on the move; it was also difficult to see because operations took place at night.

Varley studied the small pencil sketches that Jackson had made under fire and the canvases that had emerged from them once he returned to London. Jackson's work was a revelation to Varley, who had been raised on the special artist illustrations of the Boer and the Russo-Japanese Wars which had appeared in *The Sphere*, *The Graphic*, and *The London Illustrated News*. What Jackson was doing was very different. There were no paintings of mounted generals brandishing their swords, no battle charges, and no reconstructions of battle formations. Nor were there any heroes in the conventional sense.

Jackson's front-line experience had taught him that "a private is nothing, unless he disobeys an order, then there is a big fuss made over him, and he probably gets shot."[35]

What Jackson later called "the old heroics, the death and glory stuff" of traditional war painting "were gone forever."[36] As Varley told Maud, Jackson did not paint "blood & riot"; he painted "impassive desolate scenes of the country which once was."[37] Jackson and other war artists were forced to invent a new visual language, one that departed from stereotypes and conventions. Varley told Maud that he found Jackson's work "very individual" and "very fine."[38] Jackson was not only "doing good work," the war had made him, in Varley's view, into "a great artist."[39]

Viewing Jackson's work in his London studio and chatting with him about the conditions at the front gave Varley an idea of what to expect. "Gosh, it's a nightmare of a life," he told Maud after spending an evening with Jackson, "more horrible than one can ever describe."[40] The ordinary soldier, Fred continued, was caught up in a "game of life and death [which was] nothing but a huge bluff conceived by some wise guys with business instincts."[41] Though Fred admitted to Maud that "the whole blamed thing" made him tremble and that he disagreed with those who were running the war, he was undaunted by the task that lay before him. "The chance, girl, is too stupendous," he continued in his letter to Maud. "I daren't think too much of it, but I'm confident I'm going to create."[42]

If Jackson convinced Varley that the glorification of warfare was dead, then Beaverbrook's debonair art adviser showed him what kind of work was replacing the old battle pictures. Shortly after Varley arrived, he accompanied Paul Konody on a tour of London's West End galleries. A year younger than Fred, Paul Konody was dashing and confident. He was a "Bohemian-de-luxe."[43] And his artistic tastes bridged the traditional and the modernist camps. Varley therefore got the full spectrum of British artists' response to the war on that first gallery tour. At Messrs. Derry and Thoms, Varley saw stirring lithographs of the war rendered by Frank Brangwyn; there were coloured photographs of the trenches taken by British war

photographers at the Grafton Galleries; and, lining the walls of the Goupil Gallery, were paintings of Canadian officers by Sir William Rothenstein. Also on exhibition that spring was the work of a very different kind of artist, one for whom traditional representations of the war were anachronistic.

There is no doubt that Konody took Varley to see what C.R.W. Nevinson had produced while he was a war artist for the Canadians. The exhibition at the Leicester Galleries had not only been mounted under the auspices of the Canadian War Records Office, but a year earlier Konody had also produced the book, *Modern War Painting by C.R.W. Nevinson*.[44] Konody admired line, order, and harmony. He wanted his war artists to "express the poetry and rhythm" behind their subjects.[45] Yet he gave them plenty of room to express their individual vision – providing they did not distort or obfuscate the subject of war. Konody was eager to have Varley see Nevinson's work because the English artist had achieved what Konody liked most: a balance between "clear illustration and futurist abstraction."[46]

Konody also saw to it that Varley saw the work of another young modernist. On show at the Leicester Galleries were the paintings of Paul Nash. His work was poised between realism and abstraction and more dependent upon the close observation of nature than was Nevinson's work. But the landscape of war in Nash's pictures was less ordered and more self-consciously chaotic. He had no qualms about thrusting his viewer into the mud, shrapnel, and bone-bleached earth, or showing that the headless, shell-torn trees and the eerie light which pervaded the front-line were "normal" features of the modern "war-scape." Nash, like Jackson, had been a soldier in the trenches. When he became a war artist, Nash made it his mission "to bring back word from the men who are fighting to those who want the war to go on forever."[47] This is what Varley saw him do in his evocative, sometimes lyrical, always horrific paintings of the front-line.

This kind of work was new to Varley. He had most probably not seen Durand-Ruel's exhibition which introduced Impressionism to London in 1905. He had not, like Arthur Lismer, seen Roger Fry's

seminal exhibition, *Manet and the Post-Impressionists*, at the Grafton Galleries five years later. But during his tour of the galleries with Konody in the spring of 1918, Varley learned that there were two kinds of artists in Britain. The traditional painters, whom he had admired before 1912, sought to capture the beauty of warfare and found their motifs well behind the front-line. The modernists, on the other hand, attempted to capture the anguish and the agony of the battlefield.

After viewing Nevinson's and Nash's work, Varley told Maud that "there can't be lovely tones and lovely colours and lovely drawing and all that bunkum when a fellow's near paralysed with fear and the earth, the disembowelled earth[,] is festering and flinging off an abortive stench." Realizing that the artist had to speak with a new tongue, he continued, "no art conceived in the past can express the hugeness of the present."[48] And no wonder he was determined "to paint a picture in a way different to all I've ever done."[49] Seeing Nevinson's, Nash's, and Jackson's visual response to the war gave him a head start: "I realise more clearly what I must do."[50] Above all it rendered the heroic sketches he had produced for the Royal Flying Corps anachronistic.

Yet it was some time before Varley got his chance to paint at the front. On 18 April he and Cullen were attached to Company 3 of the Canadian Expeditionary Force and stationed in Seaford on the south coast of England. Numbering ten, the officer contingent of "wild young hares, full of devilment, running over with good nature" was small.[51] His fellow officers and his batman in the Princess Patricia Regiment did everything they could to make Varley comfortable. He was "pampered & made a fuss of."[52] But Varley had come to paint, not to be pampered. Within days of arriving on the south coast he was studying "the ways of fighting – under gas masks and the wearing of a helmet, and had heard the scream and whistling of exploding bombs as they cut the grass near by."[53]

Varley not only learned "the ways of fighting" at Seaford. He discovered the beauty of the South Downs. He was rhapsodic about

the dramatic white cliffs which rose some three hundred feet above the sea and seemed to "float intangibly in a pearly atmosphere."[54] "Every time I look at those marvels of hills with their great white sides facing the sea, I wonder if the scene is real."[55] Varley's descriptions of the dramatic coastline in his letters home were word pictures. He put as much effort into his writing that spring as into his painting. As Fred told Maud, if he couldn't express himself in paint, "by Jove I'll write."[56]

Varley did, nevertheless, paint every day, walking ten to twelve miles along the cliffs, or watching the men carrying out their manoeuvres around their tents, which dotted the Cuckmere Valley. From these observations he produced three small oil paintings: *Chynton Farm, S. Camp, Seaford, The Seven Sisters, Seaford*, and *Tents in Cuckmere Valley*. Then, towards the end of May, he began a major canvas. *Gas Chamber at Seaford* depicts a soldier, weighted down with protective equipment, emerging from a gas-testing chamber. The billowing gas and the ghost-like figure of the soldier rising out of the inferno are set against the grassy downs, the distant cliffs, and the sea. While Varley had successfully injected a disturbing note into an otherwise tranquil scene of the South Downs, there is nothing remarkable about the painting. He had not invented a language for these subjects. In fact he told Maud that *Gas Chamber at Seaford* was "tame, quite tame." Yet he assured her that there was much to come: "Wait until I get to France I'll lose my mild and gentle ways."[57]

Being on an army base at Seaford did not deprive Varley of female companionship. "Cullen says he's going to cable you," he confessed to Maud, "because I've met a Nurse Carter, a loveable, bright, enthusiastic little woman who imparts pleasure wherever she goes."[58] Once again Fred was teasing Maud. And once again Maud, who was living in the small rural community of Thornhill, north of Toronto, was not amused. Rural living cut her off from the city. This made her miss her husband all the more. "Do not let your heart ache lassie," Fred comforted her, "we've got to go through this and when we come out wholesome and strong, life

will be doubly dear."[59] As the summer dragged on Maud was not only lonely but in a precarious financial position. Initially, Fred sent her regular payments. By the middle of the summer, however, they became intermittent. "We military guys are always broke at the end of the month" was Fred's excuse to Maud.[60] "It's the weekends and those days in London that take your money, but [you] don't forget, if you get your money's worth."[61]

Fred's assurance that he was not being "absolutely prodigal with money," was followed up with a description of how he and his friends were "constantly trying new things & living like princes, squandering tips as if we were millionaires."[62] Fred tried to convince Maud that he was "a thoroughly respectable satisfied married man as sober as a veteran and as much in love with my little lot as a blossoming youth with his first love."[63] He told her of the $2,500 that Beaverbrook had promised to pay him in addition to his pay. Promises were, however, of little help to Maud. Lacking enough money for rent and food, she was forced to seek help from Fred's old patron, Dr. James MacCallum. She had to persuade her landlord, Major Dean, to give her an extension on the rent. Despite his tales of high living, Fred was not much better off. He had to borrow money too. Maurice Cullen and William Beatty came up with loans. The pattern of debt that Fred had hoped to avoid by working as a war artist had asserted itself once again.

Varley's idyllic life on the South Downs was interrupted in late May when he and Cullen got word that two Canadian painters were being sent to France. Telling Maud that he "wanted to go in the worst way," he ran up to London.[64] Beatty and Simpson, who were painting the troops at Whitley Camp, had heard the news and were in London too. But there were only two places available. The four men drew straws. Cullen and Beatty won. Varley retreated to the YMCA officers' club for a cup of tea before returning to Seaford. A few days

later, however, he was back in London – this time for good. Within a few days of losing the draw and his chance to go to the Front, he was installed in a studio of his own and was busy painting portraits.

This time Fred found London congenial. He nevertheless insisted that "London has changed, oh so much since I knew it before." London was a "great throbbing place."[65] The city's vitality and strength lay in its large consumer market and its ability to attract talent from Europe and North America. This gave its citizens a wealth of concerts and plays, of museums and galleries, and exposed them to the newest form of entertainment: the moving pictures.[66]

Shortly after settling into his studio at 5 The Mall on Parkhill Road in Hampstead, Varley saw D.W. Griffith's *Intolerance*, Mr. and Mrs. Drew (Maud's favourite acting couple), Charlie Chaplin's *A Dog's Life*, Mary Pickford's *The Little Princess*, and the British propaganda film, *Hearts of the World*. Sometimes Varley went to the cinema with Maurice Cullen; at other times Jackson accompanied him. But usually Varley went alone: "The beauty of a picture show is you don't need anybody with you, do you?"[67] Going to the pictures assuaged Varley's solitude – "I was lonely a wee bit last night so after dinner I went to a 'movie' & saw two things."[68] The cinema fuelled his dislike of conscientious objectors and the enemy. After seeing *Hearts of the World*, Fred told Maud that the German was "nothing better than a bacillic germ."[69]

Though Fred was lonely during the spring and summer of 1918, there is little to suggest that he was often on his own. He took his midday meal at a French or Italian restaurant – where he was introduced to the joys of eating spaghetti – with either Jackson or Cullen. During the evening the war artists shared meals in one another's studios. When Fred took over Anna Airy's studio in Hampstead – she was painting the Canadian troops at Whitley Camp – he acquired even more friends. Living on one side of his studio was "a wonderful lady pianist" and her husband. On the other was Miss Rogers and her friend Mr. Porter, whom Fred disdainfully described as "an artist who tries to be a futurist."[70] These people and their

friends invited Fred to their studios for tea, drinks, dinner, and sometimes for an evening of music. Fred's sister Lilian was also a frequent visitor. She slept in the attic at the Hampstead studio while he bedded down for the night on the main floor. They talked to one another into the early hours of the morning, their voices moving between the cracks of Lilian's floor and Fred's ceiling.

Varley acquired even more acquaintances, in addition to his fellow artists and Hampstead neighbours, because, as he told Maud, "the uniform we wear rubs off the corners of harshness — Wherever one goes, there are friends."[71] Varley had what he called "chance friends that I meet everywhere, trains, buses — street any old place, any old way, that I turn lots down."[72] Varley also had books to keep him company. The poetry of Shelley, Rabindranath Tagore's *Song Offerings*, Felix Salten's *Bambi*, and Tolstoy's *Anna Karenina* were all read by him more than once.

Fred was not, therefore, without companions or things to do. If he was lonely it was because he missed Maud, who had taught him "to see the heart of things."[73] "The idea of coming to a home of my own, to a wife and children of my own seems like a fairy dream, too good dear to realise." Fred's family, he wrote home, represented a "haven in a heartless world."[74] They were the anchor which kept his precarious ship from straying too far from the harbour. For the second time in his life, therefore, he longed for the push and pull of that relationship.

Fred missed Canada almost as much as he missed Maud and the children. "I'm as homesick as a kid," he told her that August. "Time after time" he caught himself thinking "of your clear air, your stimulating healthy, vigorous country."[75] Like the Canadian poet Wilson MacDonald, who "grew mad for savage things" during a visit to London in 1902, Varley found his "native land" during his sojourn in Britain.[76] Not surprisingly he thought about Canada more when he was in the company of his Canadian friends. Jackson told him about his post-war plans to buy land up north where he could clear the timber, build a shack, and paint. The two men talked a lot about

Thomson. They talked about establishing life classes and securing mural commissions when they returned to Toronto. And they planned future trips to Canoe Lake. "The other night he told me we'd do it again," Varley told Maud. Though Jackson was not "such a man as Tom," Fred was convinced that "we two would manage & pull along well."[77]

England, by contrast, had lost "its heart and its blood."[78] There was, Varley continued, "no life, no enthusiasm, no whole hearted set purpose."[79] The men perpetuating the war were "selfish, vain [and] muddle headed."[80] Varley's disdain for the country of his birth reached a pitch when he declared in August that Britain "doesn't deserve to win the war."[81] Though Fred could still conjure up enthusiasm for the English countryside, he was "just weary for Canada."[82]

Varley had plenty of time to reflect upon the disadvantages of living in England because the demands of being a war artist were minimal. Lack of transportation and billets in the field, along with the unwillingness of the front-line commanders to allow artists near the fighting once the Allied counter-offensive began, kept the war artists in England. In the summer of 1918 there were some twenty artists waiting to go to France. The officials running the war-art program had "balled things up." The war-records enterprise was, Varley continued, being debased by Konody's willingness "to take anybody on" and by the art director's desire to have his artists produce large pictures. Indeed, Konody's motto – "the bigger the better" – put a premium on size rather than on quality.[83]

Though Varley was annoyed that, unlike Beatty and Cullen, he had not yet got his chance at the front, he was not entirely idle after relocating in London. On 1 July he received three portrait commissions. By the end of the month he had completed portraits of Surgeon-General Foster and Captain C.P.J. O'Kelly, V.C., and had a third painting, *Lieutenant G.B. McKean, V.C.*, well under way.[84] The portrait of O'Kelly is characterized by a stiff pose, uncertain colouring, and little engagement, on Varley's part, with his subject. Just the opposite is true of the portrait of McKean. Executed with vigour

and intensity, it possesses a psychological depth that is absent in the portrait of O'Kelly. Painted in a high-keyed palette, the background and the subject are in perfect accord. The portrait of McKean, along with the portrait Varley painted of fellow war artist Cyril Barraud, shows him at his best.[85]

But Varley achieved this standard of work only when he had a good rapport with his subject. Surgeon-General Foster had been reluctant to reveal the full range of his personality to the honorary captain during the sittings. Varley had had little difficulty painting his "florid complexion" and the fat which was apparent "under his chin & a fair amount of size within his belt." But he could not make him smile. "I told him I was going to wait very patiently for a certain form in the cheek – oh, no, I couldn't get it as he was then, he'd have to smile first – Lo & behold, he *had* to smile & then he being a General & I just a captain, he seemed to realise I was putting one over on him & he swiftly assumed a stolid commanding expression. Another time I'll make him laugh," Varley concluded.[86]

The official portrait commissions of the officers and men that Varley, Jackson, Beatty, and many other war artists received were tantamount to the portrait commissions that artists had done before the war. The official war portraits now gave honour and bravery to their sitters, whereas previously they had given new money a good opinion of itself. Yet their quality naturally varied from one artist to another. When Sir William Orpen painted non-commissioned soldiers, he focused on the attire and accoutrements – the rifle and battle dress of a soldier, the cap and goggles of a pilot. When, on the other hand, he painted high-ranking officials, he focused on the personality of the subject. Augustus John, who was famous for his "lightning draughtsmanship" long before the war, painted two portraits of non-commissioned soldiers. Though known for his "firm, fluent, lyrical line," his war portraits are stiff compared to the paintings of his unknown rival, F.H. Varley. Indeed, Varley's best war portraits possess a psychological depth and a mastery of handling that is absent in John's war portraits. The paintings of "the political

stuffed-shirts" that Orpen produced at the Versailles Conference in 1919, are, in many critics' opinion, no match for Varley's portraits of the officers and men.[87]

If, as Jackson suggested, Varley "found" himself as a portrait painter during the summer of 1918, then the following autumn he discovered that he was a painter of war.[88] Varley had a good idea of what to expect when he reached the front in early September 1918. Jackson, Beatty, and Cullen had all returned with their tales. Jackson had told him about the difficulty of painting at the front and of finding subjects to paint. Beatty had boasted about the "one or two adventures" that he had experienced.[89] Varley was well aware of the psychological toll that those experiences had extracted from these artists. Jackson looked much older than his years. Beatty was suffering from haemorrhoids, and, according to Varley, was "so blooming blue" that he drank instead of ate.[90] Maurice Cullen, who was among the oldest war artists to paint in France, won Varley's respect for having endured the front better than Beatty. Though both men had kept their distance from the fighting, they nevertheless saw the result of what had taken place there. Beatty found the graves of a cousin and a former student from the Ontario School of Art, while Cullen had stumbled across the resting place of his son.

Varley also knew how his fellow war artists had interpreted their experiences on canvas and paper. Jackson had focused on the landscape. Varley found his paintings "intensely interesting."[91] Nash had shown Varley how the artist could convey the horror of warfare by throwing his viewer into the mud and refuse cluttering the front-line. Other artists – Orpen, Rothenstein, and David Cameron – had presented Varley with a very different view of how to paint the war.[92] Their pictures gave over two-thirds of the canvas to the sky. Painted well behind the line of battle, they adhered to George Moore's prescription to paint beautiful pictures.[93] Augustus John was another artist for whom the landscape of war was beautiful. Dubbed "the

wonder of Chelsea" by Moore long before 1914, John had received the most ambitious commission of any war artist: a forty-foot mural that was to hang in the war museum Beaverbrook hoped to build in Ottawa at the end of the war.[94] When Varley set out for the front in September, the cartoon sketch for John's mural, *The Pageant of War*, had just been reproduced in *Colour Magazine*. It, along with the work of the other artists working for the Canadians, was illustrated in a special number devoted to war art. This gave Varley a good idea of how his British rivals were approaching the subject.[95]

Although Varley had heard artists talk about their front-line experiences and seen their preliminary sketches, and sometimes even viewed their finished works, nothing could have prepared him for what he saw when he joined the Canadians in France in the autumn of 1918. "You must see the barren deserts war has made of once fertile country," he wrote in a letter to Maud, "see the ghastly shells of lovely towns, see the places where towns were – see the turned up graves, see the dead on the field, freakishly mutilated – headless, legless, stomachless, a perfect body and a passive face and a broken empty skull."[96] The things that Varley saw were, he told Maud, capable of making her "hair stand up."

However horrific, the war nevertheless ignited Varley's sense of adventure; it also revealed the daredevil in him. He ran "big risks" and had lots of "near shaves."[97] He made "chums with shells."[98] He had "real thrills" doing "the most grotesque things."[99] "The first day under shell fire" was, he told Maud, "exhilarating and novel." "But when you have had many days & seen the results, your novelty outlook vanishes."[100] Even so, Varley was entranced by "the intoxication of the game." If it had not been for his family he would have joined the fighting, viewing it "purely as a game, realising all the time it was hellish, but darned fascinating."[101]

Although Varley must have felt vulnerable when the only weapon to hand was a pencil, he could afford to enjoy the experience of warfare because he did not have to fight. He was an observer. He watched the men go into battle; he saw the tanks stuck in the rain-soaked earth. He waded through thigh-deep mud; he slept in tents,

wooden huts, in his Jeep, and even on the ground in the open air. He spent one night in an advanced position in the trenches. And he accompanied the battalion when they took the shell-torn city of Cambrai. (Legend has it that Varley found three pianos among the ruins there and entertained the troops by playing Beethoven sonatas for them.[102]) In these last two months of the war, though Varley probably saw more of the fighting than any other war artist, he did not have to go over the top with the men.

Varley described what he saw to a large number of correspondents – Maud, his parents, Mrs. Pinder, Lilian, Cullen, Jackson, and Beatty. Writing became a verbal counterpart to his small pencil sketches. This is how he described a barrage at zero hour when shells were flying over his head and the earth shook:

> We threw ourselves down flat. Pfff! We got up to beat it – Another Pfff! Down we went again. Up again & on – Pfff! This time we flopped in a shell hole – but the blamed thing seemed to follow us – and we were under direct observation.[103]

Being in the midst of an attack belonged, in Varley's view, "to the elemental, the superstitious, the primitive, creative."[104] He likened a barrage to the aurora borealis. Though in reality it was "a deluge of fire and bursting shell-smothering [from which] wee pigmies called men" were striving to hide, it was, he added, also "a dream of such magnificence that it is akin to the greatest flights of the spiritual."[105]

Like almost every artist who went to the front, Varley saw beauty alongside the ugliness and destruction. He was frightened as well as elated. And while he felt a great sense of pity and respect for the fighting men, he viewed the dead "with no more interest than a passing gaslamp."[106] His attempt to resolve what Paul Nash called the "ridiculous mad incongruity" of warfare, turned his world upside down.[107] Though he assured Maud that he was "still the same kid, doing silly things, losing my thoughts & running off at tangents – sitting down to a meal & forgetting it's there," he was

"restless and erratic."[108] After six weeks at the front, he could "smell California – Timbucktoo – Honolulu – South America, Mexico City." "But," he continued in a letter to Maud, he could not "smell Rous & Mann and a timeclock."[109] Nor could he "smell a studio & paint in Toronto."[110] France had proven him "to be a freak." He had become "a pagan." Christianity was dead; so too, were morals, religion, and the law. All of this heralded, he wrote, "huge changes" for the future world.[111]

After completing his tour in France, Fred felt alienated and stranded. Beatty no longer understood him. British artist H.J. Mowat, who had witnessed his daredevil antics in France, pronounced him "a vagabond by nature" and "just hopeless."[112] He was lonely. Jackson, with whom he had got on so well, had returned to Canada. "I miss him very much," Fred told Maud. "I would value his criticisms and his quiet chats."[113] Varley's doting parents could provide little consolation. Indeed Varley became increasingly suspicious of their attentiveness: "My own folks are proud of me but I bitterly know that if my work were a failure, I should be dubbed a failure too & there would be no sympathy to warm me when I most needed it."[114] Even news of the Armistice could not raise his spirits. While London went "mad – absolutely mad" on 11 November, Varley kept to his studio where "the pale ghosts of memories" were his only companions. For once Fred Varley avoided merrymaking. He had seen "too many piteous sights" to "flagwave or get drunk."[115]

What Varley wanted was Maud, his children, and Canada. He had kept his sanity in France by dreaming about the autumnal landscape around Thornhill, with its ripe pumpkins scattered amongst the corn stooks, the potato-digging that had to begin before the frost, and the view from his house up Dean's valley. Now he wanted to do more than dream; he wanted to be home, drinking the dandelion wine that Maud had made, holding her and the children close to his breast, and listening to the crickets and the frogs. Even the scream of the Yonge Street rail-car as it took the hill up to Dean's stop would have comforted Varley that autumn and winter. But

Varley could not go home; he had to work. While in France he had found some "mad subjects for painting" that would, he told Maud, show how diabolical and pitiless wars were.[116]

Varley's first paintings were watercolours. They depicted objects that had been smashed up: buildings, the landscape, roadside crucifixes, and people. In style and content they were little different from what other war artists were doing. *Dead Horse Square, Monchy* was understandably mistaken by Konody for a watercolour by Orpen. *Shell Torn Trees* resembled the hundreds of paintings that other war artists had made of the same subject. The stick-like soldiers in Varley's *The Christ Tree* echoed the ant-like figures which dominate Wyndham Lewis's *A Canadian Gun Pit*. The dark ominous mood pervading Nevinson's and Brangwyn's most successful lithographs are called to mind in Varley's *Shelled Nissen Huts*. Finally, Varley's smudged drawing of a dead soldier is as deftly handled as a drawing of a reclining soldier by John.[117] It was only when Varley worked in oil on a larger scale, and when he chose subjects which underscored the irony of warfare, that he painted "real war – real 20th century" war.[118] When Varley did this he painted to his own vision and sang with his own voice.

Varley's first large canvas, *Some Day the People Will Return*, is based on a sketch made in France. In a caption accompanying an illustration of the work, Varley wrote: "Some day the people will return to their village which is not; they will look for their little church which is not; and they will go to the cemetery and look for their own dear dead, and even they are not."[119] The painting thus heralds the end of civilization and of the old order. It sums up what Fred felt was the residue of the First World War: "hopelessness."[120]

Work kept Varley busy in London during the months of November and December 1918, as the *Canadian War Memorials Fund Exhibition* was scheduled to open at Burlington House on 4 January. Because he wanted to make an impact with his contribution, Varley worked hard. By the middle of December he still had an unfinished painting on his easel. Not wanting to rush this picture, he declined to spend Christmas and the New Year with his parents

in Bournemouth. He remained in his London studio throughout the Christmas vacation, "painting part of the time, and the other part, reading & dreaming."[121] Lilian came down from Sheffield to visit her Labour MP beau and spent two days with her brother. "I painted and she lazed around & prepared meals," Fred told Maud.[122] Varley's time with Lilian was a welcome interlude from hard work. It counteracted the stress of having to relive his front-line experiences in order to capture them in paint and canvas.

Although Varley had wondered how he would paint the war during the summer of 1918, once he began transposing his pencil sketches into paint, he saw "something worthwhile . . . something strange & marvellous" emerge on the canvas. He chose "subjects that many others don't tackle."[123] This allowed him to depart from a literal transcription of the war and get behind his subject. This was how he showed Konody, Beaverbrook, and his fellow artists in London how the war could be commemorated by the artist.

The *Canadian War Memorials Fund Exhibition* was the first blockbuster exhibition of the century. The 17th Canadian Reserve Battalion Band greeted visitors with familiar marching tunes as they walked through the cobblestone courtyard to the gallery. Coloured prints and maquettes reproducing some of the work on display, along with a lavish souvenir catalogue, *Art and War: Canadian War Memorials*, were available for purchase. It was not just the sheer size of the exhibition, the variety of styles, and the breadth of subject matter on display that made the exhibition remarkable. Nor was it the presence of the Canadian prime minister, Sir Robert Borden, at the opening of the event. It was that every artist on show was "at his best, as though a great subject brought to the surface his sincerest and most personal powers."[124]

Most of the eighty artists represented in the exhibition had produced a new kind of war art. It centred on the landscape of war and included shipyards, training camps, munitions plants, and field

hospitals. The breadth of the work on display gave the men who donned their uniforms – many for the last time – an opportunity to see where they had been and to show their friends and relatives under what conditions they had lived, fought, and seen their comrades die. It also gave those who had worked on the home front an acknowledged place in the history of the war. The exhibition provided an outlet for the continuing hostility that many felt towards the Germans summed up in the popular slogan: "Make Germany Pay." No wonder one writer saw the Burlington House exhibition as "the most important artistic event that has happened in England for many a year."[125] The *Canadian War Memorials Fund Exhibition* had showed that neither the audience nor the art had to be limited to one class, one rank, or one subject. War paintings could represent a variety of experiences, encompass all phases of warfare, and still be accessible to all sectors of society.

The largest work in the exhibition, Augustus John's twelve-by-forty-foot charcoal cartoon drawing *The Canadians Opposite Lens*, was the most disappointing. Indeed, one critic called it a "dull and essentially mediocre performance."[126] John Byam Lister Shaw's sentimental tribute to the soldier's supreme sacrifice in *The Flag*, was, on the other hand, the most popular painting. The modernist canvases of Wyndham Lewis, Nash, and Nevinson, among others, were confined to one room like delinquent children, but not ignored. And the Canadians, who were outnumbered by the British artists, "held their own."[127] Jackson's twenty small canvases were compared to the work of Van Gogh and praised by the critic of the *Observer* for their "exquisite refinement of colour." But it was Varley whom the same critic pronounced "the most distinguished and forceful of the Canadian official artists."[128]

Varley's paintings struck a chord with the critics because they avoided sentimentality. They were objective, while still conveying a "sense of all-pervading tragedy."[129] *For What?* exemplified this more than any other work in the exhibition. As the critic for *The Nation* observed, "the original effect of horror, which the soldier-artist had

stamped onto his own brain" was clearly conveyed to "the spectator in Piccadilly." Varley had dared to ask why the war had been fought and for what purpose the soldiers died. "Who dares to put that question not to the world, but," *The Nation*'s writer continued, "to himself?"[130]

Lilian gave Varley the title for the painting. "We had been talking about war and she said, for what reason Fred?" Then, Varley recalled, he "immediately replied, thanks Lil – For What?"[131] The small pencil sketch that provided the genesis of the work was made on a rainy day in France. Varley had sketched a Canadian Scottish Regiment gravedigger as he took a break from the gruesome task of burying his comrades – or what was left of his comrades. "The subject was overwhelming," Varley recalled years later, "much bigger than I could ever be."[132] While painting this "horror picture," he had not cared "a hang about art in big letters"; he had "just thought of mud & dirty water and limbs & hopeless skulls full of rain" and "got it."[133] When he looked at "the cart with the dead in it" on subsequent occasions, he told Maud, "I could cry my eyes out to think of it."[134]

For What? brought Varley's style, his experiences, and his antipathy to the claret-swigging generals who had driven the men like cattle to the slaughter, into perfect accord. By showing soldiers being dumped into a pit, Varley made a mockery of the Imperial War Graves Commission's claim that every soldier got his own grave. Books like Charles Yale Harrison's *Generals Die in Bed* (1928), Erich Maria Remarque's *All Quiet on the Western Front* (1929), and Robert Graves's *Goodbye to All That* (1929) would question the purpose of the war. But their books appeared long after the dust had settled, not, like *For What?*, within months of the Armistice and weeks before the Paris Peace Conference.

Varley was thrilled with the critical response to his work. Cullen, Beatty, and Simpson were, he told Maud, disappointments to the organizers of the exhibition compared to him. Even Jackson, whose pictures were "most beautiful in colour," had, in Varley's view, produced "room pictures" not "gallery pictures." In addition to this

there were too many of them.[135] Moreover, Varley's fellow Canadian artists had not been "welcomed by the big painters" nor had they "met the tip-toppers" at the Chelsea Arts Club.[136] The Arts Club members had made Varley "very welcome," proposing a toast to his health, and giving him an honorary membership in the club.

During the course of speaking at the Chelsea Arts Club dinner, Varley "quite enjoyed gassing & wasn't a bit nervous." He was not intimidated by his fellow artists' dress – "I notice they all wear coats, trousers & boots just like any other kind of man" – or by their consumption of alcohol – "they drink more than many other kinds." He liked the way they laughed, burst into song, and cracked jokes. All of this made him feel that he had crawled out from under the "swarming fleas" and joined "the big bugs."[137]

When more reviews of the Burlington House exhibition appeared in the press towards the end of January 1919, Varley's spirits rose even higher.[138] When twenty-five war artists threw a dinner to honour their boss, Paul Konody, Varley was at the centre of attention once again. This time he spoke on behalf of the Canadian artists who had worked for the Canadian War Memorials Fund. Among the dinner guests was Augustus John, who gave Varley "a very warm greeting" and complimented him on his contribution to the exhibition.[139] This was high praise indeed, for Varley respected John more than any other artist at this time.

No artist was unaffected by the war. Traditional painters were challenged by the emergence of the modernists. This broke up pre-war alignments; it diminished the influence of the conservative cliques who had dominated the art magazines and the walls of art galleries before the war. Women artists were no less affected. Because war painting had been largely the activity of men, women found themselves more marginalized after hostilities ended. The war-art programs not only put masculinity back into art, it broke the barrier between the subject and the artist and between form and content.

The experience of painting the Great War certainly had a profound effect upon Varley. It made him more conscious of the

subject that he was painting. It infused his future paintings with a moral overtone. And it reinforced his long-held disregard for authority. What the war did not do was to make him more aware of the political issues surrounding the war. His Toronto friend, Barker Fairley, "expected him to have some political responses" to the war when he returned to Canada. But to Fairley's amazement, "he had absolutely none."[140] Nor did the war make Varley into a modernist. Unwilling to depart from a conventional view of the world, he scoffed at anyone who obfuscated it in their art. Moreover, he retained his courtly manner, along with his soft velvet jackets and white silk ties. This Edwardian bohemian world no longer existed in England, though Varley hoped that it could be recreated in Canada. But before he could commence doing that there was more work to be done in France.

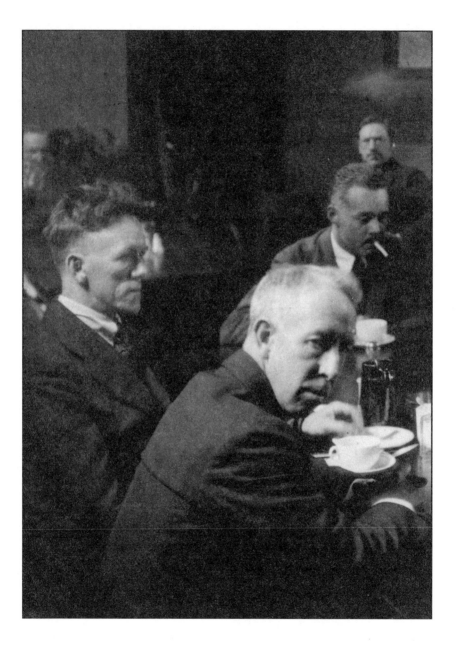

Varley at the Arts and Letters Club with A.Y. Jackson and Lawren Harris.

CHAPTER 5

Varley and the Group of Seven

Varley was in his element in January 1919. His contribution to the war-art exhibition at Burlington House brought him to the attention of the critics and artists whom he had long admired. Samuel Varley, Ethel, and his old friend Elizabeth Nutt showered him with praise after he had guided them around the exhibition. Paul Konody invited him to produce an eleven-foot-long panel for the war-memorial art gallery that was to be built in Ottawa. Lord Beaverbrook commissioned him to paint a portrait of his twelve-year-old daughter, Janet.[1] And Captain Watkins, who ran the war-art program through the Canadian War Records Office, offered Varley another tour of duty in France.

The prospect of receiving more war work and private portrait commissions was important. In his letters to Maud the previous autumn, Varley had hinted that his days as a commercial artist might be over. In January 1919 he was even more determined to avoid "the old ways of living," with all the drudgery of copy work and time-tables.[2] He put aside his nostalgia for Canada by telling Maud that he wanted to *"become known"* in England. He even suggested to Maud that she and the children move to London.[3] There they could live comfortably, he assured her, on the six months' pay that was to come following his demobilization. If he completed the panel for the war-memorial gallery, there would be a further three hundred pounds. And provided he took "full advantage of the tide" that was clearly moving in his direction, more portrait commissions were likely to come his way.[4]

With the intention of establishing himself in London, Varley asked MacCallum to send him two of his paintings from Toronto. *Indian Summer* and *Squally Weather, Georgian Bay* were large canvases and Varley knew that they would be expensive to transport to England. But he told MacCallum that he had "a hunch" that if these paintings were shown at the Royal Academy exhibition that spring "the newness of the subject would be welcomed." Contributing to London's most prestigious art event of the year would, Varley hoped, not only "advertise" his work; it might even result in picture sales. If this happened he could pay off the debts which had been mounting since his departure for England a year earlier.[5] Persuaded by this line of reasoning and eager to make contemporary Canadian painting better known on the other side of the Atlantic, MacCallum chose to ship only one of the works requested to England, *Indian Summer*.

While Cullen, Simpson, and Beatty were packing up to go home, Varley gathered his sketching equipment in preparation for another tour of duty at the front. Though his career as a war artist was not yet over, his career as a full-time painter had just begun.

Varley left London for his second tour of duty in France in late March 1919. He was accompanied by artist Cyril H. Barraud. Though British-born, Barraud had spent the year preceding the outbreak of the Great War in Winnipeg. With their Canadian experience in common, the two men got on well. After they had settled into the château which had been requisitioned by the Canadian Expeditionary Force as living quarters for the officers in Camblain l'Abbé, Varley painted Barraud's portrait.[6]

Though similar in palette to a painting of W. Theophilus Stuart Varley had completed for the University of Toronto a couple of years before leaving Canada, his portrait of Barraud is far less formal. The brushwork is more expressive. The gradation between cool and warm colours is more subtle. And Barraud's troubled expression emerges from within the canvas as though Varley had carved his face out of

the pigment. This accomplished portrait shows what Varley was capable of doing when he chose the subject, when he decided when and where to paint it, and, most important of all, when he enjoyed an easy rapport with the person he was painting.

Varley was "very happy in painting this time." In fact, he told Maud, he possessed "more hope & confidence now than ever in [his] life."[7] Two weeks later he was "gloating in the hundred and one possibilities of the medium."[8] Varley told Lismer that he was "gloating" because he had discovered a sketching medium that allowed him "to approach Nature with the same joy as 'when that I was but a tiny little boy.'"[9] Varley would always insist that "half a dozen lines on a piece of paper" were not only "vital," but sometimes "much more important than a finished canvas."[10] Nevertheless, the medium he chose for sketching on this second trip to France had something that pencil and charcoal lacked: colour.

While painting *In Arras* and several other oil sketches, Varley constructed images that were parallel to but not imitative of the subject before him. Putting broad patches of oil onto a wood panel, he built up a patchy mosaic of thick paint in contrasting colours; he paid close attention to spatial relationships, and he modelled every object so that it projected beyond the surface of the board. In doing all of these things Varley was clinging to his long-held belief "that all creative form [was] . . . governed by law & order."[11] He was also showing that one could build form through colour by combining the classical tradition – with its emphasis on drawing and design – with the painterly tradition of the Venetians.

Whatever prompted Varley to make the leap from painting on the surface of the canvas to painting beneath it must be a matter of conjecture. Perhaps it was his exposure to the modernist paintings of Nevinson and Nash at the Burlington House exhibition, maybe it was around this time that Varley discovered the work of Cézanne and Frank Brangwyn, or he might have read Clive Bell's *Art* (1914), a book which suggested that representation was subservient to "significant form." What Varley saw or read between completing *For What?* in December 1918 and embarking for France the following

spring made him look more deeply into his subject. It even "stamped under" what he described to Lismer as the "commercial taint" in his work.[12]

Along with the challenge of sketching in oil, Varley experienced a freedom of movement that had not been possible on his previous tour of duty. Walking wherever he chose to go without fear of being blown up by a mortar shell or shot by a sniper made it possible for him to discover new territory. Sanctuary Wood, "the most fateful & tragic place on the whole front"; Ypres, where the Canadians had taken the brunt of poisonous gas in April 1915; and Vimy Ridge, captured by the Canadian Expeditionary Force in 1917.[13] There were things, on the other hand, which Varley had seen on his previous trip to France. The trees were still "powdered up" and mixed with the earth; the few remaining stumps still "hurt the eye."[14] And the corpses of the men who had fought on both sides of the line were as prevalent as they had been a few months earlier.

Varley remembered, years later, how "awful" the corpses had been to look at.[15] Yet dead soldiers fascinated him: the way they resisted burial and were mocked by the harsh sun, the way the force of a shell always threw them onto their backs, and the way the body broke into bits and pieces like a china doll. "I've laughed when after kicking a Boche's stuck up arm it's sprung back again," he told Arthur Lismer. Observing "two chums . . . making a hurried grave for a pal" provided another source of bitter amusement. "The beggar wouldn't stay down, every time they pressed his legs down, his head jumped up." After the men had cursed their chum in "fifty different ways, one of them jumped on his head." Needless to say, he concluded, this did the trick, and "he was covered up."[16]

Varley and Barraud were not the only artists trying to make pictures out of the aftermath of the war. Shortly before departing for Canada that spring, Cullen had painted in France. The British artist William Rothenstein had also picked his way through "heaps of stone and brick . . . dumps of unexploded shells and bombs, shattered tanks, broken rifles," in search of subject matter.[17] Another artist, Canadian Mary Riter Hamilton, was completing the first of three

difficult years in which she lived in appalling conditions in order to make illustrations for Vancouver's military magazine, *The Gold Stripe*. And David Milne followed Varley and Barraud to northeastern France and Belgium as an officer in the Canadian War Memorials Fund in May 1919. He applied his drybrush watercolour technique to paper and created haunting images of shattered buildings and military cemeteries. Artists were not the only people clambering over the rubble less than a year after the Armistice. Trophy-seekers, souvenir-hunters, and – thanks to enterprising companies who offered weekend tours to the front – tourists were also there.

Varley was ostensibly in France to gather material for his eleven-foot panel. Yet his encounter with a group of bedraggled, war-weary German soldiers provided him with the subject for a more modest work, his canvas *German Prisoners*. Seeing a group of corpses and a gun pit and studying a Canadian War Records Office photograph of the remains of a German machine-gun-crew resulted in his most powerful post-war painting, *The Sunken Road*. This was the kind of subject matter which, he assured Lismer, would make his "wildest nightmares pale before reality."[18] In Varley's view the mingling of flesh, clothing, and equipment with the earth told the whole story of the war.

Years after the war Varley claimed that he had painted the machine-gunners in *The Sunken Road* "just as they were."[19] Yet the corpses in Varley's painting are different from the corpses in the Canadian War Records Office photograph from which he worked. You do not see the rotting flesh or the tattered shreds of clothing in the painting. Nor is it immediately obvious that two of the soldiers are decapitated. "A photograph would be horrid of the same subjects," Varley told Maud when he was preparing his canvases for the Burlington House exhibition, "because it would be deadly literal."[20] Bearing this in mind, it is not surprising that Varley should have drawn on the visual devices of the Renaissance painter Uccello, whose *Battle of San Romano* (1435-50) hung in London's National Gallery. The foreshortened, boldly modelled figures, which seem to be suspended above the debris in *The Sunken Road*, owe more to the example of this early

painter of warfare than to the photograph on which the painting is based.[21] On the other hand, the high-keyed palette, the cocky rainbow in the left hand corner of the painting, and the mellow light which bathes the entire work in a yellow hue, come directly from the mature landscape paintings of Turner.

It is not surprising that Varley's war work was in tandem with the English landscape tradition's greatest exponent. During the decade preceding and following the war, Turner's work attracted interest among the British public. An exhibition of Turner's little-known paintings had been put on show in London while Varley was living there in 1906. Another Turner exhibition was mounted at Messrs. Agnew's Gallery in the spring of 1919. Varley probably saw both exhibitions, in addition to Turner's paintings that were on permanent display at the National Gallery. Varley's admiration for what he called Turner's "magnificent expressions in pure colour of the essence of the sun," was all the more poignant because he could trace his own roots to one of the founders of the English school of landscape painting, John Varley.[22] The very mention of his own name at the Chelsea Arts Club or to Paul Konody would have certainly prompted the question: "Are you related to either John or Cornelius Varley?" Establishing his ancestral link with the founders of the English watercolour tradition would certainly have elevated Varley's status from that of a minor colonial painter to that of a well-connected English artist.

Within a few weeks of arriving in France, Varley had discovered more subjects for future canvases like *The Sunken Road* and *German Prisoners*. He had also found a theme for his proposed wall panel: the massing of troops for an early-morning barrage. The subject had nothing to do with what Varley encountered, yet it was new to him because he had not previously tackled action and movement. It also was different from what Augustus John was doing for the memorial gallery. In *Canadians at Liévin Castle*, John set a wall of static figures against the now familiar wreckage of the front. Varley, who was familiar with this work, wanted something more dramatic for his panel. He wanted action and movement. He wanted to make the

ground blow in and out so that it appeared to churn the earth to bits. He wanted to demonstrate that a barrage could be as "intensely beautiful," and as aesthetically pleasing, as the northern lights. And he wanted to make his viewers "forget the horror and reality of what it was" by showing them that the war could look beautiful even if it was not.[23] In the preparatory oil sketch for his wall panel, *Night Before a Barrage*, he did just that.[24] An intensely mysterious work, the painting is full of night-time movement and of surprises, like the subtle touch of pink and light-blue pigment.

Working out the theme for his panel, as well as finding subjects for new canvases, was, however, physically exhausting and mentally taxing. Into his second month at the front, Fred told Maud: "I never never want to see it again." Viewing the half-cultivated land and watching the people return to their damaged homes was, he continued, "too much for my make-up."[25] Fred Varley never set foot in France again.

Back in his studio in Hampstead, Varley stretched the canvases for *The Sunken Road* and *German Prisoners*. Determined to produce "the best portrait I've ever painted," he made plans to meet Lord Beaverbrook so that he could get the painting of his daughter under way.[26] He submitted *Indian Summer* to the Royal Academy for exhibition. And he began making plans to go home.

But Varley did not join the Canadian troops who were lining the docks in Liverpool in anticipation of their departure. After returning to London from France in May, his plans seemed to stall. He even seemed to disappear. Maud was desperate to locate her husband. She was anxious to avoid the uncertainties she had experienced when Fred vanished in London in 1906. Needing funds to support herself and the children, she contacted her mother in Sheffield. Though Sarah Pinder had been in frequent contact with her wayward son-in-law, she was unable to help. In fact, no one seemed to know where Varley was. When he did eventually surface, in the

middle of July, the excuse he offered for his lapse in letter-writing was feeble. He told Maud that he had not written for two months because he had had "nothing to say." The last three months had "been rotten," he continued, and he had "little work to show for it."[27] Maud would not discover why Fred disappeared, and why he virtually stopped painting that spring, until two years later. When she did discover the reason for his disappearance, the news hit her like a bombshell. It very nearly destroyed her and their marriage.

By July 1919 England had clearly diminished in Fred Varley's estimation as a place to live and to make his name. In early May he told Arthur Lismer: "The boys here can't understand why I want to go to Canada again but then they haven't been there and they don't know that there are a hundred bigger chances of progression out there than here."[28] Two weeks later he told Maud that he hoped Canada would give him "a painting chance."[29] A heat wave descended upon London early that summer, making Varley even less well disposed to the city. But it was not just the weather that prompted Varley to describe himself "as restless as the devil himself."[30] He was unhappy because his submission to the Royal Academy that May had failed to make the favourable impression on the London critics that he had expected. Only the Brighton Art Gallery showed any interest. Its exhibition committee invited Varley to submit *Indian Summer* to their autumn show. But everyone else ignored Varley and his painting. Konody does not appear to have noticed *Indian Summer*. And no critic singled it out for attention in their reviews.

The Royal Academy was not, of course, known for encouraging "daring experiments." Hardly a picture in the exhibition, according to a reporter in *The Times*, owed "anything to Manet or Monet, to say nothing of Cezanne or Van Gogh."[31] The work of John Singer Sargent, Arnesby Brown, D.Y. Cameron, and other traditional painters who had dominated the academy before the war still set the standard. Was Varley's painting ignored because it was too modern by comparison to the work of these artists? Did the widespread longing for a return to pre-war normality sound the death knell to anything which deviated from the norm? Or were London's critics

simply ill disposed to colonial artists and to colonial subject matter, as they made clear when an exhibition of Australian painting was mounted at the Royal Academy in 1923? It is more likely that the poor reception of Varley's painting had nothing to do with its style, which was hardly extreme, or its subject matter, which was not recognizably Canadian. Maybe *Indian Summer* simply got lost among the hundreds of other paintings on show.

Varley reached the Merseyside docks in late July. He had booked passage on "a wallowing tub of a boat" called the *Lapland*.[32] But the White Star Line's Royal and United States mail steamer did not depart from Liverpool on schedule. This time Varley had a valid excuse for not leaving England. Strikes and riots kept the *Lapland*, and every other ship, in port. Varley took advantage of this disruption. He paid a final visit to his parents and Ethel in Bournemouth, and he made a twenty-four-hour visit to Sheffield. Flush with the hundred pounds that Beaverbrook had given him upon completing the portrait of his daughter, Varley paid off his debts. One pound went to the keeper of the Three Merry Lads, Fred Marsden. An unspecified amount was given to his old painting companion, Willis Eden. And the enormous sum of twenty pounds went to Fred's brother, Alfred. Debt-free, Fred Varley returned to Merseyside and on August 1 boarded the *Lapland* for Canada.

Before making that final visit to France, Varley had told Maud that if he failed to complete his war work before being demobilized, he would retain his commission "and like an old soldier I'll take my time painting."[33] This is precisely what he did. Soon after reuniting with Maud and the children in Thornhill, Fred rented Jackson's atelier in the Studio Building and set to work. When Jackson returned from his painting excursion towards the end of the summer, Varley moved into Tom Thomson's shack, which was nestled in the Rosedale Ravine behind the Studio Building. At thirty-five dollars a month it was expensive, but Fred was anxious, he told Eric

Brown, to "swing into big things."[34] *The Sunken Road* and *German Prisoners* needed more attention. And the subject for the war-museum panel needed to be pulled into focus. Eric Brown and Edmund Walker helped Varley complete his war-art commissions by keeping him on the army payroll.

Although Brown and Walker were initially opposed to the war-art program, they had nevertheless handled the Canadian side of the operation for Beaverbrook. Much to their surprise, the home-front paintings and sculptures they commissioned, along with the work that was done in France and Flanders, received a great deal of attention from conservative and modernist critics alike. As a writer for the Arts and Letters Club's magazine observed, the Burlington House exhibition was "justification for those who have had faith in the future of Canadian art."[35] The war paintings were not only a success in London, but also in New York, where the collection was shown before it came to rest at the National Gallery in Ottawa.

When Varley arrived in Toronto in August 1919, 447 works from the Canadian War Memorials Fund's collection were attracting record crowds at the Canadian National Exhibition. Varley's paintings were singled out by the *Globe*'s art critic for special attention. M.O. Hammond predicted that many of Varley's "old friends" in Toronto would "rejoice at the development he has shown."[36] Varley got even more coverage in the press after his recently completed *German Prisoners* was exhibited by the Royal Canadian Academy and at the Arts and Letters Club in December 1919. Barker Fairley could not "imagine the present subject better handled."[37] The University of Toronto professor had already praised *For What?* and *Some Day The People Shall Return* in the *Canadian Magazine*: the paintings had been "executed in an impersonal way, neither laboured nor mannered." Hardly "the product of a passing fashion," Varley's work stood "apart in the collection."[38] Barker Fairley also sang his praises of Varley's work in April 1920 in the prestigious London-based art journal *Studio*. This time, Fairley's commentary was accompanied by an illustration of *German Prisoners*.[39] Spurred on by these favourable reports in the press, Varley saw to it that *For What?* was exhibited in

the Carnegie Institute's exhibition in Pittsburgh the following spring. As late as 1926 this work, along with Varley's other large war paintings, were included in the Art Gallery of Toronto's Canadian War Memorials exhibition.

The public reception of the work that Varley did for the Canadian War Memorials Fund signalled that his rites of passage as an unknown artist were over. He complained to Eric Brown that he had lost money by "going over-seas."[40] Yet compared to most of the men who had spent the war in or behind the trenches, Varley had been lucky. He had been paid to do what he liked best: to paint. He had furthered his career by amassing a body of work for which he received positive critical attention. His encounter with the British landscape had enhanced his appreciation of the unpopulated Ontario landscape. His exposure to the work of British painters of the calibre of Augustus John and Turner had reinforced his link to the English school of landscape and portrait painting. Finally, having been exhibited in the Canadian War Memorials Fund's exhibitions, Varley's work had been brought to the attention of the director of the National Gallery of Canada as well as to that of private patrons like Sir Edmund Walker. Painting the war for Canada not only made Varley realize that this was what he wanted to do once the hostilities ceased; it enabled him to remain on the payroll longer than any other war artist, with the exception of Maurice Cullen.

Indeed, as late as March 1920, Varley told Eric Brown that "the feeling of spring is having a restless effect on me this time – I find myself day after day over in France . . . longing to tackle so many of the problems again with a keener vision – but my wife tells me that I can't expect them to put on another war – no!!"[41] Varley wanted Brown to help him find a large piece of canvas so that he could begin his eleven-foot panel. Brown demurred. For one thing, there was no money left in the Canadian War Memorials Fund's budget to continue paying Varley's salary. For another, there was no venue for the proposed mural, since the plans for the construction of a memorial art gallery were quashed when the Canadian government refused to give Beaverbrook and Rothermere land on which to build it.

Consequently, Varley never got a chance to take his oil sketch of a night-time barrage beyond the preparatory stage. On 31 March 1920 he was struck off the rolls of the Canadian Expeditionary Force. With no money for art supplies, or to rent a studio, let alone for living expenses, Varley was "on rock bottom" by 1 June.[42] Though free to pursue his career as an artist full-time, he was dead broke.

While demobilization put Fred Varley into dire financial straits, the end of the war saw Canadian art blossom, especially for those artists who were fortunate enough to live in southern Ontario. Following a short post-war lull, the manufacturing, mining, and pulp-and-paper industries boomed. A healthy economy meant new money. New money brought clients to artists. Thanks to Canada's performance in the Great War, the mood of the country was buoyant too. The nationalist sentiment, which led to the signing of the Statute of Westminster in 1931, prompted a tightly knit group of university professors, editors, journalists, critics, and gallery directors to encourage Canadians to promote and buy their own art instead of importing it from Europe or the United States.

The success of the Canadian War Memorials Fund was partly responsible for the new interest in Canadian art. It showed that Canada's artists were second to none, that they could promote national identity and foster national unity through their work, if they were paid to do so. And it reinforced Eric Brown's belief that Canada did not lack artistic talent, it only lacked "encouragement and appreciation."[43] Before the war, Varley had told his sister Ethel that establishing a public art gallery in Toronto would let loose "activity and a burning enthusiasm in our clubs" and lead to "a broadening out and a full recognition demanded of Canadian art."[44] Yet it was not until after the war was over that myriad institutions and organizations devoted to the promotion of Canadian culture emerged.

Artists in Toronto got two new venues for their work when the Hart House Gallery and the Art Museum – later the Art Gallery of

Toronto, then the Art Gallery of Ontario — opened their doors to the public in the early 1920s. The National Gallery of Canada, closed since 1916, reopened in 1921 with a respectable display of contemporary Canadian painting. Journals like *Canadian Bookman*, *Canadian Forum*, and *The Rebel*, and books like Newton MacTavish's *The Fine Arts in Canada* (1925), offered an arena for the discussion of Canadian art and sculpture. Cultural organizations and societies also emerged. Their existence gave professional and amateur artists alike a place to meet, to show, to discuss and even to sell their work.

Varley benefited from this new interest in and commitment to contemporary Canadian culture. The Arts and Letters Club and the Ontario Society of Artists, among other cultural organizations, helped him to acquire portrait commissions and to exhibit and sell his landscape paintings. Magazines, books, and journals devoted to the arts discussed his work within the Canadian as well as the European and American context. The National Gallery of Canada and the Hart House Gallery not only exhibited Varley's paintings, they also acquired them for their permanent collections.[45] And, finally, the newly established Art Museum in Toronto did something that had a lasting affect on Varley as well as on Lawren Harris, A.Y. Jackson, Arthur Lismer, J.E.H. MacDonald, Frank Johnston, and Franklin Carmichael: it gave them their first exhibition as the Group of Seven.

These men had, of course, functioned as a loosely knit group before that seminal exhibition at the Art Museum in May 1920. They had sketched and camped together and shared studio space. Some of them had worked shoulder to shoulder as commercial artists; others as war artists on the Western Front. All of them had "viewed and experienced and painted in terms of the rugged and unspoiled characteristics of this country" well before the Great War.[46] But it was only during the hostilities that Jackson came to feel that "the only way we will ever get anywhere will be by a group of us working together."[47] And it was not until the war had ended that Harris invited Varley, Lismer, MacDonald, Johnston, and Carmichael to his home in Queen's Park for the purpose of forming

what MacDonald called "a friendly alliance for defence" against their detractors.[48] Varley remembered that there "were just six of us forming the Group of Seven" at that meeting in the early spring of 1920. But "six didn't sound like the right number," so, he continued, they added a seventh member – A.Y. Jackson.[49]

Harris remained the Group's prime motivator throughout its entire history. Thanks to "Lawren Harris pushing things we had shows travelling around the States" Varley said, and, "we had a good show in Paris, in London, in Brussels, and right across the country."[50] Harris made the contacts, organized the exhibitions, and sometimes even helped finance them. As the Group's secretary, MacDonald calculated exhibition costs, collected the money from picture sales, and saw to it that his fellow artists received their commissions.

Yet "the organization," as Jackson called the Group of Seven, "was a loose one."[51] It avoided the formality that characterized the Ontario Society of Artists and, above all, the Royal Canadian Academy of Art. There were no rules or selection committees, no regular meetings, and no exhibition fees. Nor did the Group issue a manifesto after their first meeting. Though they met almost daily for lunch at the Arts and Letters Club, they possessed no club rooms. As Harris wrote in the preface of the catalogue accompanying the Group's third exhibition in 1922: "Artistic expression is a spirit, not a method, a pursuit, not a settled goal, an instinct, not a body of rules."[52]

The Group was not only reluctant to dictate how its members should organize themselves. They had "no desire to control the attitude or work of other artists."[53] Lismer assured Eric Brown that there was "to be no feeling of secession or antagonism in any way." Rather, the Group aimed to "demonstrate the 'spirit' of painting in Canada."[54] Harris elaborated upon this line of thinking in a mimeographed "Statement" that was handed out at the Group's first exhibition. The members of the Group were "serious workers imbued with a creative idea and seeking to practise it." They had, he continued, "always believed in an art inspired by the country" and created through a "direct experience of the country itself." Stylistically the

Group was modern, though Harris insisted that it was "far removed from the extreme expressions of modern art in Europe."[55] Wanting their work to appeal to the general public, the members remained close to their source of inspiration, the land. Though considered too modern by some commentators, they were conservative compared to the European avant-garde who did not feel compelled to communicate with the general public or to maintain contact in their work with the recognizable world.

Harris never forgot "the thrill" of partaking in the Group of Seven's first exhibition. This was because the 121 works on display at the Art Gallery of Toronto marked "an obvious step from the past and into something that was our own."[56] Varley was equally excited. He had long held the view that contemporary Canadian painting was distinct from its European ancestor. As early as 1912, he had compared the country's art to "a strong lusty child unfettered with rank, musty ideas, [and] possessing a voice that rings sweet and clear."[57] During the war, he had come to see Canadian painting as even more distinct from Europe's. After his meeting with Harris, Lismer, Carmichael, MacDonald, and Johnston in the spring of 1920, he realized "that the way I painted was not in the old fashioned English way."[58] And when he addressed an audience at the newly founded Edmonton Museum of Art in 1924, his aims were in line with the other members of the Group. They "did not look to the older schools of art for inspiration," Varley told the small audience, "but to such countries as Scandinavia and Canada where precedent had not tied the outlook of its students and where the realization of the thing seen could be set forth in a new way that would be convincing by its sincerity."[59]

"The romantic notion that a painting was a vehicle for a unique, creative insight of its author" was not, of course, new.[60] A Neoplatonic idea, it was revived in the middle of the nineteenth century. Varley had learned it from Ruskin: a sincere response to nature allowed the artist to produce a work of art that would be convincing to anyone who viewed it. His study of Buddhism reinforced an idea he already held: the contemplation of nature was a spiritual act.

Harris's and Lismer's involvement in theosophy, and Maud's and MacDonald's commitment to Christian Science, further nourished Varley's mystical apprehension of nature.

Though never a paid-up subscriber to any religion, Varley was not averse to adopting anything that might enhance his dual perception of nature. That perception rested, on the one hand, on the belief that, as Varley put it, "nature is bigger than I am."[61] It acknowledged, at the same time, that artists, like conjurers and visionaries, possessed a mystical insight into life and nature. "We artists must empty ourselves of everything," he told Ethel Varley in 1914, "except that nature is here in all its greatness and we are here to gather it and understand it if only we will be clean enough, healthy enough, and humble enough to go to it willingly to be taught and to receive it *not* as we think it should be *but as it is* and then put down vigorously and truthfully that which we have culled."[62] Varley's anti-materialist view of the world, his reverence for nature, and his conviction that only the artist could reveal nature's mysteries to the public made him sympathetic to the Group of Seven's way of thinking.

As much as Varley and the Group liked to believe that their work was devoid of European influences, none of them had escaped the visual impact of the Great War and the way in which the war artists had chosen to paint it. British artist Paul Nash doubted that he would ever lose the image of "these wonderful trenches at night, at dawn, at sundown."[63] When Jackson returned to Canada, he "wasn't satisfied to paint anything that was serene." He wanted "to paint storms [and] . . . things that had been smashed up."[64] Shattered and broken trees, inclement weather, swamps, and the rocky shores of vast lakes were motifs evident not only in Jackson's *First Snow, Algoma* (1919-20), Carmichael's *Fire-Swept Algoma* (1920), Harris's *Above Lake Superior* (1922), and in Lismer's *Pine Wreckage* (1929), but also in Varley's *A Windswept Shore* (c. 1920).[65]

Painting at Georgian Bay at the end of August 1920 in the company of Maud and the Lismer family, Varley's brush lashed out as he took psychic possession of the landscape in much the same way that he had taken control over the trench-scape of France. His

palette is tinged with the mud of Flanders. His figures are braced against the wind, just as they had cowered under the fire of twenty-five-pound shells. Varley and the other members of the Group of Seven were transferring the iconography of No-man's-land to the northern Ontario wilderness. As Augustus Bridle noted of Varley's oil-on-panel sketches of the landscape after the war:

> Nature always seems to have had a battleground where he paints a landscape. The rocks have a crushing weight. The trees must struggle up. The wilderness is at hand. If he caught himself becoming pastoral he would paint it all out and roll up another ton of rocks.[66]

While the oil-on-panel sketches that Varley painted in the late summer of 1920 bore some affinity to Jackson's *March Storm, Georgian Bay* (1920) and Lismer's *Go Home Bay* (1921), he differed from his colleagues in the Group by thinking of himself primarily as a painter of portraits.[67] Even though Harris had contributed eight portrait paintings to the Group's 1920 exhibition, against Varley's three portraits and one character sketch, it was Varley who excelled in this genre, and who had made his name as a portrait painter before the Group of Seven came into being. He had, of course, won his war-art commission partly on the strength of the portrait sketches he had produced for the *Canadian Courier*. During the war he painted no fewer than six portraits, and, upon returning to Toronto in August 1919, this genre became the focus of his attention. As one critic correctly observed, while most of the Group of Seven "were running away from the city and from the larger subject of humanity," Varley was turning towards the figure.[68]

Varley had role models in American and particularly in British portrait painters. He had grown up on the legends of such artists as John Singer Sargent and James A. McNeill Whistler, who, long before the outbreak of the Great War, had been "cult figures for

whom the portrait was a vehicle for mystification."[69] He had read about the demonic portrait in Oscar Wilde's *The Picture of Dorian Gray* (1891) which possessed occult powers. He had heard about the lavish lifestyles of the more successful portrait painters like William Nicholson, whose clients lined up at his studio door for sittings in twenty-minute relays. He had also met the flamboyant painter Augustus John, who lived in a caravan, associated with Gypsies, and enjoyed a *ménage-à-trois*. John had long served as a role model – perhaps even as a justification – for Varley's bohemian lifestyle. Varley's unpredictable behaviour – "he seems moody and impatient," Augustus Bridle observed of Varley in 1922 – were not unlike John's fits of melancholia. Like John, once again, Varley was perceived as a loner "always . . . hunting apart from the pack."[70] While to another observer, Varley was "a sort of art Gypsy."[71]

One of the first subjects that Varley painted when he set up shop as a portrait painter in 1919 was himself.[72] The painting, *Self-Portrait*, got Varley off to a good start. It allowed him to work out the possibilities of light and to get the feeling of space without fear of wasting a sitter's time or clocking up a hefty bill to hire a model. He had a chance to experiment. And he had the luxury of failing because if things went wrong he could scrape the paint down and start all over again.

If the genre of self-portraiture "gives us access to an intimate situation in which we see the artist at close quarters from a privileged position in the place of the artist himself," then this is what the viewer gets in *Self-Portrait*.[73] Varley presents himself in three-quarter view amidst the paraphernalia of his shack-studio. Though he stands in the foreground of the picture plane, confronting the viewer head-on, we get little of what one observer described as Varley's "ugly-beautiful face."[74] Varley's features were unevenly chiselled to the point of being craggy. By 1920 they were deeply bitten with the days and the nights of thirty-eight years of turbulent living. Yet Varley chose to present a much younger, less craggy version of himself. In *Self-Portrait*, he submerged his features in the mud-brown palette of the trenches. He adopted a style which fell somewhere

between classicism and impressionist bravura evident in the work of German painter Lovis Corinth.

Was Varley unable to see his face beneath the mask that hid it? Was he incapable of reaching down to the psychological depths of his soul and putting what he saw there onto the canvas? Or was Varley's somewhat idealized version of himself simply his calling card, showing putative clients that he was capable of producing more than a photographic likeness of the subject at hand?

Successful portrait painters were considered to be a cut above the ordinary artist. They hobnobbed with the rich and the famous. They were dandies and intellectuals at the same time. They held court, wooing their clients so that they might coax them to reveal a little more of their personalities. Varley liked this aspect of the job. Always curious about the way people looked and the way they moved, he enjoyed studying their physiognomy. After an evening with the Winnipeg-based woodcut artist Walter Phillips and his wife, Gladys, in 1924, Varley sent Maud a lengthy description of the couple. "Mrs. Phillips is very ample," he began. "I believe she possesses a skeleton somewhere like everybody else, but it is wonderfully concealed." Walter Phillips, who reminded Varley of Tom Thomson, was "well made, [with] the same looseness of limbs, something the same way of laughing at an inside joke," but was "much bigger than his work."[75]

Varley was well known for his ability "to immerse himself in the mood of the sitter."[76] In another letter to Maud, he described how he did this during the course of painting the Winnipeg School Superintendent, Dr. Daniel McIntyre:

You know dear what it means to paint a character. Simply being absorbed by the sitter & by Jove, this dear old gentleman has made me a slave. We commenced finding each other in conversation and at first my vigour and general outlook floored him and he felt I knew so much more. He spoke of his work as being nothing. Creative work was the only work worthwhile and gradually the sea-saw began to move. He told me things

these last few days and said he'd never spoken so much before. He spoke of losing his wife, his son during the war, two little children age 7 and 9 who were stricken with diphtheria & were taken in 24 hours.[77]

Varley not only produced many studio portraits during these years; he often set the figure in the landscape. He had previously brought these two motifs together: in his watercolour paintings before the turn of the century, at Canoe Lake in 1914, then on the Western Front. Thanks to Augustus John, whose work he had studied during his precarious days in London before the Great War, he placed figures in the landscape again. John's work introduced Varley to some aspects of modernist French painting without straying too far from his roots which, like Varley's, lay in traditional nineteenth-century English landscape paintings. As the British art critic Frank Rutter observed, John was not an innovator but did "old things superbly well."[78] When Varley painted University of Toronto professor Peter Sandiford reclining on a rocky shore at Georgian Bay in 1922, his vibrant blue probably came from the Sheffield painter Stanley Royale, although his expressive brush work and unusual composition came directly from John's painting *The Blue Pool* (1911).[79] Varley's grouping of figures in *Evening in Camp* (1923) echoed John's composition and rendering of the figures in *Peasant Woman with Baby and Small Boy* (c. 1907). Varley's painting of his son John was equally derivative of Augustus John's paintings of his own children.[80] And one of John's favourite subjects, Gypsies, though not a new subject for Varley and a popular motif among some of his fellow painters in Toronto, prompted him to produce three stunning portraits in 1920.[81]

However influential Augustus John's work may have been, Varley was no mere imitator. His figures lack the volume and weightlessness that characterize the figures in John's best portraits. Varley's colours are more muted and therefore less pure, or less Fauve, than John's. Moreover, his portraits also owe something to the work and ideas of other artists. His painting of Vincent Massey reflects Whistler's

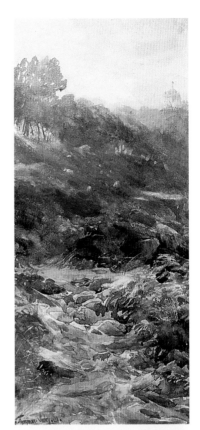

Burbage Brook, 1901.
SHEFFIELD CITY MUSEUM

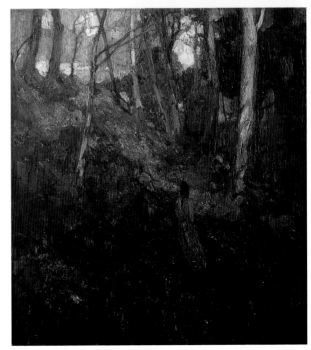

The Hillside, c. 1912.
COURTESY IRVING
UNGERMAN

Top: *Stormy Weather, Georgian Bay*, 1917.
NATIONAL GALLERY OF CANADA
Above: Mont St. Eloi, World War I, "In Arras," c. 1918-19.
UNIVERSITY OF BRITISH COLUMBIA

Above: Peter Sandiford at Split Rock, Georgian Bay, 1922.

ART GALLERY OF ONTARIO

Right: Mimulus, Mist and Snow, c.1927.

LONDON REGIONAL ART GALLERY

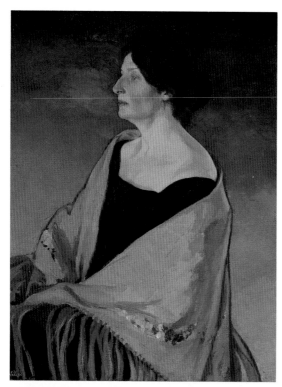

Left: *Portrait of Alice Vincent Massey,*
c. 1924-25.
NATIONAL GALLERY
OF CANADA

Below: *Cheakamus Canyon,* 1929.
PRIVATE COLLECTION

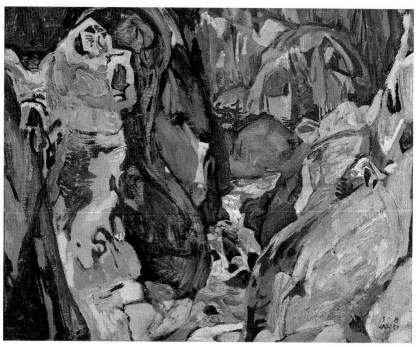

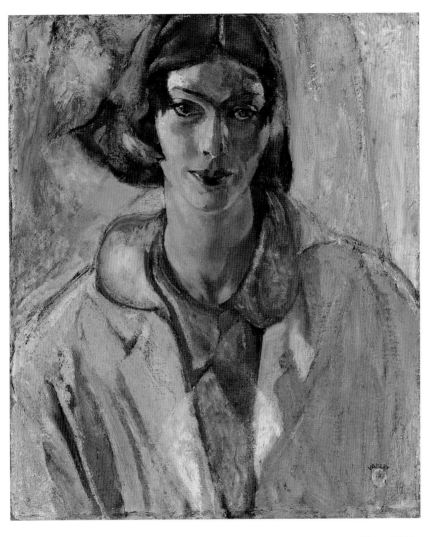

Vera, 1930.

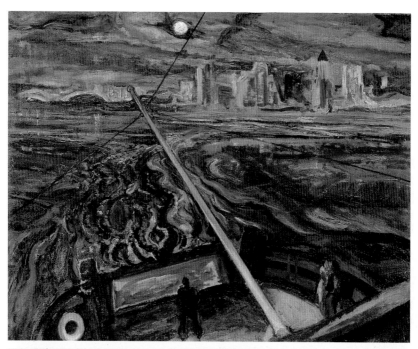

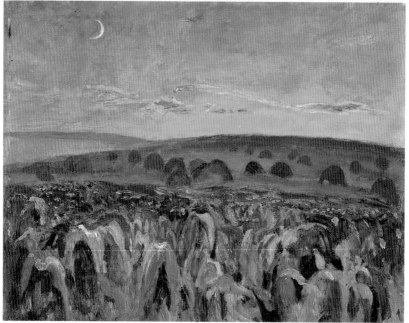

Top: *Night Ferry, Vancouver*, 1937.
McMICHAEL COLLECTION
Above: *Cornfield at Sunset*, 1943.
ART GALLERY OF ONTARIO

Erica, 1942.
TRINITY COLLEGE

Studio Door, c. 1953.
MONTREAL MUSEUM OF FINE ARTS

belief that portraits should not only entail a sympathetic arrange-
ment of "harmonies," but conform to decorative and formalist
principles. The prismatic splintering of light, which forms the back-
ground of the portrait, is reminiscent of Turner's late watercolour
paintings.[82] The austerity of the form, the emotional distance, and
the elimination of chiaroscuro, characteristic of Varley's early 1920s
landscape-with-figure paintings, may be attributed to the French
artist Puvis de Chavannes, whose work he certainly knew. But it is
the British portrait painters of the Edwardian era to whom Varley
owed his greatest debt. The unusual viewpoint taken in *Portrait Group*
(1924-25), which was painted in the little sunroom of the Varleys'
Yonge Street home, has its roots in the work of Philip Wilson Steer
as well as in Velázquez's *Las Meninas*, a painting Varley admired. The
composition and the effective use of the blue shawl in Varley's
Portrait of Alice Vincent Massey (c. 1924-25) was likely based on William
Rothenstein's widely illustrated painting, *Hablant Espagnol*.[83] And the
paintings of Varley's children were not only inspired by Augustus
John, but also by the London-based American sculptor Jacob
Epstein. Varley admired Epstein's bronze portraits of his young
daughter because he felt they conveyed "the child's character rather
than her fleeting expression."[84]

John, Steer, Whistler, Epstein, Turner, Rothenstein – and, one
could also add, Walter Richard Sickert, William Orpen, and
William Nicholson, among other British portrait painters and
sculptors – all played their part in shaping Varley's approach to por-
trait painting. As Barker Fairley observed in 1922, it was against the
work of these artists that Varley's paintings should be judged.[85]
Indeed, it was Varley's adherence to this tradition of portrait paint-
ing that allowed such British-trained art critics as Herbert Stansfield
to note that he was "the greatest portrait painter of Canada."[86]

Employment in Toronto during the 1920s as a full-time portrait
painter was possible only if an artist had a good nose for business
and could produce a "competent, conventional likeness."[87] The
emergence of new wealth, the expansion of the universities, and

the growth of the civil service kept a number of portrait painters busy. Most clients preferred to employ traditional artists like Wyly Grier, Kenneth Forbes, and J.W.L. Forster, who were fully paid-up members of the Royal Canadian Academy. Portrait commissions for perceived modernists, the likes of Fred Varley, did not come easily. Indeed, he complained to Eric Brown in the autumn of 1919 that the right female sitter had not yet come his way, though he could not have wished for a better model than Minnie Ethel Ely. His portrait, *Mrs. E.* (1921), brings the "chromatic interplay" between the figure and the background into perfect accord, resulting in one of his finest paintings from this period.[88] In answer to Varley's complaint, Brown advised him to "take someone regardless of social distinction and make them and yourself famous by sheer force of paint."[89] While Varley was not shy about asking Brown for help, he did not, like other portraitists in Toronto, advertise for clients. "If people will come to me it's alright," he told Maud, "but heavens — this selling [of] one's wares."[90] Varley was not, on the other hand, above drumming up business from the relatives or friends of the people whom he had already painted. "Whenever you think the boys are at their best and the time is ripe for them to be painted," he told Vincent Massey in 1925, "I shall be happy to commence."[91]

The majority of Varley's commissions came to him through the Arts and Letters Club. Among the university professors, businessmen, and critics whom he met there, none was more supportive than Barker Fairley. It is not surprising that Fairley was "crazy" about Varley's painting, convinced that he was "a great painter," and tried to "persuade others to think so" too.[92] Like Varley, Fairley was Yorkshire-born. He also admired landscape, especially that of northern Ontario. And he liked words and women almost as much as Varley did. According to Jackson, Fairley "had a mission to make Varley known to the world."[93] By his own admission, Fairley gave his "nights and days to Fred" because he felt that his work was "not unoriginal enough for commissions to come unsought."[94]

A professor of German at the University of Toronto, Fairley was well placed to promote Varley in several ways. He wrote articles on

Varley's work, first in the *Canadian Magazine*, then in *Canadian Forum*, of which he was a founding contributor. And he made Varley's painting the focus of his attention whenever he lectured on Canadian painting. Fairley not only sang the praises of Varley's work, he drummed up lucrative portrait commissions. A lecture by him in Sarnia, Ontario, in 1921 resulted in Varley's portrait of the daughter, Miss Mary Kenny, of a prominent local businessman. By this time, so Fairley recalled, he had already worked himself "to death" securing this and other portrait commissions such as the dean of arts at Queen's University. Painting Dean James Cappon in 1919 was "important" because it led to other academic work in Toronto as well as in Winnipeg and Edmonton.[95] The success of the portrait of Dean Cappon made it easier for Barker Fairley to persuade the conservative-minded board of Hart House that Varley was the best person to paint the portrait of Vincent Massey. Not yet embarked upon the public career that made him Canada's first native-born governor general, Massey was secretary-treasurer of Massey-Harris and involved in planning and building the University of Toronto's student-union centre, Hart House, when Varley painted his portrait. Like Dean Cappon, Massey was thrilled with the results. He showed his gratitude by hiring Varley to paint his wife, Alice Massey, his father, Chester Massey, and his father-in-law, Sir George Parkin. At up to $1,200 a painting, these commissions put a substantial amount of money into Varley's pocket.

A successful portrait depends upon an agreement between the artist and the subject. It can fail if the artist does not have a reasonably good rapport with his or her client. As a writer noted in 1901, it was incumbent upon the artist to "find the bond of sympathy – physical, pictorial or spiritual – between himself and his sitter, to make heedful selection of expression, pose, accessory, in accord with the bond" and, finally, "to leave the mark of his own personality in the portrait."[96] This was, of course, what Varley always tried to do. "He felt that people had a spirit that spoke to you – either a spirit that was good or was bad" and always tried to capture it on canvas or paper.[97]

Yet Varley was not temperamentally suited to the job. "I'm a restless lad," he told Maud in 1924, "too dammed impressionable to be healthy in this commercial life."[98] He disliked haggling over prices. He was unhappy when a client asked him to produce a realistic likeness, when what he wanted to do was "to express the feeling of the spirit rather more than the features of the person."[99] Since Varley claimed that he never set out to please anybody but himself, and since he disliked being dependent upon others, there were often problems when his goals and the expectations of his client clashed. The late arrival of a client for a sitting could prompt him to lay down his brushes and leave the studio, thus forcing his client to wait for *him*. During the course of painting James Cappon, Varley was annoyed when the dean asked, "What? What? You never worked in the Quartier Latin in Paris? But surely all good artists must get some experience in the Quartier."[100] An innocent observation by Alice Massey as to how Augustus John might have painted her portrait had the same effect: Varley lost his temper. Upset by his overreaction to her benign remark, Alice Massey "burst into tears." In an effort to calm her down, Varley fell to his knees. This is how Vincent Massey found the artist and his wife when he walked into the studio-shack. The incident took on a melodramatic aspect when Massey accused the artist of "making love" to his wife.[101]

Varley was "blunt and didn't suffer fools." This attitude increased his reputation as a "dour, emotional Yorkshireman who Ibsenizes in paint."[102] At the same time, however, he could be charming, gentlemanly, and gallant, in keeping with the Edwardian tradition in which he had been formed as an artist. One of Varley's clients described him as "a person of profound, almost mystical sensibility."[103] He could also be as flexible as he was rigid. He was known to repaint a portrait if the client, or if he himself, was not satisfied with it. Unhappy with his painting of Vincent Massey, for example, "he rubbed out the whole canvas and did it in one sitting."[104]

Official commissions presented many restrictions for a free spirit like Varley. "You're confined, you can't just go and open the gates,"

Portrait of Maud, 1925.

NATIONAL GALLERY OF CANADA

Varley told an interviewer.[105] Painting people he knew well was another matter. He could take liberties. "He used to do all sorts of strange things," one friend recalled, like "go over my face with his fingers." Painting whom he liked and when he chose enabled him to strike the right balance between producing a realistic likeness and a flattering portrait. "Please don't expect that I'm going to make this look like you," he told a friend before commencing to paint her portrait.[106] Varley's non-commissioned portraits of Maud and the children, and of friends like Barker and Margaret Fairley, were, not surprisingly, among his finest.

However much Varley enjoyed producing portraits or sketches of his family and friends, these works did not always contribute to the family income. Even the substantial amounts that he received from official portrait commissions did not keep the wolf from the door. The more Fred Varley earned, the more he spent. During the course of fulfilling three portrait commissions in Winnipeg and Edmonton in 1924, he stayed in the best hotels, where he lavishly entertained new and old acquaintances alike. "Dollars just melt," he told Maud in a letter from Winnipeg. "I give away in tips money which would be better in our coal bin."[107]

Things had been somewhat better two years earlier. During the early summer of 1922, a small inheritance from Maud's family made it possible for her and Fred to purchase a house on Colin Avenue in Toronto. By the following summer, however, Varley had defaulted on the mortgage payments and the family were evicted from their recently acquired home. Any chance that their peripatetic lifestyle might be over was quashed. The poet E.J. "Ned" Pratt and his wife, Viola, came to the family's rescue. They gave Varley, Maud, and their four children the use of a tent platform on a vacant lot acquired next to their property in Thornhill. The Pratts stretched their slim financial resources to help feed six extra mouths. And Ned Pratt saw

to it that Ryerson Press offered Varley a commission to illustrate his poems in *Newfoundland Verse* (1923). Varley jumped at the opportunity and followed Pratt's instructions to come up with "a design having a quality of spaciousness befitting ocean themes."[108]

Though Varley had given full-time employment as a commercial artist the thumbs-down in 1919, he returned to commercial art part-time a year later in order to supplement his initially meagre income. Further book-illustration commissions from Lorne Pierce at Ryerson Press led Varley to design the title page and endpapers for another work by Pratt, *The Witches' Brew* (1925), in addition to books by Marjorie Pickthall, George Locke, William Arthur Deacon, and Tom MacInnes. In 1925 Varley also contributed several pen-and-ink sketches to a portfolio of prints, compiled by members of the Group of Seven, and issued in a limited edition. And throughout the decade he produced illustrations for *Canadian Forum*. His first submission, which appeared in November 1920, was an unfinished sketch entitled *The Colliery Accident, Anxiety at the Pit-Head*, in which Varley chose to depict the miners' wives anxiously waiting for news of their husbands, rather than the coal-mining disaster itself.

In most of his illustrative work from the early 1920s, Varley continued to pay homage to the English illustrators Walter Crane and Frank Brangwyn, and to the Belgian print-maker Gisbert Combaz. These artists employed a nervous yet supple line which had its origin in the Art Nouveau style. Though Varley's illustrations clearly belong to an earlier era of illustration, the calibre of what he now produced was higher than it had been when he was employed as a commercial artist full-time. Newton MacTavish acknowledged this when he wrote in *The Fine Arts in Canada* that Fred Varley was not only a devoted portraitist, but "also a clever black and white artist."[109]

Other income came to Varley during the first half of the 1920s from winning mural commissions and mural competition prizes. The demand for large-scale decorative paintings was great at a time when new legislative buildings and churches were being built or restored. Though the field was dominated by traditional painters

like George Reid and Wyly Grier and, in the case of Manitoba's legislative buildings, by Frank Brangwyn, an ever-optimistic Varley entered the mural competitions and sometimes won.[110] In 1923 he helped eleven other artists decorate St. Anne's Anglican Church in Toronto. Supervised by J.E.H. MacDonald, the task of decorating the fourteen-year-old church, which had been built in the imperial Byzantine style, was ambitious.[111] In order to give symmetry to the overall design, the artists had to work with a limited number of colours – crimson red, Venetian red, yellow ochre, ultramarine blue, permanent green, black, umber, ivory white, and gold. They were also told what to paint. Varley was commissioned to produce several portraits of Old Testament patriarchs and prophets. In addition to this, he painted a five-by-three-metre Nativity – he included his own portrait as one of the minor figures. The murals, painted behind and around the altar, covering the interior of the apse as well as the curved triangular areas at the bottom of St. Anne's enormous dome, are stunning.

The most regular income that Varley received during these years came from his teaching. In the autumn of 1923, thanks once again to Barker Fairley, Varley taught a small group of students at Hart House's newly formed Sketch Club. When Fred and Maud took up residence in a large house on Yonge Street a year later, he turned the large living room into a studio-classroom and taught up to fourteen young men and women there during the evening. A more formal association with the classroom began in 1925. That year Jackson decided that he wanted more time for his painting and gave up his position at the Ontario College of Art. Varley took his place and taught drawing from the antique, and drawing and painting from the draped model. He had already examined for the college during the 1916-17, 1917-18, and 1919-20 academic years. In 1922, he had helped his war-artist friend, William Beatty, teach at the college's summer school course for teachers located at Maidenvale on the outskirts of Toronto. But it was not until 1925 that he got a full-time job at the school. Earning $1,500 for two terms of teaching was by far the largest salary Varley had ever received.

The Ontario College of Art had been founded in 1912 by the Royal Canadian Academician painter George Reid. Though run-down and smelling of turpentine, wet clay, paper, food, and floor oil, one student found the college to be "the friendliest place on earth."[112] The students, who trained to become teachers or commercial artists, numbered more than four hundred. They came from across the country, were predominantly female, and were committed students of art and design. After eating their lunch at McConkey's Cafe, where the waitresses shouted to the cook "Adam and Eve on a raft, leave their eyes closed," they ran across the street to view the current exhibition at the Art Gallery of Toronto.[113] On Friday evenings they listened to guest lecturers after dining with their instructors. And towards the end of the year they put on an elaborate Artists' Masquerade Ball.

The staff at the Ontario College of Art already included three members of the Group of Seven – Jackson, MacDonald, and Lismer. The level of teaching that they and the other members of the faculty gave was generally high, if not always in tune with the latest styles. Lismer, who had a reputation for helping "students to believe in themselves," was the most sought out teacher.[114] However, it was Varley who won the hearts of the female students; most had a "crush" on him.[115]

Varley enjoyed his year at the Ontario College of Art. Teaching, he claimed, was "an enrichment" to his own work. It was also a challenge: "There are so many minds and it's interesting to find the mind and see where you lift them."[116] Varley also enjoyed being at centre stage, where he had a chance to share his ideas with his students. Elie Faure's *History of Art: Vol. IV, Modern Art* (1924), which opened with a photograph of Antwerp and a discussion of that city's two most illustrious artists, Rubens and Jordaens, was Varley's art bible. He also showed lantern slides which included the work of Rubens, Epstein, Velázquez, Turner, the frieze of the Parthenon, the ceiling of Michelangelo's Sistine Chapel, and a still life by Cézanne. Varley also exposed his students to ideas which lay outside the conventional artistic and academic boundaries of the art college.

Varley's students soon learned that, for their teacher, the artistic process not only entailed the reproduction of nature, but involved balancing "the emotional and intellectual sides of the artist's make-up." Varley felt, moreover, that there was no difference between ancient and modern art or between the art of different countries because "under the progression of surface life which we call history is something real and unchangeable."[117] The extent to which he was successful in conveying these sorts of ideas to his students is evident in the letters that he received from them long after he had left the college. Most reminded Varley that he had been an "exciting and rewarding" teacher, if "often completely exasperating."[118]

Despite earning a good salary at the best art school in the country and receiving money from the odd sale of a painting, Varley could not make ends meet. He had grown up on tales of how the family's most famous painter, John Varley, had spent his life in and out of debtors' prison. Varley identified both with his ancestor and with the bohemian tradition: being down and out was part of the genius-artist equation. Believing that his work had "no commercial value" did not, however, prevent him from dreaming about being out of debt or from assuring his friends that he would soon be back on his feet.

Most of Varley's friends did not appreciate that temperament, tradition, and lineage prevented him from living like other respectable artists. Jackson felt that "Varley could have made plenty of money as a portrait painter, but he didn't want to be bothered with it."[119] While a few portrait painters obtained enormous fees for their work, most, like Varley, did not. Sir Edmund Walker and Eric Brown were initially sympathetic to Varley's financial difficulties, but soon came around to Jackson's view. Walker felt that Varley was "personally much to blame, being rather a man who works fitfully instead of industriously."[120] Eric Brown, who was convinced that Varley had received "a fair income, as good as that of many other painters," agreed. "I do not think that Varley paints much, either portraits or landscapes, and might do more and exhibit more." Brown even went on to suggest in his letter to Walker that "commercial work would not altogether harm him."[121]

Lismer knew better than to expect his boyhood friend from Sheffield to comply with the Protestant work ethic that had earned their adopted city the epithet "Toronto the-Good." Varley's "restless sensitivity, and his search for something beyond the materialism of the age" were, according to Lismer, "beyond outward forms."[122] Though he liked spending it, Varley was indifferent to money. While he did not like being in debt, he made little effort to avoid it. It was always easier for Fred to ask for a loan if he could not meet the rent or pay the grocery bill at the end of the month.

Varley focused his energies on awakening "the imagination of the on-looker" through his painting and to feeling "all things so intensely that the body trembles & aches & tears well in the eyes."[123] Accumulating material possessions could never compete, for Varley, with the joy of painting into the long hours of the night or of playing the music of Franz Schubert on the piano, or of listening to Schubert's music to the point at which he became "Schubert mad."[124] Varley was determined not to "forget or forsake" the ambitions and ideals of his student days. As he assured Maud, "I know they were true – & the only way is to return to them."[125] Yet devoting himself fully to music and art did not come without pain. "Rainbow chasers might feel much of life but by heck," he told Maud, "they must accept in their feelings the agonies as much as joy."[126] Nor did it come without the fear of failing. What he could not conceive, he told Maud in 1924, was "failure."[127]

Fulfilling the ideals and goals of his student days inevitably conflicted with his duties as a husband and father. Varley was the first to admit that "I am a disgrace to the role of married man." Yet he could "not hold to home life being the incentive to creative work" because, he admitted to Maud in 1924, "the quiet home lover is not an artist."[128] Though Varley sometimes felt that his family was a burden, Maud and the children were necessary to him. It was Maud with whom Varley shared his fears and his ambitions. It was Maud who satisfied him sexually: "I find, dearie, that I have as the days go by more & more frequent 'empty feelings' that you alone will satisfy."[129] Without her, Varley confessed on his first trip west

in 1924, "I should have wandered off & lost myself in trying to find an ideal that only I can make."[130]

Though Maud remained "stubbornly indifferent" to Fred's work, the couple had "a lot of things in common."[131] They continued to share their love of literature and, during the early 1920s, worked their way through the plays of Oscar Wilde, Molière, and August Strindberg, and the fiction of Maxim Gorki and Anatole France. They both enjoyed drinking; it was Varley who warned Maud, "Don't drink too much," when he was in Winnipeg in 1924.[132] And they both enjoyed entertaining. Even though the Varley home "always had something tacked up at the windows because there were no curtains" and, the same observer continued, "the children . . . ran about like wild things," Maud and Fred kept an open house.[133] They held "great social get-togethers" in their Yonge Street home and, their son Jim remembered, threw "tremendous parties."[134] This gave housebound Maud an opportunity to meet "a lot of exciting people . . . like Vincent Massey, people of that calibre."[135] She found a soul mate in the Group of Seven's biographer, Fred Housser, who, like her, was a devout Christian Scientist. And Maud enjoyed dancing with Lawren Harris who, she told Fred, "dances divinely."[136]

Was this the sort of life that Maud, who, according to Arthur Lismer, "never uttered a word of complaint," envisioned for herself and the children when she left Sheffield in the spring of 1913 and set out for Canada?[137] Certainly the war years at Thornhill, when Maud "couldn't get warm and . . . was all on her own," must have been dreadful. Her eldest child, Dorothy, didn't "know why she didn't go out of her mind."[138] Perhaps it was because, as Peter Varley has suggested, "my mother was much in love with him."[139] Even so, it was Maud who paid the bills when there was money to pay them, and Maud who secured the loans which kept a roof over the family's head. It was Maud who nursed the children when they were sick – "I have had Peter ill for 2 nights; I was up all night with him" – Maud who saw to it that her children became involved in the arts – "John is starting to learn the violin . . . we must try to let Dorothy take

some dancing lessons if we possibly can"[140] – and Maud who had to remember the children's birthdays – "I'm awfully sorry I forgot John's birthday," Fred wrote in 1924.[141]

Though early in her marriage Maud accepted that Fred's "work was the only thing that ever mattered to him," the paucity of money nevertheless weighed heavily on her shoulders.[142] "Nothing can be right," she told Fred in 1924, "until a woman can be financially independent."[143] Maud was not only financially vulnerable during and after the First World War, she began to lose her sense of identity. "A woman with a family who has given herself up to it for years cannot be an individual," she told Fred in 1924, adding, "I am dead to people when you are away."[144]

Maud might have fared better if Fred had not, in her words, been so "fond of the ladies."[145] During her first summer in Canada, a young waitress whom Fred had befriended before Maud arrived in Toronto visited Centre Island. Then, when Fred was in England as a war artist, he had told Maud that he could not "go through the world" with love in his heart "without it crying out to others with love in theirs."[146] This was followed, in the spring of 1919, by Fred's long silence.

It was not Varley's intention to let Maud know what had taken place between himself and Miss Florence A. Fretten in the spring and summer of 1919. Yet in May 1921, shortly after Maud had given birth to their fourth and last child, Peter, Maud discovered why Fred had all but disappeared for several months. Fred had continued to maintain contact with his former lover by letter, and Maud intercepted one of the lovers' missives. Devastated, she contemplated suicide. Then she wrote to Florence Fretten, who replied with a full account of the affair.

The romance between Varley and Florence Fretten was intense and passionate. Though Florence told Maud that she knew from the outset that "it was all wrong" and that it would "end in tragedy for all parties," Fred Varley had possessed for her "a fatal fascination." When not with him, the young Londoner, who was eleven years

Varley's junior, "was in hell." When they were together, she was unhappy. "I knew I ought to give him up," she told Maud, "but had not the power to do so." Fretten "suffered mental and physical agonies" to the point at which she worried herself "into a nervous breakdown." The motivation for her involvement probably had as much to do with the exigencies of the war as with Varley's charismatic personality. As one historian of the Great War has pointed out: "it was useless to tell a woman who had driven a truck that it was immodest to go into a pub. It was equally useless to keep up the 'fallen woman' nonsense if she chose to satisfy her natural appetites."[147] Even so, two years after Varley had returned to Canada, Florence still loved him. "For me to be with him would be in itself happiness" for which, Florence told Maud, she would "gladly do anything & bear anything for his sake."[148]

This was probably the first time that Varley had, as he put it, "besmirched myself."[149] Like Florence, and indeed like his favourite sister, Lilian, and her Scottish MP, the war had cast him into a world where "once-normal people become abnormal, where abnormal acts are treated casually – where people do and say things that before the war they would never dream of doing."[150] Yet Varley's affair with Florence Fretten was not entirely a product of the Great War. His attitude to women and to sex in general, like all of his attitudes and beliefs, was multifaceted. He could suggest to Maud that passion was "of the mind only" and then turn around and insist that it could be best expressed "through the channel of the physical."[151] Such diametrically opposed views were in keeping with the popular "assumption that artists and writers were not subject to the moral conventions governing ordinary people."[152] They were also in tandem with Havelock Ellis's claim in *The Erotic Rights of Women and the Objects of Marriage* (1919) that "sexual energy may be in large degree arrested, and transformed into intellectual and moral forms," or could serve as "the stimulus and liberation to our finest and most exalted activities."[153] Varley was familiar with Ellis's seminal work as well as with the unconventional lifestyles of artists like Augustus John. This no doubt provided him with a justification for his behaviour.

After Maud learned about the affair, Fred openly admitted to his "follies & indulgence" and to having lost his "ideals" through "wrong thoughts."[154] Yet he made no attempt to reform. "Don't want me too much," he warned Maud when she missed him in 1924.[155] There was no compensation for his former lover either, since Maud's knowledge of the affair no doubt put an end to their correspondence. Florence Fretten was left to face spinsterhood since she could not imagine herself "even now caring for anyone else."[156] Hers was the first of many hearts that Fred Varley would break and the first of the many lives that he would disrupt in the course of his life.

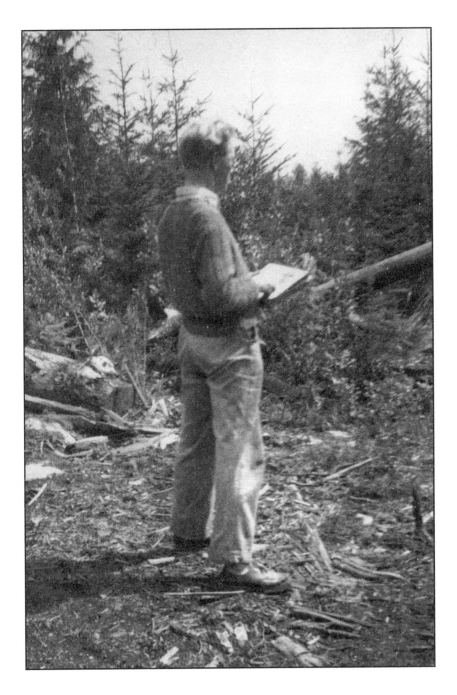

Varley sketching at Lynn Valley, British Columbia, 1937.

CHAPTER 6

Paradise Found

Varley caught his first glimpse of the Rocky Mountains in 1924. On 12 April he viewed them from high ground on the outskirts of Calgary. Although some eighty miles away, the mountains appeared to be much closer. Enchanted by the sight, he took the elevator to the sun roof of his hotel, the Palliser, and spent a further hour admiring the distant peaks. Then, just before leaving the city for Winnipeg, he visited Banff. "It was a caressingly warm morning like a summer morn," he told Maud, with "wisps of gossamer cloud clinging to the mountain sides, not even clinging – just whispering & lightly touching them before they dissolved in the bowl of the sky."[1]

Varley was "smitten" by western Canada.[2] Even before he saw the mountains, he sensed that there was "a mystery about the west."[3] His favourable response probably had something to do with the way in which he was received. Everywhere he went, first Winnipeg, then Edmonton, and finally Calgary, he was treated like a celebrity. "The artist is a wonderful man to them," he reported from Winnipeg, "but he belongs altogether to an unknown land." Though "much impressed with the Westerner," Varley felt like "a stranger speaking a foreign tongue." "They never dream of Art here," he continued, and "the appalling ignorance of the people is miserable."[4]

Ironically the western Canadian's isolation from and ignorance of the visual arts made Varley's presence there all the more poignant. Compared to eastern Canadians, who were "so dammed satisfied with themselves" and, in Varley's view, possessed "ideals without a standard or any judgment," western Canadians were enthusiastic

learners.5 They had certainly viewed the National Gallery of Canada's travelling exhibition with interest when it toured Calgary, Edmonton, and Winnipeg in 1921. A few years later, they had made good audiences at the lectures that Varley gave on the strength of his fame as a member of the Group.

It was not only the people that offered Varley a refreshing contrast to Ontario, but the landscape as well. By 1924 eastern Canada had, Fred confided to Maud, "lost all attractions." It was, he continued, "grey & murky."6 The Rocky Mountains were, however, another matter. A few days after viewing them for the first time, Varley announced that "from now on I want to paint mountains."7 The other members of the Group of Seven had been equally "smitten" with the landscape of Alberta. Jackson painted the province's mountains in 1914 when, thanks to the Canadian National Railway, he got a free railway pass. MacDonald and Harris discovered the beauties of Lake O'Hara ten years later. When Varley wrote in 1926 that "the whole country is crying out to be painted," he was in accord with the Group's nationalist thinking.8 As Jackson had put it a year earlier, the members of the Group were treating "the whole of Canada as a sketching ground."9

But these were not the only reasons Varley agreed, in July 1926, to take up a teaching post at the Vancouver School of Decorative and Applied Arts the following September. First, he was convinced that paintings of mountains would be "easier to sell" than paintings of people.10 Second, he needed a new artistic challenge. "I have not experimented for years," he told Eric Brown just after making his decision to move West, "& I want badly to try out many adventures in paint that have been caged-in too long."11 And third, by 1926 the old pattern of going into debt, moving house, making more enemies than new friends, and, above all, of receiving what he deemed to be too little recognition for his work had reasserted itself.

On the face of it, however, things looked good. Varley had been elected to the Royal Canadian Academy of Art as an associate in 1921. He was a popular contributor to the annual shows at the Ontario Society of Artists and the National Gallery of Canada. He

was commanding competitive prices for his portrait commissions. And, living in the artistic capital of English-speaking Canada, he was well placed to compete for the jobs and the exhibition venues when they were available. After the Great War, Toronto not only had more public and private art galleries than any other city in the rest of the country, it also was the centre of publishing and home to every major cultural organization and society in English-speaking Canada. In addition, the city had a number of patrons who were not afraid to spend their money on art or to help public art galleries mount exhibitions from abroad. In 1927, a year after Varley left Toronto, Harris brought the International Exhibition of Modern Art, assembled by the Société Anonyme in New York, to the Art Gallery of Toronto. With paintings by Kandinsky and Mondrian, it was the most comprehensive exhibition of modern art displayed in the city to that date. It is not surprising that one friend claimed that Varley's move to Vancouver was a mistake, "because he went out of a world that would have stimulated him artistically."[12]

Despite the growing cultural infrastructure, earning one's living as a full-time artist, even in Toronto, was not easy. A mere 2 per cent of all the artwork sold in Canada in 1924 came from the studios of Canadian artists. Those who were lucky enough to find clients for their paintings and sculptures came from the older and more conservative generation of Canadian artists. Though the Group of Seven fared better than most of their artist contemporaries, their patrons preferred to purchase small panel sketches rather than large canvases.[13] This meant that, with the exception of Harris, who was heir to the Massey-Harris fortune, most members of the Group had to find a means of support other than their painting. Of the Group's original members, Lismer and MacDonald worked first as commercial artists, then as instructors at the Ontario College of Art. A.J. Casson – who joined the Group in 1926 – and Carmichael remained at Rous and Mann as commercial artists. And Jackson taught for a year at the art school before painting full-time. Prior to 1926 Varley had never held down a teaching job for more than a year. He was not as productive as Lismer, MacDonald, Jackson, and Harris, nor, as his

performance at the British Empire Exhibition at Wembley, England, in 1924 made clear, was his work as well received.

The Canadian contribution to the Palace of Arts in Wembley marked "the turning point of the Group."[14] Art journalists of the calibre of Paul Konody showered praise on their "daring, decorative and intensely stimulating landscapes." Indeed, Konody professed himself unaware of any European school of art which showed such unity of effort, displayed "a similar combination of nature worship and respect for the laws that rule pictorial design," and exhibited "a similar balance of the representative element and abstract aesthetic principles."[15] Yet Varley's old friend from the Canadian War Memorials Fund did not single out his work for praise. Nor did many of the other foreign critics who saw the London show. Their attention was focused rather on the canvases of Thomson, Harris, Lismer, Jackson, and MacDonald. Two years after Wembley, Varley's work was ignored again when it was shown at the Exhibition of Canadian Painting at the Rochdale Art Gallery in New York.[16] A year after that, when the Group of Seven and their contemporaries exhibited at the Exposition d'art Canadien at the Jeu de Paume in Paris, it was Thomson and Jackson who, once again, caught the critics' attention. And when Canadian officials were invited to submit work to the Second British Empire Exhibition at Wembley, Varley was the only member of the Group whose work was not chosen for exhibition. Passed over by people like Konody who had praised his work just a few years earlier, Varley saw his hopes dashed for what he wanted more than anything else: acceptance for his work in the country of his birth.

Art critics at home were more generous, yet even they were not as excited by the new paintings that left Varley's studio as they had been by the canvases he had produced during and just after the Great War. In reference to Varley's contribution to the Art Gallery of Toronto in 1922, the art critic for the *Toronto Star*, Augustus Bridle, observed that he was "capable of much bigger things than anything shown."[17] Three years later Fred Housser noted in his seminal study of the

Group of Seven that Varley was "a painter with extraordinary talent and with great potential capacity for originality and feeling."[18] A year after that Lismer reported to a friend that Varley's contribution to the National Gallery of Canada's annual exhibition of Canadian art "wears well although his latest work is a bit thin."[19] "Potential" was the word that came to mind when most artists and critics discussed Fred Varley's work. "Potential" because the few paintings he exhibited frequently surpassed those produced by the other members of the Group. And "potential" because, as Lismer put it, Varley was "the most artistic of the group."[20]

As early as 1920, Jackson dubbed Varley and MacDonald the "non-producers" of the Group of Seven.[21] Certainly *Stormy Weather, Georgian Bay* (1912), *Self-Portrait* (1919), and Varley's war paintings came up for show again and again.[22] These paintings, owned by public institutions, stood in for new paintings. While few questioned the quality of Varley's new work, there was little of it. Moreover, many of his new paintings were portraits. Landscapes were what the Group's patrons wanted to buy and what a member of the Group of Seven was expected to produce. By the mid-1920s, rocks, trees, and lakes were not only part of the iconography of Canadian art, they had become "ideological icons of national struggle, achievement, and collective belonging."[23]

Small artistic output along with a preference for figurative work was not Varley's only problem during his Toronto years. Younger artists like Edwin Holgate, Randolph S. Hewton, Sarah Robertson, and Prudence Heward were showing that they were not only fine portrait painters, but equally capable of incorporating the figure into the landscape. Moreover, their approach was more in keeping with the plastic and rhythmic nuances evident in the canvases of Harris and Jackson. Varley was aware of the competition that his younger contemporaries posed. Their work might even have prompted him to set Maud and the children against the stark Ontario landscape. He certainly "objected very strongly" when two canvases by Edwin Holgate, who was a master at incorporating the figure into the

landscape, were included in the Canadian entry at the Wembley Exhibition in England.[24] Varley's fear that he might be outdone by this much younger artist turned out to be justified. Holgate's portraits were favoured by at least one art critic over Varley's canvases at Wembley and, five years later, rated above his contribution to the Canadian Exhibition of Painting at the Corcoran Gallery in Washington.[25] Nor would Varley have been pleased to learn what one friend told the director of the National Gallery about his contribution to the Royal Canadian Academy's exhibition in November 1920. "Hewton's portrait," Jackson reported to Eric Brown, "is very highly spoken of by the chaps who were down on Varley's [portrait of] Chester Massey."[26]

It is not surprising, therefore, that when Lismer turned down the job as instructor of drawing and painting at the Vancouver School of Decorative and Applied Arts, and it was offered to Varley, he did not hesitate to take it. "At last I have the opportunity I've longed for for many years," he told Brown two weeks after accepting the job, "to live by the sea, have mountains at my back door and be sufficiently free from financial worries to experiment in paint."[27] He was equally thrilled by the salary. At $3,000 per annum, Varley was about to earn double what he had received as a teacher at the Ontario College of Art. A new city, a new job, a higher salary, along with the prospect of making new friends, always fuelled Fred Varley's artistic energy. A change of venue would enable him to live on expectations and chase rainbows once again. No wonder he called the move to Vancouver a "sparkling adventure."[28]

Before departing for western Canada, Varley submitted two works — a cartoon sketch for a mural, *Immigrants*, and a portrait, *Joan* — to the Canadian National Exhibition with the idea of raising money for the move. Though he did not sell these works, he did obtain two free passes on the Canadian Pacific Railway for himself and his fourteen-year-old son, John. In early September the pair boarded the train at Union Station. Varley's eldest child, Dorothy, who saw them off with her mother, recalled that they

were "happy, happy, happy" as they embarked on their "great romantic trip out west."[29]

Maud and her remaining three children, aged sixteen, nine, and five, were left to find the money for their rail fare. She did this by holding a sale of Varley's work at the Yonge Street home. Maud was also left to pack up the family's household belongings. This was done with the help of a family friend Trevor Garstang. Finally, it fell to Maud to settle the arrears on the Yonge Street house. "It was quite a scramble," she remembered. "I left Herbert Stansfield to pay off the rent."[30] Thanks to the help of friends, Maud and the children were able to join Fred and John in Vancouver at the end of September. She was now forty and Fred was forty-five.

Varley's departure from Toronto was not mourned. According to Jackson, "everyone [was] delighted to see him go including Fairley," who had been his most loyal patron.[31]

"Ever since I saw the mountains at Banff a few years ago," Varley told a newspaper reporter shortly after arriving in Vancouver, "I have wanted to come west."[32] He was not disappointed when he caught his first glimpse of Vancouver in September 1926. "The City itself is spacious," he reported to Maud, with "some lovely houses, broad streets & the setting of hills is the last word in beauty of sil- houette."[33] Vancouver's North Shore mountains, rising three thou- sand feet out of the sea, were stunning. The city's wilderness park, crowded with ancient cedars, Douglas firs, and hemlock trees, and located on a peninsula in the centre of the city, was a reminder of what Vancouver had looked like a mere sixty years earlier, when the only evidence of European settlement was a water-driven sawmill on the north shore of Burrard Inlet. In 1926 Vancouver was already the province's largest urban settlement – it had reached the quarter- million mark just before the Great War. Founded on mineral and timber claims, as well as on land speculation, British Columbia

offered "infinite possibilities" and, as one publicity brochure claimed, "presents a field of unlimited enterprise to those brave spirits who long for fresh worlds to conquer."[34]

Within a few days of arriving in the city, Varley and John took the "electric sky ride" to the top of Grouse Mountain. Ignoring John's bad cold, father and son bathed in the icy waters of the Pacific. From their base at the Grosvenor Hotel in the heart of the city they looked for a house: "A place in town will cost $75 or $100 furnished," Varley told Maud. They also had their first look at the art school. Varley was pleased with what he saw. The school possessed "enough good antiques to make it satisfactory," the space was "beautifully clean,"[35] and, Varley told a newspaper reporter, it offered "unlimited possibilities for developing the scope of this training."[36]

During his first week in Vancouver, Varley also met his new boss. Charles Scott and his wife were, in Varley's view, "lovely characters — Scotch, very much so, the generous kind." Scott was not only a painter, he was also "a first rate violinist" and Varley looked forward to accompanying him on the piano.[37] Varley's junior by five years, the Glasgow-born artist had studied at the Glasgow School of Art and attended the art academy in Brussels before immigrating to Canada in 1912. With the outbreak of the Great War, he had returned to Britain and served with the Canadian Expeditionary Force. Unlike Varley, Scott did not have a body of work to remind him of his wartime experience. He had, however, been wounded at the Battle of Lens.

Shortly before Varley left Toronto, Brown had told him that he was "very glad that you are going to be able to introduce to B.C. the gospel of the new Canadian art movement" and wished him "great success."[38] Brown and his wife, Maud, had themselves spread the "gospel" of the Group of Seven there in 1921 and were planning another lecture tour of western Canada in 1927. Their view was very much in keeping with how most eastern Canadians — including Varley — perceived the west. "The Westerner is timid and conventional in his attitude towards art," one commentator noted in *Canadian Bookman*. "Exhibitions which would be considered mild or

academic in the east are looked on as the works of extremists in the west."39 Westerners themselves believed that the west was a cultural wasteland. As one writer put it in Vancouver's *Daily News-Advertiser* in 1904, Vancouver was a place where "the quest for the dollar . . . [left] no time for the quest of the beautiful."40

Varley had appreciably more faith in the artistic potential of the city and its people than did Brown and the eastern Canadian critics. By the end of his first week in Vancouver, he was happy with his prospects at the school. He told a reporter that he was "altogether in love with the Country here" and ready for the challenge that teaching in the unsophisticated west posed.41 "Vancouver could be the greatest art centre in the country," he told another reporter.42

Certainly, by the time Varley arrived in the city, Vancouver possessed a large number of cultural organizations devoted to art, theatre, music, and drama,43 most of them private and confined to the upper middle class. Most of the culture their members produced was of amateur quality, and wedded to British styles and traditions and even to British subject matter. Yet cultural activity in Vancouver was not solely confined to amateurs or entirely under the aegis of their cultural organizations. The newly founded University of British Columbia made a gesture towards enhancing the cultural life of the city when, in 1925, it hosted a series of lectures on Canadian painting. The organizers of the Pacific National Exhibition were no less enthusiastic about promoting the arts. From 1916 they saw to it that paintings from the permanent collection of the National Gallery of Canada were displayed between the cookery and agricultural exhibits. Two private art galleries, one devoted to British and European art – James Leyland's Fine Art Galleries – the other to Canadian painting – the Vanderpant Galleries – and several exhibition societies – the B.C. Society of Fine Art, the Vancouver Sketch Club and the Studio Club – gave the city's *nouveau-riche* paintings for the walls of their homes. Finally, semiprofessional art critics – they ranged from the conservative John Radford to the more liberal-minded Harold Mortimer-Lamb – acted as arbiters of taste in the local press.

Nor did cultural activity in post-war British Columbia lack private patrons. Recognizing a need to train "not more artisans, but artists to convert British Columbia's wealth of raw material into greater wealth of artistic finished products," a group of businessmen in Vancouver formed the B.C. Art League in 1920.[44] Thanks to their efforts, the Vancouver School of Decorative and Applied Arts was founded by the trustees of the Vancouver School Board in 1925, and the Vancouver Art Gallery was established six years later.

Fred Varley's work was known when he arrived in Vancouver in September 1926. In 1922 his work had been exhibited alongside that of the other members of the Group of Seven at the East Hastings Park exhibition fairgrounds and, a year earlier, at the B.C. Art League's gallery on West Cordova Street. Mortimer-Lamb had noted the "spontaneity and vitality" of Varley's portrait *The Sunflower Girl* in a local newspaper after seeing it in 1922.[45] A mining journalist as well as an art critic and photographer, Mortimer-Lamb had also acquired one of Varley's paintings, *Gypsy Head*, for his private collection. When Mortimer-Lamb joined forces with professional photographer John Vanderpant to found the Vanderpant Galleries in the spring of 1926, Varley had a venue for his work. Mortimer-Lamb and Vanderpant not only looked after Varley's artistic interests, they invited him, Maud, and the children to their Thursday evening musicales. This weekly event brought students from the art school together with the city's literati. They listened to Vanderpant's records – everything from Stravinsky, Richard Strauss, and Satie to a recorded monologue by Jean Cocteau. They viewed Vanderpant's latest photographs of a grain elevator, a stalk of celery, or the cross-section of a cabbage, all of which reflected the modernist approach of his friend, New York photographer Alfred Stieglitz. They listened to the city's "self-appointed intellectual" and bookstore owner, Sidney Baker, "tackling the whole history of the Gothic" with the help of his black-and-white lantern slides. And, during the break for refreshments, they participated in "pleasant little discussions and *tête-à-têtes*."[46]

Vanderpant, a Dutchman, and Varley quickly became "good buddies." "They shared the beauty of the country": both saw it as "strong and vital – different from the European landscape of their childhoods."[47] Varley and the much older Harold Mortimer-Lamb became fast friends too – at least until they found themselves competing for the attentions of the same woman.

Located on the third floor of the school-board building in downtown Vancouver, the premises of the Vancouver School of Decorative and Applied Arts were, to one observer, "inadequate in every way."[48] It was not unusual to see as many as sixty-five students – predominantly female – crowded into one of the two large studios.[49] Though "keen as mustard and brimming with talent," most of them had not "seen a museum or a gallery or anything."[50] Having someone of Varley's calibre among them was a privilege. As Jack Shadbolt put it, "Varley gave Vancouver the first genuine tingling sort of big time excitement of art" and, he continued, "we were all so proud that he was here and working among us."[51]

Varley's hours at the school were long: he taught five mornings, three afternoons, and two evenings a week. Scott admitted that the teaching load was heavy and assured Varley that, "later on we can organise it in a more satisfactory way." Even so, the job had its rewards. As Varley told Maud, "I have full scope to do what I want in teaching."[52] This was no understatement. Varley used his favourite textbooks. Elie Faure's *History of Art: Modern Art* introduced his students to the canon, stressed the importance of the artist's role as spokesman, and warned them against the dangers of following modernist trends which indulged in the cult of the ugly.[53] *The Art and Craft of Drawing*, by Vernon Blake, served to remind his students that although "one side of art be craft yet the other and greater element of it, that which inspires the craft itself, is intellectual, intangible, spiritual."[54] (This was in keeping with Varley's own belief

that aesthetic expression required intellect as well as feeling and emotion.⁵⁵) And when his students had progressed from pencil and charcoal to pastels and paint, they got "steadily, day and night," the chromatic circles and colour systems of the colour theorists Wilhelm Ostwald and Albert Munsell.⁵⁶

Varley was not an analytical teacher; he preferred to teach through demonstration. Sometimes he worked alongside his students, producing superb drawings like *Nude Standing* (c. 1930).⁵⁷ At other times he drew directly onto a student's work. If his addition "failed to come off, he would admit his fault and wield the chamois," but if his drawing was successful, "he was very happy."⁵⁸ When Varley sensed that the whole class was moving in the wrong direction, he would place a large sheet of paper on the floor, order the model to take a pose, invite his students to gather around him, ask for a small piece of charcoal, "usually a little piece because he liked to hold it at the end of his fingers," then he would proceed "to draw this model inch by inch explaining as he went the meaning of every line of every pressure point and joint, why this was that way, how it should be observed then [say], 'all right get to work,' and [leave] the room."⁵⁹ If the students were working in oil paint, Varley's methods of demon-stration were even more dramatic. Holding the brush at the end, he would literally assault the canvas. As he charged towards the easel, from a distance of six feet, he would cry: "concentrate on sucking up the essence of the subject rather than making a good painting."⁶⁰ Varley gave his students problems which he had set himself in relation to space.⁶¹ In this way he ensured that his teaching enriched his own work, while it illuminated the minds of his students.

Before Varley arrived at the school, the students' drawing was tight. "A careful blocking in from a stereotyped pose, this taking at least a two hour period," student Fred Amess recalled, "then, a careful drawing in line for two hours and another four hours of careful shading, ended with the toes on Friday afternoon."⁶² Copying, be it from a plaster cast or from a life model, was central to the teaching of art. This was how Varley had acquired his knowledge of anatomy as a student in Sheffield and Antwerp, and this was how

art students had been taught ever since the French had established the principles of academic pedagogy in the seventeenth century. Under Varley's instruction, however, copy work at the Vancouver School of Decorative and Applied Arts took on a new dimension. His students not only worked from the school's fine collection of plaster casts; they also made "dozens of quick sketches" – from five-, ten-, to twenty-minute poses – of a life model. Varley's models were "something special." "A sinuous Italian girl," brought out the Botticelli in him and his students.[63] A Russian priest got the giggles during his pose. A lovely Chinese girl and Eugene, a Japanese Canadian who cooked for the students when they repaired to Savary Island for the summer, gave the students a variety of subject matter.

As the students worked, Varley, who was usually dressed in dark-green corduroy trousers, his red-gold hair tousled, and his back straight as a rod, moved gracefully among the easels. Speaking in a low, almost hypnotic voice, he encouraged the students "to use a thin, firm outline for the light side of the form and a broad, soft line marking the edge of the shadow area." This helped them to give their drawing a sense "of considerable reflected light."[64] Once, Varley tested his students' powers of observation by emphasizing the plastic qualities of the model's feet. "Then," one student recalled, "with great guffaws he left the room." It was not until the end of the week that Varley gleefully pointed out to the class what they had not observed, that the model had six toes on her right foot.[65]

While exactitude, acquired through close copy and a knowledge of the canon, formed the basis of Varley's teaching, drawing "was not a matter of doing something precisely," but, Fred Amess continued, of "getting the essence" of the thing portrayed.[66] Another former student, Jack Shadbolt, recalled that Varley "had a romantic concept of what he wanted to do but he also had a severe notion of the technique required to do it."[67] Yet another student remembered that Varley "tried desperately" to show us that "there were so called rules, but if you can break them then you are becoming an artist."[68] Losing and finding a line, fusing the mind with the medium, releasing the spirit from the medium, and calling forms out of moving

space, were difficult tasks for students to comprehend, let alone to perform.[69] Students were frequently left struggling with their teacher's enthusiasms, which were far beyond their knowledge and ability to realize in paint or charcoal. Even so, the experience of being a student in Varley's life class was rewarding because he "made you feel that, God, this is the most wonderful thing to be doing."[70]

While most of Varley's former students agree that he was "a spout through which flowed all the new excitements of the world," there was little room to manoeuvre between their ill-formed views and the firm convictions of their teacher.[71] During her visit to the school, critic Helen Dickson noted "an air of almost crushing efficiency, of cast-iron opinions, about the full-time instructors." This was, she reported in *Canadian Forum*, "undoubtedly conducive to excellence of technique, but in my considered opinion is subversive to the development of originality in the students."[72]

Jack Shadbolt agreed. There was "no question of argument or discussion, it was simply statement, a vision."[73] The Victoria-born Shadbolt was himself haughty – Emily Carr called him a "know-it-all" – and he had a particularly hard time of it.[74] When he attended Varley's evening class he was under the spell of the social realists – particularly the Mexican muralists – whom Thomas Craven championed in *Men of Art* (1931). Varley was unsympathetic to Craven's assertion that plastic relationships were determined by human relationships and that "the purely formal qualities of art were emblematic of the historical struggles of human society."[75] But it was not only Shadbolt's loudly expressed left-of-centre views which made Varley compare him to "a huge puff-ball."[76] The young student had more book learning than artistic ability. Varley let this be known to the whole class when, after ignoring Shadbolt "until the last day of class, . . . he took Jack's drawing and ripped it in half and dropped it on the floor."[77] Seeing his work destroyed before his very eyes – and those of his classmates – and wanting Varley's "approval very much," Shadbolt was "almost in tears." "He knew that I was serious," Shadbolt continued, "but he wanted me to realize that this

thing required a serious, more basic approach and to do it you just had to sweat it out." Like other students who crossed swords with Varley, Shadbolt "never forgot" this humiliating experience.[78]

Those students with whom Varley did strike a chord got the full blast of his personality – and of his support. It was a "violent stream that was hosed upon us," Fred Amess remembered, and "those with roots were nourished, even if some were washed away."[79] "He loved to have the students around him," Orville Fisher recalled, but above all, "he loved to talk."[80] Varley drank with his students, played the piano for them, allowed them to sketch with him, and took them to the studio he had acquired on Bute Street in 1928. He was eager to introduce his students to all of those things that he loved. Varley got Fred Amess, for example, interested in ballet. (Amess has been attending performances ever since.) He gave Philip Surrey his "first taste of French wine and French cooking." Varley took the young art student from Winnipeg, thirty years his junior, to the only French restaurant in town, La Mèche. The two men ate épinards à la crème, and, even more memorable to Surrey, they sipped wine from china teacups. (The bottle of Pommard Varley had purchased before the meal at the local liquor store was concealed in a paper bag under the table where it remained throughout the meal.)[81] As in Toronto, the Varley family kept open house in the bungalow – or more precisely in the upper floor of the boathouse – which he and Maud had rented at the east end of Jericho Beach in 1927. Any number of students could be seen playing badminton or table tennis on the lawn or sketching from the balcony which hung over the beach and offered a good view of the North Shore mountains across the inlet.

"Fred believed in steeping yourself in all the arts," a former student recalled, "and not just painting and drawing."[82] He saw to it that a variety of people – Vincent Massey, Boris Hambourg of the Hart House String Quartet, ethnologists Charles Hill-Tout and Marius Barbeau, and Indian poet and Nobel laureate Rabindranath Tagore – lectured to the students at the school. Varley also believed

that, although the studio was a "workshop and as sacred as the Church," it was only a place in which "to acquire strength and knowledge." The artist's real "feeding ground," he wrote in the student newspaper, *The Paint Box*, in 1927, was "out in the city and the hills."[83] Indeed, from the moment Varley arrived in Vancouver, he was excited by "the immense possibilities of the surrounding countryside and the varying types of people."[84] He was equally aware that "the Chinese quarter of the city, Japanese fishing villages on the outskirts, and Indian villages a little way north" offered challenging subjects for the artist.[85]

As Varley discovered Vancouver's ethnic diversity, so too did his students.[86] "For a while we were Oriental," Fred Amess recalled, "running the gamut from Japanese wood-cuts, illustrated by an actual Japanese wood-cutter to Hindu mysticism."[87] Varley's students were not only introduced to Japanese prints, they were encouraged to sketch in the Japanese and Chinese areas of the city and the Lower Mainland. Even the end-of-year Beaux Arts Ball, held at the Ambassador Hotel in 1927, had a Chinese theme. Dressed in Oriental costumes, the students and faculty danced to an orchestra encased "in a large pagoda presided over by an awesome bronze Buddah."[88] "Then," Amess continued, "Mr. Varley discovered the Indians."[89] "This caused much delving into books and legends and," according to an article in *The Paint Box*, the "ransacking of memory as well as trips to the museum to see the Indian collection there."[90]

Contemporary commentators might censure the way in which Varley and his students appropriated motifs from cultures other than their own for their art. Today's critics might, equally, look unfavourably upon the director of the Victoria Memorial Museum, Marius Barbeau, who, after studying "the possibility of reviving native Indian art," came to the conclusion that "the younger generation of Indians in British Columbia have not the ability or the inclination to carry on the work of their forefathers." It was left to the students, Barbeau insisted, to "foster a new spirit among British Columbians themselves, and thus produce work that bore the unmistakable imprint of British Columbia."[91]

Thanks to Varley, the students at the Vancouver School of Decorative and Applied Arts were also introduced to the work of Emily Carr, who was caught up in the wilderness ethos of the Group of Seven, and in the possibilities that their own landscape held for artistic expression. A year before Varley joined the School, a guest lecturer by the name of M. Sherman had assured the students that there were good sketching grounds in the nearby "little sandy coves of the canyons of Capilano, Lynn and Seymour." But, he insisted, it was "the rugged and wild" coast with its "many long arms to the sea reaching back for miles to high mountains that rise straight out of the water" which offered them the greatest challenge.[92]

Mountains, fjords, impenetrable forests, and the ocean had provided European visitors to the West Coast with motifs since Captain Cook's artist, John Webber, had painted at Nootka Sound on the west side of Vancouver Island in 1778. With the exception of Statira Frame and Harry Hood, who worked within the Post-Impressionist idiom, Charles John Collings, who fused Japanese and English landscape traditions, and W.P. Weston, whose work was informed by the American Scene Painters, most of British Columbia's artists were working very much within the romantic realist tradition established by late-nineteenth-century British painters.

Writing in *The Paint Box*, one student at the school, Vito Cianci, pronounced these traditional-minded artists "complacent and self-satisfied ditherers." He mocked their "dinky little watercolor boxes, infinitesimal sheets of paper, stool, lunch box, and . . . umbrella!" Their precious watercolours, depicting "fluffy little clouds" and the domesticated aspects of the landscape, were feeble. There were, Vito Cianci insisted, other motifs in the landscape that were more indicative of British Columbia: "the majestic curve of shore and wave upon a calm beach; the lines of mountain and mist across the water; the relentless upward thrust of rounded hills; trees gnarled and twisted and blighted by the breath of forest fire, silhouetted against dull skies; wave forms magically created in swirls of snow; gaunt stumps; [and] dead branches grotesquely mingling with brilliant new growth of fireweed."[93]

Varley was no less caught up in the wilderness ethos of the British Columbia landscape than were Vito Cianci and the other students at the school. He had long felt that it was the artist's duty to "make people see the national assets that exist in scenery."[94] And he was convinced, like the Group of Seven and its followers, that the national and spiritual assets of Canada lay in the remote areas of the country. Upon arriving in British Columbia, he had been intrigued by tales of a recently discovered valley with "snow-capped mountains & a glacier coming right down to the lake – equalling Lake Louise – practically unknown to tourists."[95] Yet the majority of Varley's early oil sketches depicting the British Columbia landscape were painted within the city. Sitting in a straight-backed kitchen chair on the balcony of his Jericho Beach bungalow, "his whole being became absorbed in seeing and sensing," and, his son Peter continued, his mouth would work "as if tasting the emeralds and rose madder on the brush tips."[96] From his west-side vantage point, Varley caught the North Shore mountains in the early hours of the morning – *Dawn* (1929) – and in all kinds of weather – *Evening After Storm* (c. 1927) and *Rain Squall* (c. 1928). He also produced more generalized views of what he saw from his balcony – *Howe Sound* (c. 1927) has all the earmarks of his Ontario landscape paintings. Subsequent day-long excursions to the North Shore allowed him to paint the mountains at closer range. And in *Coast Mountain Forms* (c. 1929) he captured the twin peaks known as the Lions. In *Looking Towards Seymour* (c. 1928) he demonstrated that the trench-scapes of France and Flanders were still very much in his mind.[97]

Varley's day-long hikes in the North Shore mountains "were good tough climbs." "If Mother was along," Peter Varley remembered, "she usually led the group." Short as Maud Varley was, "she would set her own rhythm, and went up the slopes with steady determination."[98] "At Alta Lake and places like that," Maud and Fred "would go whizzing up mountains like mountain goats." It was almost as though Varley had "steel springs" in his legs.[99] He could "shoot up a craggy mountain just like an arrow," his much younger hiking partner David Brock recalled, "while the rest of us faltered

and stumbled and kept taking breathers."[100] By the end of his first year at the school, Varley and his new colleague, Jock Macdonald, had "become so enthusiastic over this country and its possibilities" that their excitement was "transmitted to the class."[101]

The juxtaposition of Vancouver and its mountainous environs was not unlike Sheffield's proximity to the Derbyshire Peak District. Hikers and artists in both cities sought to escape the pollution and the noise, the general dreariness of city living, and their own problems by fleeing to the mountains. "In these modern days of ever-increasing speed, of jazz, and of jaded nerves," Ruth Golman noted in the *Canadian Geographic Journal* in 1931, "the need and desire for the healing quiet of the out-doors becomes more and more apparent."[102]

Varley could not have agreed more. "It is a tireless country," he told a friend in Ontario, "always inviting you to climb the next peak, enticing you away, farther & farther away from the problems that were born in the valley & you know damned well you must return to them, but one returns with clearer vision & many of the fool worries have been sweated out of you."[103] He was equally aware of the similarity between his relationship to the Derbyshire Peak District and to the British Columbia mountains. "British Columbia is Heaven," he told his Sheffield friend Elizabeth Nutt, "it trembles within me and pains with its wonder as when a child I first awakened to the song of the earth at home. . . . Only the hills are bigger, the torrents are bigger, the sea is here and the sky is vast."[104] Unlike his excursions into the Peak District, Varley's sketching trips to remote areas of British Columbia were often overnight affairs. Indeed, his first journey to Garibaldi Park in 1927, and his subsequent trips there in 1929, 1932, and 1934, lasted for most of the summer.

With its sentinel at 9,000 feet, Garibaldi Park, according to one publicity brochure, was a "wild and primitive" sanctuary where a visitor might "recapture that old sense of wonder in the mystery and miracle of the wilderness."[105] One of Varley's travelling companions on his first excursion to Garibaldi, Jock Macdonald, was rhapsodic about what he described as the "unbelievably beautiful virgin country" where alpine meadows were carpeted with wildflowers,

lakes were pure emerald, glaciers fractured with rose-madder, turquoise-blue, and indigo crevasses, and the mountains were black, ochre, and Egyptian red.[106] Part of the park's attraction lay in its inaccessibility. Getting there entailed sailing up the coast on a Pacific Union Steamship Company steamer to Squamish, then riding the Pacific Great Eastern Railway along the course of the Cheakamus River to the park's nearest station, Daisy Lake, then trekking twelve miles on a rough trail which ascended 2,500 feet to the Taylor Meadows above Garibaldi Lake. Even with the help of pack horses – they carried the sleeping bags, tents, cooking equipment, and a month's supply of rations – this trip was for the hardy only.

During their first trip to the Garibaldi Park, Varley, Macdonald, Scott, and the students accompanying them found the sort of landscape which inspired them to produce work that bore the unmistakable imprint of British Columbia's coastal landscape. Panorama Ridge, Castle Towers, Sentinel, Red, and Sphinx mountains, along with Mimulus Creek and the Black Tusk Meadows, were within or adjacent to the park. The students and their teachers were not mere spectators "in this, Nature's magnificent display." They were "an essential part of it all."[107] "Humans – little bits of mind," was how Varley described his fellow hikers as they clambered up rocky slopes, crept in and out of mountain passes, fished in the streams, built little hermit cabins in sheltered places, curled up in sleeping bags, and slept under the stars.[108]

Advising a friend on how to tackle the British Columbia landscape, Varley wrote: "get the sky – the sea, the countryside into you, & paint!"[109] Varley followed his own advice. After surprising a doe and her fawn as they slept in the forest, Varley "swiftly . . . tore off his shirt and trousers and lay down in the warm hollow [where they had been], naked as a jay." Doing this allowed him "to take into his psyche . . . the 'essence' of these shy wild creatures."[110]

Varley loved the wilderness landscape in and around Garibaldi Park. The more he camped, the more he became "part of the earth, of day and night and the diversified weather."[111] Nothing deterred him from remaining in the mountains for weeks at a time. "It was

no ordeal," Jock Macdonald continued, "for him to have his food limited to Swedish bread, cheese, chocolate, raisins, nuts and sardines and his drink to Klim, Oxo cubes and coffee." Even British Columbia's unpredictable weather posed no deterrent. The first summer in the park, Varley and his friends pitched their tents at 5,100 feet in two feet of snow. On a subsequent trip when it rained, Varley insisted that the rain only made the colours truer.[112] Nor was he daunted when the North Shore peaks were covered with eight feet of snow: "It is very wonderful to leave the sheltered town & in two hours time be up in a dazzling white world, full of fantastic forms, wind carved & polished."[113]

Other artists had, of course, captured the wilderness features of the province on canvas and paper long before Varley and his small party from the school pitched their tents in Garibaldi Park. But like the English poet Rupert Brooke, who bemoaned the absence of familiar associations in the landscape when he travelled through the Rocky Mountains in 1913, most of British Columbia's artists found the mountains too big, too proud, and too magnificent to fit the literary category of the picturesque or to come within the small format of their watercolour paper or sketch pads.[114] Those – Varley, Macdonald, Collings, Frame, Scott, and Mortimer-Lamb – who did find the landscape "truly 'paintable,'" were in the minority. Even they knew that any "attempt to portray it realistically [was] to court failure."[115]

By January 1928, following his first trip to Garibaldi the previous summer, Varley told a friend that he was "teeming with things to paint" and hoped "to be well away" with his own "individual expression."[116] A month later, he wrote Eric Brown: "I feel on the edge of discovering a new field of expression" and, he added, "Sometimes I am almost there but the blamed things elude me."[117] Varley knew how he did not want to paint the British Columbia landscape. He wanted to avoid being a mere onlooker, struggling, like the romantic

realists, to make the landscape conform to foreign categories and foreign preconceptions. He did not want to fix the landscape into a series of static images, as was the practice of the American Scene Painters and most of his colleagues in the Group of Seven. What Varley wanted to do was to make his oil-on-board sketches, his watercolours, and, ultimately, his canvases breathe with his response to the landscape and to swirl with the life-force of nature. Doing this would, he hoped, ignite the imagination of the viewer and thereby complete the process that he had begun.[118]

This was not, of course, easy to do. Varley's initial attempts to capture what he called "the flotsam and ghettson [sic]" in nature frequently lapsed into design reminiscent of the endpapers that he had produced for E.J. Pratt's volumes of poetry in the early 1920s.[119] Noting this decorative element in Varley's as well as in Emily Carr's landscape paintings, Jack Shadbolt wrote in *Canadian Bookman*: "Everything writhes and swirls — surface movement at the expense of form delineation, romanticism out of control — the insidious academism of one's own formula."[120] Shadbolt might have been thinking about *Mimulus, Mist and Snow* (c. 1927) when he wrote these words. The static full-volumed mountain peaks and the sculpted clouds jar against the "organic" sense of rhythm Varley gave to the snow and the glacier. In this painting he was trying to find a visual equivalent to capture the poetic description which he, with the help of his son John, had penned: "The mists blow up from depths below / are carried far away / And peaks stand out and glaring snow / In light and warmth of day."[121] Both painting and poem were reaching out for something beyond Varley's ability to express in either medium.

If some of Varley's landscape paintings executed during his first three years in British Columbia were poorly realized, others did come to fruition. When he escaped from his own inhibition as a self-conscious member of the Group of Seven, nature's accidents emerged during the course of painting. *Coast Mountain Form* and *The Cloud, Red Mountain* depict "the morning light, gradually illuminating a dark world defining the forms" which Varley instructed his students to capture in their own work.[122] *Gorge of the Sphinx* and *Cheakamus*

Canyon, B.C. sing together, harmonizing every element in the land-scape into one song.[123] And *Fireweed* (c. 1934) vividly depicts the vegetation covering the floor of the forest.[124] The latter is a testimony to Peter Varley's memory of his father crouching down on his knees to look at fungi and at the texture of bark, tasting berries, and rubbing needles and fern fronds between the tips of his fingers until all of these "impressions, scents, colours, details entered his sensitive psyche and made it sing with happy, full joy."[125]

Significant in helping Varley to break from the formalistic painting of the Group of Seven was his exposure to the work of two women artists, Emily Carr and Statira Frame, and of one man, Charles John Collings. Varley made it known that he did not like Carr personally: he told one friend that she was masculine and dirty.[126] Carr, characteristically, repaid Varley's compliment by calling him — in reference either to his cool temperament or to his drinking habits — "a fish."[127] Even so, the two artists had mutual respect for one another's work. Varley admired Carr's ability, best seen in her oil-on-paper sketches, to bring all the elements of beach and shore or of forest and mountain into one statement. After viewing Varley's Garibaldi sketches in 1927, Carr pronounced them "most delightful," adding that they offered "a new delineation of a great country."[128]

Varley's enthusiasm for Statira Frame's oil panels and Charles John Collings's water-soaked landscape paintings was as great as his appreciation of Emily Carr's oil-on-paper sketches. Long before she arrived in the west, the Montreal-born and San Francisco-trained Frame had been working in high-keyed colours which won her the attention of Robert Henri, the prestigious teacher and leader of New York's Ashcan School. He praised Frame's "sensitiveness to the orchestration of color," her "good sense of form" and "the compositional possibilities" offered in her oil panels.[129] Varley also admired Frame's "fine sense of colour."[130] Her pinks, violets, and milky greens — colours which had appeared in his last paintings of the Great War and in his post-war portraits — became more evident in Varley's own work following his exposure to Frame's canvases.[131]

No less important to Varley's vision was his encounter with the landscape paintings of Collings, which brought the Japanese woodcut tradition into perfect harmony with English decorative painting. Hailed in London as one of the most remarkable artists since Turner, the paintings of this recluse who lived at Shuswap Lake would have been known to Varley through their exhibition in Vancouver.[132]

There is, of course, nothing unusual about taking ideas from other artists. Varley and Arthur Lismer had earlier adapted the deep-blue colour employed by their old Sheffield artist friend, Stanley Royale, to their paintings of northern Ontario. After arriving in British Columbia, Varley followed the methods of the colour theorists Albert Munsell and Wilhelm Ostwald, which he had imparted to his students at the Ontario College of Art. The way in which Varley allowed colour to pervade space, moving across the surface of the canvas and around every object in the painting, owed much to Munsell. The example of Turner's mature paintings and of Collings's, along with Munsell's colour theories, allowed Varley to give his work a sense of luminosity achieved by balancing warm and cool hues with dark and light colour values.[133] Equally, the writings of Elie Faure, which challenged the "Christian duality which defines the discord between the soul and the flesh," introduced Varley to the idea that religion does not create art, but art creates religion.[134] Finally, the writings of art historian and critic Vernon Blake made Varley aware of the "profound significance of this Far East art, to its keen sense of the insoluble junctions that exist between the rhythmic sweep of a brush stroke and the ultimate problems of the universe."[135]

Varley had long been interested in Buddhism. He had dabbled in theosophy and in other esoteric religions. He had learned from John Ruskin, at an early stage in his career, how "the aim of the great inventive landscape painters must be to give a far higher and deeper truth of mental vision rather than that of the physical facts."[136] When Varley made his first trip to Algonquin Park in 1914, he had striven to do this by emptying himself "of everything except that nature is here in all its greatness."[137] Now, some thirteen years later,

he was more conscious than ever before that "although expressing individuality," the artist was, as his friend John Vanderpant put it, a "servant related to the universal laws of life."[138]

In developing the doctrine known as The Way, or The Tao, the fifteenth-century Chinese painter Sié Ho set out six laws. They attest to the artist's ability to intuit the movement of shapes and rhythms in nature, and to apprehend the cosmic principles of existence. Long before Sié Ho set out his famous doctrine, Chinese artists of the T'ang dynasty (618-907) were depicting the landscape "so as to demonstrate one's spirit" and, at the same time, to reveal the "rhythmic vitality in the land."[139] Endemic to the practice of Chinese art was the fusing of emotions with scenery – the *yi jing* – the attention given to the calligraphic quality of the brushstroke and the subtle distinction between dark and light values. Also important was the belief that a work of art should function both as an object of contemplation and as an evocation of the poetic sentiment inherent in the landscape.

For Varley, Chinese aesthetics and Chinese paintings from the Sung dynasty (960-1279) were well suited to interpreting the British Columbia landscape. Before the Great War, Rupert Brooke had been surprised to discover that Vancouver was "more oriental" than the rest of Canada.[140] Two decades later, Varley insisted that Chinese painting had "more of the spirit of British Columbia" than any paintings he had ever seen.[141] No wonder he used some of the stylistic devices of Mi Yu-jen, Shih Chung, and other Chinese artists in his own work.[142] The vertical ordering of the landscape, evident in Chinese scroll paintings, is apparent in Varley's paintings of Cheakamus Canyon and Lynn Creek.[143] The unpainted areas of the board in *Sketch of Garrow Bay, British Columbia*, the elimination of the middle-ground and the horizon line in *Coast Mountain Form* and *The Open Window*, a device which allowed the mountains to float above the earth, and even Varley's thumbprint signature – all have their origin in Chinese painting.[144]

The clouds and mist, mountains and deep gorges became dominant motifs in Varley's painting after 1926. The sentinel tree in *Lynn*

Peak and Cedar (c. 1934), the inclusion of a figure-witness in *Weather – Lynn Valley* (c. 1935), the broken and limbless trees in *Looking Towards Seymour* (1929) were residues of his experience as a war artist in France, of his knowledge of nineteenth-century English landscape painting and of commercial art, of his encounter with Thomson and his colleagues in the Group of Seven.[145] These paintings, and others in which Varley looked above the tops of the mountains and even above the clouds to the shimmering light, were also a product of his exposure to Chinese painting and to the work of Charles John Collings and Statira Frame.

Three months after Varley returned from his first trip to Garibaldi Park, eastern Canadians got their first look at his new paintings. In November 1927 he submitted several oil sketches and canvases, all depicting the British Columbia landscape, to the *Exhibition of Canadian West Coast Art, Native and Modern* at the National Gallery of Canada. Two months later, some of these works found their way to the Group's seventh exhibition at the Art Gallery of Toronto. The reception accorded to Varley's rendering of west-coast landscape motifs was not entirely favourable. One irate reviewer compared *Mimulus, Mist and Snow* to "a mess of Chili sauce."[146] Nor were the Toronto critics enthusiastic when, two years later, Varley contributed three portraits to another Group of Seven exhibition. Writing in the *Toronto Mail and Empire*, Jehanne Biétry Salinger noted: "Varley is represented by a collection of meaningless pictures of women which are often psychic effects and are painted in sickly colours which remind one of cheap candies."[147] Attempting to explain why the west-coast artist had now become "almost an honorary member" of the Group, Augustus Bridle claimed that Varley was "too many thousand miles away from the rest of the Group to be quite sure of what they are doing."[148]

However disappointed Varley might have been by the adverse response, he made every effort – at least until 1931 – to maintain his

links with the Ontario public. He cultivated former clients and dealers in the hope that they would continue to buy and sell his work. Uncharacteristically for Varley, he kept up a lively correspondence with Eric Brown and his assistant H.O. (Harry) McCurry at the National Gallery, on the off chance that they might purchase his paintings. He spent the summer of 1928 in Toronto teaching at the Ontario College of Art, taking time out to travel to Georgian Bay with his old friend Barker Fairley. He continued to produce drawings for the Toronto-based arts publication, *Canadian Forum*, until 1931.[149] He was the driving force behind the National Gallery's western Canadian selection committee and frequently took the brunt of the criticism from his more traditional colleagues in British Columbia for choosing modernist works for exhibition in eastern Canada.[150] And in 1930 he entered a portrait, *Vera* (1929), in Lord Willingdon's art competition. (He shared first place with the much younger Toronto painter George Pepper.) This portrait was purchased, the same year, by the National Gallery of Canada. Contact with gallery officials, dealers, and patrons in central Canada was important to Varley because, during his first years in Vancouver, he felt "very isolated, not merely isolated but occasionally at enmity with people possessing appalling ignorance."[151]

The tyranny of distance, as Emily Carr was discovering at this time, was hardly conducive to keeping Varley's name before the Canadian art establishment in eastern Canada.[152] His paintings frequently got lost in transit to or from exhibitions in Toronto and Ottawa. When his patrons in the east bought his work, they did not always come through with the money. Then there was the problem of getting little or no feedback from the exhibitions to which he contributed. "I'm interested to know how my work is received," he told Arnold Mason in January 1928, and asked him "to shoot a few lines over."[153] "The country seems to have hoodood [sic] me with lack of news from the east," he complained to Eric Brown two years later.[154] When galleries showed old rather than recent work, Varley was equally annoyed. In 1932, the National Gallery was still showcasing *Stormy Weather, Georgian Bay* – a painting similar to what most of

the Group of Seven were still doing, but hardly representative of what Varley had done since the Great War.

That Varley was moving away from his colleagues in the Group became apparent when, after seeing a small sample of their work early in 1928, he told Arnold Mason that Carmichael and MacDonald had produced "pretty ordinary stuff."[155]

Things had not, of course, remained static since Varley's move to Vancouver. A leading member of the Group, J.E.H. MacDonald, died in 1932. Even before then, many commentators felt that the Group had run its course.[156] By the end of the 1920s, it had made its impact on Canadian painting and become part of the establishment it had once attacked. It had also inspired a younger generation who now wanted a share of the limelight. Varley had certainly created, as Eric Brown had hoped he would, a group of like-minded followers among the students and faculty members at the Vancouver School of Decorative and Applied Arts. By 1932 his charismatic impact upon other artists was obvious to at least one Toronto art critic: "Every painting coming from Vancouver which was interesting or fine showed a Varley influence."[157]

Varley made his mark in the west in several ways. He taught at the Vancouver School of Decorative and Applied Arts and, in the summer of 1930, at the Art Institute of Seattle in the state of Washington. He lectured on modernism in general, and on the Group of Seven in particular, at the Vancouver Art League, the Art Institute in Seattle, and at the Vancouver Art Gallery. Finally, he contributed his work to local exhibition societies – the Vancouver Art League, the Sketch Club, the Palette and Chisel Club, the First Annual Exhibition of Western Canadian Painting in 1933, and the B.C. Society of Artists. Varley also showed work in the United States: at the Annual Exhibitions of Northwest Artists in Seattle, at San Francisco's Art Association in September 1930, and at the First Annual Exhibition of Western Canadian Paintings at California's Palace of the Legion of Honor in December 1932. But Vancouver did not feel the full force of Varley's personality – according to one

fellow exhibitor he had a reputation for sweeping "others out of the picture" – until 1932.[158] That year, the newly established Vancouver Art Gallery gave Varley his second solo exhibition.

The Art Institute in Seattle had given Varley his first one-man show when, in 1931, they put forty of his paintings on display.[159] The Vancouver exhibition, however, was mounted on a much grander scale than the exhibition in Seattle. It showed fifty-five oil paintings of the British Columbia landscape, five watercolours, twenty-eight drawings, black-and-white prints – probably from the Group of Seven's 1925 portfolio publication – book-plate designs, a few portraits, and several photographs of Varley's war paintings. All but one sketch was available for purchase. At twenty-five dollars for an oil painting – three hundred at today's prices – Varley was selling his work at bargain-basement prices. The response to the exhibition was mixed. Some critics found the show to be "undoubtedly one of the most inspiring ever held in this city."[160] Others saw the exhibition as an opportunity to take a swipe at modern art. "He forgets his fine knowledge of drawing and his fine feeling for colour," John Radford wrote in the *Sun*, the result of which was "both unnatural and unpleasant."[161] News of the Vancouver solo exhibition even reached Sheffield – though it took its time. The *Sheffield Telegraph* announced that a former local boy had made good in the colonies, several months after the exhibition had closed.[162]

The success of Varley's exhibition strengthened his involvement and standing with schools, exhibition societies, and art galleries in western Canada. Yet the inspiration that had enabled him to produce the stunning body of work evident in Vancouver came not only from the coastal landscape. It came from a woman whom Varley would call "the greatest single influence in my life."[163]

Vera photographed by John Vanderpant.

CHAPTER 7

Things Fall Apart

I n June 1929, Varley told a young art student whom he had taught at the Ontario College of Art the previous summer that his marriage had "radically worn down." The couple had not "scrapped," he assured Mary Konikin, but the "old pattern," sparked by his antipathy to being "run" by Maud, had reasserted itself once again.[1] Disenchanted with Maud, and pining for Konikin, who had not answered his letters, Varley began sleeping on the couch next to the big fieldstone fireplace in the living room of the Jericho Beach house. He spent more and more time in his Bute Street studio, rarely admitting members of his family to it. He no longer drank with Maud but instead with James Butterfield, a fellow Englishman who wrote a daily column for the *Province*. Returning to Jericho Beach after a heavy bout of drinking with Butterfield and other local journalists, Varley thumped the piano – everything from Beethoven's "Moonlight Sonata" to "The Road to Mandalay." Needless to say, he woke up everyone in the house. Varley's usual watering hole was the lounge in the Georgia Hotel. There, he and his newspaper cronies consumed gin, brandy, and beer in prohibition-free British Columbia. According to one friend, Varley drank "only the most expensive and the best" alcohol.[2] This is where much of the money he earned at the art school went because, as Dorothy recalled, her father's salary certainly "didn't go into the rent or clothing."[3]

Varley loved family life, indeed, he possessed an idealized conception of the family, but he also had a "natural desire to be independent."[4] As he told his young student Philip Surrey: "*I have no*

wife, *I* have no kids."[5] And this is how he increasingly came to lead his life in Vancouver, as though he were a bachelor.

Maud, whom Surrey remembered as small and very plain when he met her in the late 1920s, had many illusions shattered during these years.[6] Her response to the all-too-familiar direction in which things were rapidly moving manifested itself in several ways. She began to walk in her sleep, often finding herself on the beach in the middle of the night. Fred accused "Mrs. V.," as he called her, of play-acting. She insisted, "No, I wasn't."[7] Once she allegedly woke Varley up in the early hours of the morning and held a large carving knife a few inches from his face,[8] but her frustrations and dismay were usually vented in less dramatic ways. She sawed logs on the beach for firewood. She partook in time-consuming bread-baking sessions. And she escaped from her increasingly dreary life by dreaming of a group of companions with whom she read poetry, played cards, and shared stories.[9]

As a father, Jim Varley recalled, Fred was "so inconsistent."[10] He could be the doting parent: pointing out the beauties of nature to John and Dorothy during a hike on Seymour Mountain; challenging his second-eldest boy to a game of badminton or table tennis (Jim could never beat his father); lavishing praise on his eldest son, John, who was a brilliant draughtsman, though sadly unable to follow in his father's footsteps because he was colour-blind. Varley's capacity for fun knew no bounds. One night he awakened his two eldest sons, collected their young neighbour Dave Brock, and headed over to John Vanderpant's home. There, Vanderpant entertained them on the piano and they all sang, and played his recording of Debussy's String Quartet. Then they piled into Vanderpant's large automobile and drove to the Jericho Golf Club. None of the happy party, who were by now well fortified with drink, were members. Undeterred, they played a round of golf, taking the four parts which corresponded to the movements in Debussy's Quartet. "If you do this as you play golf on a spring morning," Brock recalled years later, "it makes for a memorable event."[11]

Varley could be as nasty to his own and to other children as he was fun-loving. Harold Mortimer-Lamb's daughter, Molly, remembers him flicking his hand whenever she got too close: "Mr. Varley hated kids."[12] Varley was certainly incapable of counselling his own children in a quiet and restrained manner. Yet he was quick to note, as Jim discovered, "if I did anything that was the slightest bit shady."[13] Varley subjected his daughter, Dorothy, to a different kind of scrutiny. Overly possessive, he fought with her fiancé, Harry. Finally, contrary to Varley's claim that he and Maud did not "scrap," they were constantly at each other's throats. "Conflict, conflict," was how Jim remembered family life at Jericho Beach: "I went out one time so mixed up."[14]

By 1929, the wife and children who had inspired some of Varley's most powerful canvases during the first half of the decade in Toronto, had become a burden and an encumbrance to him. And the children who had initially "worshipped" their father, gradually grew, in one observer's view, to "hate" him.[15]

If Varley's private life with Maud and the children had fallen into "an old pattern," so too had his public persona as rebellious artist and passionate womanizer. At forty-eight years of age, in 1929, Varley was no less attractive than he had been when Maud first met him in 1906. As one student at the Vancouver School of Decorative and Applied Arts recalled, "he could charm the birds out of the trees with that soft voice and that little impediment in his speech."[16] Though Varley's face was craggier than ever, his eyes remained a piercing blue. His long upper lip still came down to a sharp point above his lower one. His hair, though flecked with grey, was still predominantly red. And, depending on his mood, he could still make his spare frame grow inches or appear to shrivel up to half of its size.

But it was Varley's manner, outlook, and habits, more than his physiognomy, that earned him a reputation for being different from everyone else: the way in which he kept his Millbank cigarettes loose in his pocket — "'saves me the trouble of opening the package'";[17] his liking for silk underwear; his comfortable corduroy trousers and

threadbare jackets, which looked shabby beside the three-piece suits worn by his fellow teachers at the school; his weekly purchase of the *New York Times*; his "way of making women feel unusually cared for and cared about"[18] (this resulted in a barrage of anonymous letters criticizing his morals[19]); his identification with Edwardian London and with the rebellious Group of Seven prompted more than one person to refer to him as "the last great bohemian";[20] and finally, his easy, wide-ranging, and "very open" conversation, which took his listeners into the trenches of France or awakened them to the beauty of a painting by Rubens, was never dull or boring.[21] To strangers and enemies alike, Varley seemed to be, in Dave Brock's view, "on the fringe of some unbridled half-world, defying all the rules in ways that would lead him and his body to ruin."[22] This not only differentiated Varley from every other man in the city; it made him attractive to virtually every woman who came within his ambit. This was, Philip Surrey noted with regret, "another problem poor 'Mrs. V.' had to live with."[23]

Ironically, to almost everyone who knew him, Varley appeared to be a very moral man. He gave the impression that he was very fond of his family. Although he "liked the girls," he was fastidious in his relations with women, adhering to an outmoded set of Victorian values which often verged on prudery.[24] Yet, as Jim observed, his father possessed "his own values and pretty well lived by them."[25] He had, after all, been raised on the writings of Havelock Ellis and on the short stories of Edgar Allan Poe, which depicted the artist as "a passionate, and wild and moody man."[26] He took the advice of Oscar Wilde's fictional character, Lord Darlington, who appreciated the difference "between living one's own life, fully, entirely, completely — or dragging out some false, shallow, degrading existence that the world in its hypocrisy demands."[27] And he had read H.G. Wells's controversial novel, *Ann Veronica*, which sanctioned a young couple's decision "to be immoral," to desert their posts, to cut their duties, and to take risks which destroyed their standing in "good" society.[28]

"The public is sometimes inclined to forgive idiosyncrasies and

even 'immorality' on the part of the artist," Toronto artist Bertram Brooker observed in 1936, "once he is recognized as *great*."[29] Varley's reputation as Vancouver's leading artist gave him the licence to be as rebellious as the lovers in Wells's novel and as passionate as the artist in Poe's short story "The Oval Portrait." This is not to suggest that mothers did not object when Varley invited their daughters to pose for him in his Bute Street studio,[30] or to imply that the wives of Varley's artist colleagues – Arthur Lismer's and Jock Macdonald's were two – condoned his lifestyle,[31] or that most commentators on art had abandoned Ruskin's well-established view that morality and art were synonymous, or, finally, that people did not put on their gloves whenever they dealt with Varley because, by his own admission, he was "an evil influence."[32]

Varley oscillated between the opposite poles of his personality. Sometimes he embodied the nineteenth-century conception of the artist by claiming a privileged role in society as a prophet and seer. At other times he strayed from what Jim Varley called his "fine code of ethics."[33] Varley was well aware that he was prone to move in either direction. If he had stuck to landscape painting, the polarities of his personality might not have been so extreme. But women were his favourite motif and his fatal flame.

"Every painter worth remembering," George Eliot observed in 1876, "has painted the face he admired most, as often as he could."[34] Varley appreciated the extent to which Elizabeth Siddal and Dorelia McNeill had inspired the best paintings of Dante Gabriel Rossetti and Augustus John. Initially, Maud had filled this role. She had been Fred's mistress, wife, mother, "Darling Little Girl," as well as his muse. However, by 1929, her face, as Philip Surrey recalled, was "marked with age and worry."[35] Forty-two in 1929, Maud was not young. She had become too familiar, and she was sexually undesirable to her husband. Uninterested in possessing her physically or even imaginatively, Varley could not internalize her image and thereby embark upon the kind of pictorial lovemaking that had made his earlier portraits of her sing.[36] That he should attempt to replace Maud with another female muse at this juncture of his life is

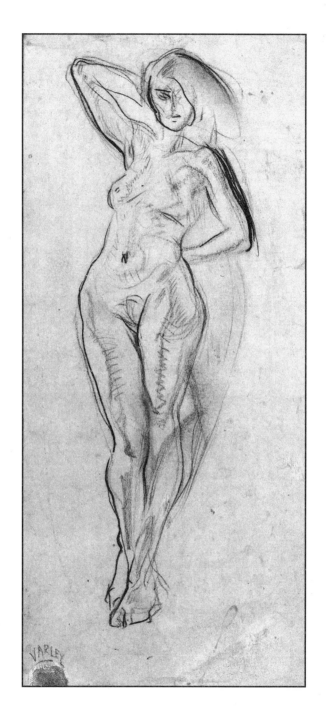

Nude Standing, c. 1930.

not surprising. Historical precedent, choice of subject matter, middle age, and his continuing search for the ideal female model determined that he would.

In the classic French movie *Jules et Jim,* the two male protagonists fall in love with the tranquil features of a statue which has recently been excavated from an island in the Adriatic Sea. Early in the film they meet Catherine, whose features closely resemble the statue's. As the story unfolds, it becomes clear that the statue is not the sanitized object that the young men initially believed it to be, but a source of trouble for them as well as for its human lookalike.

Thirty years before Truffaut's film was released in 1962, Varley had been "fascinated" by a plaster cast of "an Oriental head" at the Vancouver School of Decorative and Applied Arts. He sketched it alongside his students in the classroom. Then he moved the cast to his Bute Street studio so that he could study it further. According to Fred Amess, one of Varley's students "closely resembled the cast." "There was to her slightly oblique eyes," he recalled, "the mystic quality of the East and in her secretive smile, something of the Mona Lisa."[37] Dave Brock also found the student's face "extraordinarily interesting." "She wasn't pretty at all," he continued, "but she had large eyes, rather beetling eyebrows, and an extraordinary quality of charm."[38] Molly Bobak described the student's eyes as "almond-shaped," her mouth as delicately pursed, and her upper lip sporting "a little downy moustache, but not a dark or ugly one."[39] Of more interest to the sculptor, Bea Lennie, were the various moods which played across the student's face. Capturing these, Lennie felt, offered a "challenge for an artist."[40] Small-boned, beautifully poised, and graceful, nineteen-year-old Vera Olivia Weatherbie was the perfect model for Fred Varley. And from 1929 to 1935 she provided him with a source of inspiration as well as a point of departure.

Weatherbie personified Varley's romantic ideal of women.[41] Ever since 1912, the year he painted Eve in *Eden,* he had idealized his female

models on paper and canvas. His drawings of Weatherbie are no exception. Although unaccompanied by the traditional baggage of mythological pretexts, classical allusions, and exotic scenery, they possess the skill and bravado of an Old Master drawing. As drawn by Varley, Weatherbie's face also has an uncanny resemblance to the goddess in Botticelli's *The Birth of Venus* (1482) and to the Madonna in Rubens's *The Adoration of the Magi* (1624-26), a painting which Varley had admired at the Musée Royale des Beaux-Arts during his student days in Antwerp. Varley even referred to his most accomplished drawing of Vera, *Head of a Girl* (c. 1934), as "the Florentine head."[42]

Weatherbie's beauty was not the only thing that made her the perfect model for Varley. She was also, as Bea Lennie observed, the "perfect handmaiden" for an artist. She was patient, shy, and a good listener. She willingly tidied Varley's studio and cleaned his paintbrushes.[43] And she gave him what he needed most: unconditional love.

Some members of the Varley family insist that Varley's relationship with the young art student was "a sexual fantasy" founded on a mutual appreciation of art and of the coastal landscape of British Columbia.[44] While Varley and Weatherbie certainly felt that the countryside "belonged" to them and believed that they were "in honour bound to express it" in paint, there was more to their relationship than this.[45] They possessed a mutual interest in astrology which he had inherited from his illustrious artist-ancestor John Varley. Varley often compiled the horoscopes of his students, thereby carrying on a long family interest in the subject. They were fascinated by early Chinese painting and "thrilled with Chinatown."[46] Sketches for many of Vera's canvases were done near her East Pender home, which bordered on Chinatown. They enjoyed a drink — neat brandy was their favourite. They believed that every person was surrounded by an aura which could be represented on canvas or paper by a specific colour. Varley's interest in this matter was also like that of John Varley, who had provided the illustrations for Annie Besant's and C.W. Leadbeater's *Thought Forms* (1905), in which they proposed that "every thought gives rise to a set of correlated vibrations in the material of

this body, accompanied with a marvellous play of colour."[47] Finally, Fred and Vera were both children at heart. Jim Varley once observed his father strolling down Robson Street with Vera on his arm. As they walked, Varley threw Life-Savers into the air and attempted to catch them in his mouth. Incidents like this not only made Jim accuse his father of acting "so much like a little kid," it convinced him that Vera brought Fred "a great deal of happiness."[48]

It was this sort of thing that prompted so many people to believe that Fred and Vera were lovers. Philip Surrey openly refers in his memoirs to Varley's "great affair with Vera Weatherbie."[49] Dave Brock categorically states that "his affair with her was, of course, well known."[50] In recounting the break-up of her marriage to a CBC reporter shortly after Varley's death, Maud, who possessed the characteristic bluntness of a person from the north of England, said, "The only reason why I left was because there was somebody else there and I felt that I couldn't get near Fred any more."[51] Maud was, not surprisingly, hurt and "intensely jealous." She attempted "to keep Vera out of Fred's studio by writing a letter to Vera's parents."[52]

Vera Weatherbie, who was "terribly ashamed" by Maud's letter and tormented by Vancouver society who were "hard on her," always shied away from discussing the affair.[53] Varley, on the other hand, revelled in his memory of it. He made no secret to the press that Vera had been an enormous influence on his art and on his life.[54] He regaled his later female companions with accounts of Weatherbie's beauty and of her talents as an artist. He talked about her, to one female friend, "with the same feeling that he talked of the countryside to the extent that you felt Vera personified the landscape."[55] But it is in Varley's letters, written before and after the affair, where his strongly expressed affection for Vera demonstrates that there was more to their relationship than flirtation. Even allowing for his sentimentality, which inevitably surfaced when he was fortified with wine or whisky, his letters to Weatherbie, signed with a symbolic "X" enclosed in a circle, leave no doubt that what took place between them was both passionate *and* physical.[56]

Varley had known Weatherbie long before the affair began. In

1926, during his first year at the school, she had been a student in his drawing class. In December 1928, she had played the leading role in the school's miracle play, The Pageant of the Holy Grail. (Vera took the part of the Virgin Mary.) Throughout these years Weatherbie was welcomed into the Varley household at Jericho Beach just like any other student from the art school. Dorothy, who had been born the same year as Vera, remembers her as "very very tranquil."[57] Peter Varley insists that "Vera was very fond of the Varley boys," though Jim felt "really self-conscious and very inferior" in her presence.[58] The Varley family assumed that their father's student was nothing more than a friend and occasional model. (Vera had posed for Fred in her pageant costume during the winter of 1928-29.[59]) Sometime in the summer of 1929, however, "things became more personal" between the pair and, Dorothy recalled, suddenly Vera "wasn't there." This was a surprise, because Vera had been perceived by Maud and the children as "an ally against Daphne," another woman with whom Fred was presumed to be infatuated at the time.[60]

The affair between Varley and the student twenty-nine years his junior began in the Bute Street studio. The grandfather of one of the students, who "doted on artists," turned over his palatial mansion, Parakantas, to a small group from the Vancouver School of Decorative and Applied Arts in the late 1920s.[61] The building was grand and old-fashioned: its hitching post and the stone mounting block from which ladies had stepped into their carriages two decades earlier gave it "the stamp of old Vancouver."[62] Weatherbie and her friend Irene Hoffar occupied one studio, Lilias Farley, Sybil Hill, and Margaret Williams shared another, and Jock Macdonald and Varley each had studios of their own. This is where Varley suspended domestic norms in favour of self-expression, and let his life, real and imagined, unfold. He gave private lessons here to adult students for a brief period in 1931. This is also where he donned a secretive look and talked "as though he was an actor holding the stage" while he sketched and painted Weatherbie, as well as other students such as Norma Park.[63] Most important, it was here he discovered that he had found his greatest muse and artist helpmate.

Towards the end of his life, Varley claimed that a portrait painter had "to express the facts not the feeling." The subject, he claimed, was "so astonishingly beautiful" that she did not require any adornment from him.[64] Yet Varley's paintings of Vera Weatherbie are successful because they are not simply a realistic copy of what he saw. He painted his second canvas of Weatherbie in the autumn of 1929.[65] The woman depicted in *Vera* (1929) does not reveal any of the moods that were known to sweep across Weatherbie's face. She is contained and closed in upon herself, and is not engaged with the artist painting her. Varley's third portrait of Vera, which bears the same title but was painted a year later, is very different.[66] In *Vera* (1930) Varley pulled the figure to the front of the picture plane. He enveloped it in a hue of green. (For Varley this colour represented the spirit and, as he told Miriam Kennedy a few years later, "Vera was a green person."[67]) He also charged the whole canvas with erotic tension. As a result, the canvas is as much a tribute to Varley's prowess and his sexual conquest of his young student as it is a celebration of Weatherbie's beauty.

By painting Vera in an artist's smock, Varley was also announcing that his "'study' girl," as he sometimes called her, was more than a model.[68] Weatherbie was, indeed, an artist. She understood the process by which a portrait was created. She most probably gave Varley the very green which dominates his 1930 portrait of her. She appreciated the extent to which the model contributed to the painting by reflecting and even projecting the artist's intentions. By 1930, Weatherbie had allowed herself to be wooed by Varley's soft voice, his piano playing – he had a piano in his Bute Street studio – his worldly ways, and his artistic accomplishments. As Miriam Kennedy remembered, Varley "really wanted to engulf a person; to breathe that person in; to have that person become a part of himself."[69] This is precisely what Weatherbie allowed him to do. Herein lies the key to Varley's most compelling portrait of Vera. Weatherbie not only projected her own feelings, but reflected his too. She could do these things because she was a painter and the lover of the artist. Varley never forgot that Weatherbie was an artist in her own right. To him

she was "one of the biggest events in Canadian painting."[70] To the critics, Vera Weatherbie was "one of the most talented of the recent graduates of the Art School."[71]

After completing a postgraduate year at the school in 1930, Weatherbie received the J. Fyfe-Smith Travelling Scholarship, which gave her six months of study in England. That same year and the following one, she won honourable mention for her submission to Lord Willingdon's All-Canadian Arts Competition which had celebrated excellence in music, literature, painting, and sculpture since 1928. And in 1934 she was presented with the prestigious Beatrice Stone Medal for her painting *My-E-En* before a crowd of several hundred people at the Vancouver Art Gallery. During the late 1920s and throughout the 1930s the figurative and landscape paintings of Vera Weatherbie were exhibited up and down the west coast and at the National Gallery of Canada. Frequently, Vera's and Varley's paintings were hung side by side in the same exhibition; sometimes their work was even discussed in the same review.[72]

It is not surprising that by the late 1920s Vera and so many other women artists in Canada had become more than muses for their male counterparts. While the Great War might have pushed women artists into the background by denying them commissions as official war artists, it had not prevented them from emerging after it in their own right. Some members of the Group of Seven "had gone out of their way," as Blodwen Davies noted in 1932, "to encourage women whose work indicated the same vigorous attitude, the same frank and untraditional conception of the mission of the painter."[73] A.Y. Jackson and Lawren Harris played a significant role in promoting the work of — amongst others — Emily Carr, Annie Savage, Yvonne McKague Housser, and Lilias Torrance Newton. Arthur Lismer declared in 1934 that "the younger painters of Canada who are doing anything worthwhile these days are women."[74]

While many women artists benefited from the attention of the most influential art group in the country, they were not mere imitators of their mentors. Even before Varley left Toronto, Lilias Torrance Newton was giving him a run for his money as a rival portrait

painter. Other female artists were showing how the figure – especially the nude – could be integrated into the landscape. They were making the domestic features of the countryside as valid a subject for the artist as the unpopulated wilderness landscape. Finally, they were setting up their easels in the interior of the forest and not only in the clearings.[75]

Vera Weatherbie, who belonged to the generation of women about whom Arthur Lismer spoke with such enthusiasm, was therefore no mere muse. She was a brilliant painter. Indeed, it is usually forgotten that Varley posed for *her*. Weatherbie's *Portrait of F. H. Varley* (1930) was described by one journalist as depicting Varley "with a real head and two shadowy profiles, as though he had been spun around in a circle"; it prompted another art critic to wonder "whether the artist was endeavouring to portray Varley or his spirit."[76] Praise for Weatherbie's "striking" portrait of Varley also came from John Vanderpant. "Don't you think that Varley's portrait of Vera Weatherbie is one of the best things that West has produced yet?" he asked Eric Brown.[77] Neither Brown nor Vanderpant remarked on the strong resemblance between this painting and Varley's 1930 portrait of Weatherbie. Indeed, the thumb-print signatures, the three-quarter-length pose, and, more significantly, the similarity of palette, point to the likelihood that the two portraits were painted in tandem.

Weatherbie not only painted a stunning portrait of her teacher; according to Varley, she "taught" him too.[78] On one occasion she had "the guts" to scrape down his canvas *Dhârâna* (1932) when, Bea Lennie recalled, he was "stuck."[79] (Though initially "stunned" when he discovered what Vera had done, this was, according to Lennie, "just what he needed."[80]) Incidents like this made Varley grateful for Vera's "companionship and help."[81] As he told her in 1939: "I *learnt more of Art*, true Art, in those years than at any other period of my life."[82] When Varley was in Ottawa on a portrait commission in 1936, he missed talking to her as his paintings developed: "I got into the way of your mind and mine criticising & suggesting until the canvas belonged to both of us," he told her.[83] Long after

his affair with Weatherbie had ended, Varley continued to "treasure" the many things she had done for him or, by her influence, had made him do.[84]

Whether Varley, in his turn, helped Weatherbie to the same extent is difficult to ascertain. He remained convinced that he had not given her "50-50."[85] He even admitted to having been "selfish": "When I ask myself in what way have I helped you – I am ashamed."[86] He did, as he told Harold Mortimer-Lamb, appreciate "the rare qualities of Vera as an artist – which tremble into expression."[87] But his attempts to promote her work among private and public patrons in eastern Canada failed.[88] It would be easy to assume that, as the more mature artist, Varley was Weatherbie's mentor. He certainly had a reputation for taking over his students; even colleagues like Jock Macdonald came under his "spell," if only for a short time.[89] Yet Varley always insisted that he and Vera Weatherbie "did not paint alike."[90] And at least one observer noted, correctly, that although Weatherbie was influenced by her master, her style was "essentially individual and sincere."[91]

Though Vera's palette was dark and her style conventional during her formative years at the Vancouver School of Decorative and Applied Arts, she became a sensitive and innovative colourist.[92] Peter Varley insists that it was Weatherbie who gave Varley *his* "colour sense."[93] Varley concurred with his son's view when he told McKenzie Porter in 1959: "Without knowing it she made me see colour in new lights."[94]

While Varley might have regretted not having done more for Vera Weatherbie, he did give her confidence in herself as an artist. This prompted her to contribute to exhibitions and art competitions up and down the west coast. It also made her enrol for further postgraduate study at the Royal Academy Schools in London.

Fred was lonely after Vera left for England in the autumn of 1931. Though she felt "bad," too, it was her lover who suffered most. Without Weatherbie, Varley's Bute Street studio became "more & more cheerless." Within a few weeks of her departure, he gave it up, since she had taken "away the only reason for having it." He moved

into a studio at 603 Howe Street that was a former dancing school. Though it had four large windows, giving him a splendid view of the mountains and good light for painting, he remained "glum." He also became argumentative. Two months after Vera left, his irritability reached a pitch when he told John Vanderpant "to go to hell" for being such "a b — moralist."[95]

Despite his loneliness, Varley clearly enjoyed hearing about and contributing to Weatherbie's London adventure. He wanted her to discover the city through his eyes. He told her about his old haunts — his studio near Battersea Bridge and his flat in Melton Chambers — no doubt hoping that she would visit them and give him a report. He urged her to view Tintoretto's theatrical painting, *The Milky Way*, at the National Gallery. "God, I wish I could paint like it," he exclaimed in admiration of Tintoretto's "juicy, nice flat lines" and his "lovely woman." He also wanted Weatherbie to see Modigliani's paintings, although he was certain that they would not strike the right chord with her. Whenever she reported to him, he responded at length, no matter how trivial the matter. Weatherbie's purchase of "woollen undies," for example, unleashed his playful nature. "I can imagine you invested in them but I daren't look up. . . . Don't embarrass me, turn me round to look at the sketches & I will look again, for beauty needs no adornments, not even woollen."[96]

Varley's interest in Weatherbie's London sojourn was fuelled partly by his frustration at not having her close at hand. He was restless. Since the late 1920s he had felt isolated and "at enmity with people" who possessed, in his view, "appalling ignorance."[97] Still hoping for success in the country of his birth, he had tucked several of his own paintings of the British Columbia landscape under Weatherbie's arm when she left Vancouver. He instructed her to show them to Paul Konody. If the art critic "enthuses," Varley told Weatherbie, he would "shoot over a lot more [paintings] together with some drawings — anything if there's a ghost of a chance of making a connection."[98] If, on the other hand, "he says they are just ordinary & not worth a show," Varley cautioned, *"Don't be disappointed."*[99]

A London exhibition would have reawakened the interest that his fellow countrymen had shown in him during the war. More importantly, it would have given him the money and the pretext to join Weatherbie in London. "Just pray that I'll come and we'll go to Antwerp & Brussels," he told her. But Varley did not get the hoped-for exhibition in London. There is no evidence to suggest that Konody saw his British Columbia landscape paintings or that Vera even contacted him. He thus lost his chance to convince Weatherbie, who had not thus far been impressed by Rubens's "sacks of women," that the master's paintings were worth taking seriously.[100]

"In The Thirty's when most dreams were lost in the morbid bleak *days of depression,*" Vera Weatherbie recalled that "Varley had such faith in the morrow."[101] Fred was convinced not only of his own imminent success, but of Vera's too.[102] Jock Macdonald was equally optimistic. In 1932 he told Harry McCurry: "The school is paying no heed to stories of depression."[103] Though Varley and Macdonald were living through one of the bleakest periods in Canada's economic history, they were clearly driven by their individual wants and needs. They both were earning substantial incomes, and the Depression appeared to be incidental in their lives.

In the winter of 1932–33, however, Vancouver "hit rock bottom."[104] In February the Vancouver School Board drastically reduced the salaries of the teachers at the Vancouver School of Decorative and Applied Arts. Varley's salary, a handsome $3,500 a year, was slashed by 60 per cent and his teaching load cut by a third. This left him with an annual income of $1,400 and three and a half days of teaching a week. The salaries of Jock Macdonald and Grace Melvin were also cut. The school's director, Charles Scott, lowered his own income by only a third. With $2,666 a year and a full teaching load, Scott remained comfortably well off in an economy where prices had fallen by more than 20 per cent in four years. His three colleagues, by contrast, were left to struggle on their much-reduced incomes.

Outraged by the discrepancy in salary reductions, Varley and Macdonald registered their disapproval with the school board: "The terms suggested for allegiance to the school are to us inequitable." They proposed a fairer distribution of the money available for salaries.[105] Their plea for justice fell on deaf ears. Feeling that he had been dealt a great wrong, Varley handed in his resignation to Scott. Then he prompted Macdonald to follow suit. "With no comment or remark," the *Daily Province* reported a few months later, the Vancouver School Board accepted the resignations of the art school's most lively teachers.[106]

Neither Varley nor Macdonald had been happy at the school during the preceding three years. The increasingly domineering Scott had become a thorn in the side of both men. Macdonald felt "trapped" within the school, whereas outside of it "he was expanding his horizons."[107] Varley felt much the same. The reduction of his salary gave him a valid reason for terminating his highest-paid and longest term – seven years – of employment. On 5 April he told Eric Brown that he and Macdonald were planning "to break away and commence a school of our own."[108] Brown urged both men to seek a reconciliation with Scott. "To divide your forces at such a time, unless absolutely necessary," he cautioned, "could only weaken your position and your efforts."[109] Arthur Lismer concurred: there was "no room for two art schools" in Vancouver.[110]

Varley and Macdonald disagreed. By the end of June they were well on their way to raising the ten thousand dollars needed to get the college off the ground. They approached the Carnegie Corporation, which was funding a wide range of cultural activities in Canada.[111] Varley wrote to his old patron Vincent Massey in Toronto and to the influential lawyer father of his former student, Bea Lennie.[112] The Carnegie Corporation was not interested and Vincent and Alice Massey told Varley that they made it a rule never to give their names to any enterprise unless they were able to discharge their responsibilities in an adequate manner. Robert S. Lennie, who was closer at hand and had his own daughter to encourage, was more forthcoming. He and a small group of his

business associates and friends – Mrs. E. Bernulf Clegg, Duncan McTavish and Robert Cromee – helped secure a portion of the funds.

In the depths of the Depression, when prairie farmers and loggers and miners from the interior of the province were flooding into Vancouver in search of work and warmth, the British Columbia College of Arts Limited came into being. When the college opened its doors on 11 September 1933, half of the 234 students who entered the converted automobile showroom on West Georgia Street had moved from the old school to the new one.

As president, Varley put his personal imprint on the college from the outset. He made Macdonald a vice-president and put him in charge of commercial and industrial design and of colour theory. Harry Taüber, an Austrian set designer who had worked at Vienna's Burg Theatre and was a convert of Anthroposophy, taught costume and stage design, architecture, and choreography. Varley appointed Taüber the college's other vice-president. He chose the three best graduates of the Vancouver School of Decorative and Applied Arts – Vera Weatherbie, Bea Lennie, and Margaret Williams – to assist the male directors in, respectively, painting, sculpture, and design. Besides heading the college, Varley taught painting and drawing as well as mural decoration and commercial advertising.

The B.C. College of Arts was not reserved only for students who enrolled in the three-year diploma course. Children were taught on Saturday mornings, and working adults were offered instruction three evenings a week. (The two eldest Varley boys attended the college – Jim took modelling from Bea Lennie, and John, who was spiritually inclined, found a sympathetic teacher in Harry Taüber.) Classes were taught outside as well as inside the college. During the summer months, Varley and Macdonald took their students to Yale, on the Fraser River, or to Garibaldi Park. These painting excursions were open to all of the college's students. But however much Hélène Ladner was "dying to go" to Garibaldi with Varley and her fellow students in the summer of 1934, her mother refused to let her join the party.[113] Varley's reputation for making passes at the young students in his care had, it seemed, reached the ears of Ladner's mother.

The B.C. College of Arts was no ordinary art institution. In keeping with Elie Faure's belief that "there is not in the world a sound, a tone, a gesture, a form, a ray, or a shadow which exists alone," Varley brought all the arts into the college.[114] During the half-hour before classes the studios were flooded with Bach choruses and symphonic music. At noon the heavy monk's-cloth curtains which divided the former automobile showroom into studios were drawn back to make room for two badminton courts. And at least once a year the work of the students and their instructors was exhibited. In accordance with the college's policy of buying, selling, and dealing in works of art, everything shown was available for purchase.

Extracurricular activities were as important as formal instruction. Saturday evenings were given over to public lectures or musical entertainment. Varley kicked off the lecture series in 1933 with a talk on "Rebels in Art"; Harry Taüber followed with a discussion of Anthroposophy. The musical events, offered on alternate Saturday evenings, were as varied as the lecture topics. In the autumn of 1933, students from J.D.A. Tripp's school of music drew an audience of more than five hundred people. The following year, Toronto's Hart House String Quartet commanded a record crowd for their performance of music by little-known composers Bloch and Respighi. The students were not always observers and listeners at these extracurricular events. In January 1934, they made the costumes, masks, and stage sets, and performed in Ben Jonson's seventeenth-century play, *Volpone*. The play, one of the highlights of the college's two-year history was, as the *Daily Province* told its readers, "original in more ways than one. The audience was taken into the intimacies of the stage setting by being allowed to sit on the stage and to witness the changing of the various sets." This, together with the masks and the three-dimensional stage sets, "provided some of the cleverest work of this kind seen in Vancouver."[115]

The B.C. College of Arts set itself apart from every other art school in the country by bringing the entire community within its walls and by integrating the visual and performing arts. In order to nurture his ongoing reverence for Chinese and Japanese art, and to

accommodate Macdonald's and Taüber's interest in Eastern religions, Varley sought to "weld together into one grand activity the creative forces of Occident and Orient."[116] He prompted the Vancouver Art Gallery to mount exhibitions devoted to Chinese and Japanese painting and woodblock prints; a number of such exhibitions were held during 1933 and 1934. He encouraged Japanese- and Chinese-Canadian students to join the school, aiming for a 50-per-cent enrolment. Varley and his colleagues also planned "to open Oriental branches in the College having as instructors the best we can procure from the East."[117] Masaji Nonomura, an official at the Japanese Consulate in Vancouver, was, as Varley told Harry McCurry, "keenly alive to the possibilities of our project & will help us in every possible way to make contacts with this country through exchange of exhibition; written articles, etc."[118]

The experimental nature of the college did not go unnoticed. Students were impressed by the college's informal teaching procedure and by the individual attention the instructors gave to every student.[119] Hélène Ladner, who had just returned to Vancouver after a year's study in Brussels, remembered her teachers at the college being "very very excited about what they were doing particularly since they were breaking away from Charles Scott."[120] Writing in *Saturday Night*, H.E. Torey congratulated Varley and Macdonald for attempting to incorporate "the diverse sensibilities of the Occident and Orient" into the college, and for starting something that would be "of the greatest value to Canadian art in the future."[121] Earlier that year, W.G. Constable of the Courtauld Institute of Art in London also praised the college. After visiting Vancouver's two art schools, Constable was in no doubt as to which one was the more exciting. He was overwhelmed, he told Reta Myers of Vancouver's *Daily Province*, by the difference between the B.C. College of Arts "and the cut and dried type of academic institution that was content to live inside itself regardless of actualities of outside world forces."[122] Approval of this sort was just what Varley, Macdonald, and Taüber needed. By the end of the first year, it became apparent that more funds were required if the college were to keep its head above water.

Despite the financial difficulties which plagued the college from the outset, Varley was in his element. He was putting many of his pedagogical ideas about art and culture into practice, he had Vera Weatherbie at his side as a fellow instructor, and he was surrounded by like-minded colleagues who were taking their art in a new direction. In 1933, for example, Macdonald painted his first "automatic" painting. This was the first work that Macdonald had undertaken "with *no* pre-conceived planning."[123] After Weatherbie returned from England in 1932, she painted *Night Time* (n.d.), in which she fractured the surface of the painting's muted palette into shafts of diffused light.[124] Later, she too painted her first non-objective canvas.[125] Varley's other colleague, Harry Taüber, was not a painter, and some, like Jack Shadbolt, considered him to be "a bit of a phoney."[126] Yet the Austrian's commitment to the integration of the visual with the performing arts was of a piece with Varley's way of thinking. Taüber's insistence that the basic value of art was its abstract significance and his admiration of Wassily Kandinsky's abstract painting introduced Varley to new ways of seeing and thinking.[127] With Weatherbie, Macdonald, and Taüber for colleagues, and with Varley's own son John exploring abstract painting and esoteric religions, it is not surprising that after 1933 Varley's art was to take a new direction.

Varley complained in the autumn of 1934 that he had only the weekend besides one afternoon and one morning a week for his own work. "Needless to say," he told his mother in the draft of a letter home, "that time is all too short for a fellow who is over 50 and happens to be teeming with all manner of things to be painted." Nevertheless, Varley did find the time to get some of his ideas "out of his system."[128] Around 1933, Varley painted *Tree Tufts*, in which he reduced the elements in the landscape to their bare essentials by eliminating details and by giving the trees a geometric rendering of their life models. He also painted *Complementaries* (1933). This painting, which took Varley over six months to complete, is experimental. In it, he explored Wilhelm Ostwald's theories on the psychological sources and "scientific vibrations in colour."[129] He also worked out

what he called Munsell's "three dimensions of colour – Hue, Value and Chroma."[130] Though Varley shied away from reducing the figures – an earthy girl associated "with harvest fields" and, standing behind her, "an aesthetic type" – to geometric forms, he broke up everything else in the painting.[131]

The area behind and surrounding the figure had always been an area of exploration for Varley. In *Eden* (1912) he had used vegetation as a means of distancing the viewer from the nude and of combining all the organic elements in the painting into one statement. In his portrait paintings of the early 1920s he had employed a non-descriptive field of colour. Sometimes he allowed the background colour to move around and through the figure. At other times he held it back in order to provide a stark contrast to the foreground figure. In *Complementaries*, however, Varley made the background do much more work. Indeed, the figures are caught in a web of lines and cocooned in a film of colour which has been pulled across and wrapped around the canvas. Without the figures, *Complementaries* would have been a non-representational painting. With them it remains an exercise in juxtaposition, first of organic with inorganic forms, second, and crucially, of a modernist genre of representation – albeit one based on abstraction – with a wholly non-representational form of painting.

However much *Complementaries* represented Varley's lurch towards non-objective painting, it was merely that – a lurch. He did not want to "tear the world apart for no good reason," as he accused Picasso of doing.[132] And he refused to make colour, line, and light the dominant subjects of a painting. This made him keep one foot in the representational camp.

Varley's foray into abstractionism was over by the end of 1933. His move to Lynn Valley in the late summer of 1934 brought him back to nature. New surroundings, freedom from his family, and a deepening relationship with Vera Weatherbie saw him create his most lyrical landscape paintings to date.

❖ ❖ ❖

There was no single incident which precipitated Varley's decision to leave his family and move from Vancouver to the North Shore of Burrard Inlet in the summer of 1934. His marriage to Maud had been deteriorating and giving rise to rumour for years. As early as 1929 A.Y. Jackson had incorrectly assumed that Varley "seems to have chucked his family and they are rather a nice outfit too."[133] Keeping a roof over the heads of his wife and four children, as well as providing them with clothing and food, had never been Varley's forte. The loss of his substantial income in the spring of 1933 and the funding of the B.C. College of Arts a few months later put a further strain on his precarious budget. Also significant in his decision to leave Maud in 1934 was the death of Samuel Varley in March of that year and of Lucy Varley in 1935.

Varley's priorities had always been maintaining a studio, purchasing paints and canvas, and, increasingly, finding enough money to support his drinking habit. Though he told his mother a year after the college was under way that it was "really a wonderful place and is an eye-opener to businessmen who never thought that it could be made practical," he had to admit that it had been "fearfully hard going almost cruel for Mother [Maud] and the others." Varley was not the only member of the college's staff to be "so pinched" financially.[134] Jock Macdonald told fellow artist L.L. Fitzgerald that "although the College is progressing splendidly with a life almost of its own, it has drained us heavily and its directors pass through lean years."[135]

Even before the college came into being, however, Varley was in financial difficulties. In 1932 John Varley was forced to withdraw from his first year of study at the University of British Columbia for lack of funds. Philip Surrey remembers John being "literally in rags." Surrey "screwed up his courage" and told Varley about a sale of young men's suits at the Hudson's Bay Company. Varley made no response to his former student's suggestion. "He merely looked at me steadily straight into my eyes," Surrey recalled, " 'til I dropped mine and wondered at my audacity."[136]

When Varley left the Vancouver School of Decorative and Applied Arts he owed a year's rent, despite having received a good salary. Shortly after the B.C. College opened, his landlord, Mr. Woodworth, asked him to settle the bill for eighteen months' back rent. "Varley didn't like Mr. Woodworth asking for money," Dave Brock recalled, "so he drew himself up and said, 'No gentleman asks for money,' and he closed the door."[137] Shortly after this encounter the family were evicted from their Jericho Beach bungalow. They moved closer to the city, renting a bungalow on First Avenue near Tatlow Park. Their tenure there, however, was short-lived. Just as the college was about to celebrate the close of its first year, the bailiff arrived at the front door of the Varley home. Once again, Varley was unable to come up with the rent. The family lost all of their furniture. Maud, who had just purchased her first washing machine, saw that go out the door too. Jim Varley, who was studying for his final exams at Lord Byng High School when the family was evicted, "was so upset" that he moved in with John Vanderpant and his family. The quiet of the Vanderpants' palatial home on Drummond Drive was of little solace. When Jim came to write his exams, he "couldn't even see the paper and sat there and it was just a blank sheet of paper." "I walked out," Jim recalled, "and that was the end."[138]

After their eviction from First Avenue, the Varley family moved "to a small, ugly bungalow" in North Vancouver. This was where Philip Surrey and his mother found them in the summer of 1934 with literally nothing to eat. Responding to Maud's concern that there was no food in the house, Mrs. Surrey asked her son, "'Couldn't you buy something, even if it's only for $5?'" Surrey, who had little money himself, purchased one of Varley's watercolour paintings. He chose "the poorest" work to avoid taking advantage of his friend's poverty. He also insisted on paying ten dollars — twice the asking price for the painting.[139]

Towards the end of the summer, things became even worse for the family when Varley was admitted to St. Paul's Hospital with a mastoid problem. Thanks to a successful operation as well as to Vera

Weatherbie's nursing, he recovered in time to teach at the college that autumn.

Beset by illness and debt and trapped in a loveless marriage, Varley was looking for an escape. That summer someone, possibly Jim, told him about a house in Lynn Valley that was available for the low rent of eight dollars a month. When he peered into its window and saw that the house had a piano, he had found his bolt-hole. A few days later Varley rented the house – for himself. Tongues began to wag and have wagged ever since. "Everyone knows now that Varley left his family and moved up the mountain to a studio high in Lynn Valley and Vera, primly brought up Vera, went with him."[140] Though Vera Weatherbie was a frequent visitor to the Lynn Valley house she did not, as Molly Bobak and many others continue to believe, move in with her lover. Maud, on the other hand, was not welcome. She and the children were left to struggle without Varley. During the next three years they moved no fewer than four times.

Varley was already familiar with Lynn Valley before he moved there in the late summer of 1934. He and Vera had taken the steamer from downtown Vancouver, sailed across Burrard Inlet, ridden the streetcar to the end of the line, then walked up the hill to the Vancouver Watershed Territory. There they had painted the deserted fire ranger's cabin near Rice Lake on the Upper Road.[141] And there Varley had made the initial sketch for one of his most discussed paintings, *Dhârâna* (1932).[142]

The Vancouver Art Gallery showed *Dhârâna* twice the following December – at the All British Columbia Exhibition and at Varley's solo exhibition. Writing about the work in *Saturday Night*, Mortimer-Lamb contrasted its low tone and "sombre, intense and mystical" character to the high-keyed palette which had distinguished Varley's paintings of the Ontario landscape.[143] Another critic preferred *Dhârâna's* preparatory pencil sketch to the finished work.

The "sensitive feeling" that was evident "in each pencil stroke" bore comparison, Reta Myers wrote, to the drawings of Augustus John.[144]

Few of the critics who attended the exhibitions in the winter of 1932 made much of the painting's title. The question of what *Dhârâna* meant to Varley was left for a later generation of critics to ponder. Was it a Buddhist or a Hindu term? Did *Dhârâna* describe a state of meditation in which the mind is turned in upon itself or, conversely, is at one with nature? And why, the critics also asked, was Vera not sitting in the *åsana* yoga position?[145]

Dhârâna is a Hindu term. It describes a state of meditation in which the mind looks into the soul. Yet the circumstances under which Varley made the initial sketch for the painting and the similarity it bears with the work of two other artists suggest that the title was an afterthought rather than the genesis of the painting.

Varley got the idea for the work just as he and Vera were about to pack up their sketching equipment and return to the city. Weatherbie was sitting on the top step of the fire ranger's cabin when Varley looked up and said, "'Oh that's wonderful, just hold it.'" He tore a piece of building paper from the wall of the cabin and proceeded to make a rough charcoal sketch. During the next hour or so, Weatherbie, who was "freezing to death" even before Varley began the sketch, became "colder and colder."[146] Unaware that, as Bea Lennie put it, "the poor girl was turning blue," Varley continued to work.[147] Back in his Vancouver studio he made a pencil drawing from the rough charcoal sketch. This provided him with a template for the canvas.

Varley had not asked Weatherbie to hold her pose because it represented a mystical state. He had seen that pose before. Augustus John had used it for a series of sketches titled *Hark, Hark the Lark*, which were exhibited at London's Carfax Gallery in 1903.[148] Dante Gabriel Rossetti had asked his model to take a similar pose in *Beata Beatrix*. Housed in London's Tate Gallery, this painting had been as accessible to Varley as had the sketches of Augustus John. It was only after Varley had completed the sketch that Weatherbie recalled him having "the idea of *Dhârâna*" for the title of the painting.[149]

As Varley made clear in his 1927 essay for *The Paint Box*, he was intent on showing what went on beneath the surface of the canvas.[150] Choosing *Dhârâna* as a title for his painting helped to serve this need. Vera Weatherbie was, in his view, a spiritual person and a passionate interpreter of the landscape. She was capable of emptying her mind so that she "received the whole of her surroundings" and thereby obtained an "insight into the world."[151] To underscore her spirituality, he rendered her face and the surrounding sky and mountains in blue-green, a colour he felt represented the spirit. To connect her with the landscape, he employed a series of diagonal lines — the cabin's floorboards and railings and the background trees — which radiate from her body. Varley used these devices because he believed, incorrectly, that the term *Dhârâna* represented a meditative union with the landscape. That Varley should have attached this term to this painting is not surprising. Even though Philip Surrey did not think that Varley put "much stock" in theosophy, and Peter Bortkus insisted that Varley did not "want to speculate on what was beyond," the term *Dhârâna* was in the air, it was trendy, and so Varley used it for his painting.[152]

Lynn Valley did not offer the landscape painter the most picturesque scenery in Burrard Inlet. Parts of it had been logged and burned or drained for the construction of a reservoir. The fire-blackened stumps and swamp-soaked trees around Rice Lake were features Varley had encountered in the landscapes of the Western Front and of Algonquin Park. He liked this kind of bare-bones landscape. It allowed him to create some of his most lyrical works. It enabled him to depart from the monumental artificiality of his earlier paintings of the British Columbia landscape. For example, he celebrated the first-growth ground cover which gave rise to fireweed, huckleberry, and cranberry bushes in *Fireweed* (c. 1934). He combined the transitory effects of mist, water, and swampland and thereby paid homage to the Chinese painters of the T'ang dynasty

in *Mountain Lake* (c. 1934).[153] And in *Green Wings* (1934), he invested the trees which clung to the precipitous banks of Lynn Creek with anthropomorphic meaning.[154]

Varley did not have to go far to find his subject matter. The forest was at his front door. The large plate-glass windows on the top floor of his house gave him a good view of Lynn Canyon, Seymour Range, and Lynn Park. No other dwelling was visible. And the only sound to be heard was the roar of nearby Lynn Creek. The house was little more than a box with porches tacked on to its front and back. Its one-room main floor was unfinished and the staircase leading to the second floor had no handrail – "it just came out of a hole in the floor." Nevertheless, to Philip Surrey, the house was "marvellous . . . absolutely marvellous."[155]

The house suited Varley's needs perfectly. There was a cook-stove on which he prepared his favourite dish – a fry-up of onions topped with H.P. Sauce. The furniture comprised a table, a bed, two or three chairs, and a much-cherished piano. This is where Peter Bortkus remembers hearing a lot of piano playing as well as witnessing repeated displays of Varley's prodigious energy: "I would go to bed at 2:00 leaving him at the piano, and 7 or 8 o'clock next morning he would be preparing breakfast."[156] Jim Varley was equally in awe of his father's stamina. He rose early one morning to find his father's bed empty. Varley had been up all night sketching Grouse Mountain in the moonlight. Unaffected by the lack of sleep, he was preparing for a day's teaching at the college.[157] John Varley was a frequent visitor too, though the Lynn Valley house was strictly out of bounds to Maud. When Varley had no relatives or friends to amuse him or to be amused by him, a one-eyed rat crept out of a hole in the wall and kept him company.

The nearness of Lynn Valley to Vancouver – it was about forty-five minutes' travelling time – gave Varley a quick escape from the mounting cares of the city. His major problem was money. The B.C. College of Arts had been underfunded from the start. By the end of its second year, it was in serious difficulty. Unlike the Vancouver School of Decorative and Applied Arts, it did not have the patronage

either of the city council or of donors of the calibre of W.G. Murrin, George Kidd, or the city's former mayor, W.H. Malkin. Nor was it likely that such patrons would give to an institution that was committed to admitting Asian students. Pressure from Vancouver's Anti-Oriental Exclusionist League had put an end to Chinese immigration in 1923. The city's racists were now directing their attention towards the Japanese, whose numbers were rising and whose economic strength was growing. Lack of support from the private and public sectors of the city meant that the college's teaching salaries were well below those of the Vancouver School of Decorative and Applied Arts.

Apart from the lack of funding the institution was poorly managed. This was partly Varley's fault. He refused to take help. (Bea Lennie's father offered to form a company with a board of directors to manage the college's affairs.) "Fred had trouble dealing with people" and, Philip Surrey recalled, "tended to insult anyone who helped him or lent him money, in order to affirm his independence."[158] Fred Amess was less harsh on his former teacher: "he was an Artist not an organizer and the project failed."[159]

Varley and his colleagues not only refused to take advice from their patrons, they also were reluctant to listen to one another. "None of them," Bea Lennie recalled, "would give an inch." And, she continued, "staff meetings used to be a bit of a nightmare." Taüber "irritated" Varley. Varley was "not practical," and Macdonald, who "was trying to be all things to all people," was caught in the middle.[160] Unable to "stand the strain" and fully aware that the college "wasn't paying," Macdonald told the institution's backers that he could not go on.[161] This precipitated the college's demise. Beset by poor administration, lack of entrepreneurial support, and the realities of the Depression, "the doors of the building were locked and barred by the city and in a cloud of despair the school closed."[162]

Though Macdonald told Harry McCurry that "one glance at the company books would explain all & would reveal who fared best and worst," he was convinced that the "adventure" had been worthwhile. The college had "left a distinct record in this city" and was "looked upon with pride by the citizens." And, he concluded, there

was "no bad odour with creditors or anyone else & the students have formed a society to keep alive its memory."[163] Penniless, having cashed in his life-insurance policy in order to supplement his low salary, Macdonald moved with his wife, Barbara, and Taüber to Nootka Sound on the west coast of Vancouver Island. There the party, later joined by John Varley, who got temporary work in the fish-cannery plant, spent a year trying to live off the land. "Varley's victim," as A.Y. Jackson called Macdonald, suffered from undernourishment and overexertion.[164]

The demise of the B.C. College of Arts left a bad taste in Varley's mouth. Feeling let down by Macdonald — he harboured a grudge against him for over a year — Varley was "restless and unhappy." "No one bought his work," Philip Surrey remembered. "The school ended with debts to pay off and his marriage was no marriage."[165] With no regular employment in the city, Varley now spent most of his time in Lynn Valley where his moods oscillated between elation and despair. Writing to Eric Brown in December 1935, he lovingly described the "snow on the peaks, soft rain in the valleys, mists playing kicks with the landscape & from the gorge comes the sound of the Lynn in full flood."[166] A week later his mood had changed. "It's been a rather lonesome & quiet Christmas & end of year at Lynn," he complained to Mortimer-Lamb. "I'm not much of a success at this 'hermit life.'"[167]

It was not only the "hermit life" that got Varley down after the college closed. His relationship with Vera Weatherbie was unravelling. In December 1935 "Vera suddenly took it into her head to return to Seattle with her brother" and, he told Mortimer-Lamb on New Year's Day 1936, he had so wanted to make use of her studio "but she went before I could arrange anything." Undaunted by Weatherbie's wish to spend Christmas with her brother, Varley was nevertheless optimistic that they would combine their "efforts in a damned good painting" when she returned.[168]

The prospect that Fred and Vera would work together again was unlikely. After the closure of the college, they began to have frequent "rows." A neighbour in Lynn Valley had told Maud that "she heard

Fred yelling one night, 'You've ruined my life.'" Maud added, "I think the police was there one time."[169] Vera described this time as "a rotten period" in their relationship.[170] Varley knew that "he had hurt Vera." He regretted that "it had all ended so badly and something that had been very important to him had gone."[171]

Fred had clearly fallen out of love with Vera. He had demanded total devotion from her and received it. Yet Fred, who needed "so much love, didn't seem able to use it."[172] In a moment of self-revelation he told Mortimer-Lamb, after the affair had ended: "By this time, I suppose you will sum me up as having no use for women apart from releasing the activity of the male – m.m.m.-ph!"[173] This could not have been closer to the truth.

Varley's lack of money, which no doubt made him dependent on the more prosperous Weatherbie, only made things worse. A local photographer let him teach an evening class in his Hastings Street studio but it "didn't catch."[174] And Mortimer-Lamb and John Vanderpant commissioned him to paint portraits – just to put food on his table. By December 1935, things, as Varley told Eric Brown, were "not too rosy." He had just learned about the Group of Seven's forthcoming exhibition in Ottawa. This made him long "to get away from the death & too trying conditions" of living on the coast.[175] The prospect of attending the retrospective in Ottawa was one escape route. The possibility of having work accepted at the Royal Academy in London was another. Varley had just begun a large canvas, *Liberation* (1936), for this purpose. Its exhibition in London would, Varley told Brown in February 1936, "release me, if possible, from this imprisoned life on the coast."[176] In writing to his sisters, Lilian and Ethel, about a possible visit to London, Varley explained why he was leaving Vancouver: "I am estranged here and am no better than the unemployed worker in Vancouver, which I hoped to make the throbbing centre for the Occident & Orient."[177]

Learning of Varley's dire circumstances through Eric Brown, Harry McCurry encouraged him to come to Ottawa for the opening of the Group of Seven exhibition in the early spring of 1936. He could see the exhibition and "renew old acquaintances," and,

McCurry continued, the National Gallery might even be able "to buy a sketch or something to help out the finances."[178] When Varley told John Vanderpant a week later that the National Gallery was willing to help him "start anew" Vanderpant wrote to Eric Brown. Varley was, he told the National Gallery director, "at the end of his rope." He had to vacate his Lynn studio – "where can he go?" – and even his clothes were "turning him out."[179]

Varley added weight to Vanderpant's letter when he told McCurry that his only suit was "worse than threadbare" and his "once lusty cries" were "all but drowned in the growling threats of creditors demanding their dues." Varley also suggested how the gallery might help him: "it seems if not a duty of the State, it would be generous indeed to invite the artist and if it can be without inconvenience, assist him on his journey, so making it not only educational, but pleasurable and memorable." Varley based his case on the grounds that "after 9 years trying to buoyantly float a worthwhile craft, I am stranded in the flats surrounded by indolent and sleepy natives who yawn at me with more or less disinterested curiosity."[180]

Varley was, of course, playing to Brown's and McCurry's anti-western feelings by reinforcing their belief that the west was a backwater. Yet before either man moved to help, they wanted Vanderpant's assurance: "If he did come do you think he would be self-supporting, or reasonably so?"[181] Vanderpant told McCurry that he was "confident" that if Varley were given portrait commissions "in the field of politicians and statesmen" or a teaching position in Ottawa he would soon be on his feet. After all, he continued, Varley had recently completed portraits of himself and Mortimer-Lamb. The activity had "made him a different man," restored his courage, and – this was the trump card – it also made him forget "the bad habit of manipulating other liquids than paints and turps."[182]

Assured that Varley was not only painting again but off the bottle, McCurry cabled Vanderpant on 24 March:

MANY THANKS FOR LETTER STOP IF VARLEY COULD ACCEPT
MODEST PRICE FOR SELF PORTRAIT NOW IN OTTAWA WE WOULD

SEND PART OF MONEY ALMOST IMMEDIATELY ENABLING HIM TO
COME EAST STOP PROSPECTS OF SOME WORK HERE WORTH STUDY-
ING STOP GROUP SHOW CLOSES APRIL FIFTH[183]

Less than a week later Varley received two hundred dollars in partial payment for his *Self-Portrait* (1919).

Though Vanderpant was euphoric, Brown reminded him that Varley's success depended "so much upon his own position and poise." "His old friends consider him incorrigible but of course," Brown continued, "no one is that and I hope that difficulties have, as you suggest, had an improving effect." Ever optimistic, Brown had no doubt that with integrity of character and hard work Varley would take advantage of the opportunities that awaited him in the east. For one thing, he was convinced that the landscape of Ontario was the most appropriate vehicle for Varley's talent as a landscape painter. "He could perhaps spend a summer very cheaply in the country north of here and," Brown told Vanderpant, "paint some good things, both figure and landscape."[184] That the landscape of British Columbia had inspired Varley's best landscape paintings to date had obviously passed Brown by.

Varley left the city without any luggage. Under the impression that his father was "running away from things," Jim felt that "there was no reason for him going except turmoil here."[185]

At the same time, Vera Weatherbie began making plans for a trip to the Far East. "She must have felt very much alone then," Molly Bobak recalled, "especially after Varley left to go east."[186]

There was an ironic twist, in A.Y. Jackson's view, to what the National Gallery had done for Varley. "If something could be done to get that boy to work there is a lot of genius bottled up there — there is no artist in Canada who has had so much done for him; he thinks his life has been just a long fight in overcoming insuperable obstacles but all unconsciously set up by himself and he is so charming you can't help liking the cuss."[187]

Varley photographed by John Vanderpant in Vancouver, c. 1932.

CHAPTER 8

Paradise Lost

The art world that Varley encountered when he moved to central Canada in the spring of 1936 and that he experienced over the next fifteen years was radically different from the one he had left a decade earlier. The aftermath of the Depression and the subsequent exigencies of the Second World War put a strain on the purchasing power of private patrons of art. This had a devastating effect on full-time artists. Admittedly, through the Carnegie Corporation's and the Rockefeller Foundation's involvement in the cultural life of Canada, art institutions, exhibitions, and cultural programs found a new source of patronage. But Carnegie and Rockefeller rarely supported individual artists, though they sometimes offered them roles as educators and administrators in the institutions and activities they funded and, in some cases, created.[1]

The new generation of artists that emerged at this time was more institutionally minded than the previous one had been. Artists now challenged the wilderness ethos and the nationalist agenda which had dominated most sectors of Canadian art since the 1910s. Their interests lay in aesthetic theory and in contemporary art movements. They wanted to paint an environment which had been modified by humans. And, even before Alfred Pellan returned to Montreal from Paris in 1940 and introduced Canadians to Surrealism, some had already shown that they wanted to depart from representation and nationalism altogether.

In light of these developments, it is not surprising that throughout the 1930s the Group of Seven became the focus of a series of articles with titles like "Come Out from Behind the Pre-Cambrian

Shield" and "False Hair on the Chest" that rang the death knell of "the artistic cult of the North."[2] As Graham McInnes observed in 1938, it was "no longer fashionable to idle away a winter, and pack up to go North in the summer — as if that were the only place inspiration could be obtained." Most artists preferred, McInnes added, to portray "contemporary life" in the towns and the cities. [3]

Varley had come to Ottawa in 1936 ostensibly to attend the *Retrospective Exhibition of Paintings by Members of the Group of Seven, 1919-1933* at the National Gallery of Canada, and to re-establish contact with some of the Group's members. Yet his exposure to the canvases of his former colleagues triggered a barrage of criticism. Lawren Harris's paintings were, he wrote, "very disappointing."[4] A.J. Casson was "on the bandwagon."[5] Arthur Lismer was "undoubtedly the fellow with an open mind," although Varley saw "no sign of investigation into art as art distinct from topographical renderings of the countryside."[6] Even Varley's acknowledgement that Jackson's paintings "were lovely" was qualified by the astute observation that he was "dangerously near to mediocrity."[7] (Distressed that his favourite subject — derelict barns — was "getting very scarce," Jackson told his niece that he planned "to make some models and get a few pounds of salt and do them in the studio."[8]) While the exhibition may have served "to lift people out of the old fashioned school," it was, Varley complained to Vanderpant, simply "a beginners show."[9]

Varley's reaction to the paintings in the exhibition was strongly influenced by his response to the artists who had produced them. He made no secret of the fact that to him Harris was "precious" and "remote" and that Lismer was "a show-off."[10] He chastised Jackson for "feeling sorry for himself" when his paintings were upstaged by those of Lawren Harris at an exhibition in Toronto. "If I could find him a wife and then get him divorced if needs be," Varley told Mortimer-Lamb, Jackson would be better off.[11]

Varley's harsh criticism of the work and personalities of his former colleagues was his way of distancing himself from his own early work. The National Gallery had cobbled together most of

Varley's paintings in the show from eastern art collections. This meant that only two examples of his western Canadian work, *The Cloud* and *Dhârâna*, were on view. Eighteen portraits – most of them painted during his Toronto years – along with his signature piece, *Stormy Weather, Georgian Bay*, reinforced the general belief that Varley had done his best work during the 1920s when he had lived in Toronto and had taken his inspiration from the northern Ontario landscape. Varley knew that this was not so. His study of Chinese painting and his exposure to the work of Vera Weatherbie during the decade he had spent in British Columbia had enabled him to break away from the monumental style and in some respects the wilderness ethos of the Group of Seven. His paintings of the British Columbia landscape were undoubtedly his most mature to date. As he proudly confided to Mortimer-Lamb after viewing the Ottawa exhibition: "May I tell you that your humble [correspondent] has journeyed quite a long way since he went to the Coast."[12]

Although Varley was convinced that officials at the National Gallery agreed with his negative assessment of the Group's work, Brown and his assistant, Harry McCurry, had a vested interest in keeping the Group's name before the Canadian and the international public. The Group of Seven was, after all, their discovery, their making, and now the National Gallery's flagship. This is why Brown and McCurry made sure that the Group's work dominated the exhibitions which toured the Southern Dominions, Great Britain, and the United States during the late 1930s. It also explains why National Gallery officials persistently helped the Group of Seven's most irascible member.

Jackson's remark was hardly an exaggeration. Varley got more benefit from his association with the Group of Seven than any other member. From the moment he arrived in Ottawa, Brown and McCurry bent over backwards to help him make a fresh start in a new environment which they hoped would be "more sympathetic and appreciative than that of the Pacific Coast."[13] They put him up in the best hotel in town, the Château Laurier, where he got a taste

for high living. Later, they found him a room: "I'm in a G.D'.d. respectable house, lovely people, *all women*," Varley told Mortimer-Lamb. Brown and McCurry provided Varley with art supplies and arranged a portrait commission: the chairman of the National Gallery's board of trustees, H.S. Southam. And they rearranged one exhibition hall in the gallery so that Varley had a place to work. "They gave me a dream of a studio," he enthused to Mortimer-Lamb, "with Mr. Michelangelo & Donatello exhibiting their wares by the side and the Goddess Ceres & the Winged Victory just outside my door. . . . To think that I have the privilege of working under the same roof is very invigorating."[14] Brown and McCurry did so much to make Varley's transition to Ottawa a success that, as he told John Vanderpant, they seemed "to know more than I about what I'm going to do."[15]

Despite having been given "a dream of a studio," Varley did not enjoy painting Southam's portrait. The terms under which he agreed to undertake the commission were one problem. Brown made it clear from the outset that he and the board of trustees would formally have to approve of the painting before Varley received his money. Giving the newspaper baron a good opinion of himself and satisfying Eric Brown and the board of trustees at the same time were difficult tasks for an artist "who never played ball with the establishment."[16] Even so, Brown and his board accepted the painting and Varley was paid handsomely for it — a thousand dollars. But he had to wait for his fee.

Varley took an instant dislike to Harry Southam when he met him in April 1936. Throughout the spring of that year, Varley regaled his correspondents in western Canada with cruel descriptions of what he believed to be Southam's mental and physical shortcomings. Southam was, Varley told his friends, appallingly dull, run by his wife, and smugly self-satisfied. During the sittings Southam annoyed Varley by never crossing his legs — in Varley's view, for fear of creasing his trousers. He breathed heavily — Varley compared his breathing to a bulldog's. And he stubbornly maintained what Varley pejoratively called his Christian Science "serenity" during every

session. Southam's physiognomy – he had a tiny nose, thick lips, and a forehead that was "too stupidly solid" – irritated Varley as much as his mannerisms. However unpleasant the experience of painting Southam's portrait might have been, Varley salvaged something from it. He put Southam's "higher range of colour vibrations" to good use by bathing him in a field of "prismatic colours." This not only helped him to resolve "a damned difficult problem" concerning colour and light, but also resulted, Varley told his son John, in "a damned good painting."[17]

Not everyone agreed with Varley's assessment of the portrait. Harry Southam had a strange and unflattering smile which Varley had captured on canvas.[18] This may have been the reason Mrs. Southam took an instant dislike to the work. Though initially eager to have her own portrait painted by Varley, when Mrs. Southam saw the painting of her husband she decided, within three minutes, that it was "Hell."[19] Harry Southam, on the other hand, was favourably disposed towards the work. He suggested that Varley paint his brother Fred, purchased ten small landscape panels Varley had brought with him to Ottawa, and commissioned Varley to produce another much larger (thirty-by-forty-inch) landscape painting of a British Columbia scene.

Southam was a good catch for Varley. He was a prodigious and intelligent art collector. Willing to accept new styles, he favoured the late-nineteenth- and early-twentieth-century French modernists. He also had a soft spot for Varley's favourite contemporary painter, Augustus John. And he took an interest in Canadian artists (he bought the paintings of the Ottawa-based artist Henri Masson by the dozen). Given his penchant for commissioning portrait paintings of his family, Southam might have been equally generous to Varley,[20] but according to Harry McCurry's wife, Dorothy, "something happened" which turned Southam against Varley.[21] The much-talked-about portrait commission of Southam's brother, Fred, never materialized, and the commissioned landscape painting was not to Southam's liking when Varley completed it for him in the autumn of 1936.

While Varley might have lost a potential patron during the course of painting Southam's portrait, he nevertheless gained a better understanding of colour and of light. This fed directly into his next painting. *Liberation* (1936) was a far more experimental work than the portrait of Harry Southam.[22] During the course of painting it, Varley "savagely piled" thick daubs of paint on to the raw canvas.[23] He used charcoal and pastel as well as oil paint. He left some areas of the raw canvas bare. He *drew* the Christ figure with the paint brush; his virtuoso drawing paid tribute to "Mr. Michelangelo & Donatello's" superb knowledge of anatomy. Yet Varley was no mere copycat. He harboured "notions about a new kind of painting." According to Miriam Kennedy, "he didn't want to paint the old way." When he referred to *Liberation*, "he kept talking about painting with a blow torch."[24] And in his effort to present Christ as "an evanescent something" he certainly did apply the colours as though he were aiming a blow torch at the canvas.[25]

Varley told a friend that he had chosen the subject – the emergence of Christ from the tomb – and the size of the canvas – it was seven feet high – because they were "big & would talk to more people."[26] He hoped that *Liberation* would do more than introduce his viewers to the idea of reincarnation. He wanted the painting to "hypnotise" everyone who saw it and, he told Mortimer-Lamb in 1936, purge them of "the tomfoolery of this present death through lack of thinking."[27]

Varley was convinced that the public were "moved" by *Liberation* when they saw him painting it at the National Gallery in the spring of 1936.[28] Eric Brown was not convinced about the emotional impact of the work. Nor was the young artist Harry Kalman, who dubbed it "cabbalistic."[29] Kalman's friend at Ottawa's Contempo Studio, Leonard Brooks, was less critical. To him *Liberation* showed how Varley was "starting to deal with the problems of space which contemporary painters were dealing with."[30]

As with Varley's attempts to make a big mystical statement in *Complementaries* and *Dhârâna*, *Liberation* appears forced. Yet Varley held the work in high regard. The painting made him feel "dizzy-

headed."[31] It scared him because it looked so unreal. And it caused everything else that he had painted to date to look "stupid."[32]

From the moment Varley had conceived *Liberation* in his Lynn Valley studio early in 1936, he felt it was destined for exhibition at the Royal Academy in London. Its success there would, Varley hoped, offer him an escape from what had become a dead-end life in Vancouver. A lot depended upon the positive reception of the painting in London. Varley was "very touchy and sensitive" when British art critic Eric Newton voiced his opinion of the work shortly before he sent it to London in the spring of 1937. "No amount of praise," Newton wrote in his diary, "will satisfy him."[33]

It was important that *Liberation* succeed because, after completing *Portrait of H.S. Southam*, Varley realized that portraiture was not for him.[34] He had come to Ottawa precisely because so many important people were there to be painted, yet, as he had discovered years earlier when he had set himself up as a portrait painter in Toronto, he had neither the temperament nor the reputation to make a success of it. He wanted to paint the prime minister, R.B. Bennett, but quickly realized that there were others, like Kenneth Forbes, who would be given first refusal. He wanted to paint other members of the establishment but, as he told an interviewer a few years later, "those civil servants, politicians and diplomats are the daftest people I know of."[35] Painting the portraits of people whom he did not know, let alone respect, was anathema to Varley. He confessed to John Vanderpant: "That is the one thing I never have been able to do."[36]

A few weeks after Varley completed Southam's portrait, he secured a CPR rail pass and returned to Vancouver. Vera Weatherbie, whose companionship and involvement in his work he missed, was one draw. The house in Lynn Valley – "the only place in the world that I truly felt was mine" – was another.[37] Upon arriving in the late summer of 1936, he immediately occupied the Lynn Valley house. (In his absence, Mortimer-Lamb had secured the house for Varley by

paying the rent.) During the next few weeks Varley made day-long painting excursions into the Lynn Valley watershed. He got together with his former students Orville Fisher, Ed Hughes, and John Avison. Though he avoided his older friends, John Vanderpant saw enough of Varley's wayward lifestyle to assure Eric Brown that "the same conditions prevail."[38] Varley also saw something of Maud, who was living in the attic of a house in the west end of the city. In fact, before returning to Ottawa in late September, he persuaded her to move into the Lynn Valley home in order to keep it for his later use. (He even paid the rent until January 1937.) Although his romantic attachment to Vera Weatherbie was clearly over, they met frequently until she set sail for the Far East. After Weatherbie left Vancouver in late September, Varley found things "deadly slow."[39] By early October he was back in Ottawa.

Varley made a second, and final, visit to Vancouver the following summer. Two things had happened in the meanwhile. First, Maud, who had just received an inheritance following the death of her mother, Sarah Pinder, had bought the Lynn Valley house. Second, the Royal Academy had rejected *Liberation* in April 1937 and thereby ended Varley's much-hoped-for success in Great Britain. Although some people congratulated Varley on being turned down by the London-based Academy, he confided to Maud that "my beliefs – really unshakeable beliefs have had a set-back."[40]

Varley's response to the west during his visit in the summer of 1937 was much the same as it had been the previous year. He found Vancouver itself "a drab place for an artist to be imprisoned in."[41] But the landscape surrounding it, he told Philip Surrey, had never held "more beauty" nor had he "ached so much with desire to channel it into expression."[42]

At first things seemed to go well. He settled into the Lynn Valley house, living with Maud and the Varley boys for the first time in several years. (Dorothy, now married and qualified as a nurse, had recently contracted tuberculosis – a fact which was never mentioned by her father, who always took a greater interest in the boys.) Mrs.

Pinder's former housemaid, Edna Hicken, was visiting Maud from England that summer and her cries to Fred of "Give us a Hollywood Kiss" filled the house with laughter. A modest exhibition of Varley's sketches and of Vanderpant's photographs at the Vanderpant Galleries resulted in the sale of forty works. (This kept Varley in food and paint for the first part of his visit.) But then things began to go horribly wrong. Varley ran out of money. He had a painting rejected for exhibition at the Annual Exhibition of Northwest Artists in Seattle. And he became increasingly disturbed by the presence of Maud in what he had considered *his* house.

Maud had purchased the Lynn Valley house, then made it habitable for herself and the boys by installing a bathroom and adding a bedroom. She had done this both to put an end to her twenty-year-long housing problems and to offer Fred a home. Maud's hopes for a reconciliation with her wayward husband were, however, short-lived. The day after Fred returned to Vancouver, Maud, who liked the movies almost as much as Fred did, went to the cinema. "As she grew accustomed to the darkness," according to Peter Varley, "she saw Dad and Vera sitting together a few rows ahead."[43] Exactly what Maud observed is not known, but it must have been enough to convince her that Vera Weatherbie was still very much a part of Fred's life.

Varley's plans to re-establish himself in Vancouver were equally doomed. Even before he had laid eyes on the Lynn Valley house, he was worried that he would "not recognize it or it will not know me."[44] Once he saw the extent to which Maud had made the house more livable, he was not pleased. And when he ran out of art supplies and Maud refused to replenish them, he was angry.

Maud had already given Fred money from her inheritance. She had helped him pay off his debts before he left Ottawa in the spring of 1937. She did not want to give him any more. Acting on the advice of John Vanderpant, Maud put what remained of her inheritance towards the purchase of a lending library in North Vancouver. "This upset Dad," Peter Varley recalled, "as he was hoping for help

to get materials for painting."[45] A full-blown row ensued. Varley moved to a hotel in downtown Vancouver and began making plans to leave the city.

Varley found someone to pay his rail fare back to Ottawa: his old student, Peter Bortkus. On the day of his departure, Bortkus and John Varley packed Fred's trunk and transported it from Lynn Valley to the CPR station in downtown Vancouver. When they arrived shortly before the train was due to leave, Varley was not there. John paced up and down the platform. Bortkus feared that Fred had either lost or drunk the money he had lent him. Then, in "the nick of time," Varley arrived at the station. "He wasn't stupid," Bortkus remembered, "even though he was drunk."[46]

During much of the 1920s and 1930s Maud had lived from hand to mouth. She had to borrow money from friends and acquaintances, from Varley's sisters, and even from her own children when they were lucky enough to get jobs. Fred occasionally sent her a few dollars, although much of what he earned slipped through his fingers before he had a chance to put any of it into an envelope and address it to Maud. After being handsomely paid for painting Southam's portrait, for example, he blew most of it in a day. News of how he spent the money reached the family via Jim Varley. While working as a busboy at the Hotel Vancouver, Jim met a man who had worked at another CPR hotel, the Château Laurier in Ottawa. Fred Varley was a wealthy man, according to this young waiter. He told Jim how the staff at the Château had "fought" to serve his father. Apparently, Fred had given them ten-dollar tips for delivering jugs of ice water to his hotel room during a night-long party. "And at this particular time we were so darn hard up," Jim ruefully recalled.[47]

However much Maud might have suffered during these years, in old age she had "no regrets whatever" about her life with Fred.[48] She even shouldered the responsibility for Fred's hasty departure from Vancouver in 1937.[49] Peter Varley called his mother's purchase of the Lynn Valley house, which prompted his father's exit from the city, her "greatest mistake." Jim Varley agreed, suggesting that after the

autumn of 1937, Varley "couldn't possibly make a move in this direction" because "it was as if he was an outcast and he had been banished from this part of the world."[50]

Varley was alienated not only from Maud by the time he returned to Ottawa in the autumn of 1937. He was alienated from Eric Brown too. Though initially overwhelmed by Brown's and McCurry's generosity, he soon began to snap at the civil-service hands that were feeding him. He could not, he told Vanderpant, "afford to be imprisoned or bound by the wills of others."[51] Within weeks of his arrival in Ottawa in the spring of 1936, Varley and the institution that had rescued him from his dreary life in Vancouver were at loggerheads. Varley insisted on working in his gallery studio after 5 p.m. "I am sorry to find it cannot be done," Eric Brown informed Varley. He liked to smoke while he painted: "Much as I regret interfering with your habits," Brown added in his missive, "smoking cannot continue."[52] Brown claimed that he had no other choice but to ask Varley to vacate his studio on 1 July 1936. Brown installed the Montreal painter Mabel May in Varley's place at the gallery. It was said that whenever Varley visited the premises, Brown hid in his office in order to avoid him.

McCurry too discovered that it was difficult to pull Varley into shape and to keep his affection at the same time. When he suggested that Varley send money to Maud, he got the icy stare that Philip Surrey had received a few years earlier when he had told Fred to buy his son John a new suit. Even McCurry, who would remain more tolerant of Varley's deviant behaviour, told the Ottawa-based photographer John Helders that he did not want to have anything more to do with the difficult artist.[53]

By October 1936, Brown and McCurry were *personae non grata* in Varley's eyes. He called them arrogant, narrow-minded, selfish, and self-important.[54] Once again Varley could accept assistance only on his terms.

❖ ❖ ❖

The decade and a half following his second visit to Vancouver were the worst years of Varley's life. During the first eight years, from the age of fifty-six to sixty-three, he seesawed back and forth between Ottawa and Montreal and made a few side trips into the surrounding countryside. During the remaining seven, he lived in Toronto.

At a time when most people either reap the success or succumb to the failure of their careers, Varley scrambled to rebuild his through private and public sales, through exhibitions, and, reluctantly, through portrait commissions, commercial-art work, and loans. From 1937 to 1952, Varley was an Arctic traveller, a sporadic creator of sumptuous landscape and figurative paintings, a war artist, an inspiration to amateur artists, a nuisance to old friends, a shameless womanizer, and a drunk. He lived in sparsely furnished and ill-heated apartments in shabby rooming houses with shared bathrooms. When luck was on his side, he lived in the houses or cottages of his friends. He ate his meals out of a can – vegetable soup was a favourite – or simply sliced a Spanish onion, doused it with a little vinegar, put it between two slices of bread, and called it a meal. He hated the eastern Canadian climate with its chilling temperatures in winter. (Varley rarely went through a winter without suffering from "rotten influenza fever.")[55] He fell in and out of depression – his worst bouts occurred during the winters of 1939–40 and 1942–43. *Self-Portrait, Days of 1943* (c. 1945) speaks volumes of the despair into which he had fallen.[56] He made plans to leave the country. London and New York were two possibilities; Mexico, Bali, and the Dutch East Indies were also considered. "I'd like to Pied Piper several young students out of this country," he told Mortimer-Lamb in November 1937, "and form a colony among the heathen."[57]

Varley's quickest form of escape, however, was through the bottle. His drinking binges were legendary. Sometimes they ended in the gutter or a snowbank. In November 1942 he was rushed to the Hôtel Dieu, then moved to St. Luke's Hospital, where he spent two weeks recovering from two fractures to his skull and lacerations on his face. "Varley was seriously injured in Montreal Saturday night when he stumbled and fell while walking along the street" was how

the *Vancouver Sun* reported the mishap and how his family learned of it.[58] Six months after this accident he had another fall. "I can see double at cock-eyed angles without even a drink," he told his Ottawa drinking buddy, Len Pike.[59]

Though Varley continued to disdain commercial art as a profession for a serious artist, he was forced to return to it. In Ottawa he produced "large posters of coachmen" and a thirty-foot mural for the Chateau Cheese Company.[60] In Montreal he made thirty-one illustrations for Stephen Leacock's *Canada: The Foundations of Its Future* (1941). He submitted a series of cartoons to the *New Yorker* and illustrations of the landscape to the CNR. None were accepted for publication. Montreal artist Franklin Arbuckle discovered Varley in a commercial artist's studio. " 'Look, I've got the big boy working for me,' " the boss told him. Varley was sitting at a little desk with a few pencils and bottles of art gum. The light was very poor and, Arbuckle continued, "he was gazing at the work before him in a doze."[61] Finally, in Toronto, where he relocated in hopes of securing steady employment as a freelance artist, he did get a commission. It was for Brigdens Limited.[62]

According to Miriam Kennedy, Varley "didn't have too much trouble getting [commercial] work" even though "he didn't have his heart in it."[63] But the drawings he produced were "dreadful." He was out of tune with contemporary advertising styles and techniques. His fluid, organic black-and-white drawings looked sentimental beside the hard-edged designs and bright colours that Peter Ewart and other commercial artists working for the advertising agencies churned out.

Varley was much more successful and happier teaching art than working as a commercial artist. He sensed a "tremendous 'ache,' " he told a newspaper reporter just after arriving in Ottawa, "among business men and women for whom creation, however unskilled, provides a release for over-charged energies."[64] Amateur art groups abounded in the 1930s and 1940s. There was always a job going for an artist, provided that he or she was willing to teach for the lowly salary of fifty cents per student for two hours of instruction.

The members of the Ottawa Art Association could not believe their luck when a former member of the Group of Seven offered to teach them two mornings, two evenings, and one afternoon a week. Yet in hiring the Group's most rebellious member in the autumn of 1936, they had to take the rough with the smooth. Their illustrious teacher did not always show up in the classroom, which was located above the fish market in downtown Ottawa. And if he did arrive, he was frequently drunk or in need of a drink, which he often took during the course of the lesson. Varley would "duck behind the screen and have a nip" a former student recalled. Not one to drink alone, he would persuade a female student to join him behind the model's screen during a pause in the lesson.[65]

However much Varley complained about being forced to teach "a lot of old women in Ottawa," he nevertheless derived much satisfaction from the job.[66] "We pulled very well together," he told John Vanderpant in April 1938, "and this season I have obtained some excellent work."[67] Even so, he was aware that what he called the "dilettante spirit" of most of his students at the Art Association was a far cry from the professional attitude of his former pupils at the Vancouver School of Decorative and Applied Arts and at the B.C. College of Arts. "Not one burns up," he complained in January 1938, "even though they bluff me & say I'm wonderful."[68] Varley's students did think that he was wonderful. To Dorothy McCurry, wife of Harry, he was "so nice to people like myself who weren't going to be a painter."[69]

Despite the paucity of high-spirited students, Varley still hoped to make Ottawa "the leader in the Canadian art field."[70] But his plans were crushed when the Art Association's president, Lady Floud, left town with her husband, the British High Commissioner, Sir Francis Floud, and when Germany invaded Poland in September 1939. Harry McCurry called the Art Association's decision to shut the school down at the outbreak of the Second World War "extremely feeble." Though he now had little contact with Varley, he was nevertheless concerned for his well-being. "What Fred Varley will do I don't know," he exclaimed to portrait painter Lilias Torrance Newton.[71]

After the Ottawa Art Association folded, Varley set his sights on Montreal, where he had earlier expressed a wish "to develop a vital movement."[72] Eric Brown had recommended Varley for a teaching position there in May 1936. He had told the president of the Montreal Art Association, H.B. Walker, that no artist was better equipped "to carry on the school than Mr. Varley."[73] McCurry had made a similar pitch on Varley's behalf to the professor of art at McMaster University in Hamilton the same year.[74] But Varley had no intention of taking advantage of either man's recommendation for employment because he did not wish to remain in eastern Canada. When he decided, a year later, that he would like to stay in the east, it was too late. The Art Association in Montreal had, he was told, found someone else for the position.

Varley did not teach again until 1948. That year the director of the Doon School of Fine Arts, Ross Hamilton, was looking for artists to teach at their summer school and Varley got a job. It was ideal work for someone who liked being out of doors and enjoyed his privacy. The surrounding countryside, lying between Kitchener and Galt on the south bank of the Grand River, was picturesque. There were the ruins of an old stone mill and the causeway Homer Watson had made famous in his painting *The Floodgate* (1900). Yet the landscape was not entirely pastoral. Crowning a gentle rise known as the Pinnacle stood a copse of pine trees that was a worthy subject for any member of the Group of Seven.

During his year at Doon, Varley lived in the Red Lion Inn. His studio, located in Homer Watson's early nineteenth-century house, was a short but steep walk from the Inn. Dressed in "a soft, open-necked, long-sleeved shirt, corduroy trousers and crepe-soled walking shoes," Varley became a familiar figure.[75] "Fred had his students all over the fields," Henri Masson recalled, "and spent his days walking around looking for them."[76] "I tell them what to do, help them to choose a subject and then," Varley told a friend, "knock the Hell out of the canvas."[77]

Canadian art historian J. Russell Harper studied under Varley during the summer of 1948. He recalled how his teacher made

himself objectionable by getting "as drunk as a lord" then playing the piano until 3 o'clock in the morning.[78] Despite being woken up at all hours of the night, most of Varley's students loved him. He gave them a new appreciation for the work of J.M.W. Turner. He forced them to look at the forms and the patterns in nature. And he made them realize that the paintings they had produced prior to studying with him were "atrocities."[79] Varley's influence on these largely amateur artists was so great that even after he left the school in 1949, following his second summer there, his presence remained pervasive. One student who went back to Doon in 1951 "with great misgivings knowing the Master was no longer there" found that Varley's "spirit and words" were "still about me." "You *were* there everywhere," Ruth Wilkins told Varley in a letter to him.[80]

However popular Varley might have been at the Ottawa Art Association, or at Doon, or at Kirkland Lake, where he taught at the Kirkland Lake Arts Club during the winter of 1948–49, he resented the time that teaching took away from his own work. Had the calibre of his students been higher, he might have been happier. Had he secured a position at the Ontario College of Art in Toronto, teaching would have been a more rewarding experience. But the college "wouldn't have him."[81] It seems that Varley's reputation for doing things in his own uncompromising way was well known to art educators on both sides of the country.

Varley was not one to attach himself to institutions. Unlike Lismer, Harris, and Jackson, he did not take advantage of the growing institutionalization of culture. He dropped his membership in art organizations and refused to join new ones. He failed to secure a teaching position at a professional art school. Unlike his Group of Seven colleagues, he did not give lectures on art or take over the directorship, as Harris did in Vancouver, of an art gallery. Varley was too independent-minded to dance to anyone else's tune, which

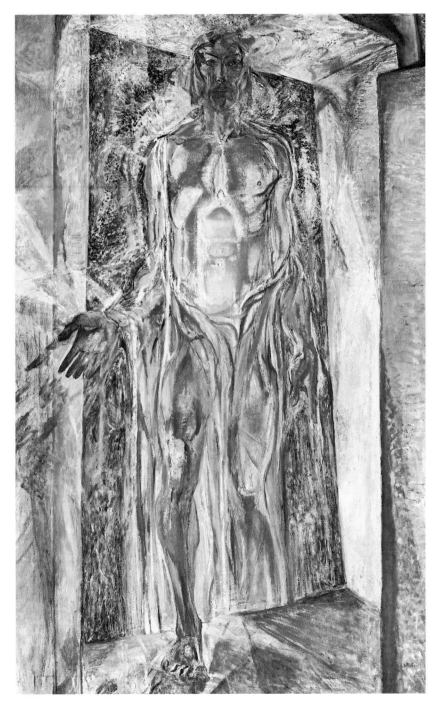

Liberation, 1936.
ART GALLERY OF ONTARIO

Top: *Mirror of Thought*, 1937. ART GALLERY OF GREATER VICTORIA
Above: *Arctic Waste*, 1938. McMICHAEL COLLECTION

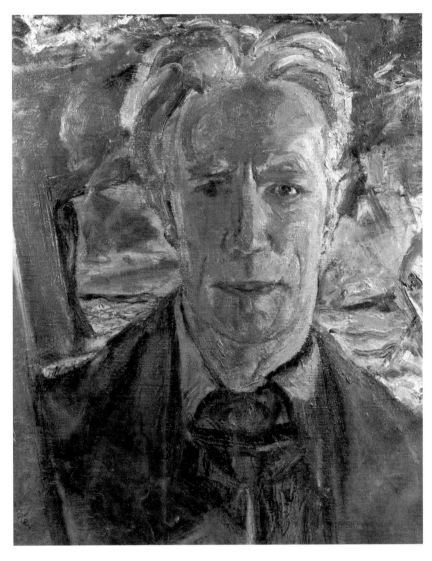

Self-portrait, Days of 1943, c. 1945.

Above: *Moonlight after Rain*, 1947. ART GALLERY OF ONTARIO
Below: The remaining members of the Group of Seven at the opening
of an exhibition of works by Lawren Harris, fall 1948. From left to right:
A.J. Casson, Lawren S. Harris, Varley, A.Y. Jackson, Arthur Lismer.
ART GALLERY OF ONTARIO

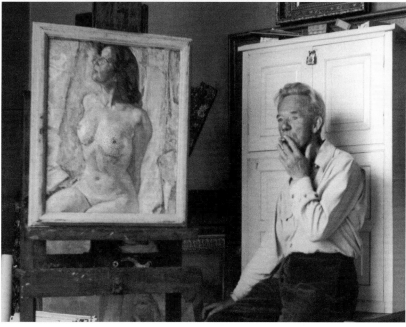

Top: Varley and a group of artists at Doon,
Ontario on a sketching trip, c. 1948.
ART GALLERY OF ONTARIO
Above: Varley at the Doon Summer
School of Fine Arts, Doon, c. 1948.
ART GALLERY OF ONTARIO

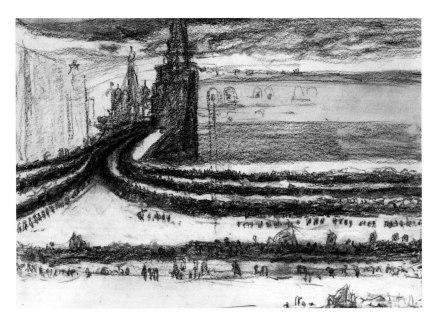

Above: May Day Procession, Moscow, 1954. ART GALLERY OF ONTARIO
Below: Varley in Vosstaniye Square, Moscow, 1954. ART GALLERY OF ONTARIO

Varley in his studio in Unionville, c. 1963. ART GALLERY OF ONTARIO

Above: Varley's sisters, Lily and Ethel, photographed in 1956.
ART GALLERY OF ONTARIO
Below: Varley and Kathleen McKay, c. 1960. ART GALLERY OF ONTARIO

involvement in any of these organizations or institutions would have demanded.

This is not to suggest, however, that he had no influence upon the serious-minded artists with whom he did come into contact during his years in the wilderness. His knowledge of art was always best imparted over a glass of beer, or preferably a tumbler of whisky, when he could relate to a person one-on-one. This is how the young Montreal-born artist Jack Nichols learned "by osmosis." He spent many evenings in Varley's cold bed-sitter-cum-studio in Ottawa watching his mentor's nicotine-stained fingers accompany his soft voice and the constant click of his ill-fitting false teeth. "It didn't really matter what he looked like," Nichols recalled in regard to Varley's appearance, "because when you were in his presence, you felt that you were with someone with real quality."[82]

A little older than Nichols, Henri Masson was less willing to be Varley's listening post. He found his "Asiatic philosophy screwy and would have arguments with him." Varley's dislike of Cézanne was, Masson continued, "very stupid." And his "tremendous admiration" for Augustus John was overblown.[83] Other artists who came within Varley's ambit during his Ottawa years – Harry Kalman, Tom Wood, Gordon Strange, and Leonard Brooks – were more tolerant. Like Nichols, they knew that Varley needed to sound off.

Part of Varley's attraction for these young artists was that he had age and experience on his side. He could remember meeting Augustus John and attending his early exhibitions in the West End of London. He had lived in Edwardian London and had been a war artist during the Great War. Varley liked to talk about his experiences. He was, in the eyes of his young friends, a martyr to his art. He was also an example, or a warning, of where a life of total dedication to, or some might call it indulgence of, an artistic profession might lead: to no-sale exhibitions, few patrons, and poverty.

Within a year of leaving Vancouver in 1936, Varley secured two solo exhibitions. *Frederick H. Varley* ARCA opened at John Heaton's Scott & Sons Art Gallery in Montreal, May 1937. Six months later,

most of this work – forty-five oil panels, canvases, folios of draw-ings, and photographs of Varley's work taken by John Vanderpant – was transported for exhibition at the James Wilson and Company Gallery in Ottawa. Varley was warned not to expect "surging masses clamouring at the doors."[84]

Both exhibitions, for which Varley paid over $100 for mounts and frames, were financial disasters. In Montreal he sold one drawing, one panel sketch (priced at $80 but knocked down to $65), and one watercolour (also reduced, from $65 to $50). In Ottawa the returns were a little better: he sold three works (two drawings and a water-colour) to the National Gallery and a number of paintings to friends. But as the Montreal dealer William Watson noted in his memoirs: "if the exhibition had been a failure, the artist sometimes compensated by assuring me 'it was a great *succès d'estime.*'"[85] This is precisely how Varley chose to see things.

The commentaries in the newspapers and the response of the artists who saw Varley's two solo exhibitions were mixed. Lilias Torrance Newton told Eric Brown that the artists in Montreal were enthusiastic about Varley's "beautiful sketches."[86] Robert Ayre of the *Montreal Gazette* praised Varley for extending "the boundaries of painted Canada" and for making "us realize that we live in a country of more than one climate." In his view, the exhibition proved Varley to be "one of the most important of Canada's painters."[87] An anonymous critic for the *Montreal Star* disagreed. Varley's departure from the literal description of nature was disturbing. The extent to which this reviewer felt that his "experiments in composition and colour" had been used for decorative ends also came into question.[88] In Ottawa, the critics were fewer in number and more favourably disposed towards Varley's work. He had "come a long way since 'Georgian Bay,'" one critic noted. "He uses greens as no one else does and tones them with reds, yellows and blues in strange combina-tions." Varley did have what the same critic called a "curiously indi-vidual" palette, but few, if any, of the commentators knew that he had acquired it from Vera Weatherbie.[89] This was partly because

neither Eric Brown nor Harry McCurry had taken an interest in Weatherbie's art as Varley hoped he would, and left the critics believing that Varley's colour, like Emily Carr's, was attributable to what Robert Ayre called British Columbia's "subtleties of tones and colours, with its almost tropic density of vegetation." Ayre went on to say that Varley had "rooted himself so well out there that in the past few months in Ottawa, when he wanted to paint, it was Vancouver he painted, out of a keen nostalgia."[90]

It is not surprising that Varley continued to draw his inspiration from the British Columbia landscape long after he had left the province.[91] "My years at Lynn were the happiest of my life," he told Jim Varley in 1951, "& the most productive."[92] But it was in Ottawa, he told Vera Weatherbie in 1941, where he had produced his "best paintings of British Columbia . . . out of nostalgia for the West." Certainly Varley never felt comfortable living in the centre of a metropolis, be it Vancouver, Montreal, or Toronto. "I get too damned lonely in a city," he continued in his letter to Weatherbie, "& make any excuse to buy a paper & sit in a pub where others are." Nor did any city in which he lived provide him with exciting subject matter. The sounds of Lynn Valley had become part of him and, as he wrote in 1941, "I still miss their company."[93]

Painting from memory was a skill that Varley had acquired as a young art student in Sheffield and one that he valued as a mature painter. As he told Mortimer-Lamb in 1940, "I think the best work done is when painting memories."[94] *Night Ferry, Vancouver* (1937) and *Moonlight After Rain* (1947) are just two of Varley's many memory-paintings.[95] Recapturing the view from the back of the ferry linking North Vancouver to the city, or from the second-floor balcony of his Lynn Valley house, and above all putting himself into these paintings helped him escape from the psychological implications of his unhappy life in eastern Canada. Asked what function the figure served, Varley told one interviewer that without it the painting would "be a very empty thing and not connected with the impressions or the thoughts" of the artist who had witnessed the scene.

As in the paintings of the Swiss artist Ferdinand Hodler, Varley's stick-like figures represented the underlying harmony of creation in symbolic terms. They were also a compositional device: "You will find that all the lines are connected with that figure," Varley told the same interviewer.[96]

Night Ferry, Vancouver is by far the most accomplished of Varley's memory-paintings. It is as rich in contrasting colours as a work by Rubens. The way in which the moonlight shimmers across the water, almost setting it ablaze, is a tribute to the late watercolour paintings of Turner. Critics did not fail to note "the uncanny quality of reflected light on dark waters and the treacherous turbulence of the wake of the vessel in the black night."[97] But for Varley, *Night Ferry, Vancouver* was more than a celebration of light and colour. Just like *Mirror of Thought* (1937) it evoked the past – Varley as the moonstruck lover, embracing Vera perhaps.[98] It also depicted the present – Varley as the lonely observer of the lovers, the city, and the surrounding landscape. A few days after completing *Night Ferry, Vancouver* Varley attempted to describe it to his former student Margaret Williams:

> Just finished a "34 x 40" of a "night ferry" Vancouver, with a crazy moon stuck on to the sky & peacock feathers playing wimpy tunes on the swirl at the stern with Vancouver looking like Vancouver, Seattle & New York. From the upper deck I look down on a sentimentalist, legs straddled – pretending he's on the high seas & by the side are a couple of crazy people looking at each other and the bally old moon is responsible, darkly responsible. On the left is a glaring light thrown on to a life belt. It looks like a life-saver out of a nickel packet & I wonder whether I can lasso the moon with it – but then I would destroy the dreams of my figures so I leave the moon brazenly nude & remain true to my impression.[99]

Each of Varley's successive memory-paintings of British Columbia became more and more dream-like and more a product of his continuing study of Chinese art. By 1947, when he painted

Moonlight After Rain, he was wrapping the landscape in a swirl of mist which evoked the delicate watercolour paintings rendered by Chinese artists of the Sung dynasty and the fairy-tale illustrations of British artist, Arthur Rackham.

While Varley's memory-paintings were deeply satisfying to him, they were not the kind of work that one expected from a member of the Group of Seven. Varley had built his reputation, with the help of the National Gallery, on his stunning portraits, on his paintings of Georgian Bay, and on his depiction of the trenches in France and Flanders. These were his signature works. And while more sophisticated critics like Donald Buchanan saw that he was the most "lyrical" and "the most luminous of the Seven in his handling of pigment," the paintings that Varley produced during his first two years in eastern Canada were not what the public wanted.[100] Had Varley continued to churn out lookalike paintings of his earlier work – as A.Y. Jackson did – he might have sold more paintings at his Ottawa and Montreal exhibitions, but he knew the difference between the creative work of art and the potboiler. And because he guarded against repetition and pandering to the public, he did not begin to enjoy substantial sales until his interests and the public's expectations came together. This began to happen only when he held his third solo exhibition at the Eaton's Fine Art Galleries in Toronto in 1944. Exhibiting in the city where the Group had made its name and offering the public a subject that two of its members had already popularized, had much to do with Varley's change of luck.

The notion that the Canadian Arctic could be a subject for Varley's art was conceived when A.Y. Jackson travelled to the Canadian Eastern Arctic in the summer of 1928. Jackson and his travelling companion, the amateur artist and prize-winning scientist Frederick Banting, were in search of "new art forms."[101] A year after their voyage, Jackson published a series of black-and-white drawings of

the Arctic landscape in the book *The Far North*. Two years after that Jackson travelled north again. This time Lawren Harris joined him on an Arctic supply ship, the ss *Beothic*. Varley saw the fruits of his two friends' expedition when Jackson's and Harris's landscape paintings and sketches of the Arctic were exhibited alongside other paintings by the Group of Seven at the Vancouver Art Gallery in 1931.

Varley had Harry McCurry to thank for arranging his three-month-long voyage through the eastern Arctic in the summer of 1938. When asked by the deputy minister of Mines and Resources, Charles Camsell, to suggest an artist who might accompany the expedition, McCurry told him that Varley would "be of great value in bringing the North West Territories to the attention of a wider public."[102] Camsell took up McCurry's suggestion and, with only five days' notice, Varley was invited to join the RMS *Nascopie* in Montreal on 9 July.

The eastern Arctic patrol ship's crew, under the supervision of Major D.L. McKeand, included, among other government officials, Terence Shortt, an ornithologist with the Royal Ontario Museum; physiographer for the Geological Survey D.A. Nichols; the post-master, F.R.E. Sparks; historian Mrs. Marion Grange; several RCMP officers; and a few tourists. Varley shared his cabin with the twenty-seven-year-old Shortt. Though in awe of his famous cabin-mate, Shortt recalled that Varley was "rather world-weary when he came aboard."[103] Having broken his two-bottle supply of whisky on his way to the ship, Varley was in a foul mood. He impressed Shortt by ringing for the steward and shouting: "Two doubles for two gents, please."[104]

There is, however, little evidence that Varley reverted to his old ways during the expedition. One month into the voyage he reported being "in dry dock − & somehow I think I'm going to carry on without it − for a day or two."[105] Though Varley told his former student Elizabeth Gowling that he was "more drunk than ever in my life," it was not from alcohol. He was, he continued in a lengthy description of the landscape, "drunk with the seemingly

impossible — the glaciers up the Greenland coast & the weather-rounded mountains, the icebergs, literally hundreds of them floating sphinxes, pyramids, mountain peaks with castles on them, draw-bridges & crevasses, huge cathedrals, coral forms magnified a thousand fold, fangs of teeth hundreds of feet high — strange caves giving out in front of them the intense singing violet of space, until the cave is as unreal as a dream."[106]

Only days before embarking on his 12,246-mile-long journey through the eastern Arctic, Varley was "drawing and painting in a desultory way." But, he continued in a letter to John Vanderpant, "when I get on the train riding away from all this ghastly atmosphere I shall be as a kid having his first holiday."[107] He was. The many letters that Varley wrote during his "90 days of adventure," along with the radio talk he gave on the CBC after returning to Ottawa, leave no doubt that this was a trip of a lifetime. Only five days into the voyage that would take him within 750 miles of the North Pole, he had discovered "a new world."[108]

It was not just the glaciers that intrigued him, but the light. "As light passing through a prism gives us the magic of spectrum colours," Varley told his radio audience when he returned to southern Canada, "so can be an Arctic sky at dawn, at sun down and occasionally through the night." Nor was the landscape any less dramatic when the sun refused to appear during a spell of inclement weather. "On drier days," Varley continued, "colour became precious, ice-floes splinter light into colour, and green of all greens, the translucent glacial green of ice beneath water, the pure violet light edging hollow caves, the sea-washed surfaces of mauve with powdering of pale rose and the palest of yellow-green, put the surrounding grey water to shame and tinged it with a dull smoulder of red like an old Chinese print."[109]

Varley was eager to paint the landscape at every hour of the day and night: "I seldom sleep for fear of missing something," he wrote to Miriam Kennedy from the *Nascopie*.[110] Shortt showed him how he could extend his sketching hours on wind-chilled days by pulling a

sock over his hand and forcing a paintbrush through the weave of the toe: "This protected his hand from the cold and gave good control of the brush."[111] When Shortt saw Varley struggling with his oils – the paint would not dry and remained sticky in the humid weather – he gave him watercolour paint and paper from his own limited supply. Varley "worked so fast and with such intensity that the stock of paper dwindled rapidly." Shortt noted in his diary that Varley complained about the insufficient supply. "Whose bloody fault is that?" Shortt recalled asking Varley. "With that," Shortt noted, Varley "became contrite and apologized."[112] Varley made up for using most of Shortt's paper by helping him to see: "I'd just been *looking at* with eyes but not *seeing* with *brain*."[113]

Shortt remembered Varley accumulating "an enormous pile of sketches and paintings."[114] Both men displayed their work around the panelled walls in the ship's saloon. Their makeshift exhibition gave the passengers a respite from the step-dancing entertainment provided by the Mounties and from the sentimental tunes which screeched from the wind-up record player. It also introduced passengers and crew to Varley's stunning paintings of the barren landscape and to his sketches of the Inuit.

Fearing that the Inuit were "rapidly losing their picturesqueness from contact with the fur traders," Jackson and Banting had publicly criticized the Hudson's Bay Company for "getting the Eskimo off their diet and giving them non-Native clothing & sleeping under canvas instead of under his skins."[115] Varley made no similar observations when he returned from the Arctic. He possessed a highly romanticized view of "the little brown people," who he recalled were "loveable" and "very friendly."[116] He made a point of shaking hands with them when they came on board. (His fellow passengers avoided doing so.) And when he returned south he told his radio audience that "the more north one goes," the more the Inuit became "a more self-reliant purer type."[117] Varley never portrayed the Inuit as individuals. Nor did Varley think that they were in danger of extinction as Jackson and Banting feared. To Varley, the Inuit offered a

compelling subject for his art. Unknowingly, he perpetuated the southern Canadian view that they were smiling, happy-go-lucky children of nature.

Varley told Mortimer-Lamb that he hoped to "bring back a wealth of work for I have been fallow for so long," and he did.[118] Shortt recalled that he and Varley worked "as we had never worked before." While Shortt painted birds and tried his hand at a few coastal profiles, Varley painted and sketched everything in sight. The best works that Varley brought home from the Arctic were not the romanticized sketches of the Inuit but watercolour paintings of the land. *Arctic Waste* (1938), for example, is as fresh and spontaneous as his written descriptions of the land.[119]

When Varley returned from the Arctic he told a friend that he "felt it would be hardly worth while to paint up his sketches for no one in this country would buy the canvases." Nonetheless, he could not resist doing so.[120] He remained haunted by the "iridescent light" that had penetrated the landscape.[121] *Midnight Sun* (1938), which burns with juicy red, mauve, and orange pigments, is reminiscent of Tom Thomson's panel sketches, as it is also of Edvard Munch's paintings.[122] Elements from his Arctic sketches – the island in *Sea Music* (c. 1939–40), for example – crept into his memory-paintings of British Columbia.[123] As late as 1941 Varley was still transposing his Arctic sketches onto canvas or recreating the landscape from memory. "I've painted one iceberg size 16 x 20 with a bloody sky behind and black peaks on the coast line startling the burning clouds," he told a friend.[124]

Though Varley's paintings of the eastern Arctic were included in his Toronto exhibition at the Eaton's Fine Art Galleries on College Street in 1944, it was a rag-bag of a show. There were stunning portrait paintings, the best of which was his sensitive painting of Harvard-trained psychiatrist Dr. Thompson, *Dr. T.* (1944).[125] There were memory-paintings of British Columbia and figurative studies that had been produced alongside his students at the Ottawa Art Association. There was a second version of *Liberation* (1943).[126] There

was a painting of a Canadian bombardier. (This, along with three other portraits, was the result of Varley's much-sought-after war-art commission in 1944.[127]) The entire show was crowded into two rooms: a central gallery containing thirty-five paintings and a smaller room which brimmed with eighty unframed drawings.

As in Varley's two earlier solo exhibitions the reception of this one was mixed. Toronto critic Pearl McCarthy felt that the exhibition showed Varley to be "bigger now" than when he had been a member of the Group of Seven.[128] Ronald Hambleton noted that before the exhibition there had been two kinds of opinion about Varley: "one kind said that Varley was Canada's finest artist and the other said that Varley was all washed up." Notwithstanding Hambleton's dislike of Varley's mystical paintings, he wrote in *Mayfair* magazine that Varley was "Canada's most misunderstood famous painter."[129] *Saturday Night* critic Paul Duval agreed that Varley's talents were "not most happily displayed in this mystical métier." He warned Varley that if he continued to produce paintings like *Liberation*, "he may yet create reason to wistfully wish that people remembered that fine canvas [*Stormy Weather, Georgian Bay*] a little more."[130] He was, on the other hand, favourably disposed towards *The Open Window* (1932), which Varley had produced more than a decade earlier.[131]

Though Varley was annoyed that the reviewers singled out *Stormy Weather* for attention, there is little indication of how he responded to the critical reviews of his Toronto exhibition.[132] He was chuffed by the "crowds of people" who attended the two-week-long show. "Even I myself feel encouraged & more optimistic of the future," he continued, "with added energy to continue for which I am thankful."[133] He was pleased that Eaton's Fine Art Galleries proposed that he exhibit with them again in the spring of 1950. And although sales were limited, Hart House's acquisition of *The Open Window* along with their offer of an exhibition the following January pleased him very much.

Sales might have been greater if more of the paintings and sketches on display had been recent. But much of the work in the

exhibition came from old stock. Varley had little new work to show, partly because his output was low. But that was not the whole story. Mary Konikin, who modelled for Varley five or six times in 1944, remembered that "as soon as one was partially finished and I liked it I would go back for our next session and ask if I could buy it. Each time it had been spoken for and as I remember it, most of them had been spoken for by other artists."[134]

Varley not only needed to have a greater output; he also needed to change his attitude to those few people who did purchase his work. When McCurry became the National Gallery's director upon the death of Eric Brown in 1939, he was repeatedly asked to help Varley. In 1941 McCurry told Polish-born Montreal artist Louis Muhlstock in response to such a plea that "I have done my very best to get people interested but I am afraid our good friend has offended practically all likely picture buyers to such an extent that I find it impossible to pry any money out of them."[135] Two years later, when Lawren Harris told McCurry that Varley was "right up against it," he too received the stock answer.[136] McCurry told Harris how he had tried to drum up portrait commissions for Varley "in a dozen different directions without much result." "I am afraid he is too well known in this part of the country to permit of much success to my efforts," McCurry explained. "If he were a little more reasonable and co-operative there would not be much difficulty."[137]

Varley's difficulty with art patrons was not entirely his own fault. Public and private art patrons were not numerous in Canada during the 1930s and 1940s. Many of those who did buy bought Varley's work on the instalment plan and sometimes defaulted on their payments. Others promised to buy but never did so. "I am continually kept expectant with promises," Varley wrote to a friend in the summer of 1941, "– and the worst of it is people admire me for my so-called integrity to an idea."[138] Even those who did buy, like the Toronto collector Charles Band, who bought *Night Ferry, Vancouver, Complementaries,* and *Dr. T.* among other paintings, liked "to bargain down."[139] Band got the portrait of Dr. Thompson for a third of the asking price.[140] Varley was never eager to part with his work, as his

correspondence with Band shows, and he could be put off by a misplaced word or gesture. When one prospective client saw twelve paintings sitting on a chair in Varley's studio, and offered to take the dozen, Varley shouted, "What the hell do you think they are, eggs?"[141] No sale was made.

Dealing with institutions was no easier for Varley than dealing with the general public. In 1942 the Toronto Art Gallery acquired *Dhârâna* for, allegedly, half its market value. The staff at the British High Commission bought two of Varley's Arctic sketches the same year as a going-away present for the High Commissioner. They were only able to come up with fifty dollars for the gift, so that was all Varley got. In 1939 the Public Archives joined in the shopping spree. They acquired their Arctic sketches for what had become the bargain-basement price of twenty-five dollars each. That was "all they had to spend," Varley told Vera ruefully.[142]

If public and private sales, along with the occasional portrait and commercial-art commission, were not enough to keep Varley afloat, how did he live? Shortly before his exhibition opened at Eaton's Fine Art Galleries in 1944, Varley told Vera Weatherbie that his "lousy half-starved life was only made possible by a few friends who believe in me."[143] According to Miriam Kennedy, Varley "had a whole circle of people who cared a great deal about him."[144] "He picked people," Harry Kalman remembered, "whether they were temporary associations or whatever they were."[145] The violinist Harold Sumberg was shocked by the people Varley associated with in Toronto. They were, he told an interviewer, "positively common . . . and very ordinary people."[146]

Varley met Yorkshire-born Len and Billie Pike in their Ottawa bookstore in 1936. Varley, the Pikes, and their friends crossed the river to Hull at regular intervals to eat pigs' knuckles and sauerkraut and drink beer at Chez Henri in Quebec. Varley met many of his other friends, including budding novelist Elizabeth Smart, at the Ottawa Art Association. He hobnobbed with the young artists at the Contempo Studios, the photographer Alex Castonguay, and,

following the outbreak of the Second World War, the artists who were attached to the Naval Art Section. They all gave Varley studio space and, frequently, painting supplies. Nor were his friends confined to the art world in Ottawa. He befriended the government carillonneur, Percival Price. When he did not want to paint, he would climb the steps of the Confederation Tower on Parliament Hill and share Percival Price's music, and his view. "It was a lovely place for seeing things," the Dominion carillonneur recalled, and Varley enjoyed watching "the changing lights, views in all four directions broken by Gothic tracery, [and] the sunsets."[147]

When Varley tired of the city, there were a number of friends, like Alice and Jim Lane and Len and Billie Pike, who had cottages in the nearby Gatineau Hills. Sometimes he stayed for the weekend. At other times his visit stretched over the week. During a long bout of depression in 1940, Varley moved in with Wing Commander C.J. Duncan and his wife, Rae. Their cottage on Lake Ontario at the Bay of Quinte was a few miles from the Trenton air-force base. There he painted, recovered from his depression, and met the mystery patron who helped to put him back on his feet. Varley never revealed the name of his patron,[148] who was a high-ranking air-force officer whom he met at a cocktail party hosted by the Duncans. The patron had once been helped onto his feet and he wanted to be able to do the same for Varley. Initially Varley responded well. It was money from this source which enabled him to move to Montreal in December 1940. After six productive months, Varley's "guardian angel" stopped sending him money.[149] By July 1941 he was sending "S.O.S." letters to his friends for money.[150]

Varley had no fewer friends in Montreal than he had in Ottawa. He "could always find somebody to stay up all night with," Miriam Kennedy recalled.[151] Philip Surrey, who had recently moved to the city, was a standby. The artists Goodridge Roberts, Fritz Brandtner, and Louis Muhlstock were regular drinking buddies. Varley did not have to leave the city for his night life. Montreal was "a wide-open town uniquely sinful in strait-laced Canada."[152] There were illegal

slot machines and casinos. And there were clubs: the Samovar was Varley's favourite. He enjoyed the floor show and the generosity of the owners who "stood Fred a lot" for black coffee and cognac.

Montreal was not only the centre of Canada's gambling and night club life, it was the centre of the emerging abstract school of painting and of socialist ideas. When Varley moved there in 1940, he looked forward to encountering new ideas that would help him solve future problems for his art. Yet he remained on the fringes of the art world. He was not part of Frank and Marion Scott's socialist-minded circle of composers, writers, and artists. He seemed to be unaware of Fernand Léger's visit to Montreal in 1943. Unlike Philip Surrey, he was not invited to join either the Contemporary Arts Society or the Eastern Group of Painters. John Lyman, who headed both organizations, was a devotee of the Modern French School, which did not make him a fan of the Group of Seven. Nor is there any indication that Varley came into contact with Montreal's Surrealist painters, Paul-Émile Borduas and Alfred Pellan, who had begun to exhibit in Montreal in the early 1940s. Even more surprisingly, Varley had nothing to do with his boyhood friend from Sheffield, who from 1941 was teaching at the Art Association of Montreal. "I saw him once shambling along the street," Lismer told a reporter, "and even when I spoke to him he did not know me."[153]

Varley moved to Toronto in 1944 when his exhibition opened at Eaton's Fine Art Galleries. He remained on the fringes of the art scene. Barker Fairley would have been Varley's most obvious contact there. But "repeatedly drunk" during his visit to Toronto in the summer of 1928, Varley had insulted Fairley's guests. According to Philip Surrey, Fairley did not "want to see him ever again."[154]

Most of Varley's friends during these years were new. He met them at bars and in restaurants — the cocktail bar in Malloney's Art Gallery and Angelo's Tavern were two favourites in Toronto — as well as in the many rooming houses where he lived. Most, like him, were "living from hand to mouth."[155] Even so, Varley's friends, who nick-named him Leo because of his red hair, lent him money when he asked for it — which was often. They took him out for a meal when

he had spent his last five dollars on a tube of paint. They paid his rail and bus fare. (Thanks to Len and Billie Pike, Varley was able to travel to Kingston to fulfil his war-art portrait commissions in 1944.) They bought his work when they could afford to do so and, in the cases of Billie Pike, Mrs. Alan Plaunt, and Louis Muhlstock, also encouraged their friends and acquaintances to buy. Finally, they gave Varley a great deal of encouragement. "Oh Fred, you *must* keep working & working," Alan Beddoe told him in 1940. "Don't be discouraged if you cannot reap large financial returns from your work."[156] And they scolded him. "What is holding you from working more than you do Leo?" demanded C.J. Duncan. "When you have the power to do such things, it's a horrible waste."[157]

Fred Varley earned the attention and care he received from his friends because he, too, could be generous. When he received an occasional windfall from the sale of a painting, his friends helped him spend the money. On one occasion, Bob Hunter stopped by at his Ottawa studio to make a final payment on a sketch. Varley celebrated the event by treating himself and Hunter to one bottle of gin and two quart bottles of ale.[158] Varley was equally popular because he was a good companion. He knew that he was entertaining. "One has the power to talk," he told John Vanderpant in 1938, "and enthuse them with an individual way of looking upon life."[159] He also knew that he was refreshingly different. "Active clear-headed business people of this world enjoy the artist's company," he told Billie Pike in 1942. "He is so different, so impractical and serves as a foil to the sanity of others."[160]

Talk was always wide-ranging with Fred Varley: the affairs of the day, mysticism, and horoscopes, which were as important to him as they had been to his ancestors. An evening with Varley usually spilled into the early hours of the morning. "There was no hope of getting to bed before dawn," one friend recalled, "if you were mixed-up with Fred Varley."[161] He kept Fred Pluto up until 4 o'clock one morning arguing about the perfume of lilacs. Though a stimulating conversationalist, "there was a point," Percival Price noted, "when Fred would go on talking and conversation would come from the

stimulus from the glass he had in his hand and it wasn't the rational Fred talking any more and that could carry on for hours."[162] Similarly, Varley took care with his letter writing. Passages often underwent several drafts and, when he was particularly satisfied with a passage or a well-turned phrase, it appeared in more than one letter. But his writing, like his conversation, lost its lucidity after midnight when he hit the bottle. Then he became sentimental and started churning out nonsense.

Women were Varley's most attentive listeners. They believed in his art and were tantalized by his easygoing way of life. Though small – he weighed 135 pounds – Varley was, despite his rough-hewn face, profoundly attractive throughout his sixties and seventies. According to Jim Leach, there were "a lot of girls who liked Leo" in Toronto. Leach did not "think they slept with him." "He talked to them, they were kind to him and when he was drunk they'd take him home and look after him."[163] "All during Fred's life," Philip Surrey recalled, "some woman appeared from somewhere to help." Women helped him in other ways. They persuaded their husbands to buy his work. They bought him clothing and food. They packed his trunk when he changed cities. They even cleaned his room. When Varley was living in Montreal, "a very attractive one came down from Toronto and stayed at the Ritz." Surrey's wife, Margaret, happened to visit Varley's studio to find the woman "down on her knees washing his floor."[164] Later, in a love letter to Jess Crosby, with whom he had a relationship from 1946 to 1952, Varley catalogued what she did for him: "[She] remakes my shirts – buys my underwear, invites me to dine with her, sleep with her & miracle of miracles, plays the piano . . . she poses for me, gives me advice which sometimes I take and in truth plans *our* future."[165]

Varley's women came from every walk of life. Barbara Delaye was his landlady in Ottawa. Jess Crosby, Miriam Kennedy, and Natalie Kessab were professional women. Most of them were between relationships. Miriam Kennedy had been married to the Montreal poet Leo Kennedy; Ottawa-based Erica Leach was unhappy in her marriage; and Natalie Kessab was recently divorced. Varley liked exotic

women, and when they were not exotic, he made them so. Miriam Kennedy became Manya or Lady from Ethiopia. And Natalie Kessab became Natasha. Kessab, who owed a lingerie shop on Sherbrooke Street West in Montreal, was the most genuinely exotic of Varley's women. Said to be of Lebanese or Armenian descent, Madame Stella, as Surrey called her, "was not young but still attractive and kept Fred supplied with all the booze he wanted." She called Varley "my golden boy" and "my Rembrandt." When Varley fell on her steps during the winter of 1942 and landed in St. Luke's Hospital, it was Natalie Kessab who gave Varley "tender loving care."[166] Though Kessab tried "to take Leo under her wing" she soon discovered that "she couldn't help him."[167] Unable to change her "Rembrandt" she decided that she was not "going to get herself bogged down with someone she didn't have faith in."[168] Kessab moved to New York and, according to hearsay, married a wealthy Greek merchant. She was the second woman to have dumped Varley. A year or so earlier Barbara Delaye had turned Varley out of her house in Ottawa.

Varley was rarely successful with women. When Leonard Brooks went abroad as a war artist with the Navy in 1944, Varley took over the second floor of his duplex in Toronto. "We used to have long talks and he wanted to tell me about his ideas of life and philosophy," Brooks's lonely wife, Riva, recalled. "He tried to influence me," she continued, "to teach me and to contradict me." Varley also attempted to woo Brooks by playing the piano and tried "to create an emotional mood" of influencing her which she did not like very much.[169] When Varley realized the extent to which he had offended the young mother, fruit and flowers would appear on her door the following day.

Those relationships with women that did work — for a time — usually began with a sketch. In 1940 Miriam Kennedy walked into his studio. It was not long, she recalled, before "we were talking about music; he began to draw."[170] The result was one of his most erotic sketches — *Manya* (1941) — and sensuous canvasas — *Sea Music*.[171] During the early stages of courting Jess Crosby, Varley told her in a letter: "I keep looking at the drawing I made on Sunday — It is

tantalising – intriguing is the word." "I've never made a drawing like it before – and," he continued, "when I think of you sitting there looking at me through your falling hair much more lovely than a small mouthed tight-lipped Mona Lisa I am eager and awakened to actively make a hundred drawings and paintings."[172] Varley turned many a plain-looking woman into a beauty. He told Billie Pike that he was scared of natural beauty until he discovered what it concealed. Only then did it become "more fascinating to draw."[173]

Women not only provided Varley with subject matter. "I was important to him," Kennedy recalled, "because I was able to get him to work." Yet "once a person was in his orbit," Kennedy continued, "he had a disregard" for her and consciously set out to destroy the relationship.[174] In other words, when Varley's women ceased to be his muse, he stopped sending them passionate letters with their hints of marriage and stopped promising them that he would take them to Lynn Valley. He then turned cold and became cruel. "I was simply another incident," was how Miriam Kennedy described her relationship with Varley.[175] According to Erica Leach, it was impossible for Varley to be faithful to one person: "He loved women," she told an interviewer, "he was probably faithful to womankind but never to one."[176] Varley's inability to sustain a relationship made him "a funny combination of the most utterly romantic and quite ruthless."[177] Varley was well aware that he possessed a split personality. He attributed the negative side to his profession – artists needed to be egotistical, ruthless, and selfish if they were to create. The unpleasant aspects of his personality were not entirely determined, however, by the profession of his choice.

Irresponsible, erratic, and irrational, Varley exhibited all the signs of an alcoholic. He was not, however, a chronic alcoholic; he was a drunk as described in modern research on this topic. He followed a roller-coaster course of going on and off the booze. "They drink until they can drink no more, then remain dry until they can stay dry no longer."[178]

Varley had been caught in the cycle of drinking and withdrawal ever since he left his mark in Antwerp as a young student. As he

grew older, his sense of failure as a husband, a father, a lover, and an artist, and his loneliness were the triggers that set off a bout of drinking. "I bought a bottle of scotch today excuse being damned lonely – now I've got it & had a drink I want company so what the hell."[179]

He missed Vera Weatherbie more than any other person. "When he spoke of Vera," Billie Pike "got the impression that he was intensely in love with her."[180] Varley wrote to Weatherbie constantly – signing with what he called "the mystic sign" of the cross in a circle. He kept her informed of his work and his life in general. He even sent her descriptions of his body: "weigh 135 lbs – have a concave form . . . my knees don't creak, my feet are not too good, but with strong shoes I manage to retain a seemly balance."[181] Once he had mailed the letter he waited eagerly for a reply. In 1939 he missed Weatherbie so much that "for friendly sentimental reasons," he looked her name up in the Vancouver telephone book only to find that she was not there.[182]

Early in 1943 the tone of Varley's letters to Weatherbie dramatically changed when he discovered that she had married six months earlier. According to Jim Varley his father was "very bitter" about this development.[183] It was not the forty-year age difference between Vera and her husband that upset Varley (Mortimer-Lamb told Varley that "she took rather desperate chances linking herself to an ancient"[184]), nor the fact that he seemed to be the last person to learn of the attachment: Vera Weatherbie had married Varley's old friend Harold Mortimer-Lamb, the person who, along with John Vanderpant, had been a key player in his resettlement in eastern Canada in 1936. Mortimer-Lamb insisted that the marriage "was based on friendship" and that "passion was never a motivating cause."[185] Nevertheless Varley could neither forgive his old friend nor help feeling that Mortimer-Lamb's eagerness to see him settled in the east had had an ulterior motive.

Varley was also remorseful because "as much as he cared about relationships he could never really keep a relationship even on a good on-going friendship."[186] One evening, Harold Sumberg remembered

him becoming "very emotional to the point of weeping visibly about the fact that he always did something to destroy his friends."[187] Certainly Varley had much to regret and consequently much to drink about. Letters from Jim and John Varley told him that Maud was doing her "best to keep active and make the most of things." But it was very difficult, they told their father, "for one of her age to find a livelihood especially when she has a bad heart to watch all the time."[188] He spoke of Maud to Miriam Kennedy "with great regret and sorrow."[189] Though he rarely mentioned Maud to Billie Pike, she was convinced that "Fred drank because of his failure to be a husband and a provider for his family."[190] When it came to his children, Varley was equally incapable of responding. "Dad, won't you please write to Peter and try to encourage him and make him realize what he surely must mean to you," a distraught Jim Varley asked him, "if there's any time during his life he needs a father it's now."[191]

Varley's drinking was also detrimental to his art. Far from stimulating his creative juices, it dried them up. When he moved to Ottawa in 1936 he became more aware than ever of the French school. In his letters to friends and in his conversations with critics he made it clear that he empathized with Matisse, André Segonzac, and Duncan Grant. Although Varley was well disposed towards some of the French modernists, he could not, in his own work, leave the three-dimensional world of illusion and adopt the two-dimensional world that modernist art demanded. Yet Varley's drinking prevented him from taking their ideas — or anyone else's — into his work. Indeed his painting lost its strength. Though Paul Duval noted in 1944 that there was "barely a trace of superficial cleverness" or "hardly a line which is traced without sensibility," he observed "a hesitant feeling almost timidity" in his work.[192] Others, like Leonard Brooks, noted "this kind of tentative thing" in Varley's painting too. Varley had a horror of repeating himself: "I condemn my work and repaint, mercilessly destroying the way ingrained through habit." He confessed that he was "afraid of making an ass" of himself and did not have the confidence to override his fears of repetition.[193]

The fact that his work, during these years, became more and more dream-like, and that he was "getting away more & more from fact," did, at times work in his favour.[194] Surely his oil portrait of Erica Leach, *Erica*, which he painted in Montreal in 1942, shows the extent to which he could loosen up the background and experiment with a wide range of colours.[195] But, for the most part, the work that he produced following his trip to the Canadian Arctic was weak. His landscape paintings of the Ontario countryside are among his poorest paintings after his maturation as an artist. Far from stimulating his growth as an artist, his move to eastern Canada had brought all of his weaknesses to the fore.

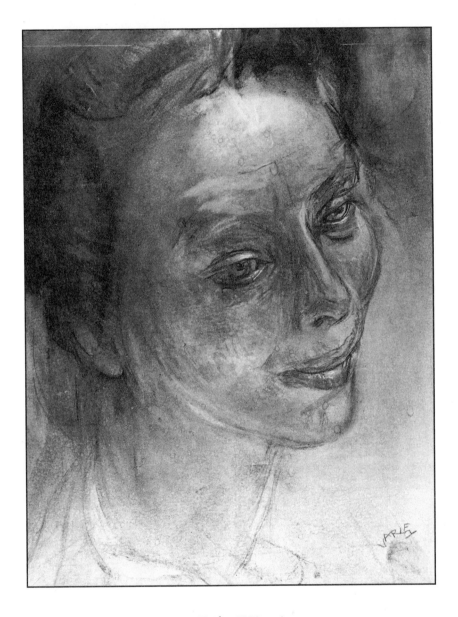

Kathy, 1953.

ART GALLERY OF ONTARIO

CHAPTER 9

The Grand Old Man

"**M**e thinks, I must get me a love, not an adventure," Varley wrote to his friend Billie Pike in 1941. He expressed his wish to develop a relationship that would last him "another 30 years."[1] Less than two years later, he told Miriam Kennedy that he was scanning the personal columns in hopes of finding "a lone spinster bemoaning her shrivelling virtues but willing to loosen her purse strings."[2] After moving to Toronto from Montreal in the winter of 1944–45, he was "praying for a wealthy widow who worships art with a capital A," as he put it to Vera Weatherbie, "she must be very very old."[3]

Kathleen Gormley McKay was not old – she was fifty-two compared to Varley's seventy in 1951 – and she was not even wealthy. But Kathy, as her friends called her, did worship "art with a capital A," and in particular she worshipped Varley's painting. "Oh Darling," she told him in 1955, "can I tell you how I believe in you and in the greatness of the paintings you create?"[4] An amateur artist herself, Kathleen McKay admired and supported Varley's talent; she became his soul mate. She sympathized with his regret at being passed over by the art establishment. She cautioned him against being "too quick to condemn and destroy" his own work.[5] And when he received a letter from Maud and carried it around in his pocket for days because he was afraid to read it, McKay told him to forget the past because it was "dead and gone."[6]

A graduate of the Royal Conservatory of Music in Toronto, McKay had sung in Healey Willan's prestigious choir. After meeting

Varley in 1951, she enjoyed singing with him. Listening to music with Varley was also a "wonderful experience."[7] Kathy, like Varley, was also a film buff; they saw *The Red Shoes* six times. And, like most of the women who became involved with Varley, Kathy McKay enjoyed a drink. She threw great parties at which she ladled out the martinis from a three-gallon punch bowl.

There is conflicting evidence as to how Fred and Kathy met. In old age McKay recalled that she met Varley by chance at the Roberts Gallery.[8] Other evidence suggests that she approached Varley with the idea of commissioning him to paint a portrait of her husband.[9] And yet another source suggests that, in response to her professed wish "to do something really practical for art," a friend told her to look after Fred Varley.[10] Kathy then wrote to Fred, so this account goes, paid a visit to his studio, and that was that.[11] What is certain is that Kathy and her husband, Donald, bought a painting by Varley sometime in 1951. A year later, they asked him if they could purchase another. "We have decided to leave our pictures when we die to the [Toronto] Art Gallery," Kathy told Fred when she approached him on this second occasion.[12]

Kathy and Donald McKay were living in genteel poverty when they met Fred Varley in 1951. A successful food chemist with Crosse & Blackwell, Donald was stricken, in his early fifties, with multiple sclerosis. Confined to a wheelchair, he was forced to make ends meet by converting his palatial Lowther Avenue home in downtown Toronto into a rooming house. The McKays took Varley into this home as a non-paying guest when he fell ill during the winter of 1952–53. After Kathy McKay had nursed Varley back to health, he continued to occupy the living room. Thus in 1952 Donald McKay acquired a chess partner, an admirer of his vast collection of classical recordings, and a competitor for the attentions of his wife.

Moving into the McKay household brought Varley's long relationship with Jess Crosby to an end. Their friendship had been built on their mutual Yorkshire background – Varley called her his Emily Brontë – and on their love of literature, music, the landscape, and

art. (Like most of Varley's women, Jess was an amateur painter.) The relationship had also been sustained by Jess's tolerance of Fred's drinking: "I had more than once picked Fred up off the floor in his studio drunken and cold," she later told Peter Varley, adding: "If you regard the person at all, you love them more."[13]

When Kathy McKay entered his life, Jess, with whom he had planned to found an art centre at her cottage in Belfountain, Ontario, was slowly cast aside. Though the break-up in 1952 "wasn't too friendly," Jess insisted that "it wasn't Fred's fault." The couple had been together, in one way or another, for over ten years and Jess was lonely after Fred left: "I used to think, if I could just have an opportunity to see Fred again." One of her last meetings with her former lover took place at Varley's Grenville Street studio. Jess walked into the studio just after Fred had had a fight with Kathy. "She had scratched his face and the blood was running," Jess recalled.[14]

Jess Crosby was not the only person who was unhappy about the sudden appearance of Kathy McKay. Alan Beddoe, who spent a day with Varley in the autumn of 1954, was not pleased either. The two men, who had been friends in Ottawa in the early 1940s, met in the autumn of 1954 at Angelo's Tavern. After consuming two bottles of Chianti, they visited the Art Gallery in Toronto, then walked to Lowther Avenue. Kathy had prepared them "a magnificent dinner." Following it, Fred played the piano and everyone sang until 3 a.m. Though a jolly evening was had by all, Beddoe felt compelled to write to Varley about his new acquaintance a few days later. Using the metaphor of a river, Beddoe told him that "you have allowed yourself to run into little confining side eddies that have kept you from the main stream of life." The diversion was, of course, Kathy McKay. "The little lady there is really very sweet and delightful — 'a thing of beauty and a joy' — but," he insisted, "not for you Fred old top!" Beddoe felt that the *ménage-à-trois* held "no real happiness" for either Fred or Kathy. Familiar with Varley's mercurial temperament, Beddoe advised him to get the "hell out of that place before your turbulent soul pours itself out into a destructive torrent

of regrettable scenes." Having seen little evidence that Varley was painting during his visit, Beddoe added that, at the age of seventy-three, Varley was "still a young and virile being" with many years of good work ahead of him.[15]

Beddoe clearly saw Kathy McKay as an obstacle to his friend's career. But Varley had already begun to paint less – and less well – before Kathy McKay appeared in his life. Far from sapping his artistic talent, Kathy, like all of Varley's women, gave it a new lease. Vera Weatherbie had been his Florentine or Botticelli woman, Natalie Kessab and Miriam Kennedy his exotics. Older and more mature than these women, Kathy was his Leonardo da Vinci woman. Varley based his 1953 graphite and chalk drawing *Kathy* on Leonardo's silver-point drawing, *Profile of a Lady*. Varley knew this exquisite drawing well. It was illustrated in his much-loved copy of Martin Johnson's *Art and Scientific Thought* (1949). Kathy McKay got Varley painting, too. In *Studio Door* (c. 1953) he brought her petite figure, quick movements, and perky demeanour to life in his most successful oil painting of the 1950s.

Varley was right when he referred to Kathy McKay as "his guardian angel."[16] She provided him with a home, bought him clothing, gave him confidence, and managed his career. "That little lady, Mrs. McKay, she's got a keen business head," Varley told an interviewer in 1964, "and she's got a retentive memory, she can remember every blessed thing, every person, what they like and what they say and so on."[17] Kathy McKay's "keen business head" steered Varley through complicated picture sales and difficult transactions with patrons, government officials, and gallery curators. It was McKay, not Varley, who took advantage of the conditions which made him a minor celebrity from the mid-1950s onwards. It was McKay who took him to Mexico, New York, the Gatineau Hills, and back to his beloved British Columbia – though not to the coast – in order to give him new material for his art. It was McKay who embraced Varley's hard-luck story and encouraged him to tell it to radio and television interviewers, to reporters and art historians, and to anyone

else who would listen. Finally, it was McKay who kept that story alive long after Varley had died.

Varley's luck had begun to change even before he met Kathy and Donald McKay. In 1949 Allan Wargon and Tom Daly decided to make a film about his life and art. The National Film Board had already produced short documentaries: *Canadian Landscape* (1941) on A.Y. Jackson; *West Wind* (1943) on Tom Thomson; *Klee Wyck* (1947) on Emily Carr; and the eponymous *Lismer* (1951). Now they wanted to add Varley to their list. They approached Varley that November. He liked the idea. Daly and Wargon wanted to shoot the film in his Grenville Street studio, but it was too "cramped and cluttered," so the producer and the director supervised the construction of a new studio. Identical to the old studio, apart from the movable walls, "Fred was delighted with the result & felt right at home."[18] And, Daly also noted, he enjoyed "being his own actor."[19]

In February 1953 Varley attended the premiere of the film at the National Museum in Ottawa. Two months later he joined the large crowd who saw *Varley* for the first time at the International Cinema in Toronto. Louis Applebaum's music, Denis Gillson's dramatic camera work, and Varley's gentle voice-over created a haunting mood. The impression Varley left on the viewer was one of indifference – to comfort, to food, and to public affairs. "Let's see what's happening in the world," Varley says as he picks up a newspaper. "War, fear, misery . . . aaah!" he exclaims then throws the newspaper aside.[20] Scenes like this left no doubt as to who was Canada's most bohemian artist. As the critic for *Canadian Art* observed, "Here in twenty minutes is revealed the very moving tragedy of an artist-genius, now beaten down by the world's malaise and then raised to great heights of creative perfection by his own loving search for form."[21]

The Canadian public did not hear much more about Frederick Varley until the following year when the *Globe and Mail* reported that

he and several other "representatives of the arts in Canada" had been invited "to see Russia's cultural achievements by the U.S.S.R. Society for Cultural Relations with Foreign Countries."[22] Cultural exchanges between Canada and the Soviet Union had been maintained throughout and following the Second World War. A collection of landscape paintings by Jackson, J.E.H. MacDonald, and Thomson, among other artists, had been presented to the U.S.S.R. by the Toronto-based Writers, Broadcasters and Artists War Council, of which Jackson was the art adviser. Exhibitions from the Soviet Union, albeit mostly photographs, had been shown at the National Gallery in Ottawa and circulated throughout the country. Three Soviet writers had visited Canada and Soviet films had been screened by the National Film Board. Now, in the spring of 1954, the National Council for Canadian–Soviet Friendship made it possible for a group of Canadian artists and writers to visit the Soviet Union. The cost of the three-week-long trip, which took the six-member delegation as far north as Leningrad and as far south as the Caucasus, was financed by the Soviet government.

It was a propitious moment to travel behind the Iron Curtain. Stalin had died a year earlier, in March 1953; travel restrictions had been relaxed; and the Canadian government was eager "to exploit the present Soviet willingness to establish more peaceful and normal relations between the two big blocs."[23] When Toronto artist Eric Aldwinckle asked what the repercussions of visiting the Soviet Union might be for a Canadian citizen, a Department of External Affairs official assured him that "the official attitude here [to the Soviet Union] is entirely neutral, there is no official approach or disapproval of visits of this kind."[24]

The Russian-based Society for Cultural Relations with Foreign Countries presented the Canadian party with a gruelling itinerary. Varley and his five travelling companions spent the first five days of their trip in Moscow, then flew to Tbilisi in Georgia, then to Odessa on the Black Sea, then back to Moscow, where they took the midnight train to Leningrad. The schedule was arduous for a man of Varley's age – he was seventy-three – and all the more difficult because

he had never been on an airplane before. In less than three weeks, Varley visited art academies and collective farms, attended opera and ballet performances, watched a football match and medieval folk dances, listened to a Cossack choir, and took in the architectural sites of wherever he happened to be. The food was as overwhelming as the schedule was hectic. It was not the quality but the quantity that posed a problem, since Varley ate little at the best of times and was even known to go without eating altogether. On more than one occasion he was overfed with a meal which consisted of smoked salmon and salad, followed by cold boiled vegetables, sliced ham and pickles, dessert, and large helpings of black bread and vodka.

Though well looked after, Varley, along with almost every other member of the party, came down with the flu. Already suffering from an arthritic leg, which remained swollen throughout the trip, he was the hardest hit. Eric Aldwinckle, the only other artist in the group, nursed him back to health on more than one occasion. A commercial artist, the English-born Aldwinckle had been an official artist during the Second World War. The two men got on splendidly. Aldwinckle admired Varley's "courage" and was "amazed at his physical stamina."[25] Even so, he had a difficult patient on his hands. During Varley's most serious bout of illness, Aldwinckle found him standing in the lobby of their hotel in Moscow preparing to join the festivities associated with the May Day parade. It was under these circumstances that Varley sketched *May Day Procession, Moscow* (1954).[26]

Though Kathy McKay had given Varley a travel diary, it was Eric Aldwinckle who proved to be the better chronicler of the two men. He recorded both his own response to the Soviet Union, and that of his companions. Told by their guide that the pillars in Tsar Nicholas II's summer residence, Tsarskoe Selo, were made of wood and not of marble, Aldwinckle noted: "When no one was looking the intrepid Mr. Varley scratched a small mark with his finger nail, and sure enough, it was as they said, plastered wood with such a high finish and clever treatment of marbling that it was difficult to believe possible."[27] Impatient with the rigid art administrators at the Academy

of Arts Institute in Leningrad, Varley asked: "Is art to go down to the level of the people? Should it not lift up people to the level of art?" This question set off a heated argument over the merits of abstract painting. Varley and Aldwinckle found themselves defending a style wtih which they were otherwise out of sympathy in order to challenge their hosts' defence of "the use of story telling." The discussion ended as abruptly as it had begun when the Russians asked: "What is the Group of Seven?" Neither Aldwinckle nor Varley managed to give their Russian hosts a satisfactory answer.[28]

The hectic itinerary left Varley and Aldwinckle little time for their own work. Varley did fill one sketch book with drawings of buildings, people, processions, and of the Kremlin, which, he told Kathy McKay, was "a dream picture of exquisite beauty different to anything I have seen & reminds me of fairy tales of the Arabian nights."[29] It was not what Varley produced on his trip to the Soviet Union that was rewarding to him, but what he saw. The collections of modern and Renaissance European art in the Pushkin Gallery in Moscow and in the Hermitage Museum in Leningrad, and icons in the churches "cast a spell" over him. The "majesty of stage effects and perfection of the dance" in a performance of Prokofiev's *Cinderella* were no less impressive. It made him "completely drunk."[30]

Underlying Varley's obvious enjoyment of Russian culture and of what the Russians had imported from Europe was the realization that "the creative spirit" was being imprisoned by the lack of encouragement.[31] Though highly critical of Socialist Realist art, he could find no fault with the ability of the artists. "Never among all my hundreds of pupils have I seen work so fluent and competent," he told a reporter after viewing the preparatory sketches of a group of students in Leningrad. When it came to finished work, however, the result was "dead and meaningless."[32] It was "terrifying and tragic, to see excellent artistry of technique" used for propaganda.[33]

On the journey home, Varley could have stayed in Prague – where he had to leave the plane in any case to be revaccinated because he had lost his vaccination papers in the Soviet Union. Or he could have visited Amsterdam and travelled from there to Paris or to London.

But Fred was homesick. He missed Kathy McKay. "I am not breaking my time by going to Paris or England," he wrote to her from Moscow on May Day. "That can wait, I want to see you too much."[34]

Varley was also anxious to be back home because the Art Gallery of Toronto was in the process of mounting a major exhibition of his work. The gallery's director, Martin Baldwin, had approached him the previous January. The news had made his "old blood" pump and glow and he had promised "to assist in every way possible."[35] The additions which Varley made to the group of paintings that Baldwin had already chosen when he returned to Toronto ensured that *German Prisoners* (1918) and a greater number of sketches of the eastern Arctic and of Lynn Valley were included in the show.

The public's enthusiasm in Canada for culture in general, and for the work of the Group of Seven in particular, was high during the two decades following the Second World War. Just as the National Film Board of Canada was capturing some members of the Group of Seven and their followers on the screen, so the National Gallery of Canada was producing silk-screen prints of their paintings, Ryerson Press was publishing monographs on their work in the Canadian Art Series, and the Art Gallery of Toronto was giving solo exhibitions to Lawren Harris in 1948, Arthur Lismer in 1950, Jackson in 1953, and Varley in 1954. In 1957, six years after the report of the Royal Commission on the National Development of the Arts, Letters, and Science, the federal government established the Canada Council and shored up the existing cultural institutions which it had helped to create. James Auld summed up the mood of the 1950s and 1960s when he wrote: "'Let's save our landmarks,' could be the theme of a growing spirit in Canada."[36]

F.H. Varley, Paintings 1915-1954 opened in October 1954 at the Art Gallery of Toronto. The exhibition had a second venue at the National Gallery of Canada, a third at the Montreal Museum of Fine Arts, and a fourth at the Vancouver Art Gallery. Everywhere the

exhibition was mounted, Varley received a great deal of attention. At the National Gallery of Canada opening in Ottawa, Harry McCurry compared Varley in stature to Augustus John.[37] In Toronto, the art critic for the *Telegram* pronounced his signature work, *Stormy Weather, Georgian Bay* superior to Thomson's *West Wind* (1917).[38] In Vancouver, Mildred Valley Thornton called Varley "the most able and versatile Canadian artist of his time."[39] And at the premier at the Montreal Museum of Fine Arts, Arthur Lismer told three hundred people: "He has no predecessors. He has no followers. He's a strange wayward and rebellious individual – a painter who reveals an environment in us and makes us the richer for it."[40]

The retrospective nature of the exhibition made it clear that Varley had done his best work during three periods of his life: the Great War, the six years following it, and the decade that he spent in British Columbia. All of the work from these periods belonged, as Carl Weiselberger noted in the *Ottawa Citizen*, to another epoch. "Such a romantic attitude," he warned his readers, "spells danger in an age that frowns upon romanticism."[41] George Swinton agreed. He told his readers in the *Queen's Quarterly* that, while Varley was "an exquisite draftsman," his late-nineteenth-century English romanticism was not only out of keeping with contemporary tendencies in art, but lacked "a certain conceptual stature."[42] Swinton regretted most of all that Varley had "never quite lived up to his magnificent war painting." Like previous critics of Varley's work, Swinton put his finger on Varley's weak point: the tentative or mystical quality that had characterized his paintings since the early 1930s. "It is perhaps this compassionate and humanist attitude in the philosophic-literary sense which limits the quality of his paintings *as paintings*," Swinton wrote. "But," he continued, "I venture to guess that his stature as keeper of an older and important tradition will grow as the years go by."[43]

Varley fared better when Swinton set his work against the other members of the Group in the *Winnipeg Tribune*. Jackson and Lismer had not substantially changed their style since the 1920s; Harris, who had become an abstract painter in the mid-1930s, had altered his style

too dramatically for the approval of most people. Swinton felt that Varley had taken a radically different course from his colleagues: "Where the Group was romantic Varley was mystic, where the Group was heroic Varley was lyrical, and, where the Group indulged in virile starkness Varley suffered from his passionate humanism."[44]

Varley reinforced the lone-wolf status that Swinton and other critics gave him during the course of the exhibition whenever he had a chance to do so. Just after the show opened in Toronto, he told a reporter that he had no case against groups, "it is simply that I work and think better alone, without the doubtful aid of wire-pulling."[45] On the other hand, his membership in the Group of Seven had initially been "a good thing." As he told the reporter: "We joined forces for several reasons: unity against public ridicule, companionship, money, influence."[46] But as the catalogue accompanying the retrospective exhibition made clear, Varley's association with artistic groups belonged to the formative years of his career.

The critics and the public alike were fascinated as much by Varley's personality as they were by the paintings and drawings in the show. "If you can separate the man from the painter," George Elliott wrote in *Canadian Art* in 1954, "you will see a restless creative spirit trapped in a cycle of recurrent despair."[47] As Jackson predicted, there was nothing of Varley's "*escapes, his seductions, wife desertion*, and general disrepute" in the exhibition catalogue.[48] In the catalogue accompanying the exhibition, the essays by Jackson, which recounted Varley's achievements as a war artist, by Jock Macdonald, which told of Varley's Vancouver years, and by Charles Band, were tame. Only Lismer in his essay dared to note how "Toronto hardly missed him," when he moved to Vancouver and how difficult it had been for Varley to keep "the pot boiling without doing a single pot-boiler."[49]

It was left to Varley himself to provide the public with a fuller account of his life. When Jock Carroll interviewed him for *Weekend Magazine* in 1955, Varley attributed his wayward behaviour to his artist ancestors. Cornelius Varley had "spent half his time in debtors prison." The brother of John Varley, Cornelius had been a mystic "who prophesied death and disaster for various people." His own

father, Samuel, had made him into a rebel at an early age by trying to persuade him "to give up this crazy idea of being an artist."⁵⁰ Maud had allegedly put an early end to his career as a writer when she destroyed the novel that he had all but completed before leaving England in 1912.

It was not just what Varley told reporters that added to the Varley legend: it was the way he behaved during an interview. Jock Carroll, who met Varley at his favourite restaurant, Angelo's Tavern, took delight in noting how, after consuming one bottle of Chianti, Varley asked: "Let's begin drinking, shall we?" When Varley described himself as "a man who gets an old-age pension and spends it drinking beer," Carroll passed it on to his readers. When McKenzie Porter interviewed Varley for *Maclean's* four years later, he revelled in describing Varley's "bouts of wine, women and song." He made the comparison between Varley and Joyce Cary's artist character, Gulley Jimson, in the novel *The Horse's Mouth* (1944).⁵¹ Varley was not, however, amused when he read Porter's cameo portrait of himself. "They made me out a roué," he told another reporter a year later in self-defence.⁵² Reporters, especially those living in "Toronto the Good," did not usually openly refer to the drinking habits of artists, or of anyone else for that matter, in the press. By the end of Varley's retrospective exhibition, however, his fondness for alcohol and women, his debts, his poverty, and his rebellious outlook had become public knowledge. Varley could always be counted on to provide good copy for any journalist who was willing to interview him over a bottle – or two – of wine at Angelo's Tavern.

Part of the reason Varley's retrospective exhibition was so successful was that most of the work in the show came from the middle years of his career – 1915 to 1938. Only five of the ninety works on display had been painted since 1950. Varley needed new work if he was going to carry his reputation through the 1950s. But Toronto, where he felt "imprisoned in the drab atmosphere of city life with its extremes of

riches and poverty," was not the place to do it.[53] Nor was British Columbia. However much he longed to paint the landscape of his beloved Lynn Valley, the fear of running into Maud kept him out of Vancouver. The Maritimes, however, were on the other side of the country. Dr. J.S. Goldie, who had a small country practice in the village of Whycocomagh on the shore of Lake Bras d'Or on Cape Breton Island, made Varley an offer he could not refuse: "a reasonably comfortable bed, a gross sufficiency of food and a completely uncomplex existence."[54]

Dr. Goldie, who had recently retired from the British army, was suffering from cancer. According to Allan Wargon, who introduced Varley to the forty-seven-year-old doctor, his "dying was more energetic than most people's living." "He roars around the countryside in a Buick car or a jeep, depending on the terrain," Wargon continued, and "sails a boat, keeps house for himself and cooks famous dishes."[55]

Dr. Goldie's friend, manufacturer and art colleague Cooper Campbell, drove Varley the 1,300 miles from Toronto to Cape Breton in May 1955. Varley's initial response to the landscape surrounding Whycocomagh was positive: "it must be next door to Heaven."[56] A week later, however, Varley's spirits fell when banks of fog and drenching rain made the heavily wooded islands, scattered throughout the lake, totally invisible. The weather improved in July, but Varley was no happier. He told his sister Ethel: "Many times I wish I'd journeyed farther afield and come to British Columbia," adding that "I would have done much more work."[57] Varley had expected so much more from the landscape: "Great seas, white horses galloping on to a bleak weather-beaten shore – to taste the tang of the sea winds on your lips." What he got instead was "the easy curve of the hills – the horizontals of floating islands, the waters of the lakes, tranquil and passionless except when a gust of wind whips up 4 inch waves with a spurt of foam on the crest."[58]

Varley's low spirits were not due entirely to the poor weather, the tame landscape, or to the fact that he was pining for Kathy McKay. Nor was the problem one of perceiving the landscape: "Today I made a composition for a large canvas – and another note

of colour beyond anything I have known." The problem lay, rather, with his inability to transform onto paper or canvas what he saw and what he felt. "What shall I do?" he asked Kathy McKay. "Just go on & I scrape out about everything I paint and next time I will *get* what I want."[59]

Faced with the challenge of living up to his new-found reputation, Varley lost his nerve. The watercolours that he produced during his five-month stay in Maritime Canada are weak and unsure. His colour is dull and unsubtle. Though Goldie was no art expert, he noted that Varley's work "mirrored the dissatisfaction he felt at the placidity of the scene," and consequently was "poor."[60]

When, in mid-October, the deer-hunting season made the woods treacherous for artists, things improved. This was when Varley began a portrait of Dr. John, as he called Goldie. It turned out to be a rewarding experience for both men. Varley rediscovered his *métier* – portraiture. While sitting for his portrait, Goldie realized how "calm, unruffled, untroubled etc." Varley could be.[61] Varley saw another side of Goldie too. He saw "deeper than my perpetual bluff and depicted me as the fellow I thought was unknown to anybody except myself," Goldie told Cooper Campbell in amazement.[62] By the time the portrait was roughed in the two men had come to know one another well.[63]

From the moment Varley arrived and opened his suitcase, revealing a dozen bottles of Black Velvet whisky, Goldie had his work cut out for him. He attempted to curb Varley's drinking, resorting to tactics which were singularly successful. Goldie was "brash and tough," "critical and a teetotaller," "impatient and forceful." For a time Goldie felt as though he was losing his battle with Varley. After Goldie locked what remained of the whisky in a cupboard, Varley caught a lift to the nearby town of Birmingham to replenish his stock. "There is a fountain of youth there," he told Goldie upon returning to Whycocomagh. "I got some rye."[64] Goldie persisted. Gradually he "saw a healthier and more active Fred emerge, thanks to diminished alcohol intake and vast doses of vitamins." Varley's appetite improved; he put on weight. And, apart from an occasional

lapse, his drinking all but stopped. As the weeks progressed, Goldie told Cooper Campbell, he "became aware of the basic fineness of the man and grew to like him a great deal." But all of Goldie's work was undone when, towards the end of the summer, Kathy and Donald McKay arrived from Toronto. Varley suddenly had two drinking companions. "The visit ended in a frightful scene which raged all night at their hotel," Goldie concluded, "and finished in my place at six a.m."[65]

In the late autumn of 1955 Varley left the Maritimes and travelled to St. Andrew's East in Quebec in order to paint the portrait of a young geologist, Tupper Porter. Dr. Goldie was left with mixed feelings. Giving an account of Varley's visit to Cooper Campbell, Goldie insisted that he was richer for the experience. But fifteen years later — having outlived the dire prediction of the doctors — he told Peter Varley that he "never drank until this evil man" came into his life. Apparently towards the end of his stay Goldie had been unable to resist Varley's repeated invitations to join him for a drink. Nevertheless he told Peter Varley: "I loved your Dad."[66]

However poor Varley's work was, he had produced enough during his five-month visit to Cape Breton and had sufficient work from his years in British Columbia in his bottom drawer to accept Jack Wildridge's invitation to exhibit at the Roberts Gallery in Toronto. Douglas Duncan had been Varley's dealer since the early 1950s, but Varley had never been happy with this eccentric man. "I cannot understand his ways," he told a friend in Vancouver.[67] Varley's decision to show exclusively at the Roberts Gallery was a good choice. Wildridge, the director, was familiar with Varley's work, having previously sold the occasional painting. The gallery had a versatile stock of artists and a reputation for supporting Toronto's emerging abstract painters as well as its more traditional artists.

When his solo exhibition at the Roberts Gallery opened on 11 February 1956, Varley characteristically had $52.59 in his savings

account at the Bank of Montreal. When the exhibition closed a couple of weeks later, his account had soared to $2,751.89.[68] And when all of the returns from the sale of work had dribbled in by early April, his account climbed to $5,573.41.

Pleased with the sales, Wildridge offered Varley another solo exhibition the following year. The 1957 show was also a sell-out; this time Varley's earnings were $3,809.08 after the gallery had taken its 33 1/3-per-cent commission. But it was Varley's 1961 solo exhibition at the Roberts Gallery, when he was 81, that hit the jackpot.[69] Sales on the first day of the show totalled $17,900. The sale of sixty-six of the seventy-five works on exhibition was big news. The story appeared in the Canadian edition of *Time*.[70] Lawren Harris told a friend that he was thrilled by Varley's success: "He'll be more wealthy than ever and be enabled to pay a number of his creditors!"[71] Varley's prices continued to rise. In 1966 sales totalled $21,000. And in 1980 a work by Varley broke all records. *Summer in the Arctic* (1939) sold for $170,000, beating the sale of a painting by the nineteenth-century artist Cornelius Krieghoff by $30,000.[72]

In 1957, when he was seventy-six, Varley for the first time earned enough money to be required to pay income tax. The same year it was Varley, and not his friends, who paid for his own paint supplies, canvas, stretchers, frames, and sketching trips. In 1965 he travelled to the Gatineau Hills near Ottawa and to the hills of Vermont in the United States. In 1966, Kathy and Fred took an art tour of Mexico, which included Mexico City, San Miguel de Allende, and Cuernavaca. From 1956 to 1967 he and McKay made annual sketching excursions to British Columbia. (They avoided Vancouver by flying to Calgary and driving from there to the Kootenays in the southeastern corner of British Columbia.) This landscape was, of course, different from the coast. The mountains were, like the Derbyshire hills in the Peak District of his youth, made of limestone, not granite. There was little underbrush and the trees were predominantly pine, cedar, and sumac. But the Kootenays did bear some resemblance to the coast. The Selkirk and Purcell Mountains

were almost as high as the Coastal range and the trees grew to the edge of the lakeshore.

On all of these trips, with the exception of that to Mexico where he fell ill, Varley produced work for sale at the Roberts Gallery. Much of it was poor and Varley knew it. "I need to bang around and suffer to paint well," he told McKenzie Porter in *Maclean's* — "there are no jagged pieces about me any more."[73] The critics were no easier on him. They had been polite and respectful at his first exhibition at the Roberts Gallery. They had called Varley a Canadian romantic, describing his Cape Breton landscape paintings as "virtually all reflective in mood."[74] Five years later the gloves were off. The British critic Eric Newton had pronounced Varley's work "uneven" during a visit to the artist's Ottawa studio in 1937.[75] But this observation had been confined to the art critic's travel diary. In 1961 Paul Duval noted in the *Toronto Telegram* "the thoughtless inclusion" of two paintings and the addition of "a few commonplace items scraped from the bottom of the Varley drawer." Even Varley's new work was rendered "virtually the same in style as those painted decades ago."[76] Their resemblance to Varley's earlier work was precisely why they were popular.

It should not have surprised Paul Duval that Varley's paintings were "being snapped up like wet flies."[77] A decade earlier Pearl McCarthy had set Varley's "pursuit of truth" against the "clever art" of the non-objective painters who were challenging traditional painting.[78] As the decade wore on, Varley's representational paintings became a foil against the growing popularity of non-objective painting. As early as 1952, two of the four artists representing Canada at the Venice Biennale were abstract artists — Alfred Pellan and Guy Robert. Four years later, non-objective painting received the support of the National Gallery of Canada when it mounted the exhibition *Canadian Abstract Painting*. A number of observers, including A.Y. Jackson, disapproved; he criticized the National Gallery in 1958 for "pushing abstract art."[79] Throughout the decade, private galleries in Toronto — The Park, Jerald Morris, and Avrom Isaacs — and in

Montreal – Galerie Agnès Lefort and Galerie du Siècle – supported modernist trends. By the early 1960s abstract painting was in full bloom and Jackson accused "the non-objective boys" of running the show, adding that "anyone who paints from nature is supposed to be weak in the head."[80] As with most of Jackson's comments about abstract painting, this one was highly exaggerated. There continued to be a large audience for the Group of Seven. As Varley told an interviewer in 1964, the Roberts Gallery were selling his paintings "like hotcakes."[81]

A look at Varley's British Columbia sketch books reveals the extent to which his work had reverted to the English watercolour tradition of his ancestors, Cornelius and John Varley. His sketches of cloud formations, of sky effects, and of other details of the landscape are like preparatory sketches for nineteenth-century watercolour paintings. He produced large drawings of the Selkirk and Purcell mountain ranges, of Kootenay Lake, of Goat Mountain, of the picturesque town of Kaslo, and of whatever he and Kathy happened to see when they stopped their car on the verge of Highway 3. These drawings showed nothing of the Chinese masters who had begun to influence his work during his years in Vancouver. As one reviewer noted in 1966: "Almost all of Varley's drawings at the Roberts Gallery show are laid out in the same way: foreground, middle ground and background as seen from a frontal point of view." "Set in rows along the gallery walls," wrote the reviewer for the *Toronto Telegram*, "the cumulative formula effect is somewhat disillusioning and even more distressing because the drawings represent Varley's work over an extended period of time."[82] Few of these ballpoint and graphite drawings were ever worked up into finished watercolours and oil paintings. That they remained in such a raw state did not matter to Varley. Art was a process, a means to an end: "I am only trying to get outside my own being, clarify my own being so that I can go ahead a little more." Roughing out a scene, even in ballpoint pen, enabled Varley to commune with nature – and to keep working. "I feel guilty if I am not working," he told an interviewer at the age of eighty-five.[83] When Lawrence Sabbath asked him what

period was the most fruitful, he replied, "Just now."[84] In this sense Varley remained closely bound to the Buddhist belief in The Tao, or The Way. A few years before his death he claimed that "It is the Way that leads to perfection and spiritual life."[85]

Varley's work was selling well from the mid-1950s onwards. He had lived long enough to see his work recognized, and to reap a rich harvest of honours. In 1961 he received an honorary LL.D. from the University of Manitoba. In 1962 he was presented with the Civic Award of Merit by the City of Toronto. Two years later, the Canada Council awarded him their medal – it came with two thousand dollars and a photograph session with Yousuf Karsh. The same year, 1964, Varley got a second retrospective exhibition, this time at the Willistead Art Gallery in Windsor, Ontario. In 1965, the National Film Board produced another film, *Varley at 85*; the University of Toronto's Hart House Art Gallery mounted an exhibition of his portraits; the National Gallery of Canada threw a dinner for the Group of Seven; and the name of a small town near Toronto was changed to Varley. "How do you feel about having Varley Village named for you?" Allan Wargon asked him in *Varley at 85*. "That's damn silly," Varley expostulated. "I don't belong to the place, it's ridiculous."[86]

The public honours which came Varley's way during these years were matched by the private tributes he received from friends and former students. Writing from Vancouver, Vera Weatherbie told him how much she had enjoyed "seeing the old favourites" at his 1954 retrospective exhibition.[87] Other former students and associates wrote too. "I'm Sadie (Shaw) remember me?"[88] "You probably don't remember me," wrote another, "I was one of your models at the V.S.A."[89] "I was in your class at the Vancouver School of Art," Vito Cianci told him in 1961, "but I want, even at this late date, to let you know that my contact with you has proved over the years to be rewarding, and your influence lasting."[90] Frank Horratin, whom Varley had taught during his student days in Sheffield in the 1890s, wrote to say "Cheerio" after seeing reproductions of Varley's work in McKenzie Porter's article in *Maclean's*.[91] Fellow artists, like the sculptors Frances Loring and Florence Wyle, reminded him of

the happy times in Toronto during the 1920s when they had been "all foolish together."[92] Jack Nichols told a television interviewer of how Varley had encouraged him during the decade in Ottawa.[93] And Charles Band, who gave the toast at Varley's annual birthday parties, told the gathering in 1964, which included Donald and Kathy McKay, Barker Fairley, and A.Y. Jackson, among others, that he owed Varley "a great deal" for helping him cultivate his taste and understanding of painting.[94]

Perhaps the most significant event, following Varley's retrospective exhibition in 1954, was his trip to England two years later. Varley's contact with his remaining siblings, Ethel and Lilian — Alfred had died in 1944 — was sporadic after he returned to Toronto in 1920. News that Lilian and Ethel were sharing their "paltry pittance" of a pension with Maud was disturbing to Varley. Even worse was the "lashing" that Lilian gave him "for leaving the kids."[95] The lashing humbled him into silence. "As you know I kept writing to you years ago," Ethel told her brother in 1950, "but your silence shut me up, except in one way and that was by thinking of you every night." "Time after time when your name has come up in conversation," she continued, "my answer to all criticism has been 'I don't know,' 'We don't know both sides.'"[96] Tension mounted between Varley and his sisters when in 1955 Ethel received Jock Carroll's *Weekend* article on her brother in the mail. Varley's claim that his father had tried to steer him into commercial art struck a sore point with Ethel: "He recognized your genius or he would never have sent you to Antwerp."[97]

Relations between Varley and his sisters improved in February 1956 when Ethel saw the National Film Board's *Varley*. She was clearly moved by the experience: "I wanted to clasp you in my arms and mother you." "It was always your face I looked at," she continued. "Oh, it was all great." Lilian was too ill to attend the screening. But Ethel and Miss Hibberson, who had been a fellow pupil at the Sheffield School of Art, joined the seventy-odd members of the Sheffield Society for the Encouragement of Art on a snowy evening in the middle of winter. Ethel gave Varley a full account

of the proceedings: "Everyone in the room seemed to be immersed in the tense atmosphere so that when – quite suddenly – the word 'The End' came there was a simultaneous groan of 'Oh!'"[98] Seeing her brother and his paintings and drawings on the screen helped repair the damage. "Who would have thought when you emigrated to Canada," she told him a few years later, "that the name VARLEY would live there forever as a result of your work."[99]

In giving an account of *Varley* the following day the *Sheffield Telegram* announced that Fred Varley was returning to Britain to exhibit his work in London.[100] Since the late 1930s, Varley had repeatedly told his sisters that a London exhibition of his work was imminent. In 1937 he had written to John Vanderpant with the news that "my sisters are fully expecting to see me in England this spring."[101] In 1950 he told Lilian and Ethel that he expected to have "a one man show there in the late Fall."[102] And in 1955 he promised his sisters, once again, that "my retrospective show which has travelled east to west in Canada is, in the Autumn of 1956, to be on view in London & other cities in England."[103] Varley did exhibit two landscape paintings in a small exhibition titled *Canadian Painting* in London at Fortnum & Mason in January 1955.[104] Whatever plans the Art Gallery of Toronto may have had to send Varley's retrospective exhibition to England the following year never materialized. It was only when Varley had the resources from his solo exhibition in February 1956 that he was able to answer Ethel's oft-repeated question: "I wonder whether we two will ever meet – you and I – and talk over old times."[105]

Jack Wildridge encouraged Varley to make the trip to England. Donald McKay gave his rival permission to take his wife with him for company. Kathy McKay recalled that just before the couple left Toronto, "Don put both arms around Fred's neck" and said: "I'm just lending her to you because I can't go myself."[106] When Fred and Kathy boarded their ship in New York a few days later, there were a dozen roses in their stateroom – a farewell gift from Donald McKay.

Varley not only wanted to visit his sisters. He also wanted to experience the English spring and to see the places that he had known in London before, during, and following the Great War. In

the first part of his 1956 sojourn he showed Kathy his favourite paintings in the Tate and National galleries, attempted to view the work of John Varley, and took her to see the Elgin Marbles, housed in the British Museum. They ate watercress sandwiches at a pub on Regent Street that Varley used to frequent. Some of the places associated with Varley's past – his studio near Battersea Park, for example – were difficult to locate. Other places that he did find proved to be disappointing. The Bond Street galleries, where he had first seen the drawings of Gwen and Augustus John and was introduced to the war paintings of Paul Nash and C.R.W. Nevinson, were "full of pot boilers."[107]

A couple of weeks after arriving in London, Varley announced to Ethel, by letter, that he was in England and would be visiting her in Sheffield within a few days. "What a thrill you gave me this morning," Ethel answered on 27 April by return post. "I read the great news over and over again before I could take it all in."[108] Four days later, Kathy and Fred left London. "He got more nervous every minute he got near Sheffield," McKay recalled.[109] When the train pulled into the station there was no one there to meet them. Disappointed, they struggled with their luggage onto a succession of noisy trams. Finally, they reached the suburb of Meadow Head, climbed up a steep hill, and found Ethel and Lilian's modest home on Greenfield Road. The house was full of memories. The antique furniture, the books, the two paintings by John Varley, and the piano were all from his parents' home. Varley and his sisters picked up the conversation from where they had left it over thirty years earlier. "They were like children the way they talked to one another," was how Kathy recalled their remarks – "Fred, if you tell me how much money you have, I will tell you how much I have."[110] The reunion was far from happy. At eighty-one, Lilian was deaf and going senile. Ethel, four years younger, was suffering from rheumatism. Weighed under by the task of looking after her housebound sister, whom she refused to put into a home, Ethel made do with the help of part-time maid.

Kathleen McKay's recollections provide the best evidence of this visit. She reported that at one point, "Lilian took my face in her two hands and looked into my eyes for the longest time and said, 'you can trust her Fred.'" Varley "was tremendously pleased," when Lilian did this.[111] Even so, "there were brushes" between Varley and his sisters throughout the visit. Seeing Fred as the youngest sibling and the only surviving male of the family made Ethel want "her very famous brother to come back and live with her and to do what she wanted."[112] Thoughts of Maud and the children cast a shadow over the visit. Varley found the situation "terrible utterly awful," and told McKay, "Thank God, dear, I have got you."[113] After showing her the family home in Havelock Square, after taking day trips to York and to the picturesque village of Eyam, and after planting some flowers in the small front garden of his sisters' home, Varley announced that he and Kathy were leaving for Ireland.

This part of the trip was more successful. Fred paid a chauffeur to drive him and Kathy around Northern Ireland. Then they took the train to Dublin, booked into the Royal Hibernian Hotel, and set out for the National Museum of Ireland, where Varley was "completely thrilled" by the portrait paintings of Jack Butler Yeats and his fellow war artist Sir William Orpen.

Though Varley had told Ethel and Lilian in 1950, "I must come back to England, which is my home," like Arthur Lismer, who returned to England for a visit in the late 1930s, Varley found that "he didn't like the English very much."[114] "He had expected to be welcome in Sheffield as he was in Canada," Kathy McKay recalled, "but he wasn't, nobody knew him."[115] According to Peter Varley, the visit "was a very unfortunate occasion."[116]

Even had Varley received the long-hoped-for solo exhibition in London, things would probably have been little different. The work of his peer, Augustus John, was passé. The traditional watercolour paintings of J.M.W. Turner were out of fashion too. Varley's work was not only informed by these two artists, but by his encounter with pre–First World War trends in commercial and Scandinavian

art and the discovery of the unpopulated landscape as a motif for his art. Set against the Festival of Britain atmosphere, which celebrated the post-war modernists Graham Sutherland, Henry Moore, and Ben Nicholson, Varley's work looked anachronistic. Varley had lived long enough to see his place in Canadian history established. But his reputation, built on Canada's need in the 1950s and 1960s for cultural heroes, was not exportable. Varley's art belonged to an earlier epoch of Canadian painting. He contributed nothing to the post-war history of Canadian art. He openly admitted that he had no sympathy with abstract art: "I can't understand it," he told Lawrence Sabbath in 1960. He was incapable of recognizing "art as being the concept of the mind of *one.*" For Varley, the creative process demanded a rapport with the figure or the landscape that he was painting: "I don't like anybody who puts themselves before the nature surrounding them."[117]

Following his trip to England, Varley corresponded with Ethel on a regular basis. There was much reminiscing on both sides. Referring to the many newspaper reports which accused her father of inhibiting Varley's career, she reminded her brother what he had written to her from Antwerp: "Pray that I may be successful Ethel not because of myself but because of Father for it will please him so."[118] Ethel took pride in quoting from this letter which she had carried around in her handbag since receiving it in 1900. She was willing to set her pride aside, however, when it came to money. "Dad died without a penny," she reminded Fred in January 1965. Worried that she might end up "in the same fix as Dad if I live many more years," she asked Fred for help.[119] Varley did not reply. Kathy McKay took over his side of the correspondence. "Why do you not write yourself?" Ethel asked him a year later. "In my last letter from Mrs. McKay, she says I am your enemy." Things had clearly changed, Ethel concluded, "since your Antwerp days when Dad and I were your best friends."[120] Eventually not even Kathy corresponded with Ethel

who, with her sister Lilian's death in 1957, was now alone. In 1969 she complained to Peter Varley: "I can't write to him because they send my letters back."[121]

Varley's correspondence with Vera Weatherbie stopped too. Now Kathy McKay, along with Charles Band, supplied news of Vera to Fred. Varley's former lover had virtually put her own painting aside. "We live a most uneventful existence," Vera Weatherbie told Charles Band in 1967, "we have lost our interest in painting as it is presented today."[122] She spent most of her time nursing her much older husband, Harold Mortimer-Lamb, who was "a chronic invalid" though he lived to the age of ninety-eight.[123] The newspaper references to Varley's favourite model were another burden for Vera. In 1964 she had a nervous breakdown, apparently "because of the gossip."[124]

Maud Varley, on the other hand, was of little interest to journalists. They ignored her until she celebrated her one hundredth birthday in 1986. So did her former Toronto friends, Lawren and Bess Harris, who were living in Vancouver. Molly Bobak stumbled across Maud in the late 1950s – "she came to my door selling Avon cosmetics." Although well into her sixties, Maud, who had not benefited from Fred's turn of luck, was still working. To Bobak's surprise, however, "she had no malice or bitterness against her husband."[125] Maud did, however, possess a few early paintings by Fred and by Tom Thomson. Money from the sale of these works took her back to England, paid for a trip to Hawaii, and helped support her to her one hundredth year. Yet if she expected anything from Varley upon his death, she was to be disappointed. In January 1962 Varley made Kathleen McKay the sole beneficiary of his estate, which amounted to $22,000.[126]

Although Varley had cut Maud completely out of his life, he did have news of her through his children. "Mother fell on the ice last January and had a very nasty break," Peter Varley informed his father in 1955.[127] "Mum is in a senior home," Dorothy told her father.[128] It was to Jim Varley that he had poured out his heart from Montreal in 1942: "I have never been more lonely in my life."[129] And it was John

Varley who almost persuaded his father, around the same time, to return to British Columbia.

More like his father than any of the other children, John was a superb draughtsman who could "beat his old man in drawing." According to Orville Fisher, "in Fred's mind there was always a competitive spirit" between Varley and his eldest son. Yet John's colour-blindness and his delicate health — he had an ulcerated stomach — prevented him from following in his father's footsteps, or from pursuing a career in any area of the visual arts. Like his father, however, he took to the bottle. When Fisher encountered him in the late 1960s at the Alcazar Hotel in Vancouver, "he was completely loaded."[130]

Peter, the youngest of the Varley children, had the least contact with his father during his formative years. "I believe now," Varley observed in 1944, "that was Peter's gain."[131] Yet it was Peter who, following his move to Toronto in the early 1950s to work as a commercial photographer, carried the family torch. In 1968 he secured a seven-thousand-dollar senior research grant from the Canada Council to make an inventory of his father's work and to collect manuscript material pertaining to his life. His intention was publicly signalled: "All information gathered — photographs of the works, copies of letters and papers, tape recordings — will be placed in The National Gallery archives for the use of scholars and researchers."[132] Peter Varley did gather a great deal of material; he deposited the Varley Inventory in the National Gallery of Canada in 1973; and he produced a loving portrait of his father in book form when he published *Frederick H. Varley* in 1983. But the research material that he had gathered was not given to the National Gallery and did not find its way into a public institution until 1995, when the National Archives of Canada bought it from him.

The Varley children had "mixed feelings" about Kathy McKay's role in their father's life.[133] She was notoriously possessive — as one friend put it, "Kathy had a heart of coal."[134] Yet as Varley became increasingly infirm — he was in and out of hospital throughout the 1960s — it was Kathy who looked after him. Jim and John were

grateful to her for taking care of him. And they knew that her task could not have been easy: "Kathy must have suffered many strains & anxieties in the past few years," John told Peter in 1968.[135] This was, indeed, an understatement. Varley's old friend, Billie Pike, remembered how he lashed out at Kathy and the nurses who, during the late 1960s, looked after him around the clock.[136] Jess Crosby visited Varley at St. Michael's Hospital in March 1965 when he was seriously ill after a fall earlier that year. "I caught him in a bad humour," she recalled, and "with his pants down." Feeling "caught out," Varley ignored her.[137] Kathy McKay enjoyed regaling the few visitors who made the pilgrimage to Unionville, to pay homage to Varley, with stories of his mischievousness. "Once during a drinking spell," she told Joyce Putman, Varley "walked around in the rain in beautiful downtown Unionville with nothing on but an umbrella." "Another time, Kathy was trying to get a bottle of booze from him, and he chased her and the bottle outside the house." She could "see that he was gaining on her, and in desperation she threw the bottle away — right through her own front window."[138]

The annual announcements of Varley's birthday in the press insisted that he was painting, that he still possessed prodigious energy, and that when he was ill he made a quick recovery.[139] As one journalist reported in 1959, "during one of his periodic drinking bouts, Varley fell down stairs, remained unconscious for two days, then suddenly he recovered."[140] Varley fell again in 1964. "You really are quite indestructible," Dr. John Goldie wrote when he learned that Varley had recovered from the accident.[141] This time, however, Varley was not making the miraculous recovery that his friend and the public expected. On his last trip to British Columbia in 1967 he did not sketch.

During the last two years of his life, Varley required constant nursing. (Kathy used the proceeds of his picture sales to pay for this care.) In November 1968 John Varley told Kathy McKay to give his father "warmest regards, if he remembers me."[142] Excessive alcohol consumption had altered the tissue in his brain. Ethel Varley asked Peter how her brother was in April 1969. Peter's description of his

father's decline over the last two years was not pleasant. Though there was a lot of laughing and joking, "You can't talk to him rationally," he told Ethel. "He can walk with somebody," Peter continued but "his legs do hurt quite a lot."[143] Fred spent most of the last year and a half of his life watching television.

Yet Varley held out longer than some of his friends. Four other members of the Group of Seven, who had lived more abstemious lives, were dead by the summer of 1969: J.E.H. MacDonald had died in 1932, Franklin Carmichael in 1945, Frank Johnston in 1949, and his old friend Arthur Lismer in March 1969. His generous patron, Charles Band, died in the summer of 1969. Lilian Varley died a year after Fred's visit to England. And Dolly Gardiner sent Varley the love letters that he had written to her deceased sister, Barbara Delaye. Varley outlived Donald McKay by one year, though he did not survive the indestructible husband of Vera Weatherbie, Harold Mortimer-Lamb. Nevertheless, Varley held out until 8 September 1969. "He had not been well," Kathy McKay recalled, "and I went upstairs in the morning to his room." When McKay pulled back the covers of Varley's bed he had "solid purple legs." Aware that he was suffering from circulatory obstruction, she rushed him by taxi to the Centennial Hospital in Scarborough. After overcoming some admission problems, Kathy went home to fetch her car, then returned to find that Peter Varley had arrived. "They wouldn't let me see him," she recalled. Then the doctor appeared. "I think we almost lost Fred," she blurted out. "Kathy dear, we did lose him," he replied.[144]

A year before his father's death, John Varley wrote to his brother Peter that he hoped that Fred would "go up in smoke & have his ashes scattered over the mountain streams." It was during a camping trip to Garibaldi Park in the mid-1930s that Varley had told his son how he wished to be buried. "I understood that he meant it as a kind of gesture of freedom," John continued, "to be released & 'spread out' over the mountain country he loved."[145] John was not around to

ensure that this was carried out. Suffering from alcohol abuse and stomach ulcers, he died, aged fifty-eight, a week before his father. The three Varley children who survived their father tried to sum up their feelings for him. Speaking into a tape recorder one summer day a little more than a year after their father's death, Dorothy, Peter, and Jim all agreed that despite Fred Varley's inconsistencies and irresponsibility, they had loved him very much. Jim spoke best when he said: "We all know he was an old bugger."[146]

Fred Varley was cremated. His ashes were not scattered in Garibaldi Park or in Lynn Valley. Like Arthur Lismer, who predeceased him by five months, Varley was public property. Like national treasures, these two members of the Group of Seven were given a quasi-royal burial. The place was a bit of consecrated ground covering a hill overlooking the Humber River. It lay adjacent to the only gallery in the country devoted to Canadian art. As early as 1965 A.Y. Jackson noted that the McMichael Art Gallery was "becoming a kind of shrine to the Group of Seven."[147] Four years later, two members of the Group were buried there and one – A.Y. Jackson – was living above the gallery.

Mirroring Varley's life, the weather on the day of his funeral, 18 September, was unsettled. The sky was alive with dark clouds which threatened to drench the group of thirty-seven mourners who had gathered to see off their old friend. Then, just as the Reverend James Tiller was about to read the service, the sky cleared to an almost sunny brightness. After he finished, Barker Fairley, now eighty-two, read a poem that he had composed while he and Varley had been on a canoe trip near Split Rock at Go Home Bay in 1928. Then Barker Fairley, along with A.Y. Jackson, A.J. Casson, Jack Wildridge, Kathy McKay, Howard Harris (the son of Lawren Harris), artists Isabel McLaughlin and Yvonne McKague Housser, and others, watched as the tiny white pine casket embossed with the words F.H. VARLEY 1881-1969 was lowered into a small opening in

the soft earth. Thirty paces from Varley's grave was a small white pine tree. Jackson had planted it five months earlier to mark the burial place of Arthur Lismer.

On the day of Varley's funeral the CBC presented "A Tribute to Fred Varley." Along with the many newspaper articles announcing Varley's death, it singled out his years as a war artist, his landscape paintings of northern Ontario, and his signature piece, *Stormy Weather, Georgian Bay*. Few commentators failed to note that Fred Varley was a rebel by nature and that financial success came to him only in his seventy-fifth year. Speaking on the CBC radio program, Maud, Kathy, and Varley's many friends attempted to give a composite picture of the artist. Yvonne McKague Housser chose to remember his beautiful colour; Gerald Tyler, a former student at The Vancouver School for Decorative and Applied Arts, his "absolutely terrific" teaching; and Maud, the fact that "his work was the only thing that ever mattered." Many of the old myths, like Samuel Varley's opposition to his artistic career, were revived. But it was Varley's black-and-white character which dominated the program. Henri Masson insisted that Varley was "a complicated man" who was "mixed up." Cultural critic Robert Ayre claimed that Varley "would rather drink than eat." Barker Fairley gave a different picture. He insisted that "Varley the lush, Varley the lecher, Varley the dissolute immoral" did not represent the truth.[148] Varley might well have agreed with these disparate views. As he once told a former student: "Sometimes I'm Jesus and sometimes I'm the other fellow."[149]

The Varley Family Tree

Richard Varley *(1751 – 1791)*

m. Hannah Fleetwood *(1750 – 1821)*
- John *(1778 – 1842) artist*
- Hannah *(1780 – 1826)*
- Cornelius *(1781 – 1873) artist*
- Elizabeth *(1783 – 1864)*
- William *(1785 – 1856)*

m. Elizabeth Thew *(dates unknown)*

Richard *(1771 – 1834)*
Samuel of Thorne *(b. April 6, 1775)*

m. Sarah West *(m. 1797)*
- Mary Ann *(b. 1798)*

m. Elizabeth Rider *(m. 1798)*
- Richard *(died at birth)*
- Betty *(b. 1802)*
- Sarah *(b. 1804)*

m. Mary Stickney *(m. 1805)*
- William *(b. 1806)*
- Richard *(b. 1807)*
- John *(b. 1810)*
- **Samuel** *(b. 1812)*

Samuel Varley *(b. 1812)* **m.** Elizabeth Bloom *(m. 1843)*

Samuel Joseph Bloom Varley *(1849 – 1934)* **m.** Lucy Barstow *(1851 – 1935, m. 2 January 1874)* Mary Elizabeth Bloom Hadfield
- Lilian *(1875 – 1957)*
- Alfred *(1876 – 1944)*
- Ethel *(1879 – 1970)*
- **Frederick Horsman Varley** *(1881 – 1969)* **m.** Maud Pinder *(1886 – 1988, m. 1910)*
 - Dorothy *(1910 – 1974)*
 - John *(1912 – 1969)*
 - James *(1915 – 1988)*
 - Peter *(b. 1921)*

NOTES

Abbreviations used in notes:

AEAG Agnes Etherington Art Gallery
AGO Art Gallery of Ontario
CBC Canadian Broadcasting Corporation
EAG Edmonton Art Gallery
MCACA McMichael Canadian Art Collection Archives
NAC National Archives of Canada
NGC National Gallery of Canada
PABC Public Archives of British Columbia
PAO Public Archives of Ontario
SCA Sheffield City Archives

CHAPTER I

1. See appendix for family tree.
2. C.M. Kauffmann, *John Varley 1778-1842* (London, 1984), p. 36.
3. NAC, Sound Archives, CAVA/AVCA 1991-0105, J. Russell Harper interview with Kathleen McKay, May 1975.
4. *Ibid.*
5. *Illustrated Guide to Sheffield and Neighbourhood* (Sheffield, 1971; originally published 1862), p. 9.
6. Edward Bradbury, "Sketching Grounds: The Peak," *Magazine of Art* (1879), vol. II, 176.
7. Ann Bermingham, *Landscape and Ideology: The English Rustic Tradition 1740-1860* (Berkeley, 1986), p. 193.

8. NAC, Sound Archives, CAVA/AVCA 1991-0105, J. Russell Harper interview with Kathleen McKay, May 1975.

9. John Mackenzie, *Propaganda and Empire* (Manchester, 1984), p. 16.

10. *Illustrated Guide to Sheffield and Neighbourhood* (Sheffield, 1971; originally published 1862), n.p.

11. The original sketches are in the Sheffield City Archives, L.C. 190.

12. AGO, Varley Papers, CBC, F.H. Varley, "My Job" [typescript], 22 May 1939.

13. Samuel Varley's father, Samuel, and his mother, Elizabeth Bloom Meggett Varley, gave birth to their son, Samuel, on 28 December 1849 at 6 Hemingford Terrace in Islington.

14. Helen C. Long, *The Edwardian House: The Middle-Class Home in Britain 1880-1914* (Manchester, 1993), p. 12.

15. CBC, Ethel Varley interviewed by Peter Varley, April 1969. According to Kathy McKay, the name Horsman came from a wealthy uncle in Chicago. National Archives of Canada, Sound Archives, CAVA/AVCA 1991-0105, J. Russell Harper interview with Kathleen McKay, May 1975.

16. CBC, Ethel Varley interviewed by Peter Varley, April 1969.

17. Professor William Ripper, who was a science teacher at the Central High School, became principal of the Sheffield Technical School in 1895.

18. AGO, Varley Papers, Ethel Varley to F.H. Varley, 12 December 1955.

19. AGO, Varley Papers, F.H. Varley, CBC, "Frederick H. Varley (no trimmings), A Yorkshire Man from Sheffield" [typescript], n.d., n.p.

20. CBC, Ethel Varley interviewed by Peter Varley, April 1969.

21. *Ibid.*

22. *Ibid.* The woman Samuel Varley would have married, according to Ethel, lived near Hull in Yorkshire.

23. *Ibid.*

24. *Ibid.*

25. *Ibid.*

26. *Ibid.*

27. AGO, Varley Papers, Ethel Varley to F.H. Varley, 7 May 1964; CBC, Ethel Varley interviewed by Peter Varley, April 1969.

28. AGO, Varley Papers, Ethel Varley to F.H. Varley, 7 May 1964.

29. CBC, Ethel Varley interviewed by Peter Varley, April 1969.

30. *Ibid.*

31. *Ibid.*

32. Frances Power Cobbs, "The Duties of Women: A Course of Lectures, 1881," cited in Pat Jalland and John Hooper, *Women From Birth to Death* (Brighton, 1986), p. 127.

33. Joanna Bourke, "Housewifery in Working-Class England, 1860-1914," *Past and Present* (May 1994), no. 143, p. 181.

34. NAC, CAVA/AVCA 1991-0105, J. Russell Harper interview with Kathleen McKay, May 1975.

35. AGO, Varley Papers, CBC, F.H. Varley, "My Job" [typescript], 22 May 1939.

36. *Illustrated Guide to Sheffield and Neighbourhood* (Sheffield, 1971; originally published 1862) p. v.

37. SCA, MC5887, Frederick Varley Papers.

38. Dianne Sachko Macleod, "Art Collecting and Victorian Middle-Class Taste," *Art History* (September 1987), vol. 10, no. 3, p. 345.

39. According to Peter Varley, his father entered the Sheffield School of Art at the age of eleven. However, Varley's name does not appear in the annual reports at the School until 1895. This would put his entrance to the School at the age of thirteen. Moreover, since the directories for the school are not extant beyond 1899, there is no record of Varley after this date.

40. E.D. Mackerness, "Art and Art-Instruction in a Nineteenth Century City: Sheffield," *Art History* (September 1978), vol. 1, no. 3, p. 261.

41. "Reports of National Competitions 1895, 1896, 1897," *The Artist* (London, 1897), p. 366.

42. *Supplement to the Directory, containing Illustrations of Works executed by Art Students showing the Principal Stages of Art Instruction* (London, 1891).

43. George J. Cox, *Art and "The Life": A Book on the Human Figure, Its Drawing and Its Design* (New York, 1933), pp. 53, 107.

44. *Still Life, Skull and Lantern* (c. 1897), ink on paper, 22.5 x 30.3 cm., McMichael Canadian Art Collection.

45. AGO, Varley Papers, F.H. Varley, CBC, "Frederick H. Varley (no trimmings), A Yorkshire Man from Sheffield" [typescript], n.d., n.p.

46. MCACA, Varley Papers, "Art Master's Death," unidentified newspaper clipping.

47. F.H. Varley to Peter Varley, undated (c. 1952), cited in Christopher Varley, *F.H. Varley, A Centennial Exhibition*, The Edmonton Art Gallery, 1981, p. 16.

48. George Elliott, "F.H. Varley – Fifty Years of His Art," *Canadian Art* (Autumn 1954), vol. XII, no. 1, p. 3.

49. MCACA, Varley Papers, "Art Master's Death," unidentified newspaper clipping.

50. Elizabeth Nutt came to Canada in 1919, Arthur Lismer and Hubert Valentine Fanshaw in 1911. See Michael Tooby, *Our Home and Native Land: Sheffield's Canadian Artists* (Sheffield, 1991).

51. *Proceedings at the Conversazione of the Sheffield School of Art* (14 February 1896), "Address and Distribution of Prizes by John D. Crace" (Sheffield, 1896), p. 18.

52. *Proceedings at the Conversazione of the Sheffield School of Art* (19 February 1897), "Address and Distribution of Prizes by James Orrock, Esq. R.I." (Sheffield, 1897), pp. 22, 28.

53. NGC, E.S. Nutt Papers, Elizabeth Nutt to H.O. McCurry, 22 December 1937.

54. *The Fifty-Seventh Annual Report of the Sheffield School of Art* (Sheffield, 1899).

55. NGC, E.S. Nutt Papers, Elizabeth Nutt to H.O. McCurry, 22 December 1937.

56. AGO, Varley Papers, Ethel Varley to F.H. Varley, 2 June 1962.

57. AGO, Varley Papers, F.H. Varley, CBC, "Frederick H. Varley (no trimmings), A Yorkshire Man from Sheffield" [transcript], n.d., n.p.

58. Arthur Lismer, "Portrait of the Artist – An Artistic Reminiscence," *The Gazette* (Montreal), 8 January 1955.

59. George J. Cox, *Art and "The Life": A Book on the Human Figure, Its Drawing and Its Design* (New York, 1933), p. 53.

60. AGO, Varley Papers, CBC, F.H. Varley, "My Home Town," July 1939, p. 6.

61. AGO, Varley Papers, Frank Horratin to Fred Varley, 2 May 1960.

62. AGO, Varley Papers, CBC, F.H. Varley, "My Home Town," July 1939, p. 3.

63. AGO, Varley Papers, CBC, F.H. Varley, "My Home Town," July 1939, p. 4.

64. John Dixon Hunt quoted in Stephen Daniels and Denis Cosgrove, "Introduction: Iconography and Landscape" in Daniels and Cosgrove, ed., *The Iconography of Landscape* (Cambridge, 1988), p. 5.

65. Edward Bradbury, "A Visit to Ruskin's Museum," *The Magazine of Art* (1879), vol. II, p. 57.

66. AGO, Varley Papers, CBC, F.H. Varley, "My Home Town," July 1939, p. 7.

67. Arthur Lismer, "Portrait of the Artist – An Artistic Reminiscence," *The Gazette* (Montreal), 8 January 1955.

68. AGO, Varley Papers, CBC, F.H. Varley, "My Home Town," July 1939, p. 9.

69. Martin Collins, *The Peak District* (Oxford, 1991), p. 4.

70. Edward Bradbury, "Sketching Grounds: The Peak," *Magazine of Art* (1879), vol. II, p. 175.

71. Andrew McCormick, *The Tinkers and Gypsies* (Wakefield, 1973; originally published 1906), pp. 5, 33; Brian Vesey-Fitzgerald, *Gypsies of Britain: An Introduction to Their History* (London, 1944), p. xvi.

72. SCA, MC5887, Samuel Varley to F.H. Varley, 11 January 1900.

73. AGO, Varley Papers, F.H. Varley to Ethel and Lilian Varley, 16 December 1947.

74. Christopher Newall, "'The Innocence of the Eye': Ruskin and the Landscape Watercolor" in Scott Wilcox and Christopher Newall, *Victorian Landscape Watercolors* (Yale, 1992), p. 29.

75. F.H. Varley quoted in "Art Is Defined by Lecturer," *Bulletin* (Edmonton), 24 March 1924.

76. Raymond Williams, *Culture and Society 1780-1950* (London, 1961; originally published 1958), p. 141.

77. Stephen Daniels and Denis Cosgrove, "Introduction: Iconography and Landscape" in Daniels and Cosgrove, ed., *The Iconography of Landscape* (Cambridge, 1988), pp. 4, 5.

78. EAG, Varley Papers, F.H. Varley to Vera Weatherbie, 9 November [1931].

79. AGO, Varley Papers, F.H. Varley to Ethel and Lilian Varley, 16 December 1947.

80. *Ibid.*

81. McKenzie Porter, "Varley," *Maclean's* (7 November 1959), vol. 72, no. 23, p. 34.

82. AGO, Varley Papers, F.H. Varley to Ethel and Lilian Varley, 16 December 1947.

83. *Ibid.*

84. Hugh McLeod, *Religion and the Working Class in Nineteenth Century Britain* (London, 1984), p. 65.

85. Edward Carpenter, *My Days and Dreams* (London, 1916), p. 135.

86. Arthur Lismer, quoted in *F.H. Varley: Paintings 1915-1954*, Art Gallery of Toronto, 1954.

87. See Anita Grant, "Arthur Lismer in the Context of Sheffield" M.A. thesis, Concordia University, August 1995.

88. Edward Carpenter, *Angel's Wings: A Series of Essays on Art and its Relation to Life* (London, 1913; originally published 1893), p. 219.

89. Scott Wilcox, "Introduction," in Wilcox and Christopher Newall, *Victorian Landscape Watercolors* (Yale, 1992), p. 13.

90. *Seven Fields* (1900), watercolour, 32.7 x 26.4 cm., Sheffield City Art Galleries.

91. Scott Wilcox, "Landscape in the Watercolor Societies," in Wilcox and Christopher Newall, *Victorian Landscape Watercolors* (Yale, 1992), p. 50.

92. MCACA, Varley Papers, "Art Master's Death," unidentified newspaper clipping.

93. AGO, Varley Papers, CBC, F.H. Varley, "My Job" [typescript], 22 May 1939.

CHAPTER 2

1. AGO, Varley Papers, Ethel Varley to F.H. Varley, 7 May 1964.

2. AGO, Varley Papers, F.H. Varley, CBC, "Frederick H. Varley (no trimmings), A Yorkshire Man from Sheffield"[typescript], n.p., n.d.

3. *Ibid.*

4. AGO, Varley Papers, Ethel Varley to F.H. Varley, 7 May 1964.

5. *Ibid.*

6. Alick P.F. Ritchie, "L'Académie Royale des Beaux-Arts d'Anvers," *The Studio* (July 1893), vol. 1, no. 4, p. 142.

7. Charles Verlat, quoted in Lennox Robinson, *Palette and Plough* (Dublin, 1918), p. 54.

8. Alick P.F. Ritchie, "L'Académie Royale des Beaux-Arts d'Anvers," *The Studio* (July 1893), vol. 1, no. 4, p. 142.

9. *Ibid.*

10. Tom Cross, *Artists and Bohemians: 100 Years with the Chelsea Arts Club* (London, 1992), p. 6.

11. *Belgian Art 1880-1914* (The Brooklyn Museum, 1980), p. 18.

12. Mark Roskill, ed., *The Letters of Vincent Van Gogh* (London, 1983), p. 256.

13. Julian Campbell, *The Irish Impressionists* (Dublin, 1984), p. 82.

14. Lowrie Warrener to Carl Schaefer, 9 December 1924, cited in Joan Murray, *Origins of Abstraction in Canada: Modernist Pioneers* (Robert McLaughlin Gallery, Oshawa, 1994), p. 20.

15. Lois Darroch, *Bright Land: A Warm Look at Arthur Lismer* (Toronto, 1981), p. 6.

16. During Varley's second year in Antwerp he moved to a more modest dwelling located in the centre of the city on Klapdorp Street, where he shared rooms with Thomas Somerfield.

17. AGO, Varley Papers, Ethel Varley to Fred Varley, 7 May 1964.

18. NAC, MG30 D401, Varley Papers, F.H. Varley to Ethel Varley, Sunday Afternoon [1900-1901].

19. NAC, MG30 D401, Varley Papers, F.H. Varley to Ethel Varley, 12:10 AM Friday Night or Saturday Noon [1901].

20. AGO, Varley Papers, F.H. Varley, CBC, "Frederick H. Varley (no trimmings), A Yorkshire Man from Sheffield" [typescript] n.p., n.d.

21. AEAGA, F.H. Varley interviewed by Lawrence Sabbath, 1960 [transcript], p. 13.

22. NAC, Sound Archives, CAVA/AVCA 1991-0105, J. Russell Harper interview with Kathleen McKay, May 1975.

23. AEAGA, F.H. Varley interviewed by Lawrence Sabbath, 1960 [transcript], p. 13.

24. AGO, Varley Papers, F.H. Varley, CBC, "Frederick H. Varley (no trimmings), A Yorkshire Man From Sheffield," n.p., n.d.

25. *Ibid.*

26. Peter Craig, "Art Looks Back in Anger" *Sheffield Telegraph*, 1 February 1960.

27. AGO, Varley Papers, Ethel Varley to F.H. Varley, 28 April 1964.

28. *Burbage Brook* (10 October 1901), watercolour, 32.4 x 14.3 cm., Sheffield City Art Galleries.

29. Steven Adams, *The Barbizon School and the Origins of Impressionism* (London, 1994), p. 19.

30. *Sheffield Telegraph*, 9 March 1906.

31. Archives of the Nationaal Hoger Instituut en Koninklijke Academie voor Schone Kunsten, Antwerp, ledger recording students, courses, among other information.

32. NAC, CAVA/AVCA 1991-0105, J. Russell Harper interview with Kathleen McKay, May 1975.

33. George J. Cox, *Art and "The Life": A Book on the Human Figure, Its Drawing and Its Design* (New York, 1933), p. 29.

34. NAC, CAVA/AVCA 1991-0105, J. Russell Harper interview with Kathleen McKay, May 1975.

35. McKenzie Porter, "Varley," *Maclean's* (7 November 1959), vol. 72, no. 23, p. 62.

36. NAC, MG30 D401, Varley Papers, F.H. Varley to Ethel Varley, Sunday Afternoon [1900-1901].

37. SCA, MC5887, Samuel Varley to F.H. Varley, 11 January 1900.

38. NAC, MG30 D401, Varley Papers, F.H. Varley to Ethel Varley, 12:10 AM Friday Night or Saturday Noon [1901].

39. NAC, MG30 D401, Varley Papers, F.H. Varley to Ethel Varley [1900].

40. NAC, MG30 D401, Varley Papers, F.H. Varley to Ethel Varley, Sunday Afternoon [1900-1901].

41. AGO, Varley Papers, Ethel Varley to F.H. Varley, 7 May 1964.

42. *Ibid.*, 18 January 1967.

43. *Ibid.*, 14 May 1964.

44. *Samuel Joseph Bloom Varley* (c. 1900-02), charcoal on paper, National Gallery of Canada. This portrait has been dated 1900 by Chris Varley [1981, p. 19] and c. 1912 by Peter Varley [1983, p. 81]; however, Samuel and Lucy Varley had been living in Bournemouth in southwestern England since 1907 or 1908 so this could not have been done in Sheffield c. 1912.

45. Kenneth McConkey, *Edwardian Portraits: Images of an Age of Opulence* (Woodbridge, Suffolk, 1987), p. 33.

46. V.S. Pritchett, *A Cab at the Door* (London, 1979; originally published 1968), p. 45.

47. NAC, MG30 D401, Varley Papers, F.H. Varley to Ethel Varley [1902]; Peter Craig, "Art Looks Back in Anger," *Sheffield Telegraph*, 1 February 1960.

48. AGO, Varley Papers, Ethel Varley to F.H. Varley, 28 April 1964.

49. CBC, Ethel Varley interviewed by Peter Varley, April 1969.

50. *Proceedings at the Conversazione of the Sheffield School of Art* (14 February 1896), "Address and Distribution of Prizes by John D. Crace" (Sheffield, 1896), p. 25.

51. Tom Cross, *Artists and Bohemians: 100 Years with the Chelsea Arts Club* (London, 1992), pp. 6-7.

52. EAG, Varley Papers, F.H. Varley to Vera Weatherbie, 9 November [1931].

53. NAC, CAVA/AVCA 1991-0105, J. Russell Harper interview with Kathleen McKay, May 1975.

54. EAG, Varley Papers, F.H. Varley to Vera Weatherbie, 9 November [1931].

55. Tom Cross, *Artists and Bohemians: 100 Years with the Chelsea Arts Club* (London, 1992), p. 37.

56. Samuel Hynes, *The Edwardian Turn of Mind* (Princeton, 1968), p. 335.

57. Dora Meeson Coates, *George Coates, His Art and His Life* (London, 1937), p. 22.

58. Alan O'Day, *The Edwardian Age: Conflict and Stability 1900-1914* (London, 1979), p. 339.

59. Cited in Tom Cross, *Artists and Bohemians: 100 Years with the Chelsea Arts Club* (London, 1992), p. 22.

60. Annie Besant and C.W. Leadbeater, *Thought Forms* (London, 1905).

61. Gary Essar, *H. Valentine Fanshaw* (Winnipeg, 1983), p. 9.

62. Kenneth McConkey, *Edwardian Portraits: Images of an Age of Opulence* (Woodbridge, Suffolk, 1987), p. 45.

63. "The London Salon," *The Times*, 13 July 1908.

64. Dora Meeson Coates, *George Coates, His Art and His Life* (London, 1937), p. 22.

65. Arthur Ransome, *Bohemia in London* (London, 1907), p. 44; G.P. Jacomb-Hood, *With Brush and Pencil* (London, 1925), p. 103.

66. Philip Macer-Wright, *Brangwyn, A Study of Genius at Close Quarters* (London, 1940), p. 71.

67. George Gissing, *Will Warburton, A Romance of Real Life* (London, 1905; originally published 1895), preface.

68. Arthur Ransome, *Bohemia in London* (London, 1907), p. 28.

69. *Ibid.*

70. J.R. Harvey, *Victorian Novelists and their Illustrators* (London, 1970), p. 169.

71. MCACA, Varley Papers, Chris Varley's transcription of F.H. Varley to Maud Varley, 16 May 1914.

72. Dora Meeson Coates, *George Coates, His Art and His Life* (London, 1937), p. 26.

73. See Eden Phillpotts, "The Farm of the Dagger" in *The Gentlewoman*, 3 October 1903 to 26 December 1903.

74. Joseph Pennell, *The Illustration of Books* (New York, 1898; originally published 1895), p. 11.

75. MCACA, Varley Papers, invitation card to F.H. Varley's lecture at the Heeley Art Club, 7 March 1906.

76. CBC, Maud Varley interviewed by Peter Varley, n.d.

77. NAC, Sound Archives, CAVA/AVCA 1990-0110, Maud Varley interviewed in "A Tribute to Frederick Varley," 20 September 1969.

78. See the painting *A Foreign Street*, Mappin Art Gallery, Sheffield.

79. CBC, Edna Hicken interviewed by Peter Varley, 30 March 1970; CBC, Maud Varley interviewed by Peter Varley, n.d.

80. CBC, Maud Varley interviewed by Peter Varley, n.d.

81. Arthur Lismer quoted in Peter Mellen, *Group of Seven* (Toronto, 1970), p. 21.

82. MCACA, Philip Surrey, "Varley as I Knew Him" [typescript], n.d., p. 2.

83. Mary Bergstein, "The Artist in his Studio, Photography, Art and the Masculine Mystique," *The Oxford Journal* (1995), vol. 18, no. 2, p. 17.

84. Alphonse Daudet, *Artists' Wives* (London, 1896), p. 12.

85. CBC, Maud Varley interviewed by Peter Varley, n.d.

86. Alphonse Daudet, *Artists' Wives* (London, 1896), p. 16.

87. CBC, Ethel Varley interviewed by Peter Varley, April 1969.

88. *Ibid.*, 30 March 1970.

89. NAC, CAVA/AVCA 1990-0110, Maud Varley interviewed in "A Tribute to Frederick Varley," 20 September 1969.

90. MCACA, Philip Surrey, "Varley as I Knew Him" [typescript], n.d, p. 3.

91. McKenzie Porter, "Varley," *Maclean's* (7 November 1959), vol. 72, no. 23, p. 63.

92. CBC, Ethel Varley interviewed by Peter Varley, n.d.

93. AGO, Varley Papers, Ethel Varley to Fred Varley, 14 May 1964.

94. Hugh McLeod, *Class and Religion in the Late Victorian City* (London, 1974), p. 337.

95. NAC, CAVA/AVCA 1991-0105, J. Russell Harper interview with Kathleen McKay, May 1975.

96. Quoted in Donald W. Buchanan, *The Growth of Canadian Painting* (London, 1950), p. 42.

97. CBC, Maud Varley interviewed by Peter Varley, n.d.

98. *Ibid.*

99. *Ibid.*

100. NAC, CAVA/AVCA 1991-0105, J. Russell Harper interview with Kathleen McKay, May 1975.

101. There is no record in the archives of the National Railway Museum in York of Varley producing work for the Southern Railway.

102. Varley produced the cover for the *Sheffield Daily Independent's* "Sheffield Supplement," 19 January 1912.

103. *Sheffield Daily Independent*, 29 February 1912.

104. Margaret Maynard, "'A Dream of Fair Women': Revival Dress and the Formation of Late Victorian Images of Feminity," *Art History* (September 1989), vol. 12, no. 3, p. 338.

105. Janet Hobhouse, *The Bride Stripped Bare* (London, 1988), p. 10.

106. Lois Darroch, *Bright Land: A Warm Look at Arthur Lismer* (Toronto, 1981), p. 7.

107. SCA, William Broadhead Papers, William Broadhead to Gertrude Broadhead, 20 February 1910.

108. SCA, William Broadhead Papers, William Broadhead to father, 17 April 1910.

109. John M. MacKenzie, *Propaganda and Empire* (Manchester, 1984), pp. 2, 100.

110. A.G. Bradley, *Canada in the Twentieth Century* (London, 1911), p. 213.

111. *Plain Facts About Ontario* (Government of Ontario, London, 1909), p. 3.

112. McKenzie Porter, "Varley," *Maclean's* (7 November 1959), vol. 72, no. 23, p. 64.

CHAPTER 3

1. W.L. Griffith, *The Dominion of Canada* (London, 1911), p. 124.

2. NAC, MG30 D401, Varley Papers, F.H. Varley to Maud Varley, n.d., [spring 1913, 22 Henry Street].

3. NAC, Sound Archives, CAVA/AVCA 1991-0105, J. Russell Harper interview with Kathleen McKay, May 1975.

4. *Smily's Canadian Summer Resort Guide* (Toronto, 1911), p. 5.

5. James Lemon, *Toronto Since 1918* (Toronto, 1985), pp. 13, 17.

6. Emily P. Weaver, *Canada and the British Immigrant* (London, 1914), p. viii.

7. NAC, CAVA/AVCA 1991-0105, J. Russell Harper interview with Kathleen McKay, May 1975.

8. W.L. Griffith, *The Dominion of Canada* (London, 1911), p. 159.

9. NAC, MG30 D401, Varley Papers, F.H. Varley to Maud Varley, 9 August 1912.

10. *A Tree Study, Collier's Wives, A Woodland,* and *A Grey Morning.*

11. Varley's illustration accompanied F.S. Brown's article "The Two Velmas," *Canadian Courier* (24 August 1912), vol. XVII, p. 24.

12. NAC, MG30 D401, Varley Papers, F.H. Varley to Maud Varley, 9 August 1912.

13. John A.B. McLeish, *September Gale* (Toronto, 1955), p. 24.

14. NAC, MG30 D401, Varley Papers, F.H. Varley to Maud Varley, 9 August 1912.

15. McKenzie Porter, "Varley," *Maclean's* (7 November 1959), vol. 72, no. 23, p. 64.

16. AEAG, F.H. Varley interviewed by Lawrence Sabbath, 1960 [typescript], p. 1.

17. NAC, MG30 D401, Varley Papers, F.H. Varley to Maud Varley, 13 February 1913.

18. SCA, MC5887, F.H. Varley to Ethel Varley, Jan. 7th (nearly 8th), [1913 typescript].

19. *Ibid.*

20. *Ibid.*

21. Basil Stewart, *"No English Need Apply" Or, Canada as a Field for the Emigrant* (London, 1909), p. 2.

22. Emily P. Weaver, *Canada and the British Immigrant* (London, 1914), p. 277.

23. J.G. Sime, *Our Little Life* (New York, 1921), p. 257.

24. NAC, MG30 D401, Varley Papers, F.H. Varley to Maud Varley, 9 August 1912.

25. PAO, MS273, Arts and Letters Club Archival Scrapbook, *The Lamps* (January 1910), n.p.

26. J.G. Sime, *Our Little Life* (New York, 1921), p. 179.

27. They were building on the ideas already expressed by W.A. Sherwood in "The National Aspect of Canadian Art," J. Castell Hopkins, ed., *Canada: An Encyclopaedia of the Country,* vol. IV, 1898, pp. 363-370.

28. According to Robert Stacey in *The Canadian Poster Book, 100 Years of the Poster in Canada* (Toronto, 1980), p. 57.

29. SCA, MC5887, Fred Varley to Ethel Varley, Jan 7th (nearly 8th), [1913 typescript]; NAC, MG30 D401, Varley Papers, F.H. Varley to Maud Varley, n.d. [March 1913].

30. *The Hillside,* watercolour, 44.3 x 32 cm., Rosa and Spencer Clark Collection, Toronto.

31. Lawren Harris, *Group of Seven* (Vancouver Art Gallery, 1954), p. 11; NAC, CAVA/AVCA 1991-0105, J. Russell Harper interview with Kathleen McKay, May 1975.

32. AEAG, F.H. Varley interviewed by Lawrence Sabbath, 1960 [typescript], p. 20.

33. William T. Little, *The Tom Thomson Mystery* (Toronto, 1970), p. 9.

34. Joan Murray, "The World of Tom Thomson," *Journal of Canadian Studies* (Autumn 1991), vol. 26, no. 3, p. 30.

35. CBC, Peter Varley interview with Maud Varley, n.d.

36. Robert McLaughlin Art Gallery, Maud Varley to Joan Murray, 15 March 1971, and 6 March 1971.

37. Joan Murray "The World of Tom Thomson," *Journal of Canadian Studies* (Autumn 1991), vol. 26, no. 3, p. 24.

38. Colin S. MacDonald quoted in Maria Tippett, *By a Lady, Celebrating Three Centuries of Art by Canadian Women* (Toronto, 1992), pp. 54-56.

39. NAC, MG30 D401, Varley Papers, F.H. Varley to Maud Varley, n.d. [April 1912].

40. Robert McLaughlin Art Gallery, Maud Varley to Joan Murray, 15 March 1971.

41. CBC, Peter Varley interview with Maud Varley, n.d.

42. NAC, MG30 D401, Varley Papers, F.H. Varley to Maud Varley, 9 August 1912.

43. *Ibid.*, n.d. [March 1913].

44. *Ibid.*

45. NAC, MG30 D401, Varley Papers, F.H. Varley to Maud Varley, 13 February 1913. The £50 offer of a loan probably helped pay the £250 rent on the Centre Island cottage from May to October.

46. NAC, MG30 D401, Varley Papers, F.H. Varley to Maud Varley, 20 April 1913.

47. *Ibid.* 28 March [1913].

48. *Ibid.*, MG30 D401, Varley Papers, F.H. Varley to Maud, n.d. [March 1913].

49. NAC, MG30 D401, Varley Papers, F.H. Varley to Maud Varley, 20 April 1913.

50. Karl Baedeker, *Baedeker's Canada* (Leipzig, 1907), p. 179.

51. NAC, MG30 D401, Varley Papers, F.H. Varley to Maud Varley, n.d. [March 1913].

52. Robert Stacey, "A Clear Northern Light" *Northward Journal: A Quarterly of Northern Arts* (1981), vol. 20, p. 10.

53. G. Campbell McInnes, "Art and Philistia: Some Sidelights on Aesthetic Taste in Montreal and Toronto, 1880-1910," *University of Toronto Quarterly* (July 1917), vol. 6, p. 52.

54. H. Mortimer-Lamb, "The Art of Curtis Williamson," *Canadian Magazine* (November 1908), vol. XXXIV, p. 71.

55. Robert Stacey, "A Contact in Context: The Influence of Scandinavian Landscape Painting on Canadian Artists Before and After 1913," *Northward Journal* (1980), no. 18/19, p. 40.

56. *World's Columbian Exposition* (Chicago, 1893); *Exhibition of Contemporary Scandinavian Art held under the auspices of the American-Scandinavian Society*, Albright Art Gallery, Buffalo, 4-26 January 1913. See Robert Stacey, "A Contact in Context: The

Influence of Scandinavian Landscape Painting on Canadian Artists Before and After 1913," *Northward Journal* (1980), no. 18/19, pp. 36-56.

57. J.E.H. MacDonald, talk given at the Art Gallery of Toronto, 17 April 1931, quoted in Charles C. Hill, *The Group of Seven, Art for a Nation* (Ottawa, 1995), p. 48.

58. Lawren Harris, "The Story of the Group of Seven," *Group of Seven* (Vancouver Art Gallery, 1954), p. 11.

59. A.Y. Jackson, "A Canadian Artist," *Victoria Colonist* 29 May 1923. This first appeared in *The Art Club of Montreal*, 21 March 1919.

60. A.Y. Jackson quoted in *Victoria Colonist*, 29 May 1923, first written in *The Art Club of Montreal*, 21 March 1919.

61. Jackson's *Terre Sauvage* (1913), NGC; Harris's *Winter Morning* (1914), NGC; Thomson's *Northern Lake* (1913), AGO; MacDonald's *Tangled Garden* (1916)NGC; and Varley's *Indian Summer* (1914-1915), location unknown.

62. SCA, MC5887, F.H. Varley to Ethel Varley, [copy], n.d., [May 1914].

63. NGC, James MacCallum Papers, A.Y. Jackson to MacCallum, 8 March 1914.

64. Lois Darroch, *Bright Land, A Warm Look at Arthur Lismer* (Toronto, 1981), p. 34.

65. SCA, MC5887, F.H. Varley to Ethel Varley, [copy], n.d., [May 1914].

66. NAC, MG30 D401, Varley Papers, F.H. Varley to Maud Varley, 3 March 1913.

67. SCA, MC5887, F.H. Varley to Ethel Varley, [copy], n.d., [May 1914].

68. *Ibid.*

69. *Ibid.*

70. NAC, MG30 D401, Tom Thomson to F.H. Varley, 8 July 1914.

71. A.Y. Jackson, *A Painter's Country* (Toronto, 1958), p. 32.

72. R.P. Little quoted in O. Addison and E. Harwood, *Tom Thomson, The Algonquin Years* (Toronto, 1969), p. 32.

73. NGC, James MacCallum Papers, Tom Thomson to James MacCallum, 6 October 1914.

74. NGC, James MacCallum Papers, A.Y. Jackson to James MacCallum, 13 October 1914.

75. NGC, James MacCallum Papers, Arthur Lismer to James MacCallum, 11 October 1914.

76. NGC, James MacCallum Papers, F.H. Varley to James MacCallum, "Wednesday" [October 1914].

77. NAC, MG3 DIII, J.E.H. MacDonald Papers, A.Y. Jackson to J.E.H. MacDonald, 5 October 1914.

78. NGC, James MacCallum Papers, F.H. Varley to James MacCallum, "Wednesday" [October 1914].

79. NAC, MG3 DIII, J.E.H. MacDonald Papers, A.Y. Jackson to J.E.H. MacDonald, 5 October 1914.

80. NGC, James MacCallum Papers, A.Y. Jackson to James MacCallum, 13 October 1914.

81. NAC, MG30 D401, Varley Papers, F.H. Varley to Ethel Varley, n.d. [May 1914].

82. AEAG, F.H. Varley interviewed by Lawrence Sabbath, 1960 [typescript], p. 12.

83. A.Y. Jackson's *The Red Maple* (1914), NGC; Tom Thomson's *In the Northland* (1915), Montreal Museum of Fine Art.

84. NGC, James MacCallum Papers, F.H. Varley to James MacCallum, "Wednesday" [October 1914].

85. The only work in addition to *Indian Summer* which resulted from the Algonquin trip was *Autumn*. This was hung at the Ontario Society of Artists exhibition in March, and at the Canadian National Exhibition in August, of 1917. Because neither painting exists today and because only *Autumn* found its way into an exhibition, they may very well be one and the same work.

86. MCACA, Frank Carmichael to Ada Carmichael, 23 March 1915.

87. NAC, CAVA/AVCA 1990-0110, A.Y. Jackson interviewed in "A Tribute to Frederick Varley," 20 September 1969.

88. A.Y. Jackson quoted in "Dr. MacCallum Loyal Friend of Art," *Saturday Night* (11 December 1943), vol. 59, p. 19.

89. Prior to 1917, Varley had asked as little as $30 for his watercolour paintings and as much as $300 for his oil paintings.

90. NGC, MacCallum Papers, F.H. Varley to James MacCallum, 15 January 1919.

91. One exception is K. Janet Tenody, who in "F.H. Varley, Landscape of the Vancouver Years" (M.A. thesis, Queen's University, April 1983), p. 7, prompted me to question the authenticity of the 1920 date.

92. NAC, MG30 D208, Lawren Harris Papers, Lawren Harris, "The Old Pine," *Notebook* [1920s].

93. Arthur Lismer, "The West Wind," *McMaster Monthly* (January 1934), vol. XLIII, no. 4, p. 16.

94. NAC, MG30 D401, Varley Papers, Tom Thomson to F.H. Varley, 8 July 1914.

95. A.Y. Jackson to J.E.H. MacDonald, 4 August 1917, quoted in O. Addison and E. Harwood, *Tom Thomson, The Algonquin Years* (Toronto, 1969), p. 75.

96. Robert McLaughlin Art Gallery, Tom Thomson Papers, Robert Ross interviewed by Joan Murray, 8 April 1971.

97. E.K. Brown, "Now, Take Ontario," *Maclean's* (15 June 1917), p. 31.

98. H. Mortimer-Lamb, "Studio Talk," *Studio* (February 1916), vol. 67, no. 275, p. 63.

99. Graham McInnes, *Finding A Father* (London, 1967), p. 160.

100. NAC, MG30 D253, Eric Brown Papers, Maud Brown "to My Dear Great Nephews and Great Nieces," [printed pamphlet], n.d.

101. NGC, Eric Brown Papers, Eric Brown to Edmund Walker, 28 May 1914.

102. *Ibid.*, 11 February 1914.

103. Eric Brown, "Studio Talk: Ottawa," *Studio* (April 1915), vol. LXIV, no. 265, p. 211.

104. Arthur Lismer, "The West Wind," *McMaster Monthly* (January 1934), vol. XLIII, no. 4, p. 164.

105. A.Y. Jackson quoted in "Dr. MacCallum Loyal Friend of Art," *Saturday Night* (11 December 1943), vol. 59, p. 19.

106. "Pictor," "The O.S.A. Exhibition" *Toronto Globe*, 15 March 1916.

CHAPTER 4

1. Harold Mortimer-Lamb, "Canadian Artists and the War," *Studio* (October 1915), LVI, p. 259.

2. Estelle M. Kerr, "The Etcher's Point of View," *Canadian Magazine* (December 1916), vol. XXXVII, p. 158.

3. A.Y. Jackson, "Reminiscences of Army Life, 1914-1918," *Canadian Art* (Autumn 1953), vol. XI, no. 1, p. 6.

4. NAC, MG3 DIII, J.E.H. MacDonald Papers, A.Y. Jackson to J.E.H. MacDonald, 5 October 1914.

5. A.Y. Jackson enlisted in June 1915 as a private in the 60th Battalion; Lawren Harris enlisted in the spring of 1916 as a private in the Canadian Officers Training Corps.

6. NAC, MG30 D401, Varley Papers, recalled in F.H. Varley to Maud Varley, 19 October 1936.

7. Robert McLaughlin Art Gallery, Maud Varley to Joan Murray, 15 March 1971.

8. AEAG, Fred Varley interviewed by Lawrence Sabbath, 1960 [transcript], p. 21.

9. University of Toronto, Sir Edmund Walker Papers, Box 22, Eric Brown to Edmund Walker, 20 November 1917.

10. NGC, Eric Brown Papers, J.M. Gibbon to Eric Brown, 24 December 1917.

11. University of Toronto, Sir Edmund Walker Papers, Box 22, Eric Brown to Edmund Walker, 2 November 1916.

12. Augustus Bridle, "Canadian Artists to the Front," *Canadian Courier* (16 February 1918), vol. XXIII, no. 10, p. 7.

13. NAC, MG3 DIII, J.E.H. MacDonald Papers, Arthur Lismer to J.E.H. MacDonald, 28 February 1918.

14. PAO, Ontario Society of Artists, Minute Book, 5 February 1918, p. 41.

15. NAC, MG30 D401, Varley Papers, F.H. Varley to Maud Varley, 14 April 1918.

16. *Ibid.*, 26 March 1918.

17. *Ibid.*,

18. PAO, Ontario Society of Artists' Papers, MU 2250, William Beatty to Robert Gagen, 8 July 1918.

19. NAC, MG3 DIII, J.E.H. MacDonald Papers, A.Y. Jackson to J.E.H. MacDonald, 6 April 1918.

20. PAO, Ontario Society of Artists' Papers, MU 2250, William Beatty to Robert Gagen, 8 July 1918.

21. NAC, MG30 D401, Varley Papers, F.H. Varley to Maud Varley, 14 April 1918.

22. *Ibid.*, 3 May 1918.

23. *Ibid.*

24. *Ibid.*, 8 November 1918.

25. *Ibid.*, 14 April 1918.

26. *Ibid.*

27. *Ibid.* This Labour M.P. was probably R.B. Cunninghame-Graham.

28. *Ibid.*, 21 April 1918.

29. *Ibid.*, 21 May 1918.

30. *Ibid.*, 14 April 1918.

31. *Ibid.*, 21 May 1918.

32. *Ibid.*, 3 May 1918.

33. *Ibid.*, 10 May 1918.

34. NAC, MG3 DIII, MacDonald Papers, A.Y. Jackson to J.E.H. MacDonald, 6 April 1918.

35. *Ibid.*, 31 May [1916].

36. A.Y. Jackson, *A Painter's Country* (Toronto, 1958), p. 40.

37. NAC, MG30 D401, Varley Papers, F.H. Varley to Maud Varley, 24 August 1918.

38. *Ibid.*, 10 May 1918.

39. *Ibid.*, 14 April 1918.

40. *Ibid.*, 10 May 1918.

41. MCACA, Arthur Lismer Papers, F.H. Varley to Arthur Lismer, 2 May 1918.

42. NAC, MG30 D401, Varley Papers, F.H. Varley to Maud Varley, 10 May 1918.

43. *Ibid.*, 16 April 1918.

44. *Catalogue of An Exhibition of Pictures of War by Nevinson, Official Artist on the Western Front*, Leicester Galleries, London, March 1918.

45. Paul Konody, "Art and Artists," *The Observer*, 26 March 1916.

46. Paul Konody, *Modern War: Paintings of CRW Nevinson* (London, 1917), p. 20.

47. Paul Nash to Margaret Nash, 16 November 1917, in Paul Nash, *Outline: An Autobiography and Other Writings* (London, 1949), p. 211.

48. NAC, MG30 D401, Varley Papers, F.H. Varley to Maud Varley, 27 May 1918.

49. *Ibid.*, 10 May 1918.

50. *Ibid.*

51. *Ibid.*, 21 April 1918.

52. *Ibid.*, 21 May 1918.

53. *Ibid.*, 3 May 1918.

54. *Ibid.*

55. *Ibid.*

56. *Ibid.*, 27 May 1918.

57. *Ibid.*

58. *Ibid.*, 10 May 1918.

59. *Ibid.*, 27 May 1918.

60. *Ibid.*, 24 August 1918.

61. *Ibid.*, 3 May 1918.

62. *Ibid.*, 21 May 1918.

63. *Ibid.*, 21 April 1918.

64. *Ibid.*, 27 May 1918.

65. *Ibid.*, 10 May 1918.

66. John Stevenson, *British Society 1914-1915* (London, 1988; originally published 1984), p. 439.

67. NAC, MG30 D401, Varley Papers, F.H. Varley to Maud Varley, 12 July 1918.

68. *Ibid.*, 10 May 1918.

69. *Ibid.*, 17 July 1918.

70. *Ibid.*, 3 July 1918.

71. *Ibid.*, 27 May 1918.

72. *Ibid.*, 24 August 1918.

73. *Ibid.*, 18 August 1918.

74. *Ibid.*

75. *Ibid.*

76. Wilson MacDonald, *The Song of the Undertow* (Toronto, 1935), pp. 127, 43.

77. NAC, MG30 D401, Varley Papers, F.H. Varley to Maud Varley, 18 August 1918.

78. *Ibid.*, 12 July 1918.

79. *Ibid.*

80. *Ibid.*, 18 August 1918.

81. *Ibid.*

82. *Ibid.*

83. *Ibid.*, 24 August 1918.

84. Varley is also reported to have produced a painting of Lt. McLeod V.C., which has vanished. See Christopher Varley, *F.H. Varley* (Edmonton Art Gallery, 1981), p. 180.

85. *Cyril H. Barraud* (March 1919), oil on wood panel, Art Gallery of Ontario.

86. NAC, MG30 D401, Varley Papers, F.H. Varley to Maud Varley, 17 July 1918.

87. Douglas Goldring, *The Nineteen Twenties* (London, 1945), p. 92.

88. NAC, MG30 D401, Varley Papers, F.H. Varley to Maud Varley, 17 July 1918.

89. PAO, Ontario Society of Artists' Papers, MU 2250, William Beatty to Robert Gagen, 8 July 1918.

90. NAC, MG30 D401, Varley Papers, F.H. Varley to Maud Varley, 24 August 1918.

91. *Ibid.*

92. See Maria Tippett, *Art at the Service of War* (Toronto, 1984), chapter 4.

93. George Moore, *Modern Painting* (London, 1898), p. 119.

94. George Moore quoted in Alan O'Day, *The Edwardian Age: Conflict and Stability 1900-1914* (London, 1979), p. 343.

95. Paul Konody, "Special Canadian War Memorials Number," *Colour Magazine* (September 1918), vol. IX.

96. NAC, MG30 D401, Varley Papers, F.H. Varley to Maud Varley, 13 October 1918.

97. *Ibid.*, n.d., [October 1918].

98. *Ibid.*, 8 November 1918.

99. *Ibid.*, n.d., [October 1918].

100. *Ibid.*

101. *Ibid.*, n.d., [October 1918].

102. Dorothy Hoover, *J.W. Beatty* (Toronto, 1948), p. 30.

103. NAC, MG30 D401, Varley Papers, F.H. Varley to Maud Varley, n.d., [October 1918].

104. *Ibid.*, 13 October 1918.

105. *Ibid.*

106. *Ibid.*, n.d., [October 1918].

107. Paul Nash to Margaret Nash, 7 March 1917, in Paul Nash, *Outline: An Autobiography and Other Writings* (London, 1949), p. 187.

108. NAC, MG30 D401, Varley Papers, F.H. Varley to Maud Varley, 8 November 1918.

109. *Ibid.*

110. *Ibid.*

111. *Ibid.*

112. *Ibid.*

113. *Ibid.*, 27 December 1918.

114. *Ibid.*

115. *Ibid.*, 8 November 1918.

116. *Ibid.*, n.d., [October 1918].

117. See F.H. Varley *Dead Soldier*, pencil drawing, private collection.

118. NAC, MG30 D401, Varley Papers, F.H. Varley to Maud Varley, 16 September 1918.

119. F.H. Varley's text and illustration in *The Canadian War Memorials Exhibition* (London, 1919), n.p.

120. NAC, MG30 D401, Varley Papers, F.H. Varley to Maud Varley, 27 December 1918.

121. *Ibid.*

122. *Ibid.*

123. *Ibid.*, n.d., [mid October 1918].

124. William Rothenstein, *Men and Memories: Recollections of William Rothenstein, 1900-1922* (London, 1932), p. 351.

125. "Art and Artists," *Observer*, 5 January 1919; though unattributed this was probably written by Paul Konody.

126. Sir Claude Phillips, *Daily Telegraph*, 7 January 1919.

127. "Burlington Exhibition, January 1919," *Manchester Guardian*, 6 January 1919.

128. "The Smaller Pictures, Canadian War Memorials Fund," *Observer*, 19 January 1919.

129. Sir Claude Phillips, *Daily Telegraph*, 7 January 1919.

130. "A London Diary," *The Nation* (11 January 1919), vol. XIV, no. 15, p. 426.

131. Lawrence Sabbath, "His Fruitful Period is Now Says Group of Seven Member," *Montreal Star*, 10 October 1964.

132. Lawrence Sabbath, "His Fruitful Period is Now Says Group of Seven Member," *Montreal Star*, 10 October 1964.

133. NAC, MG30 D401, Varley Papers, F.H. Varley to Maud Varley, 14 January 1919; *Ibid.*, 31 January 1919.

134. *Ibid.*, 31 January 1919.

135. *Ibid.*, 14 January 1919.

136. *Ibid.*

137. *Ibid.*

138. See, for example, "The Smaller Pictures, Canadian War Memorials Fund," *Observer*, 19 January 1919, p. 6.

139. AEAG, F.H. Varley interview with Lawrence Sabbath, 1960 [transcript], p. 23.

140. CBC, Barker Fairley interview in "A Tribute to Frederick Varley," 20 September 1969.

CHAPTER 5

1. This painting is now in the Beaverbrook Art Gallery in New Brunswick.

2. NAC, MG30 D401, Varley Papers, F.H. Varley to Maud Varley, 14 January 1919.

3. *Ibid.*

4. MCACA, F.H. Varley to Dr. James MacCallum [copy], 15 January 1919.

5. *Ibid.*

6. *Cyril H. Barraud* (March 1919), oil on wood panel, Art Gallery of Ontario.

7. NAC, MG30 D401, Varley Papers, F.H. Varley to Maud Varley, 28 April 1919.

8. MCACA, Arthur Lismer Papers, F.H. Varley to Arthur Lismer, 2 May 1919.

9. NAC, MG30 D401, Varley Papers, F.H. Varley to Maud Varley, 28 April 1919.

10. AEAG, F.H. Varley interview with Lawrence Sabbath, 1960 [transcript], p. 6.

11. MCACA, CBC, F.H. Varley, "My Job, Fred H. Varley ARCA" [transcript], 22 May 1939, p. 2.

12. MCACA, Arthur Lismer Papers, F.H. Varley to Arthur Lismer, 2 May 1919.

13. NAC, MG30 D401, Varley Papers, F.H. Varley to Maud Varley, 28 April 1919.

14. *Ibid.*

15. AEAG, F.H. Varley interview with Lawrence Sabbath [transcript], 1960 p. 24.

16. MCACA, Arthur Lismer Papers, F.H. Varley to Arthur Lismer, 2 May 1919.

17. William Rothenstein, *Men and Memories* (London, 1933), p. 361.

18. MCACA, Arthur Lismer Papers, F.H. Varley to Arthur Lismer, 2 May 1919.

19. AEAG, F.H. Varley interview with Lawrence Sabbath, [transcript], 1960 p. 24.

20. NAC, MG30 D401, Varley Papers, F.H. Varley to Maud Varley, 27 December 1918.

21. NAC, "The Battle After a Canadian Charge, October 1916," photograph no. 868.

22. "Sees Vision of Golden Age of Expression on the Horizon," *Journal* (Edmonton), 27 March 1924, p. 4.

23. MCACA, Arthur Lismer Papers, F.H. Varley to Arthur Lismer, 2 May 1919.

24. *Night Before a Barrage*, oil on wood panel, 29.8 x 40.6 cm., private collection.

25. NAC, MG30 D401, Varley Papers, F.H. Varley to Maud Varley, 19 May 1919.

26. *Ibid.*

27. *Ibid.*, 15 July 1919.

28. MCACA, Arthur Lismer Papers, F.H. Varley to Arthur Lismer, 2 May 1919.

29. NAC, MG30 D401, Varley Papers, F.H. Varley to Maud Varley, 19 May 1919.

30. *Ibid.*

31. *Times* (London), 9 May 1919.

32. NAC, MG30 D401, Varley Papers, F.H. Varley to Maud Varley, 25 July 1919.

33. *Ibid.*, n.d., [March 1919].

34. NGC, Eric Brown Papers, F.H. Varley to Eric Brown, 29 November 1919.

35. Arts and Letters Club, *The Lamps*, December 1919.

36. *Globe* (Toronto), 23 September 1919.

37. Barker Fairley, "The Royal Canadian Academy," *The Rebel* (December 1919), p. 126.

38. *Canadian Magazine* (November 1919), vol. LIV, no. 1, p. 9.

39. Barker Fairley, "The Royal Canadian Academy," *Studio* (15 April 1920) vol. LXXIX, no. 325, p. 80.

40. NGC, Eric Brown Papers, F.H. Varley to Eric Brown, 2 March 1920.

41. *Ibid.*

42. *Ibid.*, 1 June 1920.

43. Eric Brown, "The National Gallery," *Maclean's* (July 1916), vol. 29, no. 9, p. 34.

44. SCA, Varley Papers, F.H. Varley to Ethel Varley, 7th (nearly 8th) January 1913.

45. The National Gallery of Canada bought *John* (c. 1920) in 1921. The board of Hart House not only commissioned the portrait of Vincent Massey, it bought the portraits of *Huntley Gordon* (c. 1921), *Chester Massey* (c. 1921), and the landscape painting and sketch *The Wonder Tree* (1924).

46. Lawren Harris, c. 1960, cited in Bess Harris and R.G.P. Colgrove, ed., *Lawren Harris* (Toronto, 1976; originally published 1969), p. 41.

47. MCACA, Arthur Lismer Papers, A.Y. Jackson to Arthur Lismer, 22 May 1918.

48. Cited in Nancy Robertson, *J.E.H. MacDonald, R.C.A 1878-1932* (Toronto, 1945), p. 14. For two different views of the degree to which the Group of Seven were criticized by the press, see Charles C. Hill, *The Group of Seven, Art for a Nation* (Toronto, 1995) and Peter Mellen, *The Group of Seven* (Toronto, 1970).

49. AEAG, F.H. Varley interviewed by Lawrence Sabbath, 1960 [transcript] p. 19.

50. *Ibid.*, p. 23.

51. A.Y. Jackson, *A Painter's Country* (Toronto, 1958), p. 68.

52. "Group of 7 Foreword" to 1922 exhibition, in Peter Mellen, *Group of Seven*, (Toronto, 1970), p. 102.

53. NAC, MG30 D186, H.O. McCurry Papers, "Statement by the Group of Seven," signed by The Group of Seven [mimeograph typescript].

54. NGC, Arthur Lismer Papers, Arthur Lismer to Eric Brown, 21 March 1920.

55. NAC, MG30 D186, H.O. McCurry Papers, "Statement by the Group of Seven," signed by The Group of Seven [mimeograph typescript].

56. CBC Archives, "Venture '66 Series," Interview with Lawren Harris; *Op.Cit.*, "The Group of Seven" [typescript].

57. SCA, Varley Papers, F.H. Varley to Ethel Varley, January 7th (nearly 8th), 1913.

58. AEAG, F.H. Varley interviewed by Lawrence Sabbath, 1960 [transcript], p. 22.

59. MCACA, "Artist Tells of Aims of 'Group of Seven,'" [newspaper clipping].

60. Steven Adams, *The Barbizon School and the Origins of Impressionism* (London, 1994), p. 19.

61. AEAG, F.H. Varley interviewed by Lawrence Sabbath, 1960 [transcript], p. 4.

62. SCA, Varley Papers, F.H. Varley to Ethel Varley [copy], n.d., [May 1914].

63. Paul Nash to Mary, 6 April 1917, in Paul Nash, *Outline: An Autobiography and Other Writings* (London, 1948), p. 194.

64. Jackson quoted in Ann Davis, "An Apprehended Vision, The Philosophy of the Group of Seven" (unpublished Ph.D. thesis, York University, 1973), p. 347.

65. *Squally Weather, Georgian Bay* (1920), NGC; *A Windswept Shore* (c. 1920), McMichael Canadian Art Collection.

66. Augustus Bridle, "Group of Seven Betray No Signs of Repentance," *Toronto Star Weekly*, 8 May 1926.

67. A.Y. Jackson, *March Storm, Georgian Bay* (1920), NGC; Arthur Lismer, *Go Home Bay* (1921), AGO.

68. CBC, "Venture '66 Series," interview with Barker Fairley.

69. Kenneth McConkey, *Edwardian Portraits: Images in an Age of Opulence* (Woodbridge, Suffolk, 1987), p. 16.

70. Augustus Bridle, "Pictures of the Group of Seven Show 'Art Must Take the Road,'" *Toronto Daily Star*, 20 May 1922.

71. F.B. Housser, *A Canadian Art Movement, The Story of the Group of Seven* (Toronto, 1925), p. 114.

72. F.H. Varley, *Self-Portrait* (1919), oil on canvas, NGC.

73. Joan Kinner, ed., *The Artist By Himself* (London, 1980), p. 15.

74. Mona Gould, "Verbal Meanderings: A Collection of Recollections," *Gossip* (Toronto, August-September 1969), p. 4.

75. NAC, MG30 D401, Varley Papers, F.H. Varley to Maud Varley, 21 January 1924.

76. Barker Fairley, "Some Canadian Painters: F.H. Varley," *Canadian Forum* (April 1922), p. 594-5.

77. NAC, MG30 D401, Varley Papers, F.H. Varley to Maud Varley, 2 February 1924.

78. Frank Rutter cited in Brian Allen et. al., *The British Portrait 1660-1960* (London, 1991), p. 396.

79. F.H. Varley, *Peter Sandiford at Split Rock, Georgian Bay* (1920), AGO; Augustus John, *The Blue Pool* (1911), Aberdeen Art Gallery.

80. See Augustus John, *Casper* (1909), Fitzwilliam Museum, Cambridge; *Study of Boy* (1910), National Museum of Wales; and *Robin* (1915), private collection. Varley's *John* is in the National Gallery of Canada.

81. F.H. Varley, *Gypsy Head* (1919), NGC; *Gypsy Blood* (1919), private collection; and *Character Study* (1919-1920), lost; Augustus John, *Smiling Woman* (1909).

82. *Portrait of Vincent Massey* (1920), Hart House, University of Toronto.

83. *Portrait of Alice Vincent Massey* (1924-1925), NGC; William Rothenstein, *Hablant Espagnol*, private collection.

84. Varley quoted in "Sees Vision of Golden Age of Expression on Horizon," *Journal* (Edmonton), 27 March 1924, p. 4.

85. Barker Fairley, "F.H. Varley," in Robert L. McDougall, ed., *Our Living Tradition*, (Toronto, 1959), pp. 163-164.

86. Herbert H. Stansfield, "Portraits at the Ontario Society of Artists," *Canadian Forum* (May 1925), vol. V, p. 239.

87. Andrea Kirkpatrick, "The Portraiture of Frederick H. Varley, 1919 to 1926," M.A. thesis, Queen's University, 1986, pp. 23, 189.

88. *Mrs. E* (1921), oil on canvas, AGO.

89. NGC, Eric Brown Papers, Eric Brown to F.H. Varley, 3 December 1919.

90. NAC, MG30 D401, Varley Papers, F.H. Varley to Maud Varley, 13 April 1924.

91. University of Toronto Archives, B87-0082/349, F.H. Varley to Vincent Massey, 6 March 1925.

92. CBC, Peter Varley interview with Barker Fairley, 23 April 1969.

93. NAC, MG30 D374, Annie Savage Papers, A.Y. Jackson to Annie Savage, 21 January 1940.

94. CBC, Peter Varley interview with Barker Fairley, 23 April 1969; NGC, Eric Brown Papers, Barker Fairley to Eric Brown, 4 December 1921.

95. CBC, Peter Varley interview with Barker Fairley, 23 April 1969; *Chancellor Charles Allan Stuart* (1924), University of Alberta; *Dr. McIntyre* (1924), University of Manitoba; *Dr. Henry Marshall Tory* (1923-24), University of Alberta.

96. F. Rinder, "J.J. Shannon, A.R.A.," *Art Journal* (January 1901), p. 42.

97. NAC, CAVA/AVCA 1991-0105, J. Russell Harper interview with Kathleen McKay, May 1975.

98. NAC, MG30 D401, Varley Papers, F.H. Varley to Maud Varley, 13 April 1924.

99. AEAG, F.H. Varley interviewed by Lawrence Sabbath, 1960 [typescript] p. 8.

100. Varley quoted in McKenzie Porter, "Varley," *Maclean's* (7 November 1959), vol. 72, no. 32, p. 65.

101. CBC, Peter Varley interview with Mrs. G.G. Andrews, 5 May 1969.

102. CBC, Peter Varley interview with Barker Fairley, 23 April 1969; Augustus Bridle, "Aren't These New-Canadian Painters Crazy?" *Canadian Courier* (22 May 1920), vol. XXV, p. 10.

103. Andrea Kirkpatrick, "The Portraiture of Frederick H. Varley, 1919 to 1926," M.A. thesis, Queen's University, 1986, p. 41.

104. CBC, Peter Varley interview with Barker Fairley, 23 April 1969.

105. AEAG, F.H. Varley interviewed by Lawrence Sabbath, 1960 [transcript], p. 13.

106. NAC, CAVA/AVCA 1991-0105, J. Russell Harper interview with Kathleen McKay, May 1975.

107. NAC, MG30 D401, Varley Papers, F.H. Varley to Maud Varley, 2 February 1924.

108. Queen's University Archives, Lorne Pierce Papers, 16 January 1923; see also David G. Pitt, *E.J. Pratt: The Truant Years 1882-1927* (Toronto, 1984), pp. 225-226.

109. Newton MacTavish, *The Fine Arts in Canada* (Toronto, 1925), p. 158.

110. Varley submitted a drawing to the Royal Canadian Academy of Arts competition in 1923, and won first prize for his drawing of immigrants.

111. The twelve artists were J.E.H. MacDonald, Thoreau MacDonald, F.H. Varley, Neil Mackenzie, Arthur Martin, H.S. Palmer, H.S. Stansfield, Florence Wyle, Francis Loring, Frank Carmichael, James Bloomfield, and John Keeley.

112. Annora Brown, *Sketch From Life* (Edmonton, 1981), p. 85.

113. NAC, MG30 D305, Yvonne McKague Housser Papers, Housser, "Early Years" [typescript], p. 3.

114. NAC, MG30 D317, Nora McCullough Papers, Leah Sherman and Angela Grigor, "Oral History Interview with Norah McCullough," Concordia University, 29 August 1982, p. 21.

115. AGO, Charles Band Papers, Mary Konikin to Charles Band, 22 October 1960.

116. AEAG, F.H. Varley interviewed by Lawrence Sabbath, 1960 [transcript], p. 19.

117. F.H. Varley quoted in "Sees Vision of Golden Age of Expression on the Horizon," *Journal* (Edmonton), 27 March 1924, p. 4.

118. AGO, Varley Papers, M. Konikin to F.H. Varley, 10 November [no year].

119. CBC, "Venture '66 Series," interview with A.Y. Jackson.

120. NGC, Eric Brown Papers, Sir Edmund Walker to Eric Brown, December 1921.

121. NGC, Eric Brown Papers, Eric Brown to Sir Edmund Walker, 7 December 1921.

122. Arthur Lismer quoted in *F.H. Varley Paintings, 1915-1954*, Art Gallery of Toronto, 1954.

123. MCACA, Varley Papers, "My Job – Fred H. Varley A.R.C.A.," CBC Radio Talk, 22 May 1939, p. 2; NAC, MG30 D401, Varley Papers, F.H. Varley to Maud Varley, 13 April 1924.

124. NAC, MG30 D401, Varley Papers, F.H. Varley to Maud Varley, n.d., [Edmonton 1924].

125. *Ibid.*, 2 April 1924.

126. *Ibid.*

127. *Ibid.*, 21 January 1924.

128. *Ibid.*, 15 April 1924.

129. *Ibid.*, 2 April 1924.

130. *Ibid.*, 15 April 1924.

131. NAC, CAVA/AVCA 1990-0110, Peter Varley interviewed in "A Tribute to Frederick Varley," 20 September 1969; CBC, Peter Varley interview with Maud Varley, n.d.

132. NAC, MG30 D401, Varley Papers, F.H. Varley to Maud Varley, 2 April 1924.

133. Frances-Anne Johnston quoted in McKenzie Porter, "Varley," *Maclean's* (7 November 1959), vol. 72, no. 23, p. 66.

134. CBC, Peter Varley interview with Jim Varley, 19 May 1970.

135. NAC, Sound Archives, CAVA/AVCA 1990-0110, Maud Varley interviewed on "A Tribute to Frederick Varley," 20 September 1969.

136. NAC, MG30 D401, Varley Papers, Maud Varley to F.H. Varley, 7 April 1924.

137. Arthur Lismer quoted in McKenzie Porter, "Varley," *Maclean's* (7 November 1959), vol. 72, no. 23, p. 66.

138. CBC, Dorothy Varley interviewed by Peter Varley, 10 July 1970.

139. NAC, CAVA/AVCA 1990-0110, Peter Varley interviewed on "A Tribute to Frederick Varley," 20 September 1969.

140. NAC, MG30 D401, Varley Papers, Maud Varley to F.H. Varley, 7 April 1924.

141. NAC, MG30 D401, Varley Papers, F.H. Varley to Maud Varley, 13 April 1924.

142. NAC, Sound Archives, CAVA/AVCA 1990-0100, Maud Varley interviewed on "A Tribute to Frederick Varley," 20 September 1969.

143. NAC, MG30 D401, Varley Papers, Maud Varley to F.H. Varley, n.d., [April 1924].

144. NAC, MG30 D401, Varley Papers, Maud Varley to F.H. Varley, 7 April 1924.

145. NAC, CAVA/AVCA 1990-0110, Maud Varley interviewed on "A Tribute to Frederick Varley," 20 September 1969.

146. NAC, MG30 D401, Varley Papers, F.H. Varley to Maud Varley, 8 November 1918.

147. J.M. Winter, *The Great War and the British People* (London, 1987; originally published 1985), p. 59.

148. NAC, MG30 D401, Varley Papers, Florence Fretten to Maud Varley, 28 September 1921.

149. NAC, MG30 D401, Varley Papers, F.H. Varley to Maud Varley, 15 April 1924.

150. *Ibid.*, 5 August 1918.

151. *Ibid.*, 15 April 1924.

152. Wendell Stacy Johnson, *Living in Sin: The Victorian Sexual Revolution* (Chicago, 1979), p. 180.

153. Havelock Ellis, *The Erotic Rights of Women and the Objects of Marriage* (London, 1918), pp. 19-20.

154. NAC, MG30 D401, Varley Papers, F.H. Varley to Maud Varley, 15 April 1924.

155. *Ibid.*

156. NAC, MG30 D401, Varley Papers, Florence Fretten to Maud Varley, 28 September 1921.

CHAPTER 6

1. NAC, MG30 D401, Varley Papers, F.H. Varley to Maud Varley, 15 April 1924, also 13 April 1924.

2. *Ibid.*, n.d., [March 1924].

3. *Ibid.*, 2 April 1924.

4. *Ibid.*

5. *Ibid.*, 15 April 1924.

6. *Ibid.*

7. *Ibid.*, 13 April 1924.

8. F.H. Varley quoted in *Sunday Province* (Vancouver), 19 September 1926.

9. A.Y. Jackson, "Artists in the Mountains," *Canadian Forum* (January 1925), vol. V. no. 52, p. 112.

10. NAC, MG30 D401, Varley Papers, F.H. Varley to Maud Varley, 13 April 1924.

11. NGC, F.H. Varley to Eric Brown, 17 August 1926.

12. CBC, Peter Varley interview with Barker Fairley, 23 April 1969.

13. Charles Hill, *The Group of Seven, Art for a Nation* (Ottawa, 1995), p. 224.

14. CBC, "Venture '66 Series," interview with Barker Fairley.

15. P.G. Konody, *Observer*, 24 May 1925.

16. *Rochdale Observer*, 8 May 1926.

17. Augustus Bridle, *Toronto Star*, 20 May 1922.

18. F.B. Housser, *A Canadian Art Movement, The Story of the Group of Seven* (Toronto, 1925), p. 214.

19. PABC, Mortimer-Lamb Papers, Arthur Lismer to Harold Mortimer-Lamb, 29 February 1926; the paintings to which Lismer referred were *Self Portrait* (1919), *The Green Shawl* (the portrait of Alice Massey painted 1924-1925), and *Drawing*, n.d.

20. PABC, Mortimer-Lamb Papers, Arthur Lismer to Harold Mortimer-Lamb, 29 February 1926.

21. NGC, A.Y. Jackson Papers, Jackson to Eric Brown, 30 November 1920.

22. *Stormy Weather, Georgian Bay* was exhibited in 1921, 1924-28, 1930, 1931, and 1936. *Self Portrait* in 1920, 1921, 1923, 1924, and 1926; and *Sunken Road* in 1920, 1923, 1926.

23. Larry Pratt and Matina Karvellas, "Nature and Nation: Herder, Myth, and Cultural Nationalism in Canada," *National History* (Winter 1997), vol. 1, no. 1, p. 65.

24. NAC, MG30 D322, Norah Thomson DePencier Papers, A.Y. Jackson to DePencier, October 1925.

25. Rupert Lee, "Canadian Art at Wembley," *Canadian Forum* (September 1925), vol. V, no. 60, p. 368; "Canadian Pictures at Corcoran 'Sing a Saga of the North,'" *Art Digest* (Mid-March 1930), vol. IV, no. 12, pp. 5-6.

26. NGC, A.Y. Jackson Papers, A.Y. Jackson to Eric Brown, 30 November 1920.

27. NGC, F. Horsman Varley to Eric Browne [sic], 10 August 1926.

28. *Ibid.*, 12 August 1926.

29. CBC, Peter Varley interview with Dorothy Varley, 10 July 1970.

30. CBC, Peter Varley interview with Maud Varley, n.d.

31. NAC, MG30 D374, Annie Savage Papers, A.Y. Jackson to Annie Savage, 21 January 1940.

32. Varley quoted in *Vancouver Sun*, 19 September 1926.

33. NAC, MG30 D401, Varley Papers, F.H. Varley to Maud Varley, 12 September 1926.

34. *Canada To-Day* (London, 1926, 1927), p. 133.

35. NAC, MG30 D401, Varley Papers, F.H. Varley to Maud Varley, 12 September 1926.

36. Varley quoted in *Sunday Province* (Vancouver), 19 September 1926.

37. NAC, MG30 D401, Varley Papers, F.H. Varley to Maud Varley, 12 September 1926.

38. NGC, Eric Brown to F.H. Varley, 11 August 1926.

39. "Some Notes on Art, Varley for Vancouver," *Canadian Bookman* (August 1926), vol. 8, p. 256.

40. *The Daily News-Advertiser* (Vancouver), 16 October 1904, p. 5.

41. NAC, MG30 D401, Varley Papers, F.H. Varley to Maud Varley, 12 September 1926.

42. Varley quoted in *Sunday Province* (Vancouver), 19 September 1926.

43. For a discussion of private patronage and private cultural organizations in British Columbia, see chapters 1 and 4, Maria Tippett, *Making Culture, English-Canadian Institutions and the Arts before the Massey Commission* (Toronto, 1990).

44. Vancouver Board of School Trustees, *Twenty-Third Annual Report for the Year Ending December 31, 1925* (Vancouver, 1925), p. 19.

45. Harold Mortimer-Lamb, "The Modern Art Movement In Canada," *The Daily Province*, 15 September 1922.

46. Ada F. Currie, "The Vanderpant Musicales," *Paint Box* (June 1928), vol. 3, p. 48.

47. CBC, Peter Varley interview with Gerald Tyler, 8 July 1970.

48. Helen Dickson, *Canadian Forum* (December 1931), vol. XII, no. 135, p. 103.

49. MCACA, Arthur Lismer Papers, F.H. Varley to Arthur Lismer, [February 1928].

50. Helen Dickson, *Canadian Forum* (December 1931), vol. XII, no. 135, p. 103; CBC, Peter Varley interview with Jack Shadbolt, 27 May 1970.

51. CBC, Peter Varley interview with Jack Shadbolt, 27 May 1970.

52. NAC, MG30 D401, Varley Papers, F.H. Varley to Maud Varley, 12 September 1926.

53. Elie Faure, *History of Art: Modern Art*, vol. IV (New York, 1924).

54. Vernon Blake, *The Art and Craft of Drawing* (London, 1927), p. 11.

55. F.H. Varley, "Room 27 Speaking," *Paint Box* (June 1927), vol. 2, p. 23.

56. Wilhelm Ostwald, *The Colour Primer* (London, 1916); Albert Munsell, *A Color Notation* (Boston, 1905) p. 1; CBC Archives, Peter Varley interview with Fred Amess, n.d.

57. *Nude Standing* (c. 1930), black chalk on paper, NGC.

58. NGC, Varley Papers, Fred Amess, "Varley," [typescript] April 1955, n.p.

59. NAC, CAVA/AVCA 1990-0110, Gerald Tyler interviewed on "A Tribute to Frederick Varley," 20 September 1969.

60. Burnaby Art Gallery, Archives, 818-1063, taped interview by Judi Francis with Grace Melvin, tape 2, n.d. [destroyed].

61. AEAG, F.H. Varley interviewed by Lawrence Sabbath interview, 1960 [typescript], p. 18.

62. NGC, Varley Papers, Fred Amess, "Varley," [typescript] April 1955, n.p.

63. *Ibid.*

64. MCACA, Varley Papers, Philip Surrey, "Varley as I knew Him," [typescript], p. 1.

65. NGC, Varley Papers, Fred Amess, "Varley," [typescript] April 1955, n.p.

66. CBC, Peter Varley interview with Fred Amess, n.d.

67. CBC, Peter Varley interview with Jack Shadbolt, 27 May 1970.

68. CBC, Peter Varley interview with Orville Fisher, 8 July 1970.

69. AGO, Varley Papers, Bessie Fry to F.H. Varley, 24 August 1955.

70. Burnaby Art Gallery, Archives, 700-806, taped interview by Judi Francis with Rowan Morell, n.d. [destroyed].

71. NGC, Varley Papers, Fred Amess, "Varley," [typescript] April 1955, n.p.

72. Helen Dickson, *Canadian Forum* (December 1931), vol. XII, no. 135, pp. 102-103.

73. CBC, Peter Varley interview with Jack Shadbolt, 27 May 1970.

74. PABC, Edythe Hembroff-Schleicher Papers, Emily Carr to E. Hembroff-Brand, 17 November 1933.

75. Thomas Craven, *Men of Art* (New York, 1931), p. xxi, and Scott Watson, *Jack Shadbolt* (Vancouver, 1990), p. 10.

76. EAG, Varley Papers, F.H. Varley to Vera Weatherbie, n.d., [1940].

77. Scott Watson, *Jack Shadbolt* (Vancouver, 1990), p. 8.

78. CBC, Peter Varley interview with Jack Shadbolt, 27 May 1970.

79. NGC, Varley Papers, Fred Amess, "Varley," [typescript] April 1955, n.p.

80. CBC, Peter Varley interview with Orville Fisher, 8 July 1970.

81. MCACA, Varley Papers, Philip Surrey, "Varley as I Knew Him" [typescript], n.d.

82. CBC, Peter Varley interview with David Brock, 19 May 1970.

83. F.H. Varley, "Room 27 Speaking," *Paint Box* (June 1927), vol. 2, p. 23.

84. Varley quoted in *Sunday Province* (Vancouver), 19 September 1926.

85. Walter J. Phillips, "British Columbia Art," *Winnipeg Evening Tribune*, 19 September 1931, in Maria Tippett and Douglas Cole, *Phillips in Print, The Selected Writings of Walter J. Phillips on Canadian Nature and Art* (Winnipeg, 1982), p. 107.

86. NAC, MG30 D401, Varley Papers, F.H. Varley to Maud Varley, 15 April 1924.

87. NGC, Varley Papers, Fred Amess, "Varley," [typescript] April 1955, n.p.

88. Emily Carr College of Art, Archives, Margaret Williams "Scrapbook," undated newspaper clipping [1927].

89. NGC, Varley Papers, Fred Amess, "Varley," [typescript] April 1955, n.p.

90. "Composition," *Paint Box* (June 1927), vol. 2, p. 10.

91. "Editorial," *Paint Box* (June 1927), vol. 2, p. 5.

92. M. Sherman, "Places to Sketch," *Paint Box* (June 1926), vol. 1, no. 1, p. 23.

93. Vito S. Cianci, "Artists — and Others," *Paint Box* (June 1928), vol. 3, pp. 13-15.

94. F.H. Varley quoted in "Sees Vancouver Art Centre of the Dominion," *Province* (Vancouver), 19 September 1926.

95. NAC, MG30 D401, Varley Papers, F.H. Varley to Maud Varley, 12 September 1926.

96. Peter Varley, *Frederick H. Varley* (Toronto, 1983), p. 16.

97. *Dawn* (c. 1929), private collection; *Evening After Storm* (c. 1927), AEAG, Queen's University; *Rain Squall* (c. 1928), NGC; *Howe Sound* (c. 1927), private collection;

Coast Mountain Forms (c. 1929), NGC; and *Looking Towards Seymour* (c. 1928), Ontario Heritage Foundation Firestone Art Collection.

98. Peter Varley, *Frederick H. Varley* (Toronto, 1983), p. 18.
99. CBC, Peter Varley interview with David Brock, 19 May 1970.
100. Dave Brock, "A Fire in the Belly," *Vancouver Sun*, 3 October 1969.
101. "Editorial," *Paint Box* (June 1927), vol. 2, no. 2, p. 5.
102. Ruth D. Golman, "Garibaldi Park," *Canadian Geographic Journal* (November 1931), vol. III, p. 339.
103. MCACA, F.H. Varley to A.D.A. Mason [copy], 15 April 1929.
104. NGC, F.H. Varley to Elizabeth Styring Nutt, 1 January 1932.
105. Garibaldi Park Board, *Garibaldi Park* (Victoria, 1929), p. 3.
106. J.W.G. Macdonald quoted in *F.H. Varley Paintings, 1915-1954* (AGO, 1954), p. 7.
107. "Morning on the Black Tusk Meadows," *Paint Box* (June 1928), vol. 3, p. 63.
108. NGC, F.H. Varley to Elizabeth Styring Nutt, 1 January 1932.
109. EAG, F.H. Varley to Vera Weatherbie, n.d., [1944].
110. Mona Gould, "Verbal Meanderings: A Collection of Recollections," *Gossip* (Toronto, August-September 1969), p. 4.
111. J.W.G. Macdonald quoted in *F.H. Varley Paintings, 1915-1954* (Toronto, Art Gallery of Toronto, 1954), p. 7.
112. Burnaby Art Gallery, Archives, taped interview by Judi Francis with Bea Lennie [destroyed].
113. MCACA, Varley Papers, Varley to A.D.A. Mason [copy], 15 April 1929.
114. Rupert Brooke, *Letters from America* (London, 1916; originally published 1913) pp. 148-156; Maria Tippett and Douglas Cole, *From Desolation to Splendour, Changing Perceptions of the British Columbia Landscape* (Toronto, 1977), p. 61.
115. PABC, Harold Mortimer-Lamb Papers, H. Mortimer-Lamb, "A Land of Opportunity for the Landscape Painter," early 1930s [typescript], p. 2.
116. MCACA, Varley Papers, Varley to A.D.A. Mason [copy], 28 January 1928.
117. NGC, Varley Papers, F.H. Varley to Eric Brown, 18 February 1928.
118. NAC, MG30 D401, Varley Papers, F.H. Varley to Lil Varley and Ethel Varley, 9 February 1936.
119. CBC, Peter Varley interview with Fred Amess, n.d.
120. J.L. Shadbolt, "The Artist and His Means of Expression," *Canadian Bookman* (December 1936), vol. 14, p. 11.
121. NAC, MG30 D401, Varley Papers, verse by John Varley and Fred Varley (c. 1929).
122. AGO, Varley Papers, Bessie Fry to F.H. Varley, 24 August 1955; *Coast Mountain Form* (c. 1929), oil on wood panel, NGC, and *The Cloud* (1927), oil on canvas, AGO.
123. *Gorge of the Sphinx* (1934), ink and watercolour, AGO, and *Cheakamus Canyon* (1929), oil on wood panel, private collection, Vancouver.

124. *Fireweed* (c. 1934), oil on wood panel, private collection, Edmonton.

125. Peter Varley, *Frederick H. Varley* (Toronto, 1983), p. 23.

126. Maria Tippett, *Emily Carr, A Biography* (Toronto, 1979), p. 208.

127. University of British Columbia, Archives, Nan Cheney Papers, Emily Carr to Nan Cheney, n.d. [October 1935].

128. Emily Carr, *Hundreds and Thousands: The Journals of Emily Carr* (Toronto, 1966), 10 November 1927, p. 3.

129. "Artists and Their Doings, A Local Woman Artist," *Western Woman's Weekly* (5 October 1918), vol. 1, p. 7.

130. Maria Tippett's interview with B.C. artist and contemporary of F.H. Varley, Grace Judge, Vancouver, 5 November 1974; Eileen Johnson, "Sunlight from a Forgotten Attic," *Vancouver Life* (July 1967), p. 19.

131. Author's interview with Bea Lennie, 5 November 1973.

132. *Observer* (London) quoted in Luscombe Carroll, *The Art of Charles John Collings* (London, The Carroll Gallery, 1912), p. 10.

133. For an excellent discussion of how Varley employed Munsell's ideas, see Christopher Varley, *F.H. Varley* (EAG, 1981), p. 92.

134. NAC, MG30 D401, Varley Papers, F.H. Varley to Mary and Jim Varley, 25 March 1945; see also Elie Faure, *The Dance Over Fire and Water* (New York, 1926), p. 83.

135. Vernon Blake, *The Art and Craft of Drawing* (New York, 1927), p. 10.

136. E.T. Cook and Alexandre Wedderburn, ed., *Ruskin, Works III* (London, 1903-12), p. 395.

137. SCA, Varley Papers, Fred Varley to Ethel Varley, n.d., [May 1914].

138. NGC, John Vanderpant Papers, John Vanderpant, "Art in General; Canadian Painting in Particular," [October/November 1933].

139. Zhu Liyuan and Gene Blocker, ed., *Contemporary Chinese Aesthetics* (New York, 1995), p. 246.

140. Rupert Brooke, *Letters from America* (London, 1916; originally published, 1913), p. 508.

141. NGC, Varley Papers, F.H. Varley to Eric Brown, 17 February 1928. See also F.H. Varley to L.L. Fitzgerald, 25 September 1934, cited in Michael Parke Taylor, *In Seclusion with Nature, The Later Work of L. LeMoine Fitzgerald, 1942 to 1956* (Winnipeg, 1988), p. 16: "The Chinese artists of the 10th and 11th century seem to be the only artists who have interpreted a country such as B.C."

142. The work of these and other artists of this period are illustrated in Sherman E. Lee, *Chinese Landscape Painting* (New York, 1954).

143. See, for example, *Cheakamus Canyon* and *Lynn Creek*, (c. 1934-35), pencil and water-colour on paper, EAG.

144. *Sketch of Garrow Bay, British Columbia* (c. 1933), oil on wood panel, Vancouver Art Gallery; and *The Open Window* (1932), oil on canvas, Hart House, University of Toronto.

145. *Lynn Peak and Cedar* (c. 1934), watercolour on paper, Canada Packers Inc., Toronto; *Weather – Lynn Valley*, (c. 1935), oil on wood panel, Art Gallery of Greater Victoria; *Coast Mountain Form* (c. 1929), oil on wood panel, NGC; and *Looking Towards Seymour* (1929), oil on wood panel, Ontario Heritage Foundation, Firestone Art Collection, Ottawa.

146. Frederick C. Brunke, "'Mess of Chili Sauce' is description of one work of art," *Toronto Telegram*, 23 February 1928, p. 30.

147. Jehanne Biétry Salinger, "Freedom Fills Work by Group of Seven," *Toronto Mail and Empire*, 4 April 1930.

148. Augustus Bridle, "All Space is Occupied for Art Gallery's Opening," *Toronto Daily Star*, 3 April 1930.

149. See, for example, Varley's brush drawing *Nightsong* in *Canadian Forum* (December 1930) vol. II, p. 97; *British Columbia Coast* (August 1931), vol. 12, p. 423.

150. See, for example, "Protests against One-Man Tribunal to Select B.C. Pictures for Show," *Vancouver Sun*, 1 February 1930.

151. MCACA, Varley Papers, Varley to Arnold Mason [copy], n.d. [February 1928].

152. See Maria Tippett, *Emily Carr, A Biography* (Toronto, 1979), pp. 206-212.

153. MCACA, Varley Papers, Varley to Arnold Mason [copy], n.d. [February 1928].

154. NGC, Eric Brown Papers, F.H. Varley to Eric Brown, 8 July 1930.

155. MCACA, Varley Papers, Varley to Arnold Mason [copy], n.d. [February 1928]. Varley was referring to a few canvases that the Edmonton Museum of Art had sent to H. Mortimer-Lamb following its exhibition of the Group of Seven in October 1927.

156. Charles C. Hill, *The Group of Seven, Art For A Nation* (Ottawa, 1995), pp. 248-251.

157. MCACA, Varley Papers, Varley to Arnold Mason [copy], 28 January 1928; Jehanne Biétry Salinger, "Comment on Art, The Group of Seven," *Canadian Forum* (January 1932), vol. XII, no. 136, p. 143.

158. Grace Judge interviewed by the author, February 1977.

159. The director of the San Francisco Art Association, E. Spenjcer Macky, invited Varley to exhibit at the Fine Arts Museum of San Francisco. Varley declined, feeling that he had too little work to send to the show, and because he had not sold more work at his show in Seattle.

160. "One Man Show at Vancouver Art Gallery," *Province* (Vancouver), 2 December 1932.

161. "Visitors Impressed and Annoyed," *Vancouver Sun*, 2 December 1932.

162. *Sheffield Telegraph*, 12 June 1933.

163. McKenzie Porter, "Varley," *Maclean's* (7 November 1959), vol. 72, no. 23, p. 66.

CHAPTER 7

1. MCACA, Varley Papers, Chris Varley's transcription, F.H. Varley to "Marilka" [Mary Konikin], 4 June 1929, p. 30. See also MCACA, Varley Papers, letter to Harold Mortimer-Lamb [copy], 6 June 1936, Varley wrote that women were a "damned nuisance when they try to run a man."

2. CBC, Peter Varley interview with Miriam Kennedy, 19 July 1969.

3. CBC, Peter Varley interview with Dorothy Varley, 10 July 1970.

4. NAC, CAVA/AVCA 1990-0110, David Brock interviewed on "A Tribute to Frederick Varley," 20 September 1969.

5. NAC, MG30 D368, Philip and Margaret Surrey Papers, Philip Surrey, "Autobiography" [typescript], p. 41.

6. NAC, MG30 D368, Philip and Margaret Surrey Papers, Philip Surrey, "Autobiography" [typescript], p. 40; Peter Varley, *Frederick H. Varley* (Toronto, 1983), p. 19. Peter Varley offers an excellent discussion of family life in Vancouver during the 1920s and 1930s.

7. CBC, Peter Varley interview with Maud Varley, n.d.

8. NAC, MG30 D368, Philip and Margaret Surrey Papers, Philip Surrey, "Autobiography" [typescript], p. 41.

9. Peter Varley, *Frederick H. Varley* (Toronto, 1983), p. 19.

10. CBC, Peter Varley interview with Jim Varley, 10 July 1970.

11. CBC, Peter Varley interview with David Brock, 19 May 1970.

12. Molly Lamb Bobak, *Impressions and Sketches of a Field Artist, Wild Flowers of Canada* (Toronto, 1978), p. 20.

13. CBC, Peter Varley interview with Jim Varley, 10 July 1970.

14. CBC, Peter Varley interview with Jim Varley, 10 July 1970.

15. NAC, MG30 D368, Philip and Margaret Surrey Papers, Philip Surrey, "Autobiography" [typescript], pp. 40, 41; NAC, CAVA/AVCA 1990-0110, Philip Surrey interviewed in "A Tribute to Frederick Varley," 20 September 1969. When Peter Varley interviewed Dorothy, Jim, and John in 1970, their feelings for their father were less hostile but nonetheless critical.

16. CBC, Peter Varley interview with Bea Lennie, 4 July 1970.

17. CBC, Peter Varley interview with Dave Brock, 19 May 1970.

18. Author's interview with Beth Robinson Pierce, October 1995.

19. NGC, Eric Brown Papers, F.H. Varley to Eric Brown, 8 July 1930.

20. CBC, Peter Varley interview with Jack Shadbolt, 27 May 1970.

21. CBC, Peter Varley interview with Miriam Kennedy, 19 July 1969.

22. Dave Brock, "A Fire in the Belly," *Vancouver Sun*, 3 October 1969.

23. NAC, MG30 D368, Philip and Margaret Surrey Papers, Philip Surrey, "Autobiography" [typescript], p. 41.

24. Author's interview with Hélène Ladner, September 1997.

25. CBC, Peter Varley interview with Jim Varley, 19 May 1970.
26. "The Oval Portrait" in James A. Harrison, *The Complete Works of Edgar Allan Poe* (New York 1965), vol. IV, p. 248.
27. Oscar Wilde, *Lady Windermere's Fan* (Leipzig, 1892), Act II.
28. H.G. Wells, *Ann Veronica* (London, 1909), p. 377.
29. Bertram Brooker, ed., *The Yearbook of the Arts in Canada* (Toronto, 1936), p. xvii.
30. Eswyn Lyster, "Norma," *Westworld* (Vancouver) January/February 1982, p. 32.
31. MCACA, Varley Papers, Marjorie Lismer to Christopher Varley, 3 December 1980.
32. MCACA, Varley Papers, F.H. Varley to Dr. A.D.A. Mason [copy], 28 January 1928.
33. CBC, Peter Varley interview with Jim Varley, 10 July 1970.
34. George Eliot, *Daniel Deronda* (London, 1974; originally published 1876), p. 517.
35. NAC, MG30 D368, Philip and Margaret Surrey Papers, Philip Surrey, "Autobiography" [typescript], p. 40.
36. See, for example, *Portrait of Maud* (1925), canvas, NGC.
37. NGC, Varley Papers, Fred Amess, "Varley," [typescript] April 1955, n.p.
38. NAC, CAVA/AVCA 1990-0110, Dave Brock interviewed in "A Tribute to Frederick Varley," 20 September 1969.
39. Molly Lamb Bobak, *Impressions and Sketches of a Field Artist, Wild Flowers of Canada* (Toronto, 1978), p. 24.
40. CBC, Peter Varley interview with Bea Lennie, 4 July 1970.
41. Christopher Varley, *F.H. Varley* (Ottawa, 1979), p. 19.
42. *Head of a Girl* (c. 1933), black chalk on paper, NGC; EAG, F.H. Varley to Vera Weatherbie [May 1937].
43. CBC, Peter Varley interview with Bea Lennie, 4 July 1970.
44. Christopher Varley, *F.H. Varley* (Ottawa, 1979), p. 19.
45. EAG, F.H. Varley to Vera Weatherbie, n.d. [Ottawa, 1944].
46. *Ibid.*
47. Annie Besant and C.W. Leadbeater, *Thought Forms* (London, 1905), p. 18.
48. CBC, Peter Varley interview with Jim Varley, 19 May 1970.
49. NGC, Charles Hill interview with Philip Surrey, 14 September 1973.
50. NAC, CAVA/AVCA 1990-0110, Dave Brock interviewed in "A Tribute to Frederick Varley," 20 September 1969.
51. NAC, CAVA/AVCA 1990-0110, Maud Varley interviewed in "A Tribute to Frederick Varley," 20 September 1969.
52. CBC, Peter Varley quoted in his interview with Jim and Erica Leach, 13 July 1970.
53. *Ibid.*; Molly Lamb Bobak, *Impressions and Sketches of a Field Artist, Wild Flowers of Canada* (Toronto, 1978), p. 24.
54. McKenzie Porter, "Varley," *Maclean's* (7 November 1959), vol. 72, no. 23, p. 66.
55. CBC, Peter Varley interview with Alice Lane, October 1969.

56. The symbol X means "here you will find food, work, and/or money; generous people." Carl G. Liungman, *Dictionary of Symbols* (New York, 1991), p. 329.

57. CBC, Peter Varley interview with Dorothy Varley, 10 July 1970.

58. CBC, Peter Varley interview with Jim Varley, 19 May 1970.

59. F.H. Varley, *Head of a Girl* (c. 1929), oil on panel, Montreal Museum of Fine Arts. Also note John Vanderpant's photograph of Vera as the Virgin Mary, which may have inspired Varley's painting. Vanderpant's photograph is in the collection of Anna Vanderpant Ackroyd and Catherine Vanderpant Shelly, Vancouver.

60. CBC, Peter Varley interview with Dorothy Varley, 10 July 1970.

61. Emily Carr College of Art and Design, Archives, Bea Lennie, "Class of '29," n.d. n.p.

62. Eswyn Lyster, "Norma," *Westworld* (January/February 1982), p. 32.

63. CBC, Peter Varley interview with Miriam Kennedy, 19 July 1969.

64. NAC, CAVA/AVCA 1990-0110, F.H. Varley interviewed in "A Tribute to Frederick Varley" 20 September 1969.

65. NGC, H.O. McCurry Papers, F.H. Varley to H.O. McCurry [1932]; *Vera* (1929), oil on canvas, NGC.

66. *Vera* (1930), oil on canvas, NGC.

67. CBC, Peter Varley interview with Mrs. Alice Lane, October 1969.

68. NGC, H.O. McCurry Papers, F.H. Varley to H.O. McCurry [1932].

69. CBC, Peter Varley interview with Miriam Kennedy, 19 July 1969.

70. EAG, F.H. Varley to Vera Weatherbie, n.d. [Ottawa, 1944].

71. "All-Canadian Artists' Pictures on Exhibition," *Vancouver Sun*, 11 May 1932.

72. NGC, Vera Weatherbie Papers, *Saturday Night*, 19 December 1934 [clipping].

73. Blodwen Davies, "The Canadian Group of Seven," *American Magazine of Art* (July 1932), vol. XXV, no. 1, p. 13.

74. Arthur Lismer, "Works by Three Canadian Women," *Montreal Star*, 9 May 1934.

75. Maria Tippett, *By A Lady, Celebrating Three Centuries of Art by Canadian Women* (Toronto, 1992), see chapter III.

76. n.a., "All Canadian Artists' Pictures on Exhibition," *Vancouver Sun*, 11 May 1932; Reta W. Myers, "Art Gallery Display Is of Exceptional Merit," *Daily Province*, 12 May 1932. Weatherbie exhibited her portrait of Varley early in 1931 at the National Gallery of Canada and, later the same year, at the Vancouver Art Gallery.

77. NGC, Eric Brown Papers, John Vanderpant to Eric Brown, 6 January 1931.

78. MCACA, Varley Papers, F.H. Varley to Vera Weatherbie, 8 November 1939.

79. NAC, MG30 D401, Varley Papers, F.H. Varley to Vera Weatherbie, 7 January 1941; CBC, Peter Varley interview with Bea Lennie, 4 July 1970. The painting in question is *Dhârâna*, oil on canvas, AGO.

80. CBC, Peter Varley interview with Bea Lennie, 4 July 1970.

81. EAG, F.H. Varley to Vera Weatherbie, "Sunday Night Now," n.d. [1936].

82. *Ibid.*, 8 November 1939.

83. *Ibid.*, "Sunday Night Now," n.d. [1936].

84. *Ibid.*, 8 November 1939.

85. *Ibid.*

86. *Ibid.*, n.d. [Ottawa, 1936].

87. MCACA, Varley Papers, F.H. Varley to Harold Mortimer-Lamb, 1 March 1946 [copy].

88. *Ibid.*; NGC, Varley Papers, F.H. Varley to H.O. McCurry, n.d. [1932].

89. Author's interview with Jack Shadbolt, 11 July 1973.

90. EAG, F.H. Varley to Vera Weatherbie, n.d. [Ottawa, 1944].

91. NGC, Vera Weatherbie Papers, *Saturday Night*, 19 December 1934 [clipping].

92. See, for example, Vera Weatherbie, *Cottage With Trees* (n.d.), oil on canvas, Art Gallery of Greater Victoria; also see Janet Tenody, "F.H. Varley, Landscape of the Vancouver Years," M.A. thesis, Queen's University, 1983, p. 84.

93. CBC, Peter Varley commenting while interviewing his brother Jim Varley, 19 May 1970.

94. McKenzie Porter, "Varley," *Maclean's* (7 November 1959), vol. 72, no. 23, p. 66.

95. EAG, F.H. Varley to Vera Weatherbie, 9 November [1931].

96. *Ibid.*

97. MCACA, Varley Papers, F.H. Varley to A.D.A. Mason [copy], [February 1928].

98. EAG, F.H. Varley to Vera Weatherbie, 9 November [1931].

99. *Ibid.*

100. *Ibid.*

101. AGO, C.S. Band Papers, Vera Weatherbie to Charles Band, 16 November 1960.

102. EAG, F.H. Varley to Vera Weatherbie, n.d. [Ottawa, 1936],

103. NGC, H.O. McCurry Papers, J.W.G. Macdonald to H.O. McCurry, 14 June 1932.

104. Alan Morley, *Vancouver from Milltown to Metropolis* (Vancouver, 1961), p. 178.

105. Burnaby Art Gallery Archives [typescript], n.d. They suggested salaries of $2,105 for Scott, $1,684 for Varley, $1,474 for Macdonald, and $1,055 for Grace Melvin.

106. Reta Myers, "In the Domain of Art," *Daily Province* (Vancouver), 11 June 1933.

107. Burnaby Art Gallery Archives, Denis R. Reid and R. Ann Pollock, "J.W.G. Macdonald, The Western Years 1926-1946," March 1969 [typescript], p. 6.

108. NGC, Eric Brown Papers, F.H. Varley to Eric Brown, 5 April 1933.

109. NGC, Eric Brown Papers, Eric Brown to F.H. Varley, 18 April 1933.

110. NGC, Carnegie Corporation File, Arthur Lismer, "Report on Western Lecture Tour," [typescript], July 1935.

111. See Maria Tippett, *Making Culture, English-Canadian Institutions and the Arts Before the Massey Commission* (Toronto, 1990), pp. 114-115.

112. NAC, MG30 D401, Varley Papers, F.H. Varley to R.S. Lennie, 29 June 1933.

113. Author's interview with Hélène Ladner, September 1997.

114. Elie Faure, *History of Art, Modern Art* (New York, 1937; originally published 1924), p. xvii.

115. *Daily Province* (Vancouver), 6 January 1934.

116. NGC, Elizabeth Nutt Papers, F.H. Varley to Elizabeth Nutt, 1 January 1932 [sic] [typescript]; MCACA, Varley Papers, "The British Columbia College of Arts Ltd. Prospectus, 1933-1934."

117. NGC, H.O. McCurry Papers, F.H. Varley to H.O. McCurry, 16 April 1934.

118. NGC, H.O. McCurry Papers, F.H. Varley to H.O. McCurry, 16 April 1934.

119. Dennis R. Reid and R. Ann Pollock, "J.W.G. Macdonald, The Western Years: 1926-1946" (Burnaby Art Gallery, March 1969) [typescript], p. 7.

120. Author's interview with Hélène Ladner, September 1997.

121. H.E. Torey, "Where East Meets West," *Saturday Night*, 21 April 1934.

122. Reta W. Myers, "In the Domain of Art," *Daily Province* (Vancouver), 18 November 1933.

123. McCord Museum Archives, J.W.G. Macdonald Papers, Jock Macdonald to Maxwell Bates, 30 July 1956.

124. Vera Weatherbie, *Night Time* (n.d.), oil on canvas, Art Gallery of Greater Victoria, no. 74-20.

125. PABC, MS 2834, Harold Mortimer-Lamb Papers, "Weatherbie" [typescript], n.a. n.d., listing works by Vera Weatherbie.

126. CBC, Peter Varley interview with Jack Shadbolt, 27 May 1970.

127. NGC, B.C. College of Arts Papers, Hélène Ladner, "Taüber Lectures, 1933," p. 2.

128. AGO, Varley Papers, F.H. Varley to "My Dear Little Mother," 1 November 1934 [inscribed drafts].

129. AEAG, F.H. Varley interviewed by Lawrence Sabbath, September 1960 [typescript], p. 11. For an excellent discussion see Ann Davis, *The Logic of Ecstasy, Canadian Mystical Painting 1920-1940* (Toronto, 1992), pp. 84-86.

130. For F.H. Varley's remarks referring to *Complementaries*, see MCACA, Varley Papers, "Varley, Information re: Paintings, derived from meetings with Varley April 2nd and 6th, 1954," p. 2. Note also that Ostwald's book, *Colour Science*, was published in 1931.

131. *Complementaries* (c. 1933), oil on canvas, AGO. *Tree Tufts* (c. 1933), oil on panel, and *Tree Tops and Clouds* (c. 1930), both in the NGC, should also be considered here for their abstract qualities. *Evening in Camp* (1923), oil on canvas, private collection, might very well be the genesis of *Complementaries*.

132. CBC, Peter Varley interview with Miriam Kennedy 19 July 1969.

133. PABC, Harold Mortimer-Lamb Papers, A.Y. Jackson to Harold Mortimer-Lamb, 21 December [1929].

134. AGO Archives, Varley Papers, FHV to mother and wife [drafts], 1 November 1934.

135. FitzGerald Centre, University of Manitoba, J.W.G. Macdonald to L.L. FitzGerald, 25 September 1934.

136. MCACA, Philip Surrey, "Varley as I Knew Him" [undated typescript], p. 4.

137. CBC, Peter Varley interview with Dave Brock, 19 May 1970.

138. CBC, Peter Varley interview with Jim Varley, 10 July 1970.

139. MCACA, Philip Surrey, "Varley as I Knew Him" [undated typescript], p. 4.

140. Molly Lamb Bobak, *Impressions and Sketches of a Field Artist, Wild Flowers of Canada* (Toronto, 1978), p. 24.

141. Varley's *Fire Ranger's Cabin, Lynn Valley* (1932) was exhibited at the Vancouver Art Gallery, 5 October 1930; see Vera Weatherbie, *Solitude* (n.d.), oil on board, Art Gallery of Greater Victoria, no. 74-121.

142. F.H. Varley, *Dhârâna* (1932), oil on canvas, AGO.

143. H. Mortimer-Lamb, "British Columbia Art," *Saturday Night*, 10 December 1932.

144. "Varley Works Are Inspiring," *Vancouver Province*, 2 December 1932.

145. See, for example, Barry Lord, *History of Painting in Canada, Toward a People's Art* (Toronto, 1974), p. 179; Ann Davis, *Logic of Ecstasy, Canadian Mystical Painting 1920-1940* (Toronto, 1992), pp. 134-135; Megan Bice and Sharyn Udall, *The Informing Spirit, Art of the American Southwest and West Coast Canada, 1925-1945* (McMichael Canadian Art Collection and the Taylor Museum for Southwestern Studies, Colorado Springs Fine Arts Centre, 1994), p. 68. The most important study of the painting is an undated, anonymous typescript in the archives of the Vancouver Art Gallery.

146. NAC, CAVA/AVCA 1990-0110, Vera Weatherbie interviewed in "A Tribute to Frederick Varley," 20 September 1969.

147. CBC, Peter Varley interview with Bea Lennie, 4 July 1970.

148. A.D. Fraser Jenkins, *Augustus John: Studies for Compositions, Centenary Exhibition* (National Museum of Wales, 1978), see figures 22, 23, 24.

149. NAC, CAVA/AVCA 1990-0110, Vera Weatherbie interviewed in "A Tribute to Frederick Varley," 20 September 1969.

150. F.H. Varley, "Room 27 Speaking," *Paint Box* (June 1927), vol. 2, p. 23.

151. National Film Board, *Varley*, 1953; author's interview with Jack Nichols, 15 March 1996.

152. NGC, Philip Surrey interviewed by Charles Hill, 14 September 1973, vol 1,. n.p.; CBC, Peter Varley interview with Peter Bortkus, 3 January 1970.

153. *Mountain Lake* (c. 1934), watercolour, NGC.

154. *Green Wings* (c. 1934), oil on board, NGC.

155. NGC, Philip Surrey interviewed by Charles Hill, 14 September 1973, vol. 1, n.p.

156. CBC, Peter Varley interview with Peter Bortkus, 3 January 1970.

157. CBC, Peter Varley interview with Jim Varley, 19 May 1970.

158. MCACA, Philip Surrey, "Varley as I Knew Him," [undated typescript], p. 4.

159. NGC, Varley Papers, Fred Amess, "Varley," [typescript] April 1955, n.p.

160. CBC, Peter Varley interview with Bea Lennie, 4 July 1970; CBC, Peter Varley interview with Gerald Tyler, 8 July 1970.

161. NGC, H.O. McCurry Papers, J.W.G. Macdonald to H.O. McCurry, 29 December 1936; CBC, Peter Varley interview with Gerald Tyler, 8 July 1970.

162. Burnaby Art Gallery Archives, Denis R. Reid and R. Ann Pollock, "J.W.G. Macdonald, The Western Years 1926-1946," March 1969 [typescript], p. 8.

163. NGC, H.O. McCurry Papers, J.W.G. Macdonald to H.O. McCurry, 29 December 1936.

164. NGC, H.O. McCurry Papers, A.Y. Jackson to H.O. McCurry, 30 September 1936.

165. MCACA, Philip Surrey, "Varley as I Knew Him," [undated typescript], pp. 6-7.

166. NGC, Eric Brown Papers, F.H. Varley to Eric Brown, 26 December 1935.

167. MCACA, Varley Papers, F.H. Varley to Harold Mortimer-Lamb, 1 January 1936 [copy].

168. *Ibid.*

169. CBC, Peter Varley interview with Maud Varley, n.d.

170. AGO, Varley Papers, Vera Weatherbie to F.H. Varley, 19 January 1961.

171. CBC, Peter Varley interview with Miriam Kennedy, 19 July 1969.

172. *Ibid.*

173. MCACA, Varley Papers, F.H. Varley to Harold Mortimer-Lamb, 6 June 1936 [copy].

174. AGO, Varley Papers, Vera Weatherbie to Kathy McKay, 29 April 1969.

175. NGC, Eric Brown Papers, F.H. Varley to Eric Brown, 7 December 1935.

176. *Ibid.*, 1 February 1936.

177. NAC, MG30 D401, Varley Papers, F.H. Varley to Ethel and Lilian Varley, 9 February 1936.

178. NGC, H.O. McCurry Papers, H.O. McCurry to F.H. Varley, 12 February 1936.

179. NGC, Eric Brown Papers, John Vanderpant to Eric Brown, 23 February 1936.

180. NGC, H.O. McCurry Papers, F.H. Varley to H.O. McCurry, 23 February 1936.

181. NGC, H.O. McCurry Papers, H.O. McCurry to John Vanderpant, 13 March 1936.

182. NGC, H.O. McCurry Papers, John Vanderpant to H.O. McCurry, 21 March 1936.

183. NGC, H.O. McCurry Papers, H.O. McCurry to John Vanderpant, 24 March 1936.

184. NGC, Eric Brown Papers, Eric Brown to John Vanderpant, 25 March 1936.

185. CBC, Peter Varley interview with Jim Varley, 10 July 1970.

186. Molly Lamb Bobak, *Impressions and Sketches of a Field Artist* (Toronto, 1978), p. 24.

187. NGC, A.Y. Jackson Papers, A.Y. Jackson to H.S. Southam, 8 April 1936.

CHAPTER 8

1. Maria Tippett, *Making Culture, English-Canadian Institutions and the Arts before the Massey Commission* (Toronto, 1990), pp. 144-155.

2. Paraskeva Clarke, "Come Out From Behind the Pre-Cambrian Shield," *New Frontier* (April 1937), vol. 1, no. 2, pp. 16-17; Frank Underhill, "False Hair on the Chest," *Saturday Night*, (3 October 1936), vol. LI, no. 48, pp. 1, 3.

3. Graham McInnes, "Canadian Art," *Queen's Quarterly* (Summer 1938), vol. XLV, no. 2, pp. 242-243.

4. NAC, MG30 D373, John Vanderpant Papers, F.H. Varley to John Vanderpant, Easter Monday [1936].

5. CBC, Peter Varley interview with Henri Masson, 20 May 1969.

6. NAC, MG30 D373, John Vanderpant Papers, F.H. Varley to John Vanderpant [copy], Easter Monday, [1936].

7. MCACA, F.H. Varley to Harold Mortimer-Lamb, 6 June 1936 [copy].

8. NAC, MG30 D351, A.Y. Jackson Papers, A.Y. Jackson to Naomi Jackson Groves, 12 April 1937.

9. NAC, MG30 D373, John Vanderpant Papers, F.H. Varley to John Vanderpant, Easter Monday [1936].

10. CBC, Peter Varley interview with Henri Masson, 20 May 1969.

11. MCACA, F.H. Varley to Harold Mortimer-Lamb, 6 June 1936 [copy].

12. NAC, MG30 D373, John Vanderpant Papers, F.H. Varley to John Vanderpant, Easter Monday [1936].

13. NGC, Eric Brown Papers, Eric Brown to F.H. Varley, 16 April 1936.

14. MCACA, F.H. Varley to Harold Mortimer-Lamb, 6 June 1936 [copy].

15. NAC, MG30 D373, John Vanderpant Papers, F.H. Varley to John Vanderpant, Easter Monday [1936].

16. CBC, Peter Varley interview with Henri Masson, 20 May 1969.

17. MCACA, Chris Varley's transcription of F.H. Varley to John Varley [?], 14 May 1936.

18. CBC, Peter Varley interview with Henri Masson, 20 May 1969.

19. MCACA, Varley Papers, F.H. Varley to Harold Mortimer-Lamb [copy], 6 June 1936.

20. Lilias Torrance Newton painted several portraits of the Southam family in the late 1930s.

21. CBC, Peter Varley interview with Dorothy McCurry, 17 May 1969.

22. *Liberation* (1936-1937), oil on canvas, AGO.

23. MCACA, Chris Varley's annotations of F.H. Varley to John Varley [?], 15 February 1937.

24. CBC, Peter Varley interview with Miriam Kennedy, 19 July 1969.

25. NAC, MG30 D373, John Vanderpant Papers, F.H. Varley to John Vanderpant, 15 February 1937.

26. AGO, Varley Papers, F.H. Varley to Barbara DeLaye, 2 January 1941.

27. NAC, MG30 D373, John Vanderpant Papers, F.H. Varley to John Vanderpant, 6 June 1936.

28. EAG, F.H. Varley to Vera Weatherbie, 18 January 1937.

29. CBC, Peter Varley interview with Harry Kalman, April 1969.

30. CBC, Peter Varley interview with Leonard Books, April 1969.

31. MCACA, Chris Varley's annotations of F.H. Varley to John Varley [?], [copy], 12 June 1936.

32. EAG, F.H. Varley to Vera Weatherbie, 18 January 1937.

33. NAC, MG30 D273, Eric Newton Papers, Eric Newton, "American Journey," 1 March 1937.

34. *Portrait of H.S. Southam*, canvas, NGC.

35. McKenzie Porter, "Varley," *Maclean's* (7 November 1959), vol. 72, no. 23, p. 66.

36. NAC, MG30 D373, John Vanderpant Papers, F.H. Varley to John Vanderpant, 6 April 1938.

37. EAG, F.H. Varley to Margaret Williams, 12 April 1937.

38. NGC, Eric Brown Papers, John Vanderpant to Eric Brown, 17 August 1936.

39. MCACA, Varley Papers, Chris Varley's transcription F.H. Varley to John Varley, 22 September 1936, p. 66.

40. NAC, Varley Papers, MG30 D368, F.H. Varley to Maud Varley. 29 April 1937.

41. NGC, Eric Brown Papers, F.H. Varley to Eric Brown, 30 August 1937.

42. NAC, MG30 D368, Varley Papers, F.H. Varley to Philip Surrey, 6 November 1937.

43. Peter Varley, *Frederick H. Varley* (Toronto, 1983), p. 29.

44. EAG, F.H. Varley to Margaret Williams, 12 April 1937.

45. Peter Varley, *Frederick H. Varley* (Toronto, 1983), p. 29.

46. CBC, Peter Varley interview with Peter Bortkus, 3 January 1970.

47. CBC, Peter Varley interview with James Varley, 19 May 1970.

48. CBC, Peter Varley interview with Maud Varley, n.d.

49. NAC, CAVA/AVCA 1990-0110, Maud Varley interviewed in "A Tribute to Frederick Varley," 20 September 1969.

50. CBC, Peter Varley interview with James Varley, 19 May 1970.

51. NAC, MG30 D373, John Vanderpant Papers, F.H. Varley to John Vanderpant, Easter Monday [1936].

52. NGC, Eric Brown to F.H. Varley, 15 June 1936.

53. MCACA, Chris Varley's transcription, John Helders to John Vanderpant, 18 November 1936.

54. NAC, MG30 D401, Varley Papers, F.H. Varley to Maud Varley, 19 October 1936.

55. NAC, MG30 D373, John Vanderpant Papers, F.H. Varley to John Vanderpant, 5 November 1937.

56. *Self-Portrait, Days of 1943* (1945), oil on canvas, Hart House, University of Toronto.

57. MCACA, Varley Papers, F.H. Varley to Harold Mortimer-Lamb [copy], 17 November 1937.

58. *Vancouver Sun*, 30 November 1942.

59. NAC, Varley Papers, F.H. Varley to Len Pike, 5 April 1943.

60. CBC, Peter Varley interview with Erica Leach, 13 July 1970.

61. NGC, "Franklin Arbuckle recalls," *Maclean's*, 7 November 1959.

62. AGO, Varley Papers, "Diary," 1 February 1945.

63. CBC, Peter Varley interview with Miriam Kennedy, 19 July 1969.

64. "Varley Says City Could Lead in Art Field," *Ottawa Journal*, 24 October 1936.

65. CBC, Peter Varley interview with David Williams, 6 May 1969.

66. MCACA, Varley Papers, F.H. Varley to Harold Mortimer-Lamb [copy], 12 November 1936; AEAG, Lawrence Sabbath interview with F.H. Varley, 1960 [typescript], p. 19.

67. NAC, MG30 D373, John Vanderpant Papers, F.H. Varley to John Vanderpant, 6 April 1938.

68. MCACA, Chris Varley's transcription, F.H. Varley to John Varley [?], 13 January 1937.

69. CBC, Peter Varley interview with Dorothy McCurry, 17 July 1969.

70. "Varley Says City Could Lead in Art Field," *Ottawa Journal*, 24 October 1936.

71. NGC, Eric Brown Papers, Lilias T. Newton to Eric Brown, 29 September 1939.

72. NGC, Eric Brown Papers, F.H. Varley to Eric Brown, 30 August 1937.

73. NGC, Eric Brown Papers, Eric Brown to H.B. Walker, 4 May 1936.

74. NGC, H.O. McCurry Papers, H.O. McCurry to L.D. Longman, Professor of Art, McMaster University, 8 April 1936.

75. Peter Varley, *Frederick H. Varley* (Toronto, 1983), p. 41.

76. CBC, Peter Varley interview with Henri Masson, 20 May 1969.

77. NAC, MG30 D401, Varley Papers, F.H. Varley to Jess Crosby, n.d. [June 1948].

78. NAC, CAVA/AVCA 1991-0150, J. Russell Harper, May 1975.

79. AGO, Varley Papers, John Watson to F.H. Varley, 27 August 1948.

80. AGO, Varley Papers, Ruth E. Wilkins to F.H. Varley, 18 December 1951.

81. Author's interview with Jack Nichols, 15 March 1996.

82. *Ibid.*

83. CBC, Peter Varley interview with Henri Masson, 20 May 1969.

84. **MCACA**, Varley Papers, F.H. Varley to Harold Mortimer-Lamb [copy], 17 November 1937.

85. William R. Watson, *Retrospective: Recollections of a Montreal Dealer* (Toronto, 1974), p. 58.

86. **NGC**, Lilias T. Newton Papers, Lilias Torrance Newton to Eric Brown, 4 June 1937.

87. Robert Ayre, "Varley Opens up the West Coast and Suggests Other Dimensions," *Montreal Gazette*, 29 May 1937.

88. "Pictures by F.H. Varley at Scott's Gallery," *Montreal Star*, 27 May 1937.

89. E.W.H., "Frederick H. Varley Exhibits Paintings," *Ottawa Citizen*, 24 November 1937.

90. Robert Ayre, "Varley Opens up the West Coast and Suggests Other Dimensions," *Montreal Gazette*, 29 May 1937.

91. See *Moonlight at Lynn* (c. 1960) oil on canvas, McMichael Canadian Art Collection, and *Mirror of Thought* (1937), oil on canvas, Art Gallery of Greater Victoria.

92. **MCACA**, Chris Varley's transcription, F.H. Varley to Jim Varley, 17 January 1951.

93. **EAG**, F.H. Varley to Vera Weatherbie, 29 July 1941.

94. **MCACA**, Varley Papers, F.H. Varley to Harold Mortimer-Lamb [copy], 10 May 1940.

95. *Night Ferry, Vancouver* (1930), oil on canvas, McMichael Canadian Art Collection; *Moonlight After Rain* (1947), oil on canvas, AGO.

96. **AEAG**, Lawrence Sabbath interview with F.H. Varley, 1960 [typescript], p. 3.

97. E.W.H., "Frederick H. Varley Exhibits Paintings," *Ottawa Citizen*, 24 November 1937.

98. *Mirror of Thought* (c. 1935-1936), oil on canvas, Art Gallery of Greater Victoria.

99. **EAG**, F.H. Varley to Margaret Williams, 12 April 1937.

100. Donald W. Buchanan, "Variations in Canadian Landscape Painting," *University of Toronto Quarterly* (October 1940), vol. X, no. 1, p. 41.

101. A.Y. Jackson quoted in "Artist-Explorer," *Canadian Bookman* (July 1927), vol. LX, no. 7, p. 332.

102. **NGC**, H.O. McCurry to Charles Camsell, 30 June 1938.

103. Terence Shortt, "Arctic Sketchbook, 1938," *The Beaver* (Winter 1982), p. 4.

104. Jeremy Brown, "Varley and Shortt," *The Beaver* (Autumn 1978), p. 54.

105. **AGO**, Varley Papers, F.H. Varley to "Little Squirrel" [Barbara Delaye], 7 August 1938.

106. **EAG**, F.H. Varley to Elizabeth Gowling [copy], [September 1938].

107. **NAC**, MG30 D373, John Vanderpant Papers, F.H. Varley to John Vanderpant, 28 June 1937.

108. AGO, Varley Papers, F.H. Varley to Harold Mortimer-Lamb, 13 July [1938].

109. AGO, Varley Papers, F.H. Varley, "'Nascopie,' CBC Radio Talk," 1938, p. 2.

110. NAC, MG30 D401, Varley Papers, F.H. Varley to Miriam Kennedy, 11 August 1938.

111. Jeremy Brown, "Varley and Shortt," *The Beaver* (Autumn 1978), p. 55.

112. Terence Shortt, "Arctic Sketchbook, 1938," *The Beaver* (Winter 1982), p. 8.

113. Jeremy Brown, "Varley and Shortt," *The Beaver* (Autumn 1978), p. 55.

114. Terence Shortt, "Arctic Sketchbook, 1938," *The Beaver* (Winter 1982), p. 4.

115. "Painter Says Canada Does Not Appreciate Arctic Possessions," *Toronto Star*, 10 September 1927; editorial, *Daily Star* (Toronto), 12 September 1927.

116. NAC, MG30 D401, Varley Papers, F.H. Varley to "My dear Sisters," 25 August 1938.

117. AGO, Varley Papers, F.H. Varley, "'Nascopie' CBC Radio Talk," p. 1.

118. AGO, Varley Papers, F.H. Varley to Harold Mortimer-Lamb [copy], 13 July [1938].

119. *Summer in the Arctic* (1938), watercolour, private collection; *Arctic Waste* (1938), watercolour, McMichael Canadian Art Collection.

120. NAC, MG30 D171, Carl Schaefer Papers, Jim Forsythe to Carl Schaefer, 5 March 1939.

121. CBC, Peter Varley interview with Miriam Kennedy, 19 July 1969.

122. There are two oil paintings called *Midnight Sun* (1938), 30.5 x 38.1 and 36.8 x 29.2 cm., both housed in private collections.

123. *Sea Music* (c. 1939-1940) canvas, private collection.

124. AGO, F.H. Varley to Barbara Delaye, 10 January 1941.

125. *Dr. T.* (1944), canvas, private collection.

126. *Liberation* (1943), canvas, private collection.

127. In 1942 Varley approached Vincent Massey and Lord Beaverbrook about the possibility of obtaining a war art commission. See MCACA, Varley Papers, Lord Beaverbrook to F.H. Varley, 19 October 1942, and Vincent Massey to F.H. Varley, 28 January 1943. Although Varley was not an official war artist, he was commissioned by the War Artists Committee to produce three portraits of military personnel at Kingston. One of them, *Canadian Soldier* (1942), canvas, is the property of the Art Collection Society of Kingston.

128. Pearl McCarthy, "Varley of Today Mature in Power," *Globe and Mail*, 4 November 1944.

129. Ronald Hambleton, "The Return of Varley," *Mayfair* (December 1944), vol. XVIII, no. 12, p. 104.

130. Paul Duval, "Vigorous Veteran of Canadian Art – Frederick Horsman Varley," *Saturday Night* (16 December 1944), vol. LX, no. 15, p. 35.

131. *The Open Window* (1932), canvas, Hart House, University of Toronto.
132. NAC, MG30 D401, Varley Papers, F.H. Varley to Alan Beddoe, 16 January 1945.
133. EAG, F.H. Varley to Vera Weatherbie and Harold Mortimer-Lamb, 4 November 1944.
134. AGO, Varley Papers, Mary Konikin to C.S. Band, 22 October 1960.
135. NGC, H.O. McCurry Papers, H.O. McCurry to Louis Muhlstock, 12 December 1941.
136. NGC, H.O. McCurry Papers, Lawren Harris to H.O. McCurry, 14 September 1943.
137. NGC, H.O. McCurry Papers, H.O. McCurry to Lawren Harris, 17 September 1943.
138. NAC, MG30 D401, Varley Papers, F.H. Varley to Billie Pike, n.d. [summer 1941].
139. CBC, Peter Varley interview with Jess Crosby, 1969.
140. AGO, Varley Papers, F.H. Varley to Charles Band, 12 August 1946.
141. NAC, CAVA/AVCA 1990-0110, Dave Brock interviewed in "A Tribute to Fred Varley," 20 September 1969.
142. EAG, F.H. Varley to Vera Weatherbie, 8 November 1939.
143. EAG, F.H. Varley to Vera Weatherbie, n.d. [1944].
144. CBC, Peter Varley interview with Miriam Kennedy, 19 July 1969.
145. CBC, Peter Varley interview with Harry Kelman, April 1969.
146. CBC, Peter Varley interview with Harold Sumberg, 5 December 1969.
147. CBC, Peter Varley interview with Percival Price, 21 January 1970.
148. Fred Pluto, who was one of Varley's drinking buddies in Ottawa, has said that a Major Asquith advanced some money. (CBC, Peter Varley interview with Fred Pluto, 6 July 1970.)
149. NAC, MG30 D401, Varley Papers, F.H. Varley to Billie Pike, 22 July 1941.
150. *Ibid.*, 2 July 1941.
151. CBC, Peter Varley interview with Miriam Kennedy, 19 July 1969.
152. William Weintraub, *City Unique, Montreal Days and Nights in the 1940s and 1950s* (Toronto, 1996), p. 52.
153. McKenzie Porter, "Varley," *Maclean's* (7 November 1959), vol. 72, no. 23, p. 66.
154. NAC, MG30 D368, Philip and Margaret Surrey Papers, Philip Surrey to Margaret Surrey, n.d. [July 1939].
155. CBC, Peter Varley interview with Fred Pluto, 6 July 1970.
156. AGO, Varley Papers, Alan Beddoe to F.H. Varley, 28 December 1940.
157. AGO, Varley Papers, C.J. Duncan to F.H. Varley, n.d. [January 1941].
158. EAG, F.H. Varley to Vera Weatherbie, 20 January 1937.
159. NAC, MG30 D373, John Vanderpant Papers, F.H. Varley to John Vanderpant, 6 April 1938.

160. NAC, MG30 D401, Varley Papers, F.H. Varley to Billie Pike, 21 August [1942].

161. CBC, Peter Varley interview with Miriam Kennedy, 19 July 1969.

162. CBC, Peter Varley interview with Percival Price, 21 January 1970.

163. CBC, Peter Varley interview with Jim Leach, July 1970.

164. MCACA, Varley Papers, Philip Surrey, "Varley as I Knew Him," [typescript], p. 7.

165. NAC, MG30 D401, Varley Papers, F.H. Varley to Jess Crosby, n.d. [June 1949].

166. NAC, MG30 D368, Philip and Margaret Surrey Papers, Philip Surrey, "Autobiography," [1980], p. 86.

167. CBC, Peter Varley interview with Erica Leach, 13 July 1970.

168. CBC, Peter Varley interview with Louis Muhlstock, 12 July 1969.

169. CBC, Peter Varley interview with Riva Brooks, 24 April 1969.

170. CBC, Peter Varley interview with Miriam Kennedy, 19 July 1969.

171. *Manya* (1941), pencil on paper, private collection.

172. NAC, MG30 D401, Varley Papers, F.H. Varley to Jess Crosby, 21 June 1949.

173. NAC, MG30 D401, Varley Papers, F.H. Varley to Billie Pike, 2 August 1942.

174. CBC, Peter Varley interview with Miriam Kennedy, 19 July 1969.

175. CBC, Peter Varley interview with Miriam Kennedy, 19 July 1969.

176. CBC, Peter Varley interview with Erica Leach, 13 July 1970.

177. CBC, Peter Varley interview with Miriam Kennedy, 19 July 1969.

178. Arnold M. Ludwig, *Understanding the Alcoholic's Mind* (New York, 1988), p. 51.

179. AGO, Varley Papers, F.H. Varley to Barbara Delaye, 13 December 1940.

180. CBC, Peter Varley interview with Billie Pike, May 1969.

181. NAC, MG30 D401, Varley Papers, F.H. Varley to Vera Weatherbie, 31 October 1938.

182. EAG, F.H. Varley to Vera Weatherbie, 9 November 1939.

183. CBC, Peter Varley interview with Jim Varley, 19 May 1970.

184. AGO, Varley Papers, Harold Mortimer-Lamb to F.H. Varley, 27 December 1942.

185. PABC, Harold Mortimer-Lamb Papers, "Handwritten Reminiscences of Harold Mortimer-Lamb," n.d.

186. CBC, Peter Varley interview with Miriam Kennedy, 19 July 1969.

187. CBC, Peter Varley interview with Harold Sumberg, 5 December 1969.

188. AGO, Varley Papers, Jim Varley to F.H. Varley, 17 July, 1945.

189. CBC, Peter Varley interview with Miriam Kennedy, 19 July 1969.

190. CBC, Peter Varley interview with Billie Pike, May 1969.

191. AGO, Varley Papers, Jim Varley to F.H. Varley and John Varley, n.d. [1939].

192. Paul Duval, "Vigorous Veteran of Canadian Art," *Saturday Night*, 16 December 1944, p. 35.

193. NAC, Varley Papers, F.H. Varley to Billie Pike, 14 March 1941.

194. MCACA, Varley Papers, Chris Varley's transcription, F.H. Varley to John Vanderpant, 5 April 1937 [copy].

195. *Erica* (1942), Trinity College, University of Toronto.

CHAPTER 9

1. NAC, MG30 D401, Varley Papers, F.H. Varley to Billie Pike, 14 March 1941.

2. NAC, MG30 D401, Varley Papers, F.H. Varley to Miriam Kennedy, 10 August 1942.

3. EAG, F.H. Varley to Vera Weatherbie Lamb, n.d. [1945].

4. AGO, Varley Papers, Kathleen McKay to F.H. Varley, 6 December 1955.

5. *Ibid.*

6. *Ibid.*, n.d. [1952].

7. *Ibid.*, n.d.

8. Author's interview with Kathleen McKay, 27 September 1995.

9. Peter Varley, *Frederick H. Varley* (Toronto, 1983), p. 45.

10. McKenzie Porter, "Varley," *Maclean's* (7 November 1959), vol. 72, no. 23, p. 66.

11. CBC, Peter Varley interview with Jess Crosby, 1969.

12. AGO, Varley Papers, Kathleen McKay to F.H. Varley, 5 January 1952.

13. CBC, Peter Varley interview with Jess Crosby, 1969.

14. *Ibid.*

15. AGO, Varley Papers, A.E. Beddoe to F.H. Varley, 25 October 1954.

16. NAC, CAVA/AVCA 1991-0105, J. Russell Harper interview with Kathleen McKay, May 1975.

17. AEAG, Lawrence Sabbath interview with F.H. Varley, 1960 [typescript], p. 16.

18. MCACA, Varley Papers, Tom Daly to Chris Varley, 30 December 1980.

19. CBC, Peter Varley interview with Tom Daly, 23 July 1969.

20. AGO, Varley Papers, Allan Wargon, "Varley" [filmscript], 15 October 1951.

21. "Varley – a Film Review by George Elliott," *Canadian Art* (Spring 1953), vol. X, no. 3, p. 60.

22. Lotta Dempsey, "Three Toronto Artists Plan Tour of Russia," *Globe and Mail*, 1 April 1954. The artistic delegation consisted of Varley, Eric Aldwinckle (artist), Michelaine LeGendre (marionettist), Madeleine St. Germain (social worker), Charles Lemoine (poet), and Pierre St. Germain (journalist).

23. John Hilliken and Donald Barry, *Canada's Department of External Affairs* (Kingston, 1995), vol. II, p. 112.

24. NAC, MG30 D234, Eric Aldwinckle Papers, J.W. Holmes to Eric Aldwinckle, 29 March 1954.

25. NAC, MG30 D234, Eric Aldwinckle Papers, "Diary of Russia," 9 April 1954.

26. *May Day Procession, Moscow* (1954), crayon, pastel and wash on paper, AGO.

27. NAC, MG30 D234, Eric Aldwinckle Papers, "Diary of Russia," 13 April 1954.

28. *Ibid.*, 23 April 1954.

29. AGO, Varley Papers, F.H. Varley to Kathleen McKay, n.d. [Moscow, April 1954].

30. *Ibid.*

31. AGO, Varley Papers, F.H. Varley on Russian trip [handwritten paper], April 1954.

32. "What Two Canadian Artists Saw in Russia," *Maclean's*, 1 October 1954, p. 10.

33. AGO, Varley Papers, F.H. Varley on Russian trip [handwritten paper], April 1954.

34. AGO, Varley Papers, F.H. Varley to Kathleen McKay, 1 May 1954.

35. AGO, Varley Papers, F.H. Varley to Martin Baldwin, 25 January 1952 (sic), 1954.

36. James Auld, "Opening the Public Eye," *Performing Arts in Canada* (Spring 1966), p. 11.

37. W.Q.K., "Extensive F.H. Varley Exhibition on View at the National Gallery," *Ottawa Journal*, 27 November 1954.

38. *Toronto Telegram*, 2 October 1954.

39. Mildred Valley Thornton, "Varley Paintings on Display Here," *Vancouver Sun*, 13 April 1955.

40. "Portrait of the Artist – an Artistic Reminiscence," *Montreal Gazette*, 8 January 1955.

41. Carl Weiselberger, "Retrospective Exhibition of Paintings," *Ottawa Citizen*, 27 November 1954.

42. George Swinton, "Our Lively Arts – Painting in Canada," *Queen's Quarterly* (winter 1955-56), vol. LXII, no. 4, p. 543.

43. *Ibid.*

44. George Swinton, "Frederick Horsman Varley," *Winnipeg Tribune*, 19 February 1955.

45. "Veteran," *Saturday Night*, 28 March 1950, p. 19.

46. Mollie Stewart, "Aristocrat of Artists Celebrates Birthday," *Toronto Telegram*, 3 January 1964.

47. George Elliott, "F.H. Varley, Fifty Years of His Art," *Canadian Art* (autumn 1954), vol. 12, p. 3.

48. NGC, A.Y. Jackson Papers, A.Y. Jackson to William Hubbard, 1 August 1954.

49. Arthur Lismer quoted in *F.H. Varley, Paintings 1915-1954* (Art Gallery of Toronto, 1954) pp. 4, 7.

50. Jock Carroll, *Weekend Magazine* (1955), vol. 5, no. 1, pp. 7, 8.

51. McKenzie Porter, "Varley," *Maclean's* (7 November 1959), vol. 72, no. 23, p. 31.

52. *Daily News* (Nelson, British Columbia), 14 September 1960.

53. SCA, MD 5887, F.H. Varley to Ethel Varley, 16 August 1955.

54. AGO, Varley Papers, Dr. J.S. Goldie to F.H. Varley, 20 March 1955.

55. AGO, Varley Papers, Allan Wargon to F.H. Varley, 8 July 1960.

56. AGO, Varley Papers, F.H. Varley to Kathleen McKay, 1 June [1955].

57. NAC, Varley Papers, F.H. Varley to Ethel Varley, 16 August 1955.

58. Vancouver Art Gallery Archives, F.H. Varley to Cooper Campbell, 18 July 1955.

59. AGO, Varley Papers, F.H. Varley to Kathleen McKay, "Darling," n.d. [1955].

60. Vancouver Art Gallery, J.S. Goldie to Cooper Campbell, 31 January 1956.

61. AGO, Varley Papers, J.S. Goldie to Kathleen McKay, 17 October [1955].

62. Vancouver Art Gallery, J.S. Goldie to Cooper Campbell, 31 January 1956.

63. This portrait has not been located by the author.

64. CBC, Peter Varley interview with John Goldie, July 1970.

65. Vancouver Art Gallery Archives, J.S. Goldie to Cooper Campbell, 31 January 1956.

66. CBC, Peter Varley interview with John Goldie, July 1970.

67. AGO, Varley Papers, F.H. Varley to L.J. Kerr, 8 February 1955.

68. AGO, Varley Papers, Varley's Bank of Montreal savings book, p. 1.

69. AGO, Varley Papers, George Hulme to F.H. Varley, 12 April 1961.

70. "Vision of Grace," *Time*, 20 January 1961, pp. 12-13.

71. PABC, E.J. Hughes Papers, Lawren Harris to Harold Mortimer-Lamb, 19 January 1961.

72. *Globe and Mail*, 30 May 1980.

73. McKenzie Porter, "Varley," *Maclean's* (7 November 1959), vol. 72, no. 23, p. 71.

74. "A Canadian Romantic," *Toronto Telegram*, 11 February 1956.

75. NAC, MG30 D273, Eric Newton Papers, Eric Newton, "American Journey," 1 January 1937.

76. Paul Duval, "For Frederick H. Varley: A Limelight Long Deserved," *Toronto Telegram*, 14 January 1961.

77. *Ibid.*

78. Pearl McCarthy, "Varley's latest work reveals his mastery," *Globe and Mail*, 4 March 1950.

79. NAC, MG30 D322, Norah Thomson DePencier Papers, A.Y. Jackson to Nora DePencier, 20 March 1958.

80. MCACA, Arthur Lismer Papers, A.Y. Jackson to Viven [?], 23 February 1961.

81. AEAG, Lawrence Sabbath interview with F.H. Varley, 1960 [typescript], p. 15.

82. *Toronto Telegram*, 1 January 1966.

83. CBC, 650-420-3, *Varley at 85*, 20 April 1965.

84. AEAG, Lawrence Sabbath interview with F.H. Varley 1960 [typescript], pp. 12, 8.

85. CBC, 650-420-3, *Varley at 85*, 20 April 1965.

86. CBC, 650-420-3, *Varley at 85*, 20 April 1965.

87. AGO, Varley Papers, Vera Weatherbie and Harold Mortimer-Lamb to F.H. Varley, 21 December 1955; see also Vera Weatherbie to F.H. Varley, 19 January 1961.

88. AGO, Varley Papers, Sadie Shaw to F.H. Varley, 15 April, n.d.

89. AGO, Varley Papers, Kathleen MacNeill to F.H. Varley, 20 April 1965.

90. AGO, Varley Papers, Vito Cianci to F.H. Varley, 6 February 1961.

91. AGO, Varley Papers, Frank Horratin to F.H. Varley, 2 May 1960.

92. AGO, Varley Papers, Florence Wyle and Frances Loring to F.H. Varley, 1 January 1960. It was during the 1920s that Florence Wyle had produced the bust of Varley which is housed in the NGC.

93. CBC, 650-420-3, *Varley at 85*, Jack Nichols interviewed, 20 April 1965.

94. AGO, Varley Papers, C.S. Band, "Ladies & Gentleman," [1964].

95. NAC, MG30 D401, Varley Papers, F.H. Varley to Jim and Margaret Varley, 17 January 1951.

96. AGO, Varley Papers, Ethel Varley to F.H. Varley, 12 January 1950.

97. AGO, Varley Papers, Ethel Varley to F.H. Varley, 17 April 1955.

98. AGO, Varley Papers, Ethel Varley to F.H. Varley, 9 February 1956.

99. AGO, Varley Papers, Ethel Varley to F.H. Varley, 5 July 1962.

100. *Sheffield Telegram*, 10 February 1956.

101. NAC, MG30 D393, John Vanderpant Papers, F.H. Varley to John Vanderpant, 5 November 1937.

102. NAC, MG30 D401, Varley Papers, F.H. Varley to "sisters" [Lilian and Ethel Varley], 28 April 1950.

103. NAC, MG30 D401, Varley Papers, F.H. Varley to Ethel Varley, [December 1955].

104. The two works were listed as *Storm* and *Storm and Mountain View*.

105. AGO, Varley Papers, Ethel Varley to F.H. Varley, 13 May 1955.

106. NAC, CAVA/AVCA 1991-0105, J. Russell Harper interview with Kathleen McKay, May 1975.

107. *Ibid.*

108. AGO, Varley Papers, Ethel Varley to F.H. Varley, 27 April 1956.

109. NAC, CAVA/AVCA 1991-0105, J. Russell Harper interview with Kathleen McKay, May 1975.

110. *Ibid.*

111. *Ibid.*

112. *Ibid.*

113. Author's interview with Kathleen McKay, 16 September 1995.

114. NAC, MG30 D305, Yvonne McKague Housser Papers, Arthur Lismer to Yvonne McKague Housser, 15 June 1936; author's interview with Kathleen McKay, 27 September 1995.

115. NAC, CAVA/AVCA 1991-0105, J. Russell Harper interview with Kathleen McKay, May 1975.

116. CBC, Peter Varley interview with Billie Pike, 18 May 1969.

117. AEAG, Lawrence Sabbath interview with F.H. Varley 1960 [typescript], pp. 11, 6.

118. AGO, Varley Papers, Ethel Varley to F.H. Varley, 7 May 1964. Particularly disturbing to Ethel Varley was an article in the *Sheffield Telegraph*, 1 February 1960, which charged Samuel Varley with throwing his son out of the house for refusing to follow a career in commercial art.

119. AGO, Varley Papers, Ethel Varley to F.H. Varley, 15 January 1965.

120. AGO, Varley Papers, Ethel Varley to F.H. Varley, 25 June 1966.

121. CBC, Peter Varley interview with Ethel Varley, July 1969.

122. AGO, Varley Papers, Vera Weatherbie to Charles Band, 5 February 1967.

123. PABC, Harold Mortimer-Lamb Papers, "Handwritten Reminiscences of Harold Mortimer-Lamb."

124. CBC, Peter Varley interview with Jim and Erica Leach, 13 July 1970.

125. Molly Lamb Bobak, *Impressions and Sketches of a Field Artist, Wild Flowers of Canada* (Toronto, 1978), p. 76.

126. The estate included royalties from the illustrations he produced for Edmund Carpenter's *Eskimo* (Toronto, 1959), the residue of Varley's savings, and all works of art and amounts owing to Varley from the Roberts Gallery. Upon Varley's death on 8 September 1969, Kathleen McKay moved the bulk of his work into the AGO. It remained there for two years. Then, McKay took it back. In 1974, 1976, 1977, and 1979 she did sell and give the Gallery several works. But the bulk of the collection ended up, following her death in December 1996, in the Frederick Horsman Varley Art Gallery in Unionville, which was established in 1997.

127. AGO, Varley Papers, Peter Varley to F.H. Varley, 25 March 1955.

128. AGO, Varley Papers, Dorothy Varley to F.H. Varley, n.d.

129. NAC, MG30 D401, Varley Papers, F.H. Varley to Jim Varley, 20 August 1942.

130. CBC, Peter Varley interview with Orville Fisher, 8 July 1970.

131. NAC, MG30 D401, Varley Papers, F.H. Varley to Jim Varley, January 1944.

132. Jean Sutherland Boggs in Peter Varley, *Frederick H. Varley* (Toronto, 1983), p. 13.

133. AGO, Varley Papers, Jim Varley to Kathleen McKay, n.d., and John Varley to Kathleen McKay, 11 November 1968.

134. "Kathleen Gormley McKay, Lives Lived," *Globe and Mail*, 15 January 1997.

135. AGO, Varley Papers, John Varley to Peter Varley, 18 April 1968.

136. CBC, Peter Varley interview with Billie Pike, 18 May 1969.

137. CBC, Peter Varley interview with Jess Crosby, December 1969.

138. Joyce Putman, *Seven Years with the Group of Seven, A Memoir in the World of Pictures* (Kingston, 1991), p. 73.

139. See, for example, "Fred Varley Celebrating 88th Birthday," *Montreal Gazette*, 4 January 1969.

140. McKenzie Porter, "Varley," *Maclean's* (7 November 1959), vol. 72, no. 23, p. 31.

141. AGO, Varley Papers, Dr. John Goldie to F.H. Varley, 3 January 1965.

142. AGO, Varley Papers, John Varley to Kathleen McKay, 11 November 1968.

143. CBC, Peter Varley interview with Ethel Varley, April 1969.

144. Author's interview with Kathleen McKay, 16 September 1995.

145. AGO, Varley Papers, John Varley to Peter Varley, 18 April 1968.

146. CBC, Peter Varley in conversation with Dorothy Varley (Sewell) and Jim Varley, 10 July 1970.

147. NAC, Dorothy Dyde Papers, MG30 D231, A.Y. Jackson to Dorothy Dyde, 31 October 1965.

148. NAC, CAVA/AVCA 1990-0110, Barker Fairley *et al.* interviewed in "A Tribute to Frederick Varley," 20 September 1969.

149. CBC, Peter Varley Interview with Orville Fisher, 8 July 1970.

LIST OF ILLUSTRATIONS

(Paintings and drawings are by F.H. Varley unless otherwise indicated.)

Still Life — Skull and Lantern, c. 1897.
Ink on paper, 22.5 x 30.3 cm.
Presented to the McMichael Canadian Art Collection in loving memory of my father, Harold Brownhill, friend and colleague of Fred H. Varley during their early years in Sheffield, England, by his daughter, Eugenie M. MacLeod. McMichael Canadian Art Collection. (1993.21.3).

Seven Fields, 1900.
Watercolour on paper, 32.7 x 26.4 cm.
Mappin Art Gallery, Sheffield. Reproduced by permission of the Sheffield Galleries and Museums Trust.

Portrait of Samuel J.B. Varley, c. 1900-02.
Charcoal on buff woven paper, 37.8 x 37.0 cm.
National Gallery of Canada, Ottawa. Gift of Ethel Varley, Sheffield, England, 1969, in memory of the artist. Acc. #15912.

Burbage Brook, 1901.
Watercolour on paper, 32.4 x 14.3 cm.
Mappin Art Gallery, Sheffield City Museum. Reproduced by permission of the Sheffield Galleries and Museums Trust.

"Eve wandered in the valley ill at ease," 1903.
Illustration reproduced in *The Gentlewoman*, October 24, 1903, page 565.

F.H. Varley with *Eden*, 1912.
Photograph.
Sheffield *Daily Independent*, 29 February 1912.

The Hillside, c. 1912.
Watercolour on paper, 44.3 x 32 cm.
Courtesy Irving Ungerman.

The Battlefield after a Canadian Charge, 1916.
Photograph.
National Archives of Canada. (PA868).

Stormy Weather, Georgian Bay, 1917.
Oil on canvas, 132.6 x 162.8 cm.
National Gallery of Canada, Ottawa. Acc. #1814.

For What?, 1918.
Oil on canvas, 147.2 x 182.8 cm.
Copyright Canadian War Museum. Catalogue #8911.

Some Day the People Will Return, 1918.
Oil on canvas, 182.8 x 228.6 cm.
Copyright Canadian War Museum. Catalogue #8912.

Mont St. Eloi, World War I, "In Arras," c. 1918-19.
Oil on wood, 29.8 x 40.6 cm.
University of British Columbia, The Morris and Helen Belkin Art Gallery. Gift of N.A.M. MacKenzie.

The Sunken Road, 1919.
Oil on canvas, 132.4 x 162.8 cm.
Copyright Canadian War Museum. Catalogue #8912.

Cyril H. Barraud, 1919.
Oil on panel, 38.1 x 33.0 cm.
Art Gallery of Ontario, Toronto. Purchased with donations from AGO Members, 1990. Photo: AGO / Carlo Catenazzi.

Self-portrait. 1919.
Oil on canvas, 61.0 x 50.8 cm.
National Gallery of Canada, Ottawa. Purchased 1936. Acc. #4272.

Group of Seven seated around table at the Arts and Letters Club (detail), c. 1920.
Photograph.
Art Gallery of Ontario. Acc. #PH-13 #2.

Peter Sandiford at Split Rock, Georgian Bay, 1922.
Oil on wood panel, 21.0 x 26.7 cm.
Art Gallery of Ontario, Toronto. Presented in memory of Dr. Martin Baldwin by
the Art Institute of Ontario, 1968. Photo: AGO / Carlo Catenazzi.

Maud and Fred Varley at Georgian Bay, n.d., c. 1922
Photograph
Art Gallery of Ontario. Acc. #PH-465-1

Portrait of Alice Vincent Massey. c. 1924-25.
Oil on canvas, 82.0 x 61.7 cm.
National Gallery of Canada, Ottawa. (15558) Vincent Massey Bequest, 1968.

Portrait of Maud, 1925.
Oil on canvas, mounted on beaverboard, 50.5 x 60.7.
National Gallery of Canada. Purchased 1978. Acc. #23152.

Mimulus, Mist and Snow, c. 1927.
Oil on canvas, 69.5 x 69.5 cm.
London Regional Art Gallery.

The Cloud, Red Mountain, 1927-28.
Oil on canvas, 87.0 x 102.2 cm.
Art Gallery of Ontario, Toronto. Bequest of Charles S. Band, Toronto, 1970. Photo:
AGO.

Cheakamus Canyon, B.C., 1929.
Oil on wood panel, 30.5 x 38.1 cm.
Courtesy Mrs. Ross A. Lort, Vancouver.

Vera. 1930.
Oil on canvas, 61.0 x 50.6 cm.
National Gallery of Canada, (15559) Vincent Massey Bequest, 1968.

John Vanderpant, *Portrait of Vera Weatherbie*, c. 1930.
Photograph.
Art Gallery of Ontario.

Nude Standing, c. 1930.
Black chalk on paper, 27.0 x 12.1 cm.
National Gallery of Canada, Ottawa. Purchased 1937. Acc. #4356.

John Vanderpant, *Frederick Horsman Varley*, c. 1932.
Photograph
Vancouver Art Gallery (VAG 90.68.19). Courtesy Vancouver Art Gallery. Photo:
Trevor Mills.

Dhârâna, 1932.
Oil on canvas, 86.4 x 101.6 cm.
Art Gallery of Ontario, Toronto. Gift from the Albert H. Robson Memorial
Subscription Fund, 1942. Photo: AGO.

Vera Weatherbie, *Solitude*, c. 1932.
Oil on wood panel, 29.7 x 37.3 cm.
Art Gallery of Greater Victoria.

Complementaries, 1933.
Oil on canvas, 101.0 x 85.0 cm.
Art Gallery of Ontario, Toronto. Bequest of Charles S. Band, 1970. Photo: AGO.

The Open Window, c. 1933.
Oil on canvas, 102.9 x 87.0 cm.
Hart House, University of Toronto.

Head of a Girl, c. 1934.
Charcoal and charcoal wash on woven paper, 23.9 x 23.1 cm.
National Gallery of Canada, Ottawa. (Acc. #4305) Purchased 1936. Photo: NGC.

Liberation, 1936.
Oil on canvas, 213.7 x 134.3 cm.
Art Gallery of Ontario, Toronto. Gift of John B. Ridley, 1977. Donated by the
Ontario Heritage Foundation, 1988. Photo: AGO. Acc. #L77.131.

The Artist Sketching at Lynn Valley, 1937.
Photograph.
Art Gallery of Ontario. Acc. #PH-464-1.

Night Ferry, Vancouver, 1937.
Oil on canvas, 81.9 x 102.2 cm.
McMichael Canadian Art Collection. Purchase 1983. (Acc. #1983.10).

Mirror of Thought, 1937.
Oil on canvas, 50.7 x 60.9 cm.
Art Gallery of Greater Victoria.

Arctic Waste, 1938.
Watercolour over graphite on paper, 23.0 x 30.8 cm.
McMichael Canadian Art Collection. Gift of Mrs. E.J. Pratt. (1969.9.2).

Erica, 1942.
Oil on panel, 28.2 x 37.1 cm.
Trinity College Archives (P1098/1093).

Cornfield at Sunset, 1943.
Oil on panel, 30.0 x 38.1 cm.
Art Gallery of Ontario, Toronto. Gift from the Fund of the T. Eaton Co. Ltd., for
Canadian Works of Art, 1951. Photo: AGO / Larry Ostrom.

Self-portrait, Days of 1943, c. 1945.
Oil on canvas, 49.5 x 40.7 cm.
Hart House, University of Toronto.

Moonlight after Rain, 1947,
Oil on canvas, 61.2 x 71.1 cm.
Art Gallery of Ontario, Toronto. Gift from the Douglas M. Duncan Collection,
1970. Photo: AGO/ Larry Ostrom.

The remaining members of the Group of Seven at the opening of an exhibition of
works by Lawren Harris, fall 1948.
Photograph
Art Gallery of Ontario, Toronto. Acc. #PH-150-1.

Varley at the Doon Summer School of Fine Arts, Doon, 1948.
Photograph.
Courtesy the Edward P. Taylor Research Library, Art Gallery of Ontario. Original
photo: Gift of Mrs. Donald McKay. Photo: AGO/ Carlo Catenazzi. Acc. #PH-643.

Varley and a group of artists on a sketching trip. c. 1948.
Photograph
Courtesy the Edward P. Taylor Research Library, Art Gallery of Ontario. Original photo: Gift of Mrs. Donald McKay. Photo: AGO/ Carlo Catenazzi. Acc. #PH-645.

Kathy, 1953.
Graphite and coloured chalks on prepared paper, 28.6 x 21.0 cm.
Art Gallery of Ontario, Toronto. Gift from the Fund of the T. Eaton Co. Ltd., for Canadian Works of Art, 1964. Photo: AGO. Acc. #53/21.

Studio Door, c. 1953.
Oil on canvas, 101.6 x 76.5 cm.
The Montreal Museum of Fine Arts. Purchase. Horsley and Annie Townsend Bequest. Photo: The Montreal Museum of Fine Arts, Marilyn Aitken.

May Day Procession, Moscow, 1954.
Crayon, pastel and wash on paper, 24.1 x 34.8 cm (sight).
Art Gallery of Ontario, Toronto. Gift from the John Paris Bickell Bequest Fund, 1955. Photo: AGO / Brigdens.

Varley in Vosstaniye Square, Moscow, 1954.
Photograph.
Courtesy the Edward P. Taylor Research Library, Art Gallery of Ontario. Original photo: Gift of Mrs. Donald McKay. Photo: AGO/ Carlo Catenazzi. Acc. #PH-646.

Varley's sisters, Lily (aged 80) and Ethel (77), 1956.
Photograph.
Courtesy the Edward P. Taylor Research Library, Art Gallery of Ontario. Original photo: Gift of Mrs. Donald McKay. Photo: AGO/ Carlo Catenazzi. Acc. #PH-647.

Varley and Kathleen McKay c. 1960.
Photograph.
Courtesy the Edward P. Taylor Research Library, Art Gallery of Ontario. Original photo: Gift of Mrs. Donald McKay. Photo: AGO/ Carlo Catenazzi. Acc. #PH-644.

Varley in his studio in Unionville, c. 1963.
Photograph.
Courtesy of Art Gallery of Ontario. Original photo: Gift of Mrs. Donald McKay. Photo portrait by Elizabeth Fry. Acc. #PH-156-1.

INDEX